# GRAHAM SUTHERLAND

RONALD ALLEY

# GRAHAM SUTHERLAND

THE TATE GALLERY

**The Graham Sutherland Gallery**
Picton Castle, The Rhos, Haverfordwest, Dyfed SA62 4AS

The Collection was given by Graham Sutherland in recognition
of his debt to that part of Wales as the inspiration of many
of his finest works. It has been greatly enlarged since his
death and is housed in part of Picton Castle made available
by the Hon. Hanning Philips and his wife, Lady Marion.

The Gallery is open:
1 April – 30 September every day except Monday
10.30 – 12.30 / 1.30 – 5.00
Open on Bank Holidays
For further information telephone Rhos (043 786) 296

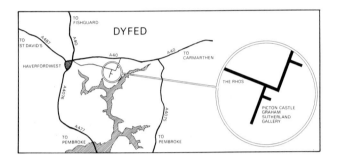

ISBN 0 905005 48 1
Published by order of the Trustees 1982
for the exhibition of 19 May – 4 July 1982
Published by the Tate Gallery Publications Department,
Millbank, London SW1P 4RG
Designed by Sue Fowler
Printed by Balding + Mansell, Wisbech, Cambs.

**This exhibition is sponsored by Mobil**

# Contents

Cover: 'Thorn Tree' 1945 (detail, Cat.no.125)
Frontispiece: Sutherland with his sketch-book
in Pembrokeshire, 1976. Photo: Gilbert Adams FRPS

# Foreword

A retrospective exhibition of Graham Sutherland's work has been part of our programme for some time and we were looking forward to organising it in collaboration with the artist himself. Sadly Sutherland's death in February 1980 has turned this into a memorial exhibition. As a tribute to him and because a full-scale retrospective exhibition of his work in this country is long overdue (twenty-eight years have passed since the one at the Tate Gallery in May 1953), we decided to plan it on a large scale and show his entire development, from the early etchings through to the late works, inspired once again by Pembrokeshire, and including examples of the posters, china and glass which he designed in the 1930s.

The owners of his works have been most generous and co-operative, and although a few items we wanted were not available, this is without doubt the largest and most comprehensive exhibition ever of Sutherland's work, and it brings together very many of his finest paintings of all periods. We should like to express our warmest thanks to all the lenders, including those who have wished to remain anonymous. H.R.H. the Prince Philip, Duke of Edinburgh, has kindly lent a study for the Coventry tapestry, while other important studies for the tapestry have come from Coventry Cathedral and the Herbert Art Gallery, Coventry. The Vicar and Parochial Church Council of St Matthew's, Northampton, have lent the great 'Crucifixion' of 1946, which has never been shown outside the church before. A number of major paintings, including a substantial proportion of the late works, have come from Italian collections; Italy is a country where Sutherland had many admirers and friends.

For help in organising the exhibition we are particularly grateful to Mrs Kathleen Sutherland for her support and encouragement; James Kirkman for assistance in tracing works; Roger Berthoud for making available a set of proofs of his biography of Sutherland, in advance of publication; Gilbert Lloyd and Marlborough Fine Art for a contribution towards the cost of the colour plates in the catalogue; John Longstaff of Marlborough Fine Art for information and help with photographs; Basil Alexander, Sir Norman Reid and Gordon Bennett for arranging the loan of works from Picton and from the Estate; and Mr and Mrs Pier Paolo Ruggerini for their unfailing helpfulness and generosity. We are most grateful to Mobil for their sponsorship of the exhibition.

My colleague Ronald Alley, the Keeper of the Modern Collection, has selected the exhibition and written the catalogue.

Alan Bowness
Director

# Introduction

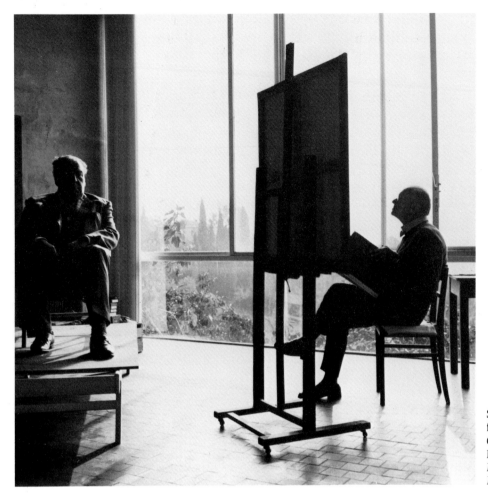

Sutherland making studies
for the portrait of Lord
Goodman in his studio at
Menton in 1973
*Photo by Erich Auerbach,
FRPS*

Though some of Graham Sutherland's works are widely known, even to the
general public not much interested in modern art (such as 'Entrance to a Lane',
the portraits of Maugham and Churchill, and the Coventry Tapestry), there
have been few attempts to show his production as a whole and to follow his
remarkable and varied development through all its stages. Even the re-
trospective exhibition at the Tate in 1953, his last major retrospective in this
country, was very incomplete as it included none of the early etchings and not a
single example of the works done as an official war artist; and he continued to be
productive for more than twenty-six years after that, right up to his death in
February 1980. Owing to the great success which he had in Italy in the last ten
years of his life, and the large number of his exhibitions there, most of his late
works went straight into collections abroad and have never been seen in Britain.
This exhibition provides therefore a unique opportunity to see in its full range
the work of one of the greatest British artists of this century.

Sutherland was born in London in 1903, the son of a lawyer who later
became a civil servant, employed first in the Land Registry Office and then in the
Board of Education. His family background was therefore a conventional
middle-class one, comfortable but far from wealthy. After leaving Epsom College
in 1919 and being given some preliminary coaching, he was apprenticed as an
engineer at the Midland Railway Works in Derby, because his parents thought

that this would give him a secure livelihood. Though he did not actively dislike the work, he was no good at mathematics and after about a year succeeded in persuading his father that he would never make an engineer and that he should be allowed to study art, which is what he really wanted. However his time at Derby was far from wasted, as it gave him a familiarity with machines and large factory floors which was to be useful to him later on in his paintings of blast furnaces and foundries as an official war artist, and in his studies of mechanical forms.

As there were no vacancies in the Slade School, which was his first choice, he became a student in 1921 at London University's Goldsmith's College School of Art, specialising in engraving. This was the period of a great engraving boom, when there was a flourishing market for contemporary etchings both in Britain and the United States. Though the teaching in the engraving department at Goldsmith's was good as far as basic techniques were concerned, it was unimaginative and rather academic. Sutherland and his small circle of friends made pastiches of Rembrandt, Dürer and Whistler until the day, apparently in the autumn of 1924, when one of them chanced to find an etching by Samuel Palmer in the Charing Cross Road. As Sutherland recalled later:

*I remember that I was amazed at its completeness, both emotional and technical. It was unheard of at the school to cover the plate almost completely with work, and quite new to us that the complex variety of the multiplicity of lines could form a tone of such luminosity. . . . As we became familiar with Palmer's later etchings, we 'bit' our plates deeper. We had always been warned against 'overbiting'. But we did 'overbite' and we 'burnished' our way through innumerable 'states' quite unrepentant at the way we punished and maltreated the copper. . . . It seemed to me wonderful that a strong emotion, such as was Palmer's, could change and transform the appearance of things.* [1]

This passion for Samuel Palmer, almost exactly 100 years after Palmer's own visionary Shoreham period and beginning just before the great Palmer exhibition at the Victoria and Albert Museum in 1926, led Sutherland to make a series of small, densely worked etchings of rural England, thatched cottages and churches, fields with stooks of corn, the setting sun and the first evening stars, which were intensely poetic evocations of a more or less lost world of innocence and religious piety. (He became a convert to the Roman Catholic Church in December 1926 in preparation for his marriage to a fellow-student at Goldsmith's, Kathleen Barry, who was herself a Catholic). Thus he admired and was friendly for a time with the older etcher F.L. Griggs, a master technician, whose vision of medieval England, with life centred round the great Gothic churches, was somewhat akin to his own.

It seems surprising indeed in retrospect that Sutherland, known later as a daring 'modern' artist, should have begun in such a backward-looking style, but at that period ignorance about the new twentieth-century art movements was still widespread in this country. Only one of the teachers at Goldsmith's, Clive Gardiner, attempted to introduce the students to the work of artists such as Cézanne, Picasso and Matisse, and at that time Sutherland was not yet interested. Gradually however, by about 1927, he began to realise that things were happening in art which could not be ignored and that he was in danger of finding himself in a cul-de-sac. A greater simplification started to appear in his work; more significantly, the first signs emerged of an interest in writhing vegetation, twisting tree roots and other similar organic forms. However it is

probable that he would have gone on making etchings for longer had it not been for the Wall Street Crash in October 1929, which put a sudden end to purchases by American collectors and led soon afterwards to a slump in sales of prints to British collectors as well.

Though Sutherland made several further etchings after 1929 – including 'Pastoral', in which one can see for the first time clear intimations of his later development – he now turned to experimenting with watercolours and oils. No longer receiving a steady income from sales of prints through the Twenty-One Gallery (where he had had two successful one-man exhibitions of prints in 1924[2] and 1928), he was obliged to support himself until 1939 partly by designing posters, china, glass and other forms of applied art, and even submitted designs in 1935 for a King George V postage stamp. The two bodies which took the lead in commissioning good artists to design posters in the 1930s were Shell-Mex & B.P. Ltd (for whom Sutherland designed four posters) and London Transport (for whom he did five); and he also made at least one apiece for the Post Office and for the Orient Line, run by Colin Anderson. Several of these, such as '...From field to field' and 'Brimham Rock', rank among the finest produced in Britain at this period, and show a development from a naturalistic style to a freer, more imaginative treatment. Similarly his designs for the decoration of china, earthenware and glass dating from 1933–4 are notable for their freshness, neatness and professionalism.

Only very few watercolours and a single small oil painting of the period 1930–4 seem to have survived, and it is clear that the transition to painting was not easy. He seems to have started in a style rather similar to that of the last etchings and to have gradually developed looser, bolder brushstrokes, but without achieving anything very personal. Traces of the influence of Paul Nash appear from time to time (Nash providing a natural link between the Samuel Palmer tradition and the modern movement in British art). However it was not until his first visit in 1934 to Pembrokeshire, a county that was to be a crucial source of inspiration to him from then on, that he began to find his way as a painter.

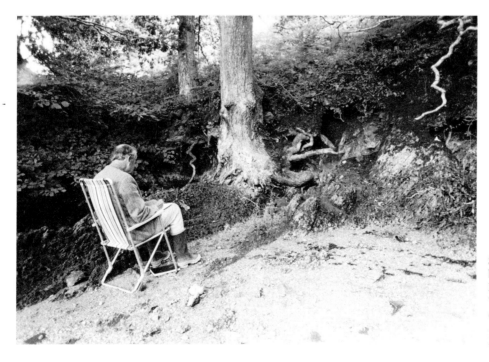

Sutherland drawing a tree beside the private beach at Benton Castle in 1970. This very tree appears in catalogue nos.207, 211, 212 and 269
*Photo by Giorgio Soavi*

'It was in this country that I began to learn painting', he wrote afterwards to Colin Anderson in a letter which is reprinted on pp. 23–6 of this catalogue. 'It seemed impossible here for me to sit down and make finished paintings "from nature". Indeed, there were no "ready made" subjects to paint . . . I found that I could express what I felt only by paraphrasing what I saw.'[3] The bare structure of the land around St David's fascinated him, but the landscape did not lend itself to 'scenic' painting in the conventional manner. He therefore soon gave up trying to produce finished works of art out of doors, on the spot, capturing effects of light and weather and so on (something at which in any case he was not particularly good), and began to make drawings in a sketchbook which he could work up into pictures in his studio. In his watercolours the landscape began to take on a life of its own, with all the forms caught up in a unifying rhythm.

The walled wood at Monk Haven, near St Ishmaels
*Photo by Giorgio Soavi*

A clue to his attitude at the time is provided by his article 'A Trend in English Draughtsmanship', published in *Signature* in July 1936, in which he attempted to characterise the type of draughtsmanship which is 'subjective, and depends on the disposition of the artist to design from his inner consciousness'.[4] The artists whom he cited as representative of this trend were William Blake (especially the late Blake of the Dante drawings and the wood-engravings for Thornton's Virgil), late Turner, Henry Moore and Paul Nash, whose drawings for Sir Thomas Browne's *Urne Buriall and the Garden of Cyrus* he described as 'a poetic and imaginative achievement without equal to-day in this country'. The inconsistencies of style in Blake's early work were, he felt, partly due to his having borrowed too extensively from other artists without refreshing his imagination by making studies from nature. 'Had he nourished his conceptual ideas by familiarising himself with the ways of nature, his art might have reached the perfection of its maturity at an earlier period.'[5]

Nature was always, or almost always, the starting point for his own work, however far removed from conventional nature images the end-products might sometimes appear to be. The Pembrokeshire landscape was a revelation to him as it was full of forms and suggestions totally new to him, forms which seemed to

lend themselves to the ideas which had begun to develop in his mind over the previous two or three years, and shapes which were very like those he had seen in the paintings reproduced in *Cahiers d'Art*, particularly in the works of Miró. He began to notice that if one keeps one's eyes open almost everything in landscape is potential material for painting. Though never regarding himself as a true Surrealist, he learnt from Surrealism that there was worthy subject-matter for painting in objects the painter would never have looked at before, and that forms which interested him existed already in nature, and were waiting for him to find them. Just as Henry Moore drew inspiration from pebbles and bones, which he collected and took home with him, so Sutherland was fascinated by such 'found objects' as root forms, gnarled tree trunks and fragments of thorn trees, which demonstrated the principles of organic growth. Objects like these, which most people would hardly notice, were divorced from their context and treated as things having intrinsic value of their own.

How this process of seeing reality, but seeing it in a new way, actually operated in practice was described by Sutherland as follows:

*The first reaction, of course, is through the eye. Perhaps one goes for a walk. There is everything around one; but one reacts to certain things only, as if in response to some internal need of the nerves. The things one reacts to vary. I have myself sometimes noticed a juxtaposition of forms at the side of a road, and on passing the same place next week they are gone. It was only at the original moment of seeing that they had significance for me.*

*I sometimes make notes. However brief they may be, this practice is useful to me; I can take my subject home with me as it were. If I react fully – with no preconceptions – it is as if I had never seen my subject before. In the studio, I remember; it may be an hour ago or years, and I react afresh. The images dissolve; objects may lose their normal environment and relationship. Then things seem to be drawn together and redefined in the mind's eye in a new life and a new mould – there has been a substitution, a change. But I feel this to be valid only in so far as the process of digestion has preserved in the substance of my material – paint and canvas – the sensation of the original presence, in its new and permanent form.*[6]

The practice which he adopted from the mid-1930s onwards when searching for material was to go for walks with no particular preconceived ideas. He took a small notebook and he looked left and right as he was walking, and then suddenly he would see something and make a note of it. Later he might come back and make a more complete study. These notes were extremely important as they were the basis of the final painting, and in addition they had the virtue of speed.

*The moment of seeing is often fleeting and I will see something which fascinates me, but if I have not had time to make a note at the moment of recognition, it may be useless to me to return, as the object which I have seen will have disappeared and mean nothing to me. It must be there, of course, but the flash of recognition has passed. It is a thing that you see suddenly and it can't be recaptured. It is the element of the accident and the accidental encounter which is important.*[7]

These unpredictable moments of illumination, when some natural form seems to take on a kind of presence, a life, a personality (and which have been compared with the Wordsworthian moments of vision) are at the heart of much of his work, and give it a particular magic. Forms suggest other forms, correspondences in the Symbolist sense of the word develop between organic

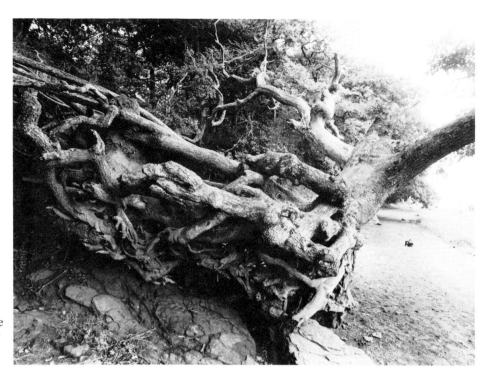

Sutherland's favourite tree
on the bank of the estuary
at Picton
*Photo by Giorgio Soavi*

forms and figures, figures and stones, organic forms and machines; landscape forms can take on a threatening or erotic character.

The growing imaginative power of his work, and sense of drama, bore fruit in the works shown in his first two one-man exhibitions of drawings and paintings at Rosenberg & Helft in 1938 and the Leicester Galleries in 1940, in pictures such as 'Entrance to a Lane', 'Gorse on Sea Wall' and 'Green Tree Form'. Whereas 'Entrance to a Lane' was just a place which he paraphrased and simplified, both 'Gorse on Sea Wall' and 'Green Tree Form', like various other works of this period, contained conscious allusions to the human figure. The colours became much stronger and bolder, and the designs more highly charged and monumental, sometimes with forms viewed end on in violent foreshortening, and there was increasing use of the idioms of the international modern movement.

Just when he had begun at last, in his mid-thirties, to be recognized as a major oil painter, there seemed a danger of his career being suddenly interrupted. His second one-man exhibition of paintings in May 1940 more or less coincided with the fall of France. In the situation of frantic emergency which followed, he had already put his name down to learn munition gauge making when Kenneth Clark arranged for him to be employed as one of the official war artists. The war artists' scheme had been inaugurated on the lines of the one created half-way through the First World War, to employ artists to make a visual record of the war in all its aspects and boost public morale, and also (less overtly) as a way of ensuring that as many as possible of the most gifted artists survived the war.

Sutherland approached the new tasks with great anxiety as he was unsure how he would react to such a different type of subject-matter; indeed his attempt to draw military aircraft was not a success. However as soon as the bombing began and he was sent to South Wales to make drawings of bomb damage he found the scenes moving and enthralling. The drawings and paintings he made both there and in London, in the months that followed, are among the most vivid and memorable records of the Blitz, with shattered buildings under

ominous black skies. Crumpled girders and lift-shafts totter and writhe like mortally wounded animals; there are scenes of total devastation and silence, after all the people had gone. Later he was sent to make drawings and paintings of blast furnaces and iron foundries, then scenes of tin mining in Cornwall, limestone quarrying in Derbyshire and opencast coal mining in Wales. Finally, after the liberation of France, he was sent to Paris (the first time he had ever been abroad) to make studies of the damage done by the R.A.F. to railway marshalling yards and flying bomb depots. His method throughout was to make rapid notes on the spot which were worked up at home into more elaborate drawings, culminating in a definitive version, the largest and most finished, which he handed over to the War Artists' Advisory Committee. Just as in doing his drawings of bomb damage he became fascinated by the way different types of material respond to violent explosions, so his scenes of mining and quarrying, and even his pictures of blast furnaces, have the recurrent theme of man's conflict with nature from which he only just emerges victorious. They have about them something of the nightmarish and claustrophobic atmosphere of Dante's Inferno.

Though all but a small part of his time from August 1940 until April 1945 was taken up with work of this type (mostly drawings rather than paintings), he also managed to make a limited number of watercolours and a few oil paintings of landscape themes, so the continuity of his nature work was never entirely disrupted. In certain of his pictures painted towards the end of the war or shortly afterwards, such as 'The Lamp', the colours are much brighter, perhaps as an expression of relief. There is also a tendency towards more frontal compositions, without plunging vistas, and a greater strength of design.

The commission in 1944 to paint a large picture of the 'Crucifixion' for the church of St Matthew's, Northampton, faced him with the problem of painting the human figure for the first time on a life-size scale and was also the first of his works on religious themes, which were to culminate later in the design for the Coventry Tapestry. Before beginning systematic work on the commission in April 1946 he had painted a series of 'Thorn Trees' and 'Thorn Heads', inspired by the notion of the crown of thorns, in which the thorn trees became by imaginative displacement a metaphor for anguish and a kind of 'stand-in' for the 'Crucifixion'. The 'Crucifixion' itself, a work of great power and intensity of feeling, represented a complete break away from the insipid religiosity of most twentieth-century church art and owed much both to Grünewald and to recently published photographs of the victims of the German death camps.

In the spring of 1947 he made his first visit to the South of France and was so struck with it that he returned later the same year, and spent part of each year there regularly from then on, buying a house at Menton in 1955 which became his principal home. The sunshine and warmth greatly attracted him, while the landscape was totally different from anything he had seen before in its type of vegetation and dryness. Moreover the move can be seen as symptomatic of his ambition to transcend national boundaries and become an international artist. He visited Picasso and Matisse on his second visit in the autumn of 1947, and saw Picasso quite regularly for some years after that.

The most striking immediate effect of his move was his adoption of Mediterranean subjects such as vine pergolas, palm palisades, banana leaves, cacti and cicadas, accompanied by a heightening and lightening of his colour. His palette of pinks, yellows, purples, pale blues and reds evoked the steady, brilliant glow of the southern light and marked the fulfilment of that trend

towards the liberation of colour which had begun to show itself increasingly in his work. The compositions, with their linear emphasis, bold patterning and large areas of bright colour, had a very decorative character. (After a while he began to find these works too decorative and exotic, and sought to recapture the mystery and psychological overtones of his earlier period).

It was in the South of France, at St-Jean-Cap-Ferrat, that he met Somerset Maugham, which was to lead in 1949 to the painting of his first portrait. Arising apparently out of a chance remark that, if he ever painted portraits, Maugham was the sort of person he would like to paint, and undertaken tentatively as an experiment, it proved an immediate success and opened up a new career as a portrait painter which he was to pursue in parallel to his nature work from then on. The portrait of Maugham was followed by that of Lord Beaverbrook in 1951, the Hon. Edward Sackville-West in 1953–4 and Sir Winston Churchill in 1954, all of which were very different and strikingly original in treatment. Though he regarded his portraits as an integral part of his work, he never accepted more than a very limited number of commissions (a total of about fifty in all over more than thirty years), and turned down offers if he felt that the head and character of the sitter did not interest him. Apart from a few portraits of friends, the sort of people he preferred to paint were those who had achieved power and fame – Dr Adenauer and Helena Rubinstein in their different ways are further examples of this – who had had pressures put on them, or who had the character necessary to direct great enterprises. Many of them were therefore elderly, with forceful personalities and well-marked features.

Instead of painting his portraits direct from the sitters, Sutherland's procedure was to make a number of drawings and sometimes one or more oil sketches from life and then paint the definitive portraits away from the models in his own studio (just as his paintings of landscape forms were done from drawings and not on the spot). The sittings usually took place in the sitter's own ambience and part of the time was taken up with conversation, designed to create a relaxed atmosphere in which the sitter would behave as naturally as possible. Meanwhile Sutherland would be watching and waiting for some expression and pose which seemed characteristic, something he could seize on as the quintessence of that individual or, as he put it, 'to pin down the essence of a person'. The pose would therefore either be one which the sitter considered was especially significant for himself or which was adopted unconsciously in the course of the sittings; but it also had to have an overall rhythm which held the composition together. Sometimes a few photographs, usually just snapshots, would be taken as supporting material. Though Sutherland greatly admired the portraits by Picasso in which appearances are subject to a radical metamorphosis and yet the likeness still remains, his own method was to make a straightforward attempt to put down what he had seen in front of his eyes, to produce the equivalent of the impact that person had had on him, and the degree of paraphrase was therefore much less than in his nature paintings. They were almost always extremely good likenesses, but the best of them went much beyond that as penetrating studies of character.

In the same year as his first portrait, 1949, Sutherland also began to paint a series of 'Standing Forms' in which he attempted to place his forms in a realistic setting, forms developed from the bits of trees and plants he had been collecting and based as always on the principles of organic growth. They were placed upright like figures, sometimes two or three lined up in a row, and in different types of setting: sometimes outdoors against a hedge, for instance, and

sometimes indoors in front of a curtain, and with correspondingly different effects of light. As he explained at the time:

*To me they are monuments and presences. But why use these forms instead of human figures? Because, at the moment, I find it necessary to catch the taste – the quality – the essence of the presence of the human figure: the mysterious immediacy of a figure standing in a room or against a hedge in its shadow, its awareness, its regard, as if one had never seen it before – by a substitution . . . . They give me a sense of the shock of surprise which direct evocation could not possibly do.*[8]

Therefore unlike the early landscapes which were almost always totally devoid of the human figure, these works were very much concerned with the suggestion of the human figure and the human presence but in an indirect way. The forms were sometimes very strongly modelled like objects in the round and standing on plinths like pieces of sculpture; indeed Sutherland even made about six sculptures at the same period, modelling in plaster forms similar to those in the paintings.

Much of his time in the 1950s, from 1953 onwards, was taken up with work on the huge tapestry of 'Christ in Glory in the Tetramorph' which he had been commissioned to design for the new Coventry Cathedral. There was first the work on the actual design, including dozens of drawings of different sizes and three large cartoons, with many experiments with different poses, changes in the disposition of the emblems of the Evangelists and so on; and then, once the weaving was started, the long exacting task of working over the photographic blow-ups to make the forms more precise wherever necessary and carry out last-minute modifications.

His output of paintings from about 1955 until the tapestry was finished at the end of 1961 was therefore relatively small, but the works produced tended to show a move towards a more straightforward and traditional approach to nature, partly as a result of his work as a portrait painter, with its close attention to exact observation; also perhaps because of his regular summer visits to Venice from 1950 onwards and his increasing familiarity with Venetian painting. This change can be seen, for instance, in the series of paintings of animals which he began in 1947–8 and continued on and off until the late 1960s, continually extending his menagerie of images – cicadas, monkeys, herons, eagles, toads, rams, bats and so forth – until the theme was finally summed up and brought to a conclusion in the suite of colour lithographs 'A Bestiary and Some Correspondences' made in 1967–8. The later works tend to be more realistic in treatment and sometimes even show the animals in life-like settings. There was also a tendency to adopt a more sensuous handling of paint, with freer, more expressive brushwork.

The paintings of landscape themes which he made in the early 1960s have little of the exotic character of the first South of France works, but nevertheless were usually based on subjects found close to his house at Menton, and often in his own garden: themes such as mysterious, shadowy paths or entrances to steep passages descending between hedges. At the same time he also painted animals, both real and imaginary, studies of plant-like machine forms, and a series of sumptuously decorative pictures of fountains with erotic overtones. Finally, unique in his work, were two large 'Interiors' made in 1965 and 1966–7 inspired by a huge hangar-like space in Venice which he had been allowed to use as a studio and by the sunlight filtering through one of its tall windows.

Sutherland with his
painting materials in
Sandy Haven in 1970
*Photo by Giorgio Soavi*

This period of an exceptional diversity of interests (which perhaps also indicates a certain lack of direction) came to an end when Sutherland was asked by Pier Paolo Ruggerini in 1967 to return to Pembrokeshire for the first time for over twenty years to help with the preparation of a film on his work for Italian television; a film which had been inspired by the great success of his retrospective exhibition at the Galleria Civica d'Arte Moderna in Turin in 1965. Persuaded with difficulty, he found that the Pembrokeshire landscape, which he thought he had exhausted, had just as much fascination for him as ever. As soon as he had finished the 'Bestiary', he went back again for a longer visit and from then on, for the rest of his life, returned there several times each year and based almost all his paintings on Pembrokeshire themes. Instead of usually staying in the region of St David's, he now made the Lord Nelson Hotel at Milford Haven his base and found inspiration mainly along two small estuaries in southern Pembrokeshire: Sandy Haven, as before (together with the curious walled wood at nearby Monk Haven), and the River Cleddau, about twelve miles away. The strange twisting forms of the trees growing on the banks of the Eastern Cleddau at Picton eroded by the tide provided a particularly rich source of ideas. In some cases images drawn from two or more areas some miles apart were combined in the same work.

One of the features which distinguishes these late works from those of his first Pembrokeshire period is a much greater amplitude. This is not only a question of scale – though many are in fact considerably larger than those done before – but also of composition and handling. The treatment tends to be frontal, with the forms in shallow layers parallel to the picture plane, and there is an emphasis on verticals and horizontals, and on simple, almost geometrical shapes. The compositions are characterised by a state of harmonious balance, sometimes achieved through near-symmetry and sometimes through the juxtaposition of a large form and a smaller, complementary one; writhing baroque-like forms are counterbalanced by vertical and horizontal lines to produce an equilibrium of movement and repose. The approach is painterly, with the colours applied thinly and at times almost stained into the canvas, and with a play of light and

shade. Though there are still overtones of drama in these works, it is not the sudden dramatic confrontation of the early period but something graver and more elegiac, with a haunting quality of stillness and silence.

Feeling that he owed a great deal to Pembrokeshire and would like to give something back, he formed the idea in the early 1970s of presenting a group of his works directly inspired by Wales for the benefit of Pembrokeshire and the nation. The Hon. Hanning Philipps and his wife Lady Marion offered to make a space available in an annexe to Picton Castle, less than a mile away from the estuary at Picton which was one of his principal sources of inspiration, and the Graham Sutherland Gallery was opened there in 1976. The collection has since been expanded by further gifts from Mrs Sutherland, and is now known as the Graham and Kathleen Sutherland Foundation.

Sutherland continued to be active and creative right up to the end of his life, and his last works, such as the two series of aquatints 'The Bees' and 'Apollinaire: Le Bestiaire ou Cortège d'Orphée', show him exploring new themes and opening up new possibilities.

Though his work influenced a number of younger British artists in the 1940s, including Craxton, Minton, Vaughan and Ayrton, he was too much of an individualist and his vision too personal for him to have been a member of any group. He was an outstanding colourist, a highly original portrait painter, a war artist of distinction, the creator of several of the few modern religious works which are likely to have permanent lasting qualities, and a gifted printmaker in a variety of media. But above all he will no doubt be remembered for the nature paintings which form the bulk of his work, paintings in which natural forms take on a heightened intensity and presence, and undergo strange imaginative transmutations. It is an art full of emotion, combining close observation with the workings of a powerful imagination; a rich and mysterious contribution to the art of our time.

Ronald Alley

Notes

[1] Graham Sutherland, 'The Visionaries': Introduction to the exhibition catalogue *The English Vision*, William Weston Gallery, London, October–November 1973.

[2] The date of the first exhibition has usually been given as 1925, but Roger Berthoud, in his new book on Sutherland, *Graham Sutherland: A Biography* (Faber and Faber 1982), has shown that it was actually in 1924, when he was aged only twenty-one.

[3] Graham Sutherland, 'Welsh Sketch Book' in *Horizon*, v, March 1942, p.234.

[4] Graham Sutherland, 'A Trend in English Draughtsmanship' in *Signature*, No.3, July 1936, p.7.

[5] *Ibid*, p.10.

[6] Graham Sutherland, 'Thoughts on Painting' in *The Listener*, XLVI, 1951, p.376.

[7] Noel Barber, *Conversations with Painters* (London 1964), p.44.

[8] Graham Sutherland, 'Thoughts on Painting' in *The Listener*, XLVI, 1951, p.377.

# Biographical Outline

**1903**
24 August. Born in London, son of a lawyer who later became a civil servant.

*c.*1910–11
The family moved to Sutton in Surrey.

**1912–17**
Went to a preparatory school at Sutton.

**1917–19**
At school at Epsom College.

**1919–20**
Course in mathematics at Battersea Polytechnic and with a crammer to prepare for an engineering career.

**1920–1**
Engineering apprentice at the Midland Railway Works at Derby.

**1921–6**
Studied at Goldsmith's College School of Art, University of London, specialising in etching.

**1924**
A finalist in the engraving section of the Prix de Rome. First one-man exhibition of engravings and drawings at the Twenty-One Gallery, London.

**1924–7**
Shared lodgings at Blackheath with Milner Gray.

**1925**
Elected an associate member of the Royal Society of Painter-Etchers and Engravers (A.R.E.).

**1926**
Became a Roman Catholic.

**1927–39**
Taught two days a week at Chelsea School of Art (etching until *c.*1934).

**1927**
29 December. Married Kathleen Barry and went to live at Farningham in Kent. (Moved from there to Eynsford in 1931 and to Sutton-at-Hone in 1933).

**1928**
Second one-man exhibition at the Twenty-One Gallery.

**1928–33**
Made annual visits to Dorset.

*c.*1930
Began to paint, following the decline in the market for etchings and engravings.

*c.*1932–9
Supported himself partly by designing posters, china, glass and fabrics.

*c.*1934
Changed to teaching book illustration and composition.

**1934**
Made his first visit to Pembrokeshire (Dyfed), which he revisited each summer until the Second World War; inspired by the landscape there, gradually began to find his way as a painter.

**1936**
Contributed two oil paintings to the International Surrealist Exhibition in London.

**1937**
Moved to the White House at Trottiscliffe in Kent, his English home for the rest of his life.

**1938**
First one-man exhibition of paintings at the Rosenberg & Helft Gallery, London.

**1939–40**
Stayed for twelve months at the beginning of the war as a guest of Kenneth Clark at Upton House, Tetbury, Gloucestershire; continued to teach one day a week at Chelsea until June 1940.

**1940**
Second one-man exhibition of paintings at the Leicester Galleries, London.

**1940–5**

Worked as an official war artist, drawing and painting scenes of bomb damage, blast furnaces, tin mining, limestone quarrying, etc. Had little time for painting on his own but was able to visit Wales every year 1940–5.

**1941**

Retrospective exhibition (with Henry Moore and John Piper) at Temple Newsam, Leeds.

**1944**

December. Brief visit to France to make studies of bomb damage done by the R.A.F.

**1945–6**

Taught once a week at Goldsmith's. Friendship with Francis Bacon and was one of the first to champion his work.

**1946**

First New York one-man exhibition at the Buchholz Gallery, run by Curt Valentin. Painted the 'Crucifixion' for St Matthew's, Northampton.

**1947**

First visit to the South of France, where he spent part of each year from then on. Began to paint palm palisades, vine pergolas, etc. Met Picasso and Matisse.

**1948**

Appointed a Trustee of the Tate Gallery. One-man exhibitions at the Hanover Gallery, London, and the Buchholz Gallery, New York.

**1949**

Painted his first portrait, that of Somerset Maugham. Phase of sculptural 'monuments and presences' begins (until 1957).

**1950**

Commissioned to paint 'The Origins of the Land' for the Festival of Britain exhibition. Made his first visit to Venice, where he returned for two or three weeks almost every summer for the rest of his life.

**1951**

Retrospective exhibition at the Institute of Contemporary Arts, London. One-man exhibition at the Hanover Gallery.

**1952**

Made his first experiments with sculpture. Commissioned to design a vast tapestry for Coventry Cathedral. One-man exhibition of studies for 'The Origins of the Land' at the Redfern Gallery, London.

**1952–3**

Exhibition in the British Pavilion at the Venice Biennale in 1952 (awarded the Acquisition Prize of the Museu de Arte Moderna, São Paulo); enlarged versions of this exhibition were afterwards shown in Paris and (in 1953) in Amsterdam, Zurich and at the Tate Gallery.

**1953**

One-man exhibition at the Curt Valentin Gallery, New York.

**1954**

Resigned as a Trustee of the Tate Gallery. Painted the portrait of Sir Winston Churchill.

**1954–5**

Retrospective exhibition in Vienna, Innsbruck, Berlin, Cologne, Stuttgart, Mannheim and Hamburg.

**1955**

Bought La Villa Blanche at Menton. One-man exhibition at the Arthur Jeffress Gallery, London. Exhibited at the São Paulo Bienal.

**1955–61**

Mainly occupied painting portraits and supervising the design and execution of the Coventry tapestry.

**1957**

Received the Foreign Minister's Award at the 4th International Exhibition of Contemporary Art, Japan.

**1959**

One-man exhibitions at the Arthur Jeffress Gallery and at the Paul Rosenberg Gallery, New York.

**1960**

Awarded the Order of Merit.

**1961**

One-man exhibition at the Galleria Galatea in Turin; the first of over twenty one-man exhibitions in Italian commercial galleries (mostly after 1970).

**1962**

Received Honorary Degree of Doctor of Literature from Oxford University.
One-man exhibition at Marlborough Fine Art, London, where he had further one-man exhibitions in 1966, 1968, 1972, 1974, 1977 and 1979.

**1964**

Exhibition of studies for the Coventry Tapestry at the Redfern Gallery.
Visited New York for the first time in connection with his second (and last) exhibition at the Paul Rosenberg Gallery.

**1965–6**

Retrospective exhibition at the Galleria Civica d'Arte Moderna, Turin, in 1965 and the Kunsthalle, Basle in 1966.

**1967**

Retrospective exhibition in Munich, The Hague, Berlin and Cologne.
Revisited Pembrokeshire for the first time for over twenty years in connection with a film on his work for Italian television.

**1968**

Publication of the series of twenty-six lithographs entitled 'A Bestiary and Some Correspondences'.

Began from 1968 visiting Milford Haven in Pembrokeshire several times a year in connection with his work.

**1969–70**

Exhibitions of his graphic work in Hanover and Nuremberg.

**1972**

Elected honorary member of the National Institute of Arts and Letters and the American Academy of Arts and Letters in New York. Guest of honour at the ixe Biennale Internationale d'Art, Menton.

**1973**

Named Commandeur des Arts et des Lettres in France and Honorary Fellow of the Accademia di S.Luca in Rome.

**1974**

Awarded the Shakespeare Prize, Hamburg.

**1976**

Inauguration of the Graham Sutherland Gallery at Picton.

**1977**

Completion of the series of aquatints 'The Bees'. Retrospective exhibition of portraits at the National Portrait Gallery, London.

**1979**

Exhibition of selected works from Picton at Marlborough Fine Art.
Exhibition of a selection of his wartime drawings at the Palazzo Reale, Milan, and in Florence.
Completion of the series of aquatints 'Apollinaire: Le Bestiaire ou Cortège d'Orphée'.

**1980**

17 February. Died in London.

# West Pembrokeshire

## showing the main areas where Sutherland worked

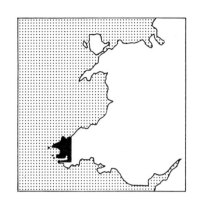

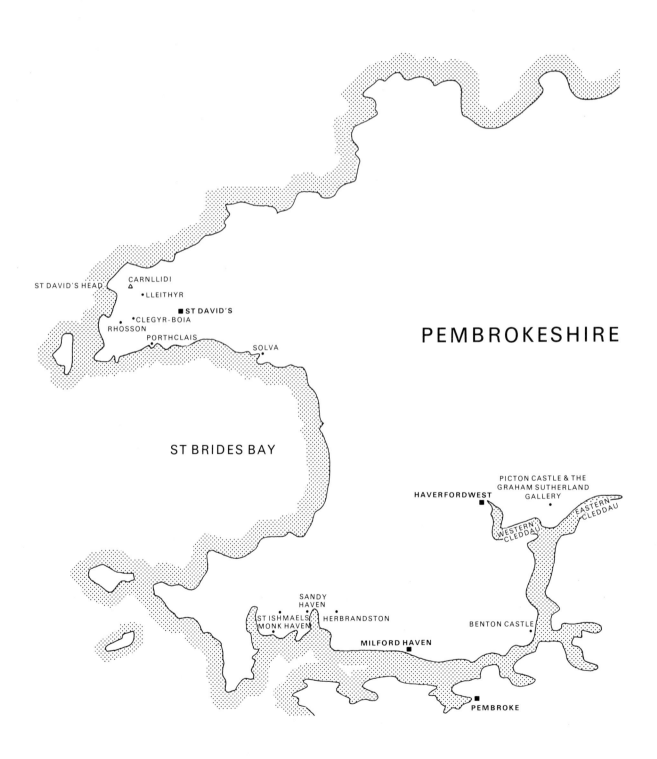

ST DAVID'S HEAD

CARNLLIDI △

• LLEITHYR

■ ST DAVID'S

• CLEGYR-BOIA
RHOSSON •
PORTHCLAIS •

SOLVA •

PEMBROKESHIRE

ST BRIDES BAY

PICTON CASTLE & THE
GRAHAM SUTHERLAND
GALLERY

HAVERFORDWEST ■

EASTERN
CLEDDAU

WESTERN
CLEDDAU

SANDY
HAVEN

ST ISHMAELS • HERBRANDSTON
MONK HAVEN

BENTON CASTLE

MILFORD HAVEN ■

■ PEMBROKE

# Graham Sutherland: 'Welsh Sketch Book'

A letter to Colin Anderson first published in *Horizon*, v, April 1942, pp.225–35

Dear Colin,

You ask about the places which have started me off – which have started ideas for my paintings. Certainly I would rather write to you about such places than about the paintings themselves; for how can a painter explain his paintings? The onlooker may come to like them through familiarity, or he may hate them. It is quite impossible to follow with any exactitude the path taken by the brain in the fixing of images seen by the eye, stored in the mind, and drawn out of the subconscious. But in describing the sort of things that start one off – the country that one likes, perhaps, and its peculiarities, it may be possible to give some kind of hint as to the genesis of the paintings.

The mind of a painter, of course, is a reservoir for *all* kinds of emotions and impressions. He who is over-discriminating becomes narrow in achievement. Yet a singleness of purpose over certain periods of time is necessary. A painter will have certain preoccupations with regard to his subject, and a passion for it.

I expect that you may have noticed that for the last few years I have been preoccupied with a particular aspect of landscape – and not only that, but, for the most part, with a particular area of country.

It was in 1934 that I first visited Pembrokeshire. I was visiting a country, a part of which, at least, spoke a foreign tongue, and it certainly seemed very foreign to me, though sufficiently accessible for me to feel that I could claim it as my own.

After a good deal of wandering about, I came upon two very remarkable passages of country situated in the arms of land which embrace the great area of St Bride's Bay. The arm towards the north is like an isosceles triangle on its side, the narrowest angle forming St David's Head to the west. One approaches across a wide plain from the north, its emptiness relieved by the interlocking of tightly-packed strips of field and their bounding walls of turf-covered rocks. One soon notices an irregularity of contour on the horizon which resolves itself into what appears to be two mountains. As one approaches still closer one sees that these masses of rock scarcely attain a height of more than seven hundred feet. But so classically perfect is their form, and so majestic is their command of the smoothly-rising ground below, that the mind comfortably corrects the measurement of the eye, and holds their essential mountainous significance. A rocky path leads round the slopes of the nearer mountain, where, to the west, the escarpment precipitates itself to a rock-strewn strip of marsh, marked out with the crazy calligraphy of the foundations of primitive hut dwellings; from here the ground rises to a vast congregation of rocks, fallen cromlechs, and goats' caves, which continue their undulating and bewildering disorder, until they plunge, in the terraces of St David's Head, into the table of the sea. The southern slopes yield to the plain again; but here the land, gradually sloping to the sea, is studded with rocky cairns of every size. Between these are fields, each with a spear of rock at its

centre. It is as if the solid rock foundation of the earth had thrown up these spears to transfix and hold the scanty earth of the fields upon it. Farms and cottages – glistening white, pink, and blue-grey – give scale and quicken by their implications our apprehension of the scene.

In this direction, nearer the sea, the earth is comparatively flat, but this flatness is deceiving and makes the discovery of little steep valleys more surprising. These valleys possess a bud-like intricacy of form and contain streams, often of indescribable beauty, which run to the sea. The astonishing fertility of these valleys and the complexity of the roads running through them is a delight to the eye. The roads form strong and mysterious arabesques as they rise in terraces, in sight, hidden, turning and splitting as they finally disappear into the sky. To see a solitary human figure descending such a road at the solemn moment of sunset is to realize the enveloping quality of the earth, which can create, as it does here, a mysterious space limit – a womb-like enclosure – which gives the human form an extraordinary focus and significance.

At the risk of talking like a guide-book, I must tell you of the area to the south. I shall never forget my first visit. We approached by a flat winding road and had slipped into one of the little valleys such as I have attempted to describe. To the left this opened out to reveal what appeared to be a watery inlet narrowing to its upper end. As the road progressed we caught further glimpses of this and curiosity was roused. We had intended making for a village called Dale, marked on the map as lying to the north side of the mouth of Milford Haven. Fortunately, we missed the road and found ourselves descending a green lane buried in trees, which, quite unexpectedly, led to a little cove and beach by the banks of a narrow estuary.

Here is a hamlet – three cottages and an inn crouch under the low cliffs. A man is burning brushwood cut from a tree, bleached and washed by the sea. The flame looks incandescent in the evening light. The tide in the estuary (or pill, as such inlets are called here) is out, and we walk across the sandy bed of the opening and look down its winding length to the place where it narrows to the upper end.

I wish I could give you some idea of the exultant strangeness of this place – for strange it certainly is, many people whom I know hate it, and I cannot but admit that it possesses an element of disquiet. The left bank as we see it is all dark – an impenetrable damp green gloom of woods which run down to the edge of low blackish moss-covered cliffs – it is all dark, save where the mossy lanes (two each side) which dive down to the opening, admit the sun, hinged, as it were, to the top of the trees, from where its rays, precipitating new colours, turn the red cliffs of the right-hand bank to tones of fire. Do you remember the rocks in Blake's 'Newton' drawing? The form and scale of the rocks here, and the minutiae on them, is very similar.

The whole setting is one of exuberance – of darkness and light – of decay and life. Rarely have I been so conscious of the contrasting of these elements in so small a compass.

The right bank has fields above the cliff, some covered with ripe corn, others with rough gorse-clad pasture. The life-giving sound of the mechanical reaper is heard. Cattle crouch among the dark gorse. The mind wanders from contemplation of the living cattle to their ghosts. It is no uncommon sight to see a horse's skull or horns of cattle lying bleached on the sand. Neither do we feel that the black-green ribs of half buried wrecks and the phantom tree

roots, bleached and washed by the waves, exist but to emphasize the extraordinary completeness of the scene. Complete, too, is the life of the few inhabitants – almost biblical in its sober dignity. The people in this part appear quite incurious of the activities of a foreigner. The immense soft-voiced innkeeper and his wife, small as he is big, sit, when they are not working, bolt upright, on a hard bench in the cool gloom of the parlour which forms the only 'bar' of the inn, or they sit – for he is ferry-man and fisherman, as well as innkeeper – gazing across the ferry.

The quality of light here is magical and transforming – as indeed it is in all this country. Watching from the gloom as the sun's rays strike the further bank, one has the sensation of the after tranquillity of an *explosion* of light; or as if one had looked into the sun and had turned suddenly away.

Herons gather. They fly majestically towards the sea. Most moving is the sound of snipe which flicker in their lightning dash down the inlet, to and from the sea.

These and other things have delighted me. The twisted gorse on the cliff edge, such as suggested the picture 'Gorse on Sea Wall' – twigs, like snakes, lying on the path, the bare rock, worn, and showing through the path, heath fires, gorse burnt and blackened after fire, a tin school in an exuberant landscape, the high overhanging hedges by the steep roads which pinch the setting sun, mantling clouds against a black sky and the thunder, the flowers and damp hollows, the farmer galloping on his horse down the estuary, the deep green valleys and the rounded hills and the whole structure, simple and complex.

It was in this country that I began to learn painting. It seemed impossible here for me to sit down and make finished paintings 'from nature'. Indeed, there were no 'ready made' subjects to paint. The spaces and concentrations of this clearly constructed land were stuff for storing in the mind. Their essence was intellectual and emotional, if I may say so. I found that I could express what I felt only by paraphrasing what I saw. Moreover, such country did not seem to make man appear little as does some country of the grander sort. I felt just as much part of the earth as my features were part of me. I did not feel that my imagination was in conflict with the real, but that reality was a dispersed and disintegrated form of imagination.

At first I attempted to make pictures on the spot. But soon I gave this up. It became my habit to walk through, and soak myself in the country. At times I would make small sketches of ideas on the backs of envelopes and in a small sketch book, or I would make drawings from nature of forms which interested me and which I might otherwise forget. The latter practice helped to nourish my ideas and to keep me on good terms with nature. Sometimes, through sheer laziness, I would lie on the warm shore until my eye, becoming riveted to some sea-eroded rocks, would notice that they were precisely reproducing, in miniature, the forms of the inland hills. At all events, I never forced myself here, or consciously looked for subjects. I found it better to visit this country because I liked it – and ideas seemed to come gradually and naturally.

I have confined myself to writing about a particular area and I do this because it was in this area that I learned that landscape was not necessarily scenic, but that its parts have an individual figurative detachment. I found that this was equally true of other places which I visited later; but the clear, yet intricate construction of the landscape of the earlier experience, coupled with an emotional feeling of being on the brink of some drama, taught me a

lesson and had an unmistakable message that has influenced me profoundly. Well, I think there is not much else – it is only a rough outline, but it may go some way towards answering your request.

Editor's footnote
The estuary in south Pembrokeshire (now Dyfed) so vividly described is Sandy Haven. Sutherland makes no mention of the further, third area which was to be of great importance to him during his second Pembrokeshire period and a fertile source of images: the estuary of the Eastern Cleddau at Picton, with its twisted oak trees and conglomerate rocks.

# Catalogue Explanations

The following monographs, and an article on the early prints by R.A. Walker, are listed in abbreviated form in the catalogue entries:

| | |
|---|---|
| Arcangeli | Francesco Arcangeli, *Graham Sutherland*, Milan 1973 |
| Cooper | Douglas Cooper, *The Work of Graham Sutherland*, London 1961 |
| Hayes | John Hayes, *The Art of Graham Sutherland*, Oxford 1980 |
| Man | Felix H. Man, *Graham Sutherland: Das graphische Werk 1922–1970*, Munich 1970 |
| Melville | Robert Melville, *Graham Sutherland*, London 1950 |
| Révai | Andrew Révai (ed.), *Sutherland. Christ in Glory in the Tetramorph: The Genesis of the Great Tapestry in Coventry Cathedral*, London 1964 |
| Sackville-West, 1943 | Edward Sackville-West, *Graham Sutherland*, Harmondsworth 1943 |
| Sackville-West, 1955 | Edward Sackville-West, *Graham Sutherland*, Harmondsworth 1955 |
| Sanesi | Roberto Sanesi, *Graham Sutherland*, Milan 1979 |
| *Sutherland: The Wartime Drawings* | Roberto Tassi, *Sutherland: The Wartime Drawings*, London and New Jersey 1980 |
| Tassi | Roberto Tassi, *Graham Sutherland: Complete Graphic Work*, London 1978 |
| Walker | R.A. Walker, 'A Chronological List of the Etchings and Drypoints of Graham Sutherland and Paul Drury' in *Print Collector's Quarterly*, XVI, 1929, pp.94 and 96 |

In the catalogue entries dimensions are given in inches followed by centimetres in brackets; height precedes width. Catalogue numbers marked with an asterisk indicate the work is reproduced in colour. The following abbreviations are used for the position of inscriptions: r. – right; l. – left; t. – top; c. – centre; b. – bottom. Wherever possible, three reproductions are listed for each work, including the earliest and at least one in colour.

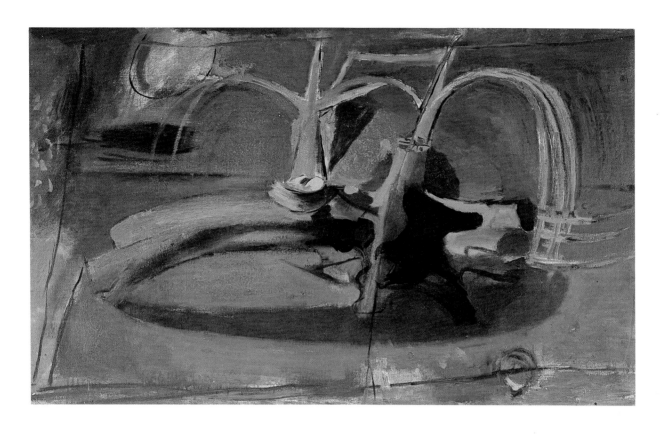

**52** **Red Tree** 1936

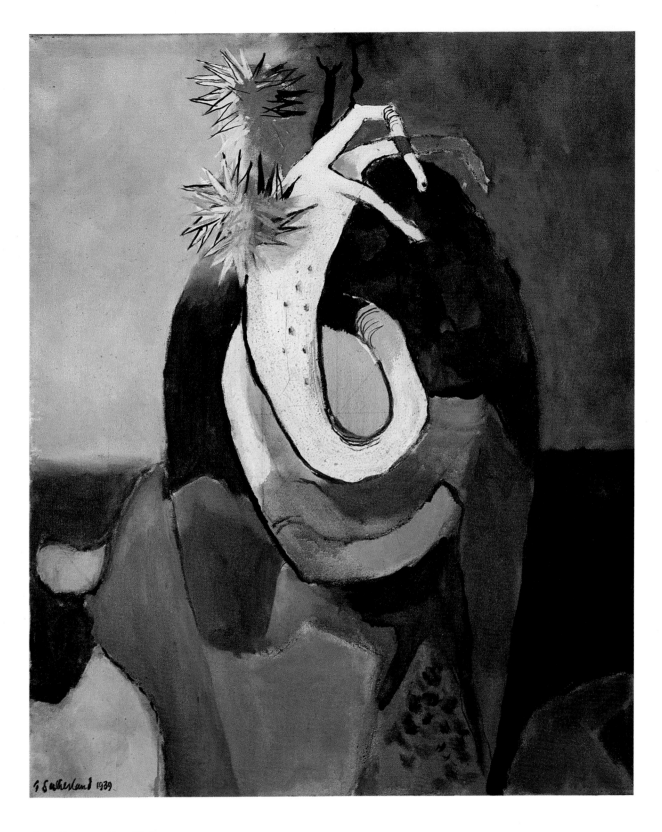

**65 Gorse on Sea Wall** 1939

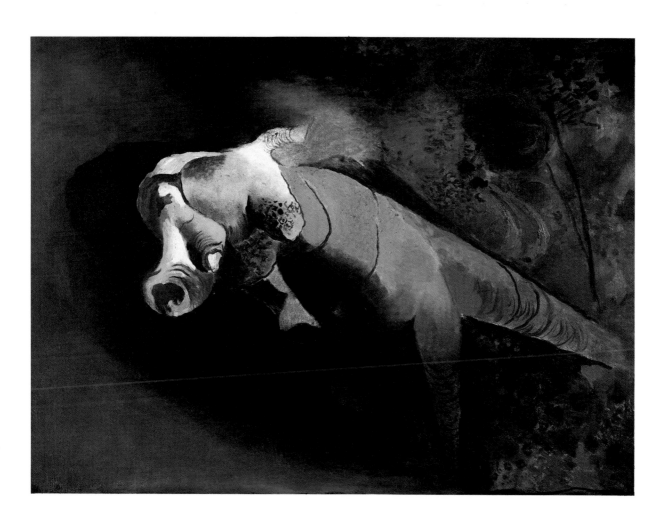

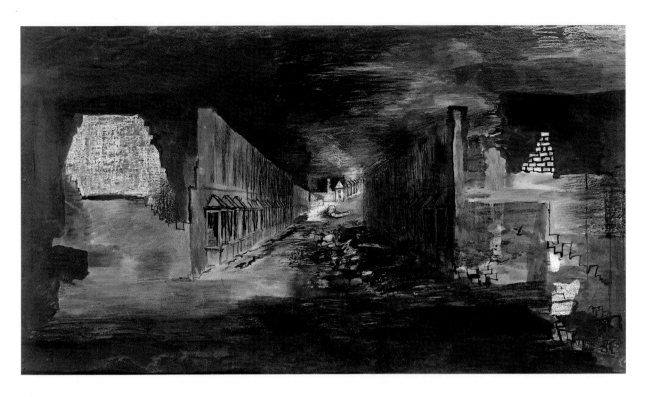

93   Devastation 1941: an East End Street   1941

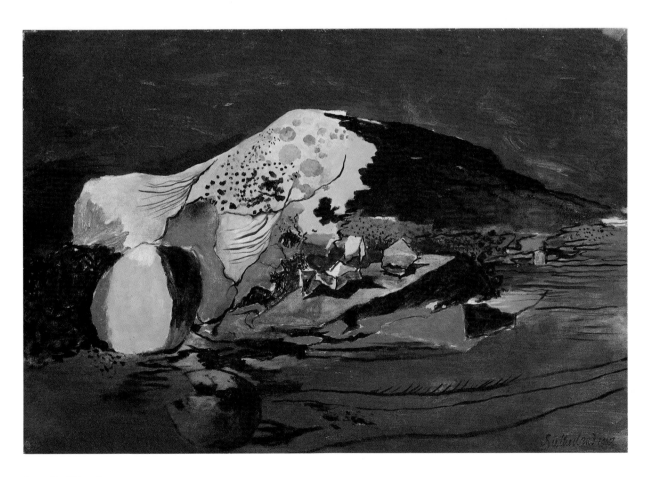

82   Red Landscape   1942

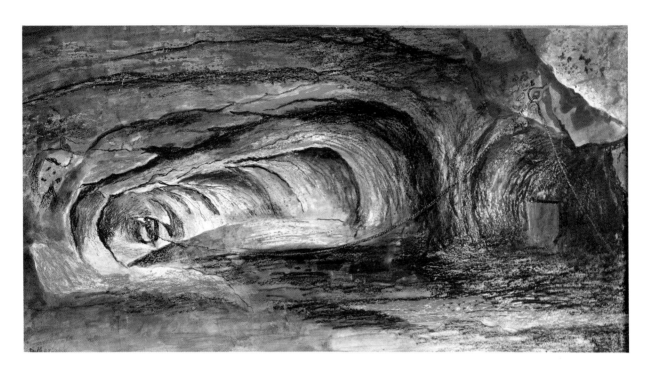

102    Tin Mine – a Declivity    1942

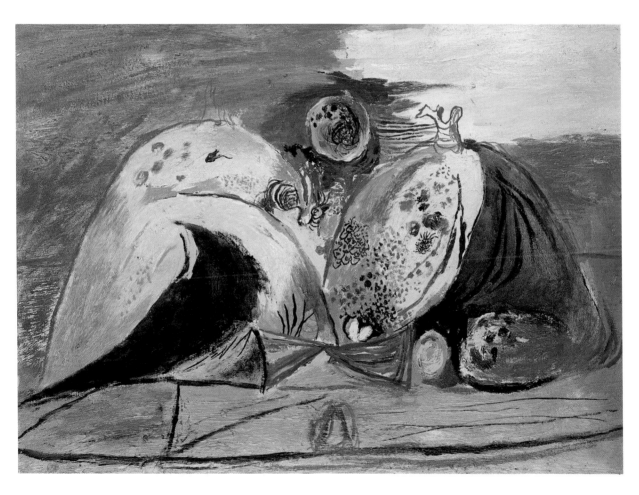

86    Folded Hills    1943

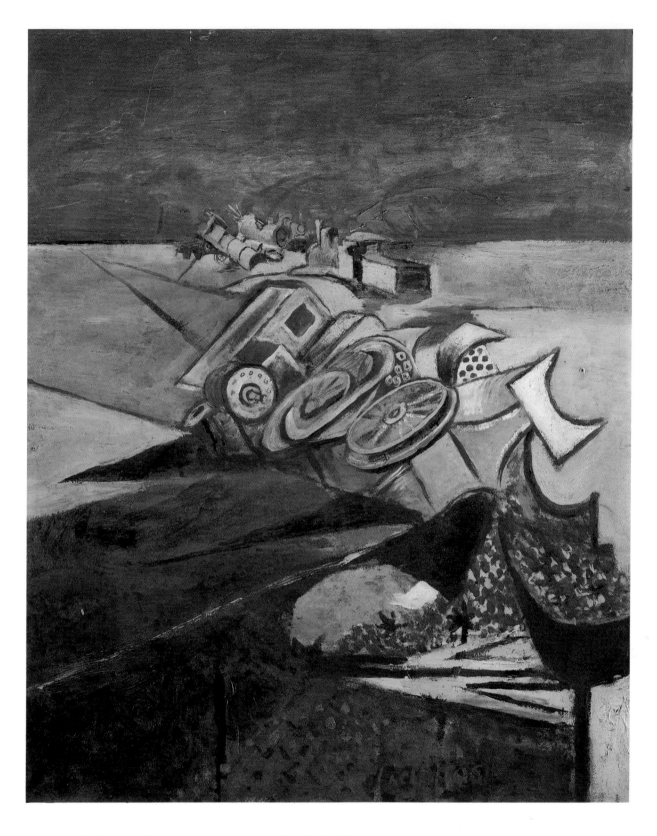

115   Marshalling Yard, Trappes: Damage Done by the R.A.F.   1945

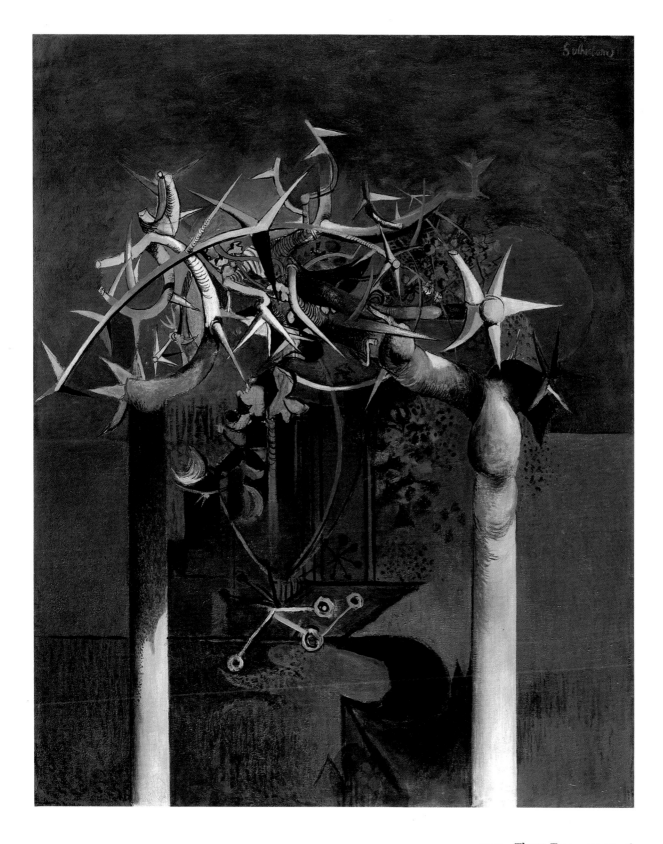

**125  Thorn Tree  1945–6**

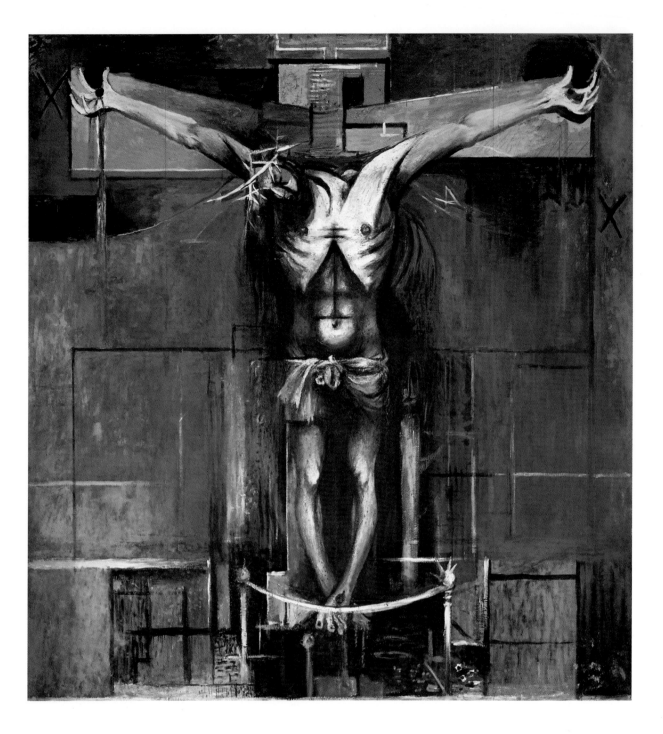

**129  Crucifixion  1946**

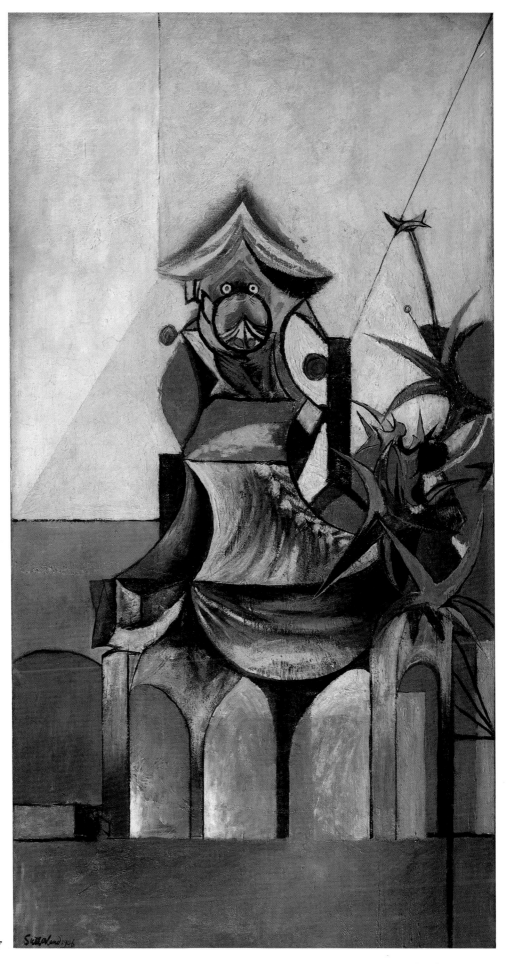

131 Chimère II 1946-7

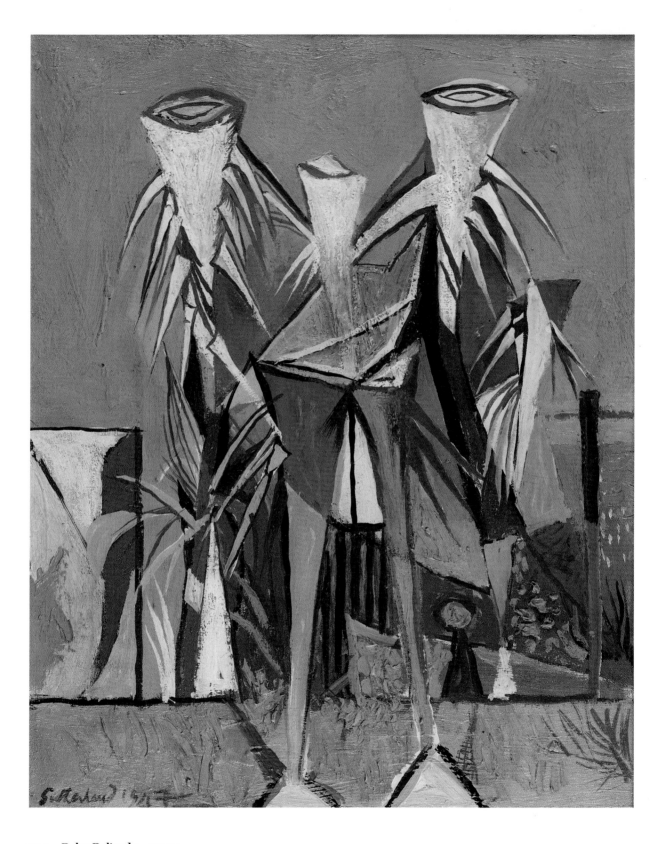

134   **Palm Palisade**   1947

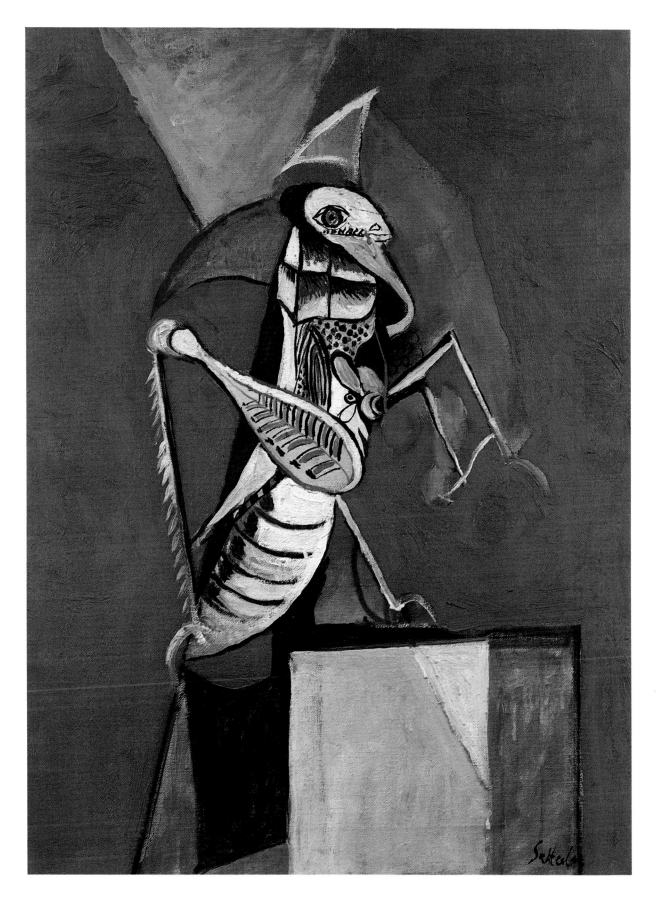

137   Cigale I   1948

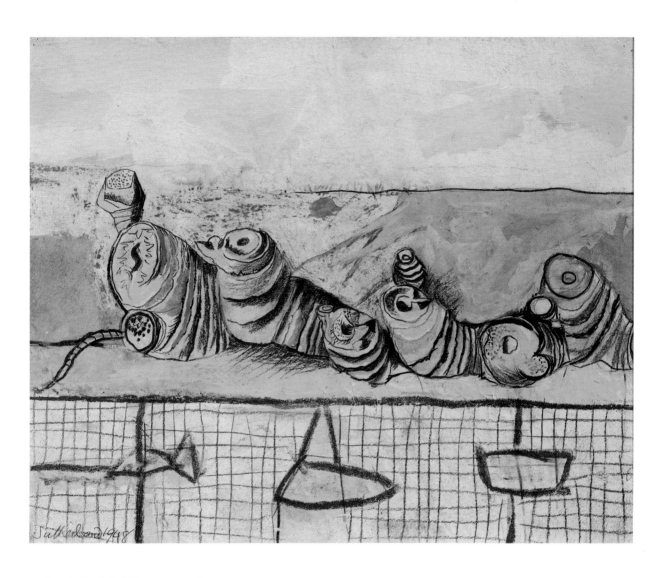

246   Articulated Forms   1948

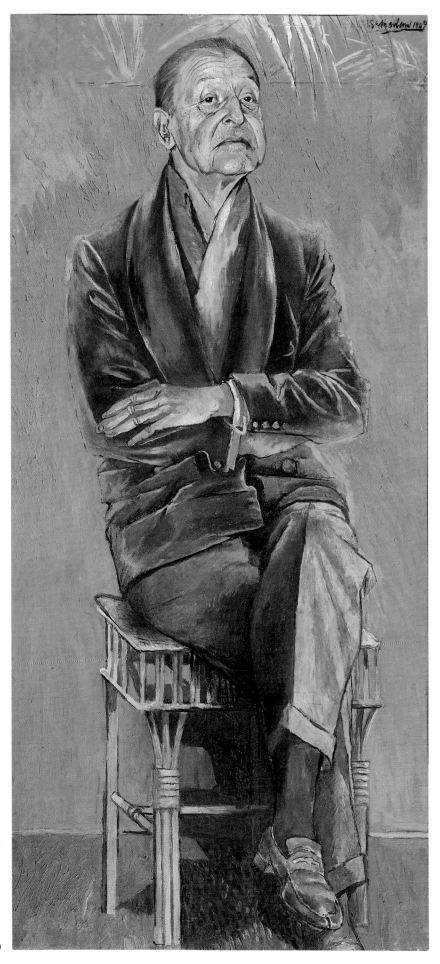

178  Somerset Maugham  1949

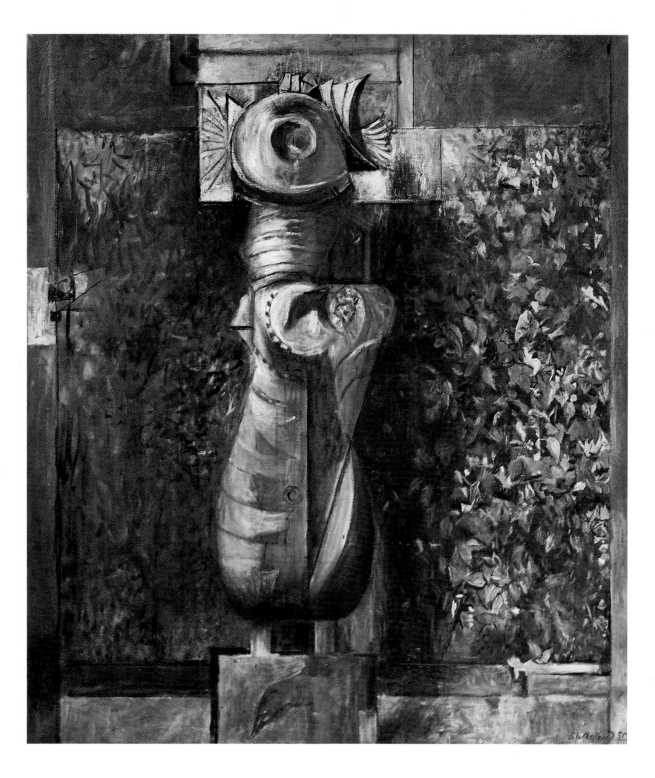

**142** **Standing Form against a Hedge** 1950

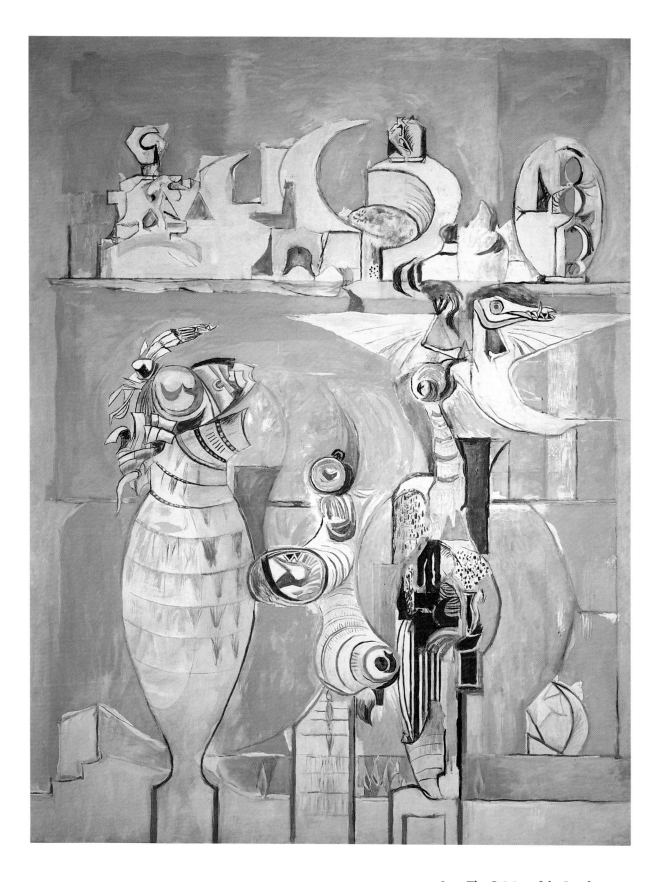

169  The Origins of the Land  1951

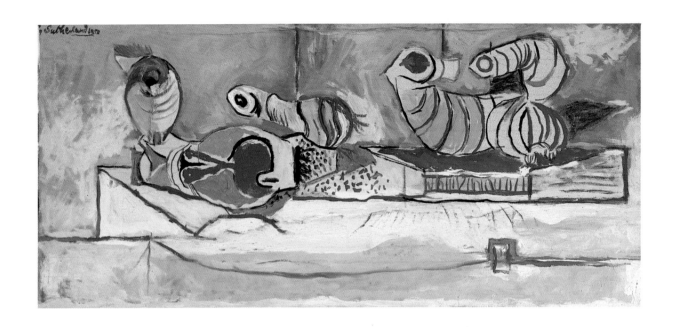

143    Two Forms in a Terraced Landscape    1951

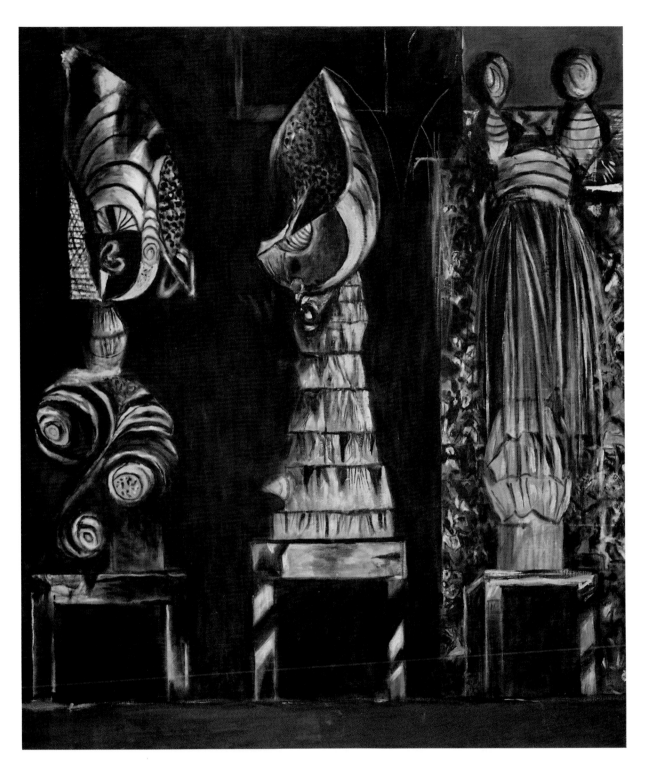

148    Three Standing Forms in a Garden II    1952

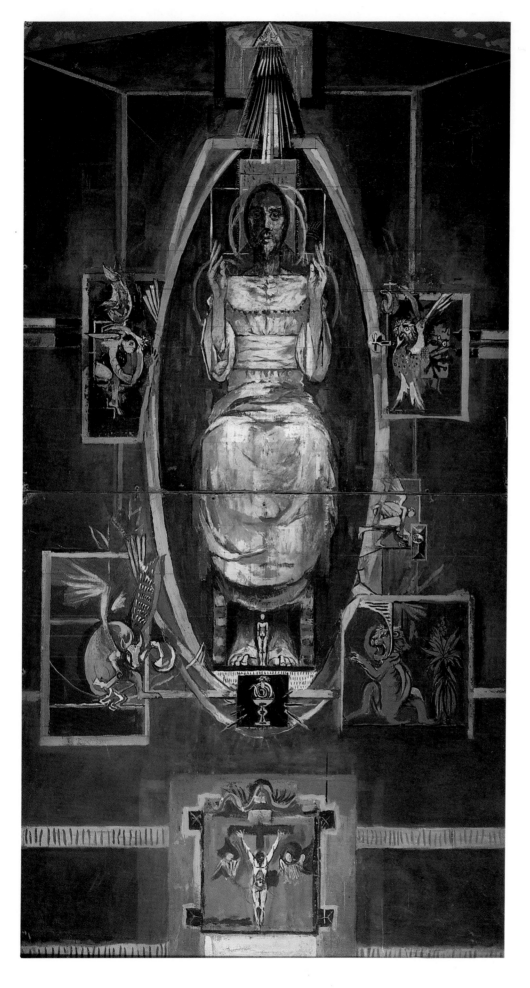

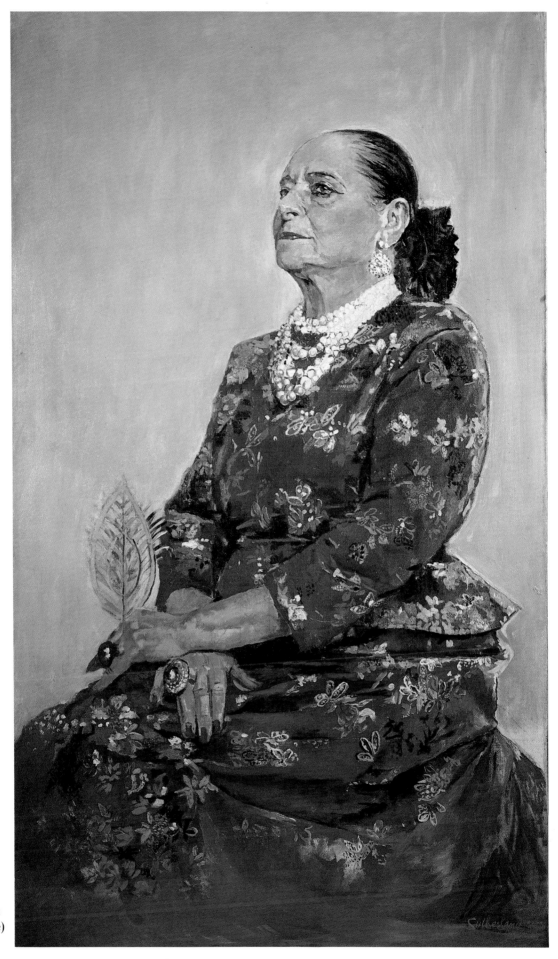

184
**Helena Rubinstein
(Princess Gourielle)
Seated** 1957

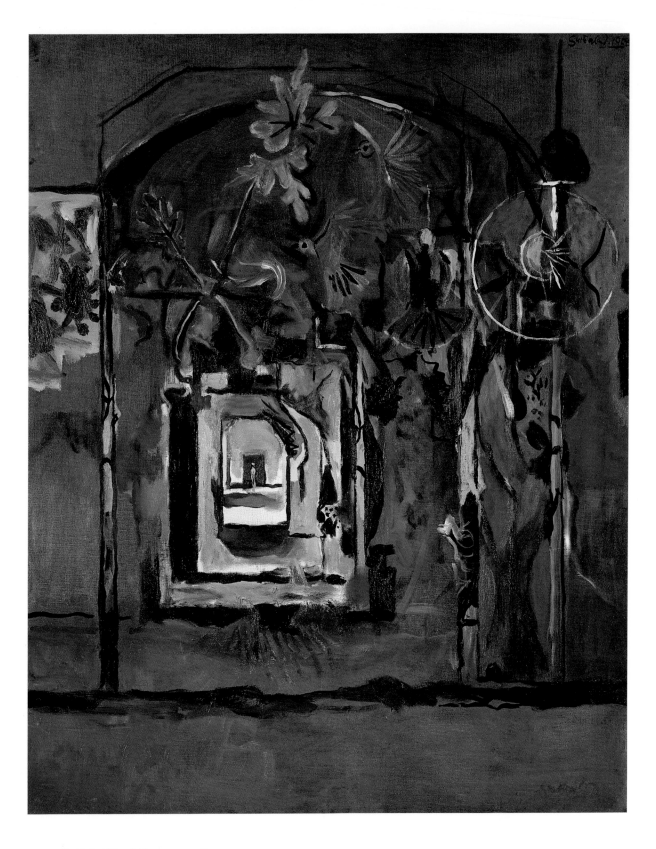

157    Path in Wood No.3    1958

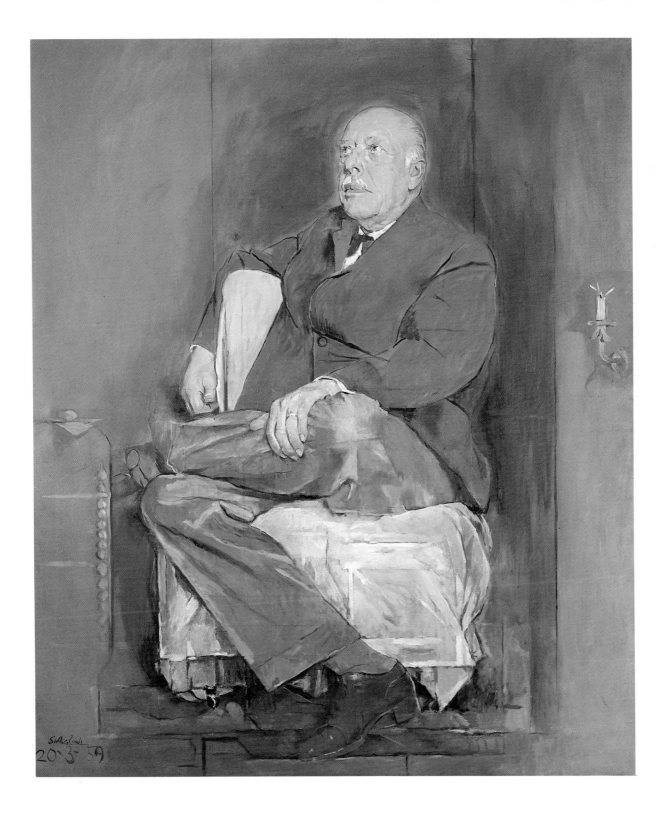

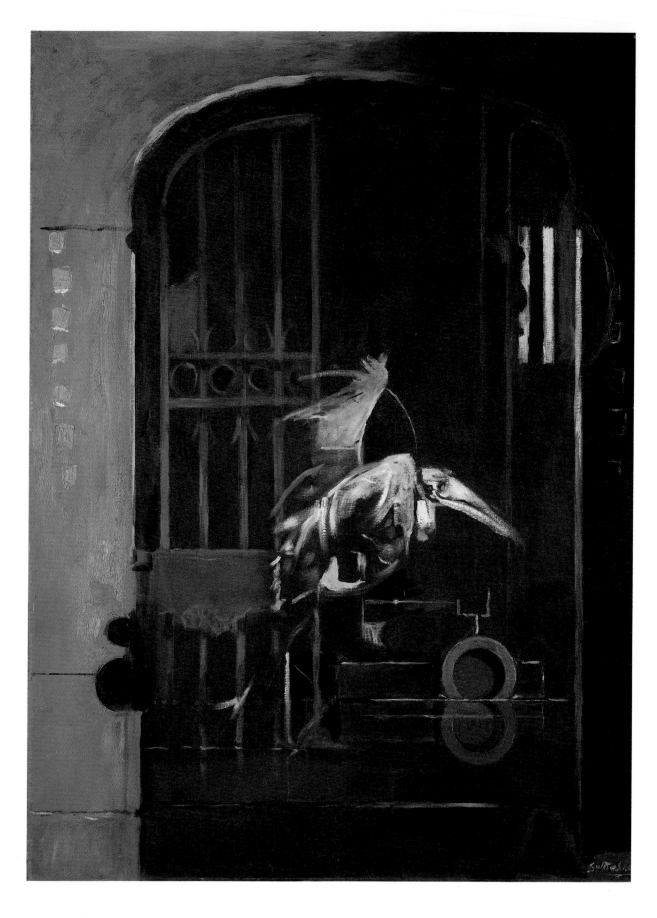

160    Dark Entrance    1959

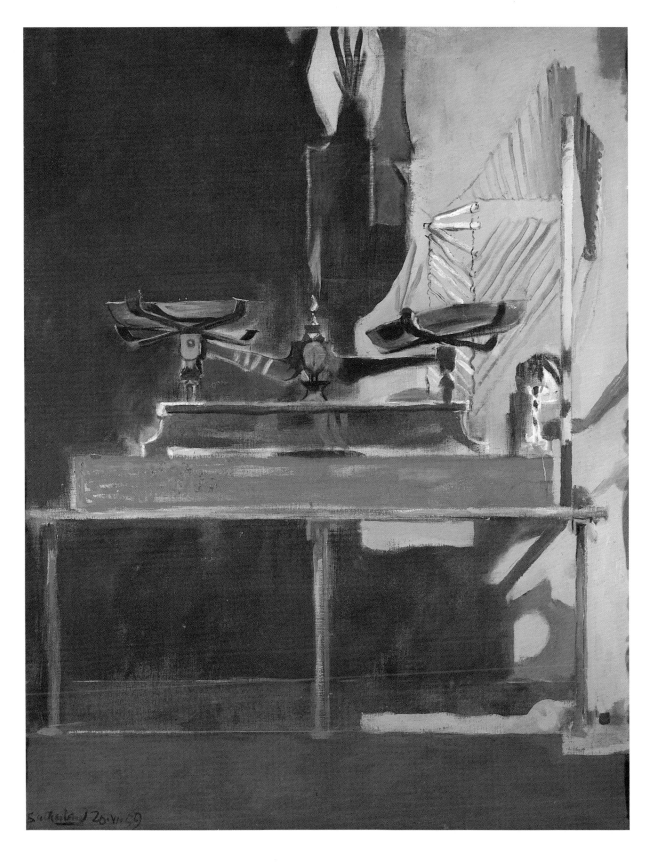

159   The Scales   1959

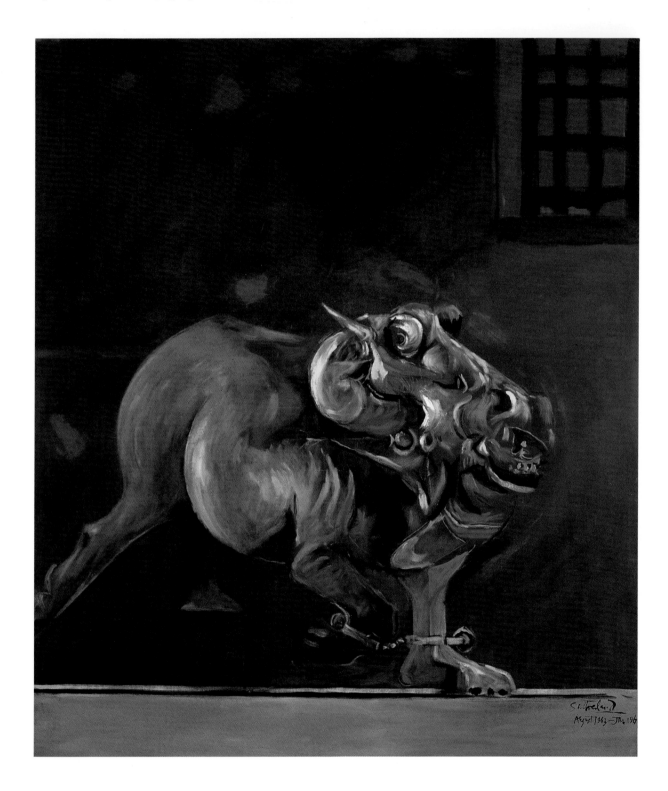

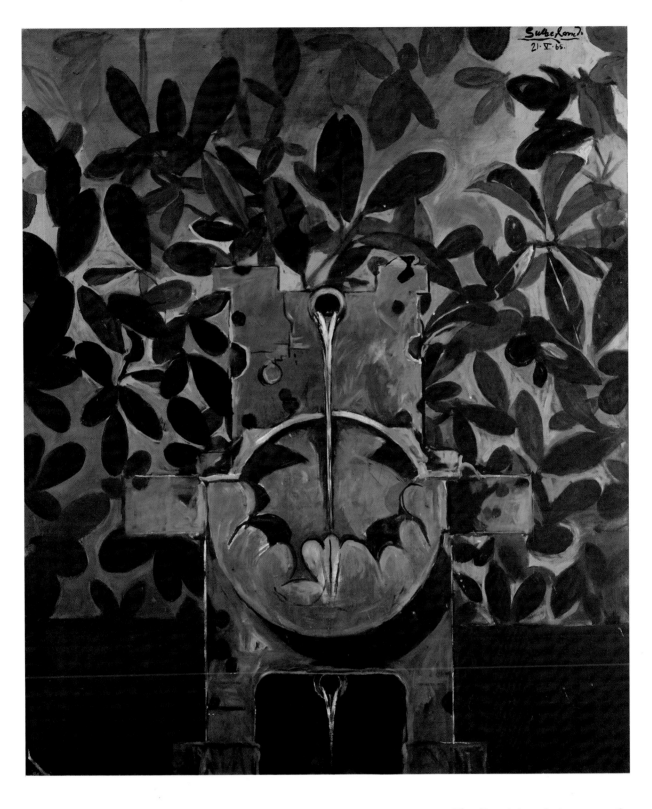

200 Blue Fountain – Autumn 1965

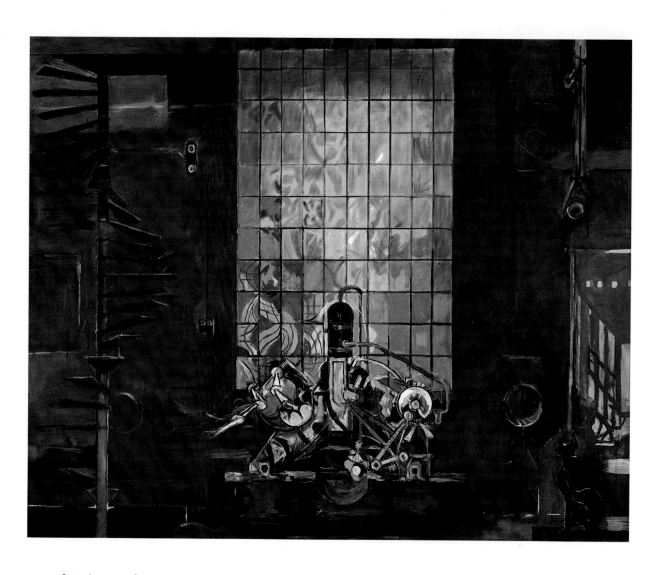

**202** **Interior** 1965

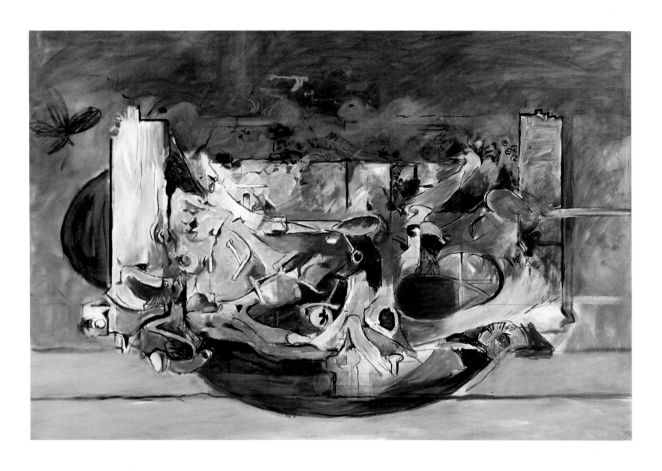

205  U-Shaped Form  1968

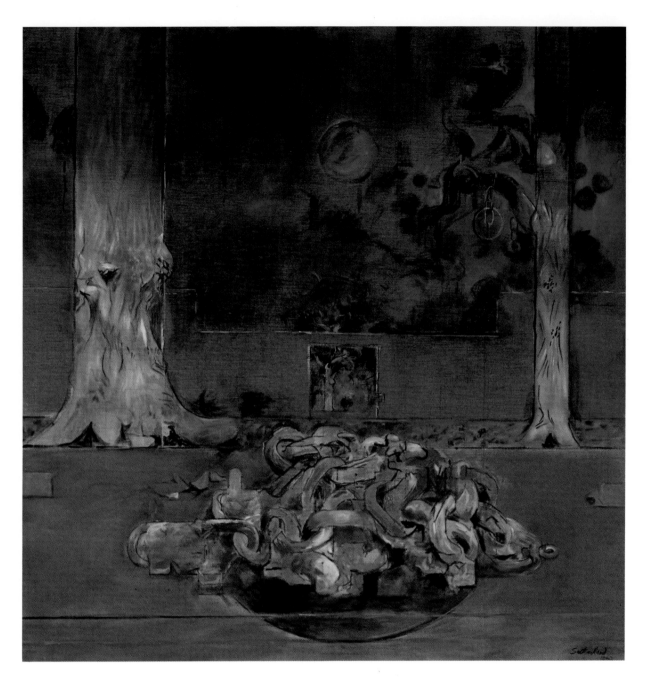

213  Forest with Chains II  1973

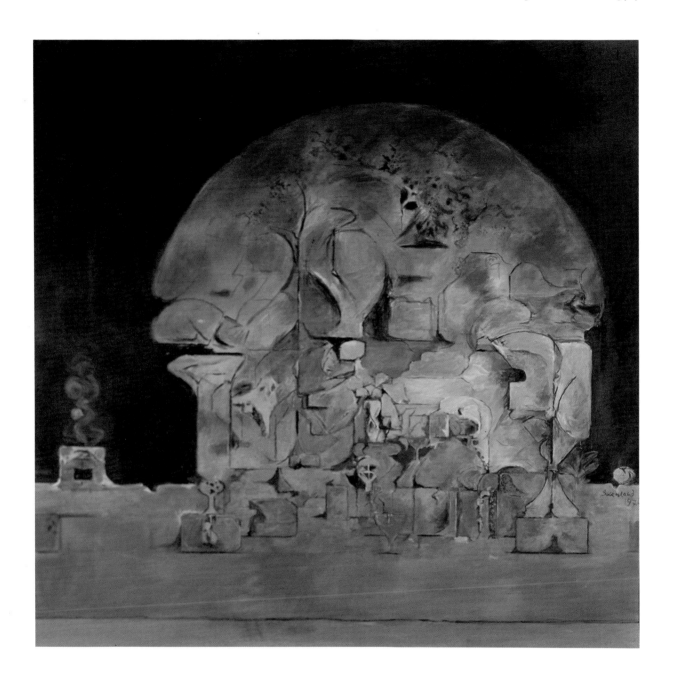

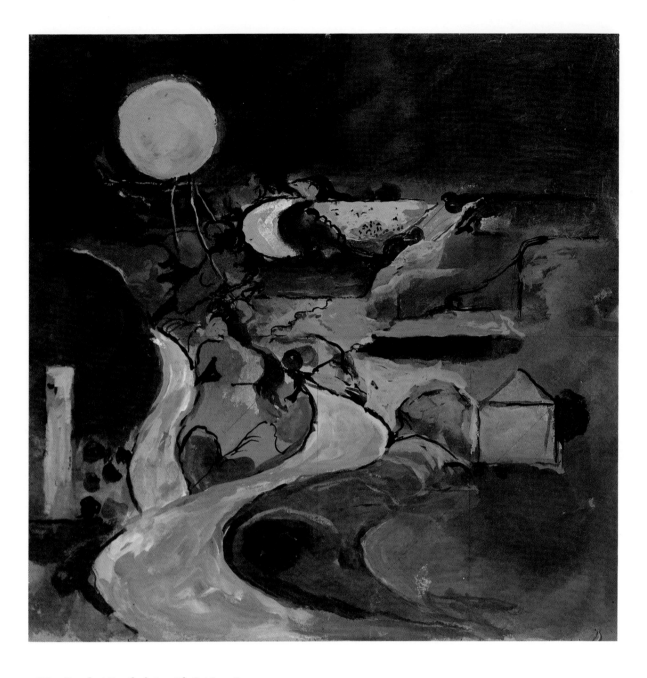

266    Road at Porthclais with Setting Sun   *c.* 1975

# The Early Work

The exhibition begins with a group of the early etchings with which Sutherland first made his reputation, including almost all those of a Samuel Palmeresque type. After giving up etching soon after 1930, he turned to painting, but did not begin to find his way as a painter until 1934 when he made his first visit to Pembrokeshire. During the difficult transitional period he supported himself partly by designing posters, china, glass and other forms of applied art. This room contains a number of his early watercolours and drawings, showing the gradual evolution of his style, and ends in 1936 with four of his earliest surviving oil paintings.

1

**1   The Black Rabbit   1923**

Inscribed '1st State. 4th proof.' b.l.
Etching and crayon, $7\frac{5}{8} \times 8\frac{3}{8}$ (19.2 × 21.3)
Lit: Walker No.10 I; Man No.11 I, n.p. and repr.: Tassi No.8 I, pp.16, 47 and 220, repr. p.47; Hayes, pp.10–11, 49, repr. pl.1
*The Trustees of the British Museum*

While Sutherland was a student at Goldsmith's College he made frequent expeditions to Arundel in Sussex and its neighbourhood, to draw from nature. This etching shows a view of the River Arun from the slopes of Arundel Park, and the title is that of a public house. In the second, final state the tree on the right is more finished. (This impression of the first state has some hatching in this area in crayon.)

His earliest known engravings are drypoints done in 1922. Already by 1923 he had achieved remarkable proficiency, working here somewhat in the tradition of Whistler.

2

**2   The Sluice Gate   1924**

Inscribed 'Graham Sutherland. MCMXXIV.' b.r.
Etching, $5\frac{1}{2} \times 5\frac{1}{4}$ (14 × 13.3)
Lit: Walker No.14 IV; Man No.15 IV, n.p. and repr.; Tassi No.10 IV, pp.48 and 226, repr. p.48
*Victoria and Albert Museum, London*

In this strongly contrasted study of light and shade, the main influence appears to be Rembrandt.

**3   Number Forty-Nine   1924**

Inscribed 'Graham Sutherland.' b.r.
Etching, $6\frac{7}{8} \times 9\frac{3}{4}$ (18 × 25.2)
Lit: Walker No.21 (state uncertain); Man No.22 (state uncertain), n.p. and repr.; Tassi No.14 (state uncertain), pp.16, 19, 50 and 224, repr. p.50
Repr: *Print Collector's Quarterly*, XVI, 1929, p.78
*Victoria and Albert Museum, London*

The title is the number of the cottage, marked on the door. Though the choice of a picturesque old cottage

with a thatched roof in a state of advanced disrepair may have been suggested by a knowledge of Samuel Palmer's work, the style is still completely factual and precise, more Dürer-like, with a great amount of meticulously observed detail.

**4     Village** 1925

Inscribed 'Graham Sutherland imp.' b.r.
Etching, $6\frac{7}{8} \times 8\frac{7}{8}$ (17.5 × 22.5)
Lit: Walker No.22 III; Man No.23 III, n.p. and repr.; Tassi, No.20 III, pp.53 and 227, repr. p.53
*Victoria and Albert Museum, London*

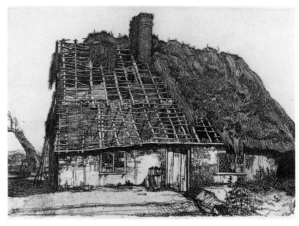

3

Samuel Palmer's etchings, which Sutherland and his friends discovered in the autumn of 1924, encouraged them to adopt a visionary, poetic approach to nature and to make prints which were very heavily worked and reworked, with a dense mesh of lines (a technique which was anathema to their teachers at Goldsmith's). Here the lines create a dark, rich texture which suggests a kind of pulsation, as though the whole of nature was throbbing with inner life.

The scene is pastoral, with a girl collecting potatoes in a basket in the foreground and rolling tilled fields beyond leading to a far-off village and distant hills. Despite the fairytale-like atmosphere, it was based mainly on scenery around Cudham in Kent, but with elements from Warning Camp in Sussex.

4

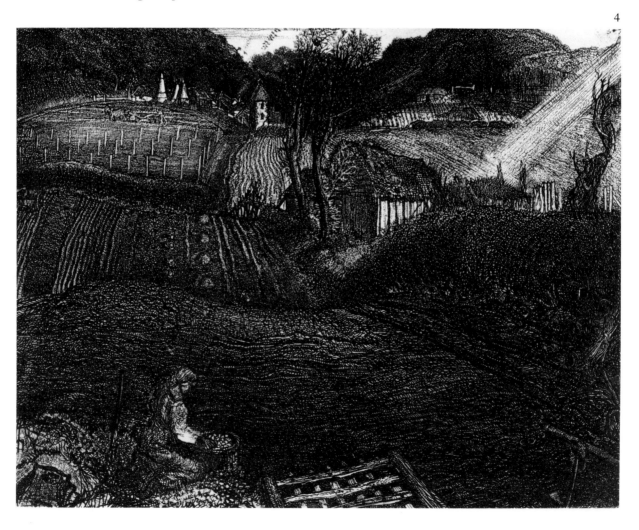

5

5 **Pecken Wood** 1925

Inscribed 'GRAHAM SUTHERLAND MCMXXV†'
in the plate t.r. and in the margins 'Final State'
b.l. and 'Graham Sutherland' b.r.
Etching, $5\frac{3}{8} \times 7\frac{3}{8}$ (13.5 × 18.9)
Lit: Walker No.23 V; Man No.24 V, n.p. and
repr.; Tassi No.21 V, pp.19–20, 54 and 224,
repr. p.54
Repr: *Fine Prints of the Year*, III, 1926, pl.52
*Tate Gallery*

Not only do Sutherland's Samuel Palmeresque etch-
ings of 1925–7 have no connection with modern art,
but the rural world which they depict is one of the
past, the evocation of a mode of village life which had
almost completely passed away. The emphasis is on
the autumnal fertility of nature, with man living in
communion with nature, and usually the moment
depicted is when the sun is setting, or near setting, and
the stars are beginning to come out.

The cross after the date presumably means 'the year
of Our Lord'.

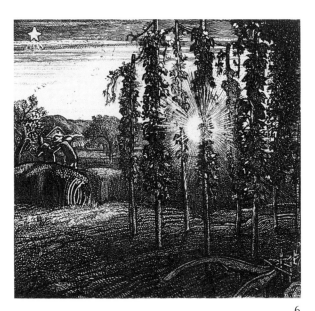

6

6 **Cray Fields** 1925

Inscribed 'Graham Sutherland' b.r.
Etching, $4\frac{3}{4} \times 4\frac{7}{8}$ (12 × 12.5)
Lit: Walker No.24 VI; Man No.25 VI, n.p. and
repr.; Tassi No.19 VI, pp.20, 52 and 221,
repr. p.52
Repr: *Fine Prints of the Year*, IV, 1926, pl.45
*Tate Gallery*

The sun blazing behind the trees, offset by the evening
star, creates the impression, despite the tiny format, of
a moment of enraptured magical intensity.

7 **St Mary Hatch** (two impressions) 1926

Both inscribed 'GRAHAM SUTHERLAND / INV.
ET FEC. MCMXXVI†' in the plate b.l., and the
lower with the inscription given below
Etchings, each $4\frac{7}{8} \times 7\frac{1}{4}$ (12.4 × 18.7)
Lit: Walker No.25 II; Man No.26 II, n.p. and
repr.; Tassi No.22 II, pp.55 and 226, repr. p.55
Repr: *Print Collector's Quarterly*, XVI, 1929, p.82
*The Trustees of the British Museum*

7

That some of the etchings of this time are intended to
have a religious undertone is borne out by the fact that
one of these impressions, both made before the plate
was trimmed, is inscribed in pencil: 'DOMINE QUIS
HABITABIT IN TABERNACULO TUO AUT QUIS RE-
QUIESCET IN MONTE SANCTO TUO QUI INGREDITUR
SINE MACULA ET OPERATA JUSTITIAM.' This is a
passage from Psalm 14 in the Vulgate, which is Psalm
15 in the Authorised Version: 'Lord, who shall abide
in thy tabernacle? Who shall dwell in thy holy hill? He
that walketh uprightly, and worketh righteousness.'
It was at the end of this year, in December 1926, that
Sutherland became a Roman Catholic after undergo-
ing a long course of instruction.

Here village life is depicted as one of honest toil
centred round the church, whose lych-gate and
graveyard are visible on the right.

8    **Lammas** 1926

Inscribed 'G.S. INV. ET FEC. MCMXXVI†' in the
plate in reverse b.l.
Copper etching plate, $4\frac{9}{16} \times 6\frac{9}{16}$ (11.6 × 16.7)
*Private collection*

The copper plate from which the pair of etchings No.9
was printed.

9    **Lammas** 1926
(first and final states)

Upper print of first state not inscribed
Lower print of fifth, final state inscribed 'G.S.
INV. ET FEC. MCMXXVI†' in the plate b.r. and
signed 'Graham Sutherland imp.' in margin
b.r.
Both etchings $4\frac{3}{8} \times 6\frac{1}{2}$ (11.2 × 16.2); the upper
one reworked in ink and gouache
Lit: Malcolm C. Salaman, 'A Gossip about
Prints' in *Apollo*, V, 1927, pp.84–5, repr. p.84;
Walker No.26 I and V; Man No.27 I and V, n.p.
and repr.; Tassi No.23 I and V, pp.56 and 223,
repr. p.56
*The Trustees of the British Museum*

The upper print, apparently the only impression of
the first state, is extensively worked over in ink and
gouache. It differs from the final state in various
respects, such as that the sky has a different cloud
pattern at the top right, the star is in a different place,
there is no plough at the bottom right, no wall on the
right and no roof behind the cottage on the right.
Sutherland has painted in a sheaf of corn in the
bottom right corner. This is typical of his method of
working at this period and the British Museum owns a
number of other early etchings which are modified in
this way, as well as series of impressions showing
different states, with repeated small changes.

Lammas day is the first day of August. The word
Lammas derives from the fact that loaves made from
the first ripe grain were formerly consecrated on this
day.

10    **May Green** 1927

Inscribed 'IN FESTO VISITATIO/NE/ GS INV.
MCMXXVII' in the plate b.l.
Etching, $4\frac{1}{2} \times 6\frac{3}{8}$ (11.3 × 16.1)
Lit: Walker No.27 VI; Man No.28 VI, n.p. and
repr.; Tassi No.25 VI, pp.57 and 224, repr. p.57
Repr: *Fine Prints of the Year*, V, 1927, pl.41
*Victoria and Albert Museum, London*

There appear to be allusions here to the manger and
the Nativity, with the sun poised just above the cradle-
like stack of wood and a white dove about to alight.
The inscription in the plate apparently reads 'IN
FESTO VISITATIONE', which can be translated as 'On
a birthday visitation'.

11    **Drawing for 'The Meadow Chapel'** 1928

Not inscribed
Ink and gouache on paper, $4\frac{1}{2} \times 6$ (11.4 × 15.4)
*The Trustees of the British Museum*

9

9

10

11

This is one of the few surviving drawings for the early etchings and is related to states IV to VII because all the sheep's heads are down. Among other notable differences from the final, twelfth state, there are more birds in flight, no marked cloud formations, the tombstones are different and the foliage of the trees on the right is more extensive.

### 12   The Meadow Chapel 1928

Not inscribed
Copper etching plate, $4\frac{5}{8} \times 6\frac{3}{16}$ (11.7 × 15.7)
*Private collection*

The copper plate from which the etching No.13 was printed.

13

### 13   The Meadow Chapel 1928

Inscribed 'Graham Sutherland –' b.r.
Etching, $4\frac{1}{2} \times 6$ (11.4 × 15.4)
Lit: Walker No.29 XII; Man No.30 XII, n.p. and repr.; Tassi No.26 XII, pp.59 and 224, repr. p.59
Repr: *Fine Prints of the Year*, VI, 1928, pl.44
*Victoria and Albert Museum, London*

Although the mood is still Palmeresque, the emphasis on the simple block-like shapes of the chapel and the curving wall indicate a growing awareness of contemporary movements in art.

### 14   Hanger Hill 1929

Inscribed 'Final State' b.l. and 'Graham Sutherland' b.r.
Etching, $5\frac{1}{2} \times 5\frac{1}{4}$ (14.1 × 13.2)
Lit: Man No.31 VI, n.p. and repr.;
Tassi No.27 VI, pp.59 and 222, repr. p.59
Repr: *Apollo*, IX, 1929, p.386
*The Trustees of the British Museum*

14

Here the Palmer-like vision begins to take on a note of menace, and is combined with a shift of perspective and a patterning of the trees inspired probably by Paul Nash; this is the first sign of Nash's influence. The fourth and fifth states of this etching (the one exhibited is of the sixth, final state) both incorporate dedications to F.L. Griggs.

### 15   Cottage in Dorset 1929

Inscribed 'Graham Sutherland' b.r. towards centre
Etching, $5\frac{5}{8} \times 7$ (14.2 × 18)
Lit: Man No.33, n.p. and repr. (as 'Cottage in Dorset'); Tassi No.28, pp.60 and 221, repr. p.60 (as 'Cottage in Dorset')
Repr: *Studio*, XCIX, 1930, p.350 (as 'Wood End'); *Fine Prints of the Year*, VIII, 1930, pl.45 (as 'Wood End')
*The Trustees of the British Museum*

Sutherland visited Dorset regularly every year from 1928 to 1933. This etching was originally known as 'Wood End'.

16   **Wood Interior**  1929–30

Not inscribed
Copper etching plate, $4\frac{3}{4} \times 6\frac{1}{2}$ (12 × 16.5)
*Private collection*

The copper plate from which the etching No.17 was printed.

17   **Wood Interior**  1929–30

Inscribed 'Graham Sutherland.' b.r.
Etching, $4\frac{3}{4} \times 6\frac{3}{8}$ (12 × 16.2)
Lit: Man No.32 II, n.p. and repr.; Tassi No.29 II, pp.20–21, 61 and 228, repr. p.61
*Victoria and Albert Museum, London*

As Roberto Tassi, in his catalogue of Sutherland's prints, points out: 'The definitive advance towards what was to be the true world of Sutherland came in 1929, when he seems to have shaken off the Palmer-inspired mysticism and to have achieved a more direct, dramatic relationship with nature: his surfaces were now almost completely occupied by trees, great woods and their shadows' (Tassi, p.20).

The twisting roots of the tree on the right anticipate his later work.

18   **Road at Well Hill**  1930

Inscribed 'Graham Sutherland 1930' b.r.
Watercolour and pencil on paper,
$9\frac{5}{8} \times 13\frac{3}{4}$ (24.5 × 35)
First exh: New English Art Club, London, November–December 1930 (297)
*MacMillan and Perrin Gallery, Toronto, Canada*

In a letter about this watercolour dated January 1963, Sutherland wrote:

*It was done just at the time that I was ceasing to do etchings and engravings and starting to paint. It must have been done I would think in the Spring of 1930 and it is in fact a road at the village called Well Hill not far from Shoreham in Kent. I was known in those days in the rather specialist field of engraving only and I was exploring and experimenting in trying to broaden my horizon and the means of working.*

A neat, deftly patterned design somewhat in the manner of Paul Nash, it shows a road seen at more or less the same oblique angle as the one in the etching 'Cottage in Dorset' of 1929 (No.15).

19   **Pastoral**  1930

Inscribed 'Pastoral' b.l. and 'Graham Sutherland' b.r.
Etching and engraving, $5\frac{1}{8} \times 7\frac{5}{8}$ (13 × 19.5)
Lit: *Fine Prints of the Year*, XI, 1933, p.viii, repr. pl.46; Man No.34 IV, n.p. and state III repr.; Tassi No.30, pp.21, 62 and 224, repr. p.62
Repr: Sackville-West, 1943, pl.2
*Tate Gallery*

This is the first work in which one can see clear indications of how Sutherland's style was to develop

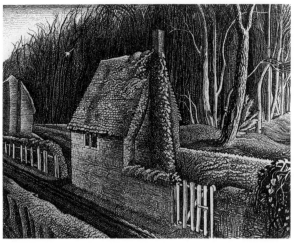

15

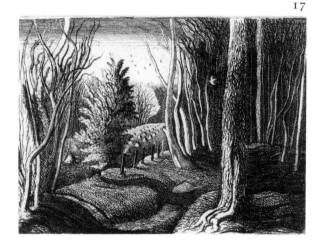

17

18

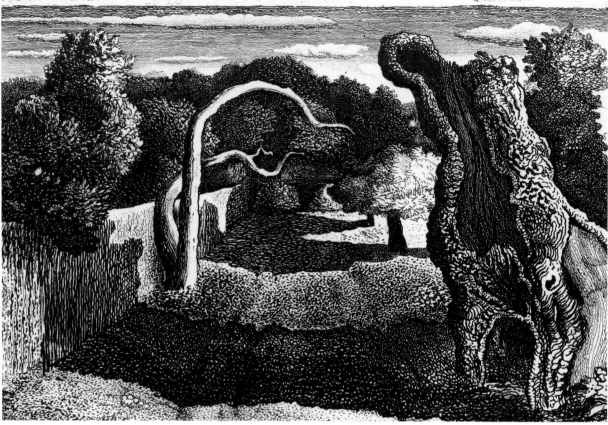

19

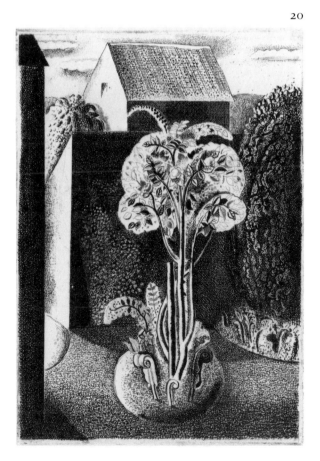

20

later on. Not only is the scene charged with drama, heightened by strange dark shadows, but the writhing forms of the dead tree on the left, and even more the gnarled, monster-like forms of the hollow tree trunk on the right, look forward to the works of his two Pembrokeshire periods.

**20    The Garden** 1931

> Inscribed '$\frac{3}{6}$ own proof'. b.l. and 'Graham Sutherland' b.r.
> Etching, $8\frac{1}{2} \times 6\frac{1}{8}$ (21.7 × 15.6)
> Lit: *Fine Prints of the Year*, IX, 1931, p.viii; Man No.35, n.p. and repr.; Tassi No.31, pp.63 and 222, repr. p.63; Hayes, pp.12, 52, repr. pl.6
> *Victoria and Albert Museum, London*

A rose tree in the artist's garden at Farningham is transformed into a symbol of organic growth, its plumy forms picked out like an aura by the sunlight coming from behind, to the left. There is a marked interest in contrasting patterns, straight lines against curves, dark against light, and the image has an overall crispness and neatness.

Its more modern, Paul Nash-like character caused the Royal Society of Painter-Etchers and Engravers to refuse to hang it in their exhibition, which led Sutherland eventually to break with the Society, of which he had been an associate member since 1925.

## 21 Oast House 1932

Inscribed 'Graham Sutherland' b.r.
Etching, $6\frac{3}{4} \times 10\frac{3}{8}$ (17.3 × 26.4)
Lit: *Fine Prints of the Year*, x, 1932, p.vii; Man
No.36 II, n.p. and repr.; Tassi No.32, pp.64 and
224, repr. p.64
*The Trustees of the British Museum*

The last of Sutherland's early etchings, which apparently served as the basis for the first of his posters. The latter is captioned 'Everywhere You go You can be sure of Shell. Near Leeds, Kent', which gives the location.

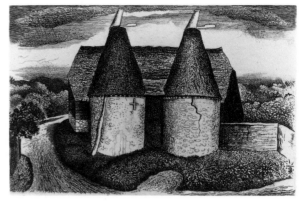

21

## 22 Near Leeds, Kent 1932

Inscribed 'Graham Sutherland.' b.r.
Gouache on paper, 21 × 38 (53.3 × 96.5)
First exh: *Fifty Years of Shell Advertising
1919–1969*, 195 Piccadilly, London,
June–July 1969 (30) as 'Near Leeds, Kent.
Oasthouses'
*Shell U.K. Ltd*

The original artwork for No.23.

## 23 Near Leeds, Kent 1932

Inscribed 'Graham Sutherland.' in the print b.r.
Lithograph, 30 × 45 (76.2 × 114.3)
Repr: *Commercial Art and Industry*, xv, 1933,
p.15
*Joint Shell-Mex and B.P. Archive*

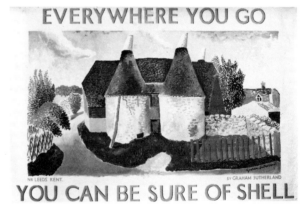

23

This was Sutherland's first poster, or rather lorry bill, designed for Shell-Mex and B.P. Ltd and published in the first half of 1932 (probably in the spring). Under the enterprising direction of Jack Beddington, Shell-Mex and B.P. Ltd had begun about 1930 to commission a wide range of avant-garde artists, including young or little-known ones, to design the posters used on the sides and backs of the firm's fleet of petrol delivery lorries. Like 'The Great Globe, Swanage', which Sutherland designed for them shortly afterwards, this one belonged to the series known as 'Landscapes: "You can be sure of Shell"', in which the picture was a straightforward view of some landscape motif. The image in this case was based on Sutherland's last early etching, 'Oast House' (No.21), made the same year. It was printed by the Baynard Press.

**24    The Great Globe, Swanage** 1932

Inscribed 'Graham Sutherland' b.l.
Gouache on paper, 21 × 38 (53.3 × 96.5)
First exh: *Fifty Years of Shell Advertising
1919–1969*, 195 Piccadilly, London,
June–July 1969 (34)
*B.P. International Ltd from the joint Shell-Mex
and B.P. Archive*

The original artwork for No.25.

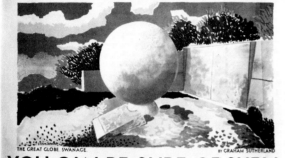

EVERYWHERE YOU GO

THE GREAT GLOBE SWANAGE.                    BY GRAHAM SUTHERLAND

YOU CAN BE SURE OF SHELL

25

**25    The Great Globe, Swanage** 1932

Inscribed 'Graham Sutherland' in the print b.l.
Lithograph, 30 × 45 (76.2 × 114.3)
Lit: Kenneth Clark, *Another Part of the Wood: a
Self-Portrait* (London 1974), pp.253–4
Repr: *Architectural Review*, LXXVI, 1934,
between pp.2 and 3 in colour; *Modern Publicity
1934–5*, 1934, p.47 in colour; Hayes, fig.3
*Victoria and Albert Museum, London*

Sutherland's second lorry bill for Shell-Mex and B.P.
Ltd, published in the autumn of 1932 and printed by
Waterlow & Son Ltd. When Kenneth Clark (later Lord
Clark) opened an exhibition of *Pictures in Advertising
by Shell-Mex and B.P. Ltd* at the New Burlington
Galleries in June 1934, he was particularly impressed
by this design, which was the first work by Sutherland
to catch his attention.

The Great Globe, ten feet in diameter, weighing
forty tons, is a chiselled globe of the world surrounded
by quotations. Made in the 1880s, and something of a
local curiosity, it also intrigued Paul Nash, who used a
photograph he had taken of it to illustrate his article
'Swanage, or Seaside Surrealism', published in *The
Painter's Object*, ed. Myfanwy Evans, in 1937.

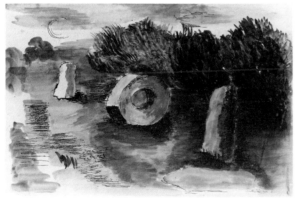

26

**26    Men-an-Tol** 1933

Inscribed 'Sutherland, 1932–3' b.r.
Ink and watercolour on paper,
20⅜ × 30 (51.7 × 76.2)
Repr: Cooper, pl.5b; Sanesi, pl.6; Hayes, pl.13
in colour
*Marlborough Fine Art (London) Ltd*

One of the very few surviving watercolours of this
period. It depicts the stones known as Men-an-Tol at
Lanyon in West Cornwall, which were believed at one
time to have magical properties: it was an ancient
pagan custom to draw sick children through the hole
in order to cure illnesses. As Sutherland visited
Cornwall in 1933 the drawing was probably done
then, on the spot, out of doors. The date 1932–3 now
on the drawing was added many years later, after it
came up for sale at Sotheby's in November 1969.

It is painted in a style similar to that of his posters of
the same period, more vigorously and loosely than in
his watercolours of about 1930, and with larger
brushstrokes, but still closely based on the scene in
front of him. His only surviving early oil painting,
'Dorset Farm' 1932 (repr. Cooper, fig.1) is also painted
in much the same manner.

## 27 Design for a Cup and Saucer ('White Rose') 1933

Inscribed 'Graham Sutherland.' b.r.; also with
two sets of instructions in ink, initialled and
dated 'G.S.25.VI.33'
Ink, watercolour and pencil on paper,
10½ × 8¼ (26.5 × 21)
Lit: Noel Carrington, 'Artists and Industry at
Harrods' in *Design for To-day*, II, 1934,
pp.461–4
*Coalport, Stoke-on-Trent*

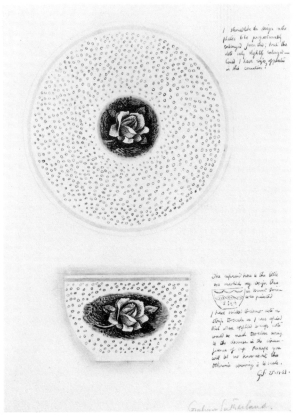

27

Sutherland's designs for china, pottery and glass in
the early 1930s were made in connection with a
project devised by T.A. Fennemore, a director of the
firm of E. Brain and Co., Stoke-on-Trent, the makers
of Foley China, who in 1933 conceived the idea of
inviting a number of leading artists to make designs
for reproduction, and of placing them before the
public on a large commercial scale. The artists who
participated included Duncan Grant, Vanessa Bell,
Ben Nicholson, Barbara Hepworth, John Armstrong,
Laura Knight and Frank Brangwyn. Since Brains
only made china, Fennemore also enlisted the co-
operation of Messrs Wilkinson of the Royal Stafford-
shire Pottery, manufacturers of earthenware, and
Stuart & Sons, the glass manufacturers; an exhibition
of the china, pottery and glass resulting took place at
Harrods in October–November 1934. Though this
was an artistic success, and was even hailed by Noel
Carrington in *Design for To-day* as 'probably the
greatest advance in pottery decoration this century', it
sadly proved to be a commercial failure, as the buyers
in the trade preferred not to take the risk of investing in
the new designs.

E. Brain and Co.'s pattern books for the period, now
in the possession of Messrs Coalport, contain seven
designs by Sutherland for the decoration of Foley
China, though one or possibly two appear to be the
same. However only four seem to have been used.
The two which were widely agreed to be especially
successful, and among the finest of all the designs
produced for this project, were this one, the 'White
Rose' design, and the one known as 'Green Daisy' or
'Green Stars'.

This drawing is an actual working design for 'White
Rose' and is annotated by Sutherland as follows:

*[alongside the plate] I should like the design on the plates
to be proportionally enlarged from this; but the dots only
slightly enlarged – Could I have sizes of plates in this
connection?*
*[alongside the cup] The cup used here is the little one on
which my design thus in burnt sienna was painted.*
*I have omitted to draw dots on strip to scale as I was
afraid that when applied to cup dots would be much too
close owing to the decrease in the circumference of cup.
Perhaps you will let me know about this otherwise
drawing is to scale.*

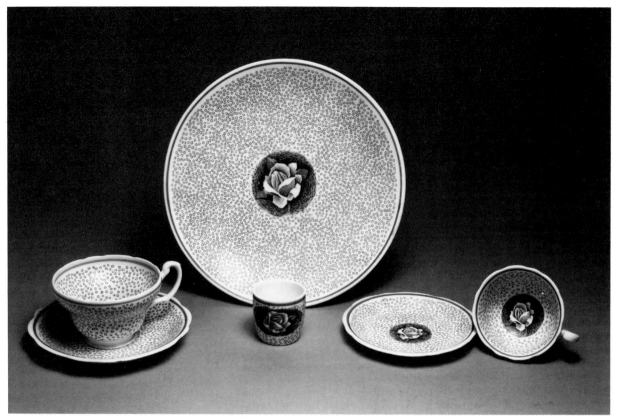

28

28   **Part of a Tea-set ('White Rose')** 1933

Each piece inscribed 'FOLEY/ENGLISH BONE
CHINA/ by/Graham Sutherland/ARE/
ARTIST'S/COPYRIGHT RESERVED/MADE IN
ENGLAND' on base; the base of the coffee cup
only inscribed 'v626'
Bone china: plate, diameter $8\frac{15}{16}$ (22.8)
        coffee cup, diameter $3\frac{1}{8}$ (7.9);
        height $1\frac{3}{4}$ (4.4)
        saucer, diameter $4\frac{3}{4}$ (12.2)
        tea cup, diameter $3\frac{3}{4}$ (9.5); height
        $2\frac{1}{4}$ (5.8)
        saucer, diameter $5\frac{5}{8}$ (14.3)
        egg cup, height $1\frac{3}{4}$ (4.5)
*Victoria and Albert Museum, London*

Part of a tea-set made by E. Brain and Co. in their Foley
China range; the pieces are decorated in black with a
transfer-printed pattern and painted in green. The
drawing No.27 is a study for the plate and the tea cup.

A colour illustration on p.33 of the book edited by
Noel Carrington and Muriel Harris, *British Achieve-
ment in Design* (London 1946), shows two plates and a
cup and saucer with this design but with the rose
coloured pink.

The inscription 'v626' on the bottom of the coffee
cup is the number of this design in E. Brain and Co.'s
pattern book.

29   **Part of a Tea-set**
    **('Green Daisy' or 'Green Stars')** *c.*1933–4

Each piece inscribed 'FOLEY / ENGLISH BONE
CHINA / By / Graham Sutherland / ARE /
ARTIST'S / COPYRIGHT RESERVED' on base
Bone china: bread-and-butter plate, diameter
        $5\frac{3}{16}$ (13.1)
        milk jug, height $2\frac{7}{16}$ (6.4)
        jug and cover, height $4\frac{1}{2}$ (11.4)
        cup, diameter 5 (10.2); height $2\frac{1}{2}$
        (6.4)
        saucer, diameter $6\frac{3}{16}$ (15.6)
Repr: *Design for To-day*, II, 1934, p.464 (a cup
and saucer and a plate); Noel Carrington and
Muriel Harris (ed.), *British Achievement in
Design* (London 1946), p.22 (the same
photograph)
*Victoria and Albert Museum, London*

Also made by E. Brain and Co. as part of their Foley
China range. The pen lines were reproduced by en-
graving and transfer, and the colour band and dots
applied freehand by brush. Though usually known as
the 'Green Daisy' design, the title given in E. Brain and
Co.'s pattern book is 'Green Stars'.

### 30 Tureen, Cover and Stand 1934

The tureen and stand both inscribed
'DESIGNED BY / Graham Sutherland / ARE /
PRODUCED IN / Bizarre / by / Clarice Cliff /
WILKINSON LTD / ENGLAND / COPYRIGHT
RESERVED / FIRST EDITION' and 'MADE IN /
ENGLAND' on the base; the stand also has an
impressed mark '34' on the base; the cover is
not inscribed
Semi-porcelain: tureen (including cover and
        handles), diameter $10\frac{3}{4}$ (27.4),
        height $4\frac{3}{4}$ (12)
        stand, diameter $10\frac{1}{8}$ (25.7)
*Victoria and Albert Museum, London*

Pieces from a dinner-set made by A.J. Wilkinson Ltd in
semi-porcelain.

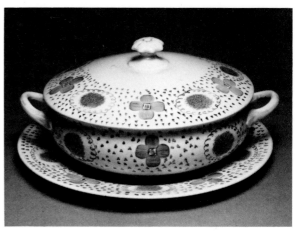

30

### 31 Design for a Flower Vase and a Large Fruit Dish 1934

Inscribed with a letter to Mr Stuart and with
annotations (all printed below)
Pencil and watercolour on paper,
22 × 30 (55.8 × 76.2)
*Stuart Crystal*

Working drawings for a flower vase and a large fruit
dish to be made by Stuart & Sons, the glass manufac-
turers of Stourbridge. The fruit dish is No. 32.

The drawings for the flower vase are annotated:
'*Flower Vase* (1) / Engraved design', 'Each / spiral
slightly different' and 'FIVE SPIRALS ON EACH VASE
EQUIDISTANT'.

The drawing for the fruit dish is annotated: '*Large
fruit dish*' and 'Shallow Cutting (intaglio?) unpolished
/ perhaps spots in centre'.

There is also a letter to Mr Stuart as follows:

*Sutton Place Cottage Sutton-at-Hone Kent*

*Dear Mr Stuart,*

*I don't think the design No. 1 will present any
difficulties. No. 2 and 3 look absurd on paper but quite
well on the glass painted white. I should really prefer
No. 2 engraved but I understand that you want some
designs for cutting & I have tried to allow for this. Time
seems badly against us & I could probably do very much
better in the designs for cutting if I actually saw it being
done. We are going for our holidays on or about Aug 8th
& via the Cotswolds to S. Wales – perhaps we could call
in and see you at the works – though it will be, I am
afraid, too late for practical purposes.*

*Do you think it impossible technically to carry out the
designs as freely as this. I feel that English designs have
become too inflexible and that designs should be, as it
were, written, or freely carved on the static glass. I shall
await your opinion with interest.*

*Yours sincerely,*
*Graham Sutherland*

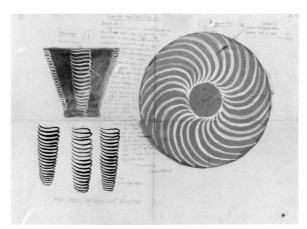

31

32

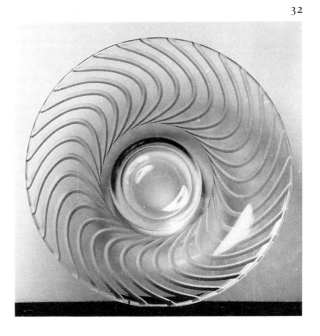

**32 Fruit Dish** 1934

Inscribed 'DESIGNED BY / GRAHAM SUTHER-
LAND' and 'Stuart / ENGLAND' on the base of
the foot
Crystal glass, circular, diameter 14 (35.5);
height $4\frac{1}{4}$ (10.8)
Repr: Hayes, fig.2 (the large dish in the centre
of the photograph)
*Victoria and Albert Museum, London*

The fruit dish made from the drawing No.31.

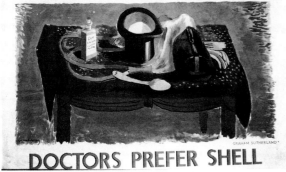

33

**33 Doctors Prefer Shell** 1934

Inscribed 'Graham Sutherland.' in the print b.l.
Lithograph, 30 × 45 (76.2 × 114.3)
*Shell U.K. Ltd*

A lorry bill issued by Shell-Mex and B.P. Ltd towards
the end of 1934, one of a series known as 'Concho-
philes' with texts such as 'Tourists prefer Shell/You
can be sure of Shell'. The series also included 'Explorers'
(McKnight Kauffer), 'Tourists' (Tristram Hillier) and
'Footballers' (Paul Nash). It was printed by Vincent
Brooks, Day & Son.

34

**34 Road with Rocks** 1935

Not inscribed
Ink and wash on paper,
$13\frac{1}{2}$ × $21\frac{1}{2}$ (34.3 × 54.6)
First exh: *Some Drawings of the Past Fifty Years*,
National Gallery, London, November 1940 –
March 1941 (72)
Repr: *Signature*, 1, November 1935, facing
p.28; Sackville-West, 1943, pl.4; Cooper, pl.8b
*Kenneth Clark*

One of the earliest surviving Pembrokeshire draw-
ings, a scene to the west of St David's, looking west
across Treswni Moor. Though dated 1936 in the cata-
logue of the Henry Moore, John Piper and Graham
Sutherland exhibition at Temple Newsam, Leeds, in
1941, it was reproduced in the November 1935 issue
of Oliver Simon's magazine *Signature* to illustrate an
article by Paul Nash on 'New Draughtsmen', and
drew from Nash the comment: 'The whole conception
is nebulous and abstract, the method fluid, almost
precipitate. A feeling of nervous, scarcely controlled
energy pervades the drawing, yet it achieves a subtle
harmonious unity. Its whole atmosphere is evocative,
its message lyrical.' Not only is there a rhythm that
runs throughout the composition, but the delicate
washes and stippling give the impression that every-
thing is half-floating.

**35    Lobster Claw** 1935

Inscribed 'Sutherland. 1935' b.r.
Gouache and watercolour on paper,
8 × 13 (20.5 × 33)
First exh: *Graham Sutherland*, Galleria Civica
d'Arte Moderna, Turin, October–November
1965 (3a, repr.)
Repr: Cooper, pl.5e; Hayes, pl.12
*Picton Castle Trust*

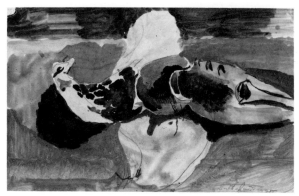

35

Graham and Kathleen Sutherland included almost all
the early Pembrokeshire drawings then still in their
possession as part of their gift to found the Graham
Sutherland Gallery (now known as the Graham and
Kathleen Sutherland Foundation) at Picton in 1976.
Most of them are quite small – exploratory ideas
which were never carried any further – but they illus-
trate the increasing freedom with which he handled
form and colour. The dates on them have to be treated
with caution, as they usually seem to have been added
later and do not appear in early photographs.

**36    Pembrokeshire Landscape** 1935

Inscribed 'Sutherland 1935' b.r.
Gouache on paper, 6⅜ × 8 (16 × 20.5)
First exh: *The Sutherland Gift to the Nation*,
Marlborough Fine Art, London, April 1979
(works not listed)
Repr: Hayes, pl.16
*Picton Castle Trust*

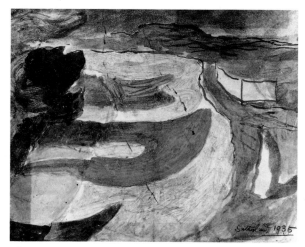

36

Sutherland annotated a colour reproduction of this:

*As far as my memory is reliable, this water-colour
derives from a road Nr Rhosson about 1½ miles from St.
David's to the South West. The 'outcrop' on the horizon ·
is typical of the area. I should say that the shadows of the
setting sun show a good deal of 'poetic licence'. The
standing stone at that time was there. There are, alas,
not many left now.*

However it is now thought that the view is more likely
to be on the east side of St Bride's Bay, between
Druidston and Nolton Haven, and looking north.

**37    Pembrokeshire Landscape** 1935

Not inscribed
Ink and gouache on paper,
14 × 21½ (35.6 × 54.6)
First exh: *Contemporary Art Society: The First
Fifty Years 1910–1960*, Tate Gallery, April–
May 1960 (142)
Repr: Cooper, pl.7b (dated 1936); Hayes, pl.19
in colour
*National Museum of Wales, Cardiff*

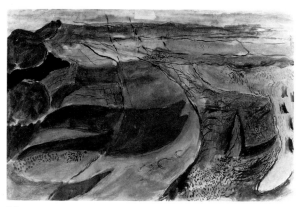

37

Evidently painted from the small gouache of this
subject at Picton (No.36), which is dated 1935.

**38    Hills at Solva** 1935

Inscribed 'Sutherland 1935' b.r.
Ink and wash on paper, 5½ × 9¼ (14.2 × 23.5)
First exh: *The Sutherland Gift to the Nation*,
Marlborough Fine Art, London, April 1979
(works not listed)
Repr: Cooper, pl.7a
*Picton Castle Trust*

38

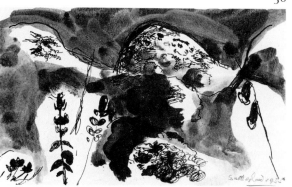

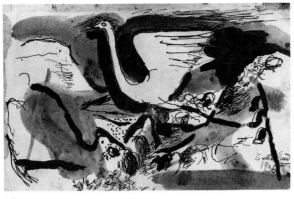

39

**39    Swan** 1935

Inscribed 'Sutherland/1935' b.r.
Ink and wash on paper, $5\frac{1}{2} \times 9\frac{1}{4}$ (14 × 23.5)
First exh: *The Sutherland Gift to the Nation*,
Marlborough Fine Art, London, April 1979
(works not listed)
Lit: *Sutherland in Wales*, p.32 repr.
Repr: Hayes, pl.9
*Picton Castle Trust*

Described in the Picton catalogue as a 'compositional
sketch made at Solva'.

**40    Solva** and **Valley above Porthclais** 1935

Inscribed '1935/Solva Hills' and 'valley above/
Porthclais' t.c.
Ink and wash on paper, $5\frac{1}{2} \times 8\frac{1}{2}$ (14 × 21.5)
First exh: *Graham Sutherland: Drawings of
Wales*, Welsh Arts Council touring exhibition,
June–October 1963 (3, repr.)
Lit: *Sutherland in Wales*, p.33 repr.
Repr: Cooper, pl.6a; Arcangeli, pl.1 in colour;
Hayes, pl.8
*Picton Castle Trust*

The left side is a study made on the Gribin at Solva; the
right side is one made from the entrance to Porthclais,
looking north-west.

Sutherland was particularly fond of the drawing on
the right, a brilliant compact design in which the
roads curl like ribbons through the landscape, and the
whole scene seems to be organically alive. Not only
did it serve as starting point for the picture 'Welsh
Landscape with Roads' (No.50), painted in 1936, but
he returned to it, with its Y-shaped junction of roads,
a number of times in the last years of his life.

40

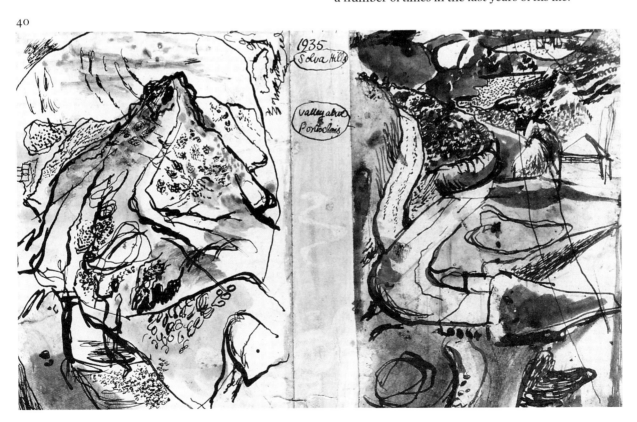

**41** **Three Designs for King George V 7d Postage Stamp** 1935

Not inscribed
**a.** lithograph (yellow), $10\frac{1}{4} \times 8\frac{7}{8}$ (26 × 22.5)
**b.** lithograph (grey), $10\frac{1}{4} \times 8\frac{7}{8}$ (26 × 22.5)
**c.** lithograph (pink) and gouache, $10\frac{1}{4} \times 8\frac{7}{8}$ (26 × 22.5)
*National Postal Museum*

A change in the rates for parcel post in 1935 created a need for 7d and 8d stamps, because the current King George V definitive issue included no values between 5d and 9d. Four artists were therefore invited to submit designs for a new 7d stamp: Barnett Freedman (who had designed the very successful Silver Jubilee set issued earlier in the year), Agnes M. McCance, Robert Gibbings and Graham Sutherland. Apparently Sutherland was invited at the suggestion of Barnett Freedman, who was a friend of his.

Sutherland went to the trouble of making a lithograph and submitted proofs from it in three different colours, together with two further designs consisting of the head, oval and crown cut from the lithographs, surrounded by different borders hand-coloured in gouache. However nothing came of any of these designs since George V died soon afterwards, in January 1936.

As in his designs for china and glass, Sutherland's approach was very thorough and highly professional.

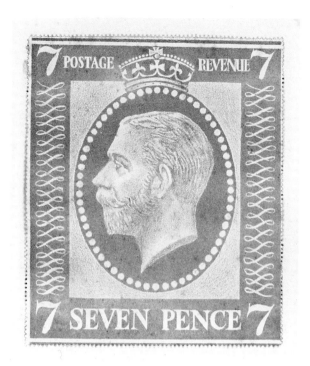

41b

**42** **Thunder Sounding: Christmas Card for Robert Wellington** 1935

Inscribed 'CHRISTMAS: / 1935', 'Robert / Wellington', 'sends his best / wishes / for' and 'Christmas / & / 1936' on various objects in the composition
Lithograph (black) on card, $4\frac{1}{4} \times 7\frac{3}{8}$ (10.8 × 18.9)
Lit: Man No.39, n.p. and repr.; Pat Gilmour, *Artists at Curwen* (London 1977), p.82; Tassi No.35, pp.66, 227, repr. p.66
*Cambridge University Library*

42

A Christmas and New Year card made for Robert Wellington in late 1935 and printed at the Curwen Press. Sutherland had become friendly with Robert Wellington, who ran the Zwemmer Gallery, and it was Wellington who recommended him to visit Pembrokeshire in 1934 because he thought the landscape round St David's might interest him. He later commissioned the colour lithograph 'The Sick Duck' of 1936 for a series of original artists' prints for schools.

Here a winged figure runs on to the scene carrying a flag with the words 'CHRISTMAS: 1935', while the message is continued on three spring-like forms tilted at different angles. Sutherland afterwards used this same design as the basis for his oil painting 'Thunder Sounding' of 1936 (No.45).

45

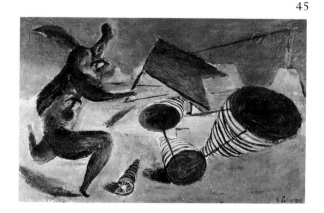

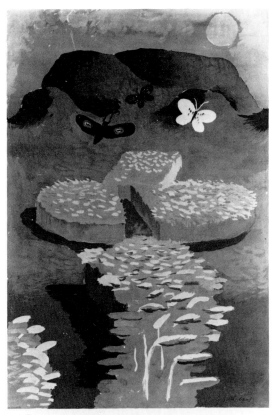

'How sweet I roamed···

43

44

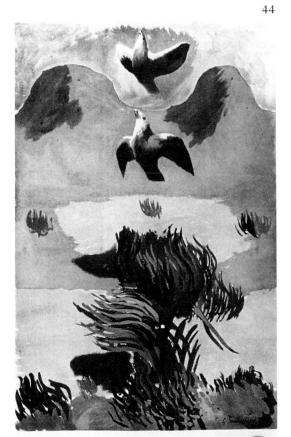

···From field to field'

**43 How sweet I roamed . . . 1936**

Inscribed 'G. Sutherland' in the print b.r.
Lithograph, 40 × 25 (101.5 × 63.5)
Lit: Hayes, pp.44, 53
Repr: *Art for All: London Transport Posters
1908–1949* (London 1949), pl.50
*London Transport Executive*

The two bodies most active and enterprising in commissioning good British artists to design posters in the 1930s were Shell-Mex and B.P. Ltd, as previously mentioned, and London Passenger Transport Board under the guidance of Frank Pick. Sutherland made altogether four posters for Shell and five for London Transport, the earliest of the latter being 'Cottage Interior' of 1933 (a room with a table by a window through which one sees part of a garden). 'How sweet I roamed . . .' and '. . . From field to field', his third and fourth posters for London Transport, were conceived as a pair, and the wording on them is taken from the opening line of one of the Songs of William Blake:

*How sweet I roam'd from field to field,
And tasted all the summer's pride . . .*

They are freer and more imaginative than any of his early poster designs.

**44 . . . From field to field 1936**

Inscribed 'G. Sutherland' in the print b.r.
Lithograph, 40 × 25 (101.5 × 63.5)
Repr: *Art for All: London Transport Posters
1908–1949* (London 1949), pl.51; Harold F.
Hutchinson, *London Transport Posters* (London
1963), pl.43 in colour as 'Countryside'
(without the strip at the bottom with the
lettering); Hayes, fig.4
*London Transport Executive*

Poster for the London Passenger Transport Board; the right-hand companion to 'How sweet I roamed . . .' (No.43).

**45 Thunder Sounding 1936**

Inscribed 'G. Sutherland' b.r.
Oil on panel, 14½ × 23 (36 × 58.5)
First exh: *The International Surrealist Exhibition*,
New Burlington Galleries, London, June–July
1936 (339)
Repr: Hayes, pl.23
*Private collection*

One of the two pictures which Sutherland exhibited in the famous International Surrealist Exhibition in London in 1936. Sutherland, who was invited by Roland Penrose, never regarded himself as a Surrealist and disliked the sort of painting where there are arbitrary juxtapositions of images.

This picture was adapted from his design for the Christmas card for Robert Wellington made towards the end of 1935 (No.42), but with the omission of the lettering which had been the basis for the composition. The scene, now unexplained, takes on an air of fantasy.

The other painting shown in the exhibition served

in turn as the inspiration for his design for the cover of the *Curwen Press Newsletter* of June 1936 (No.46). It too incorporated a pair of spring-like forms.

### 46 Cover for 'Curwen Press News Letter', No.12 1936

The design incorporates the words 'THE CURWEN PRESS', 'NEWS LETTER / NO 12' and the letters 'A–Z'
Lithograph (black, red),
$10\frac{1}{4} \times 7\frac{1}{2}$ (26 × 19)
Lit: Oliver Simon, *Painter and Playground: an Autobiography* (London 1956), p.137, repr. pl.iv; Man No.40, n.p. and repr. (as 'A–Z'); Pat Gilmour, *Artists at Curwen* (London 1977), p.82; Tassi No.36, pp.66 and 220, repr. p.66 in colour (as 'A–Z')
*Curwen Press*

The cover for the *Curwen Press News Letter*, No.12 of June 1936. The design was broadly adapted from the oil painting 'Mobile Mask' of 1936, which was one of Sutherland's two pictures in the International Surrealist Exhibition at the New Burlington Galleries in June–July 1936, but which seems to have been lost or destroyed. (It is reproduced in Myfanwy Evans (ed.), *The Painter's Object*, London 1937, p.89.) The imagery appears to show a lithographic stone bearing a tiny drawing which is overprinted with a numbered grid, while the letters A and Z in contrasting type stand for the Press's concern with fine typography.

Sutherland had met and become very friendly with Oliver Simon, a director of the Curwen Press, in 1935, and it was through Simon that several of his works were reproduced in the periodical *Signature* and that he became a member of the Double Crown Club (see No.51). There is a postcard to Oliver Simon postmarked 17 February 1936 in which Sutherland says: 'I shall be delighted . . . to do the News Letter cover as suggested.'

46

### 47 Welsh Landscape 1936

Inscribed 'Sutherland 36' b.r.
Gouache on paper, 9 × $11\frac{1}{2}$ (23 × 29)
First exh: *Graham Sutherland: Recent Acquisitions of Watercolours, Gouaches and Drawings*, Marlborough Fine Art, London, October 1966 (6, repr.)
Lit: *Sutherland in Wales*, p.33 repr.
Repr: Arcangeli, pl.6 in colour
*Picton Castle Trust*

This was described by Sutherland in the 1970s as 'One of my few more or less "straight" landscapes. The elements for it came from the road leading from Newgale to Broadhaven which flanks St Bride's Bay. I was interested obviously in the arabesques of the road as it mounted, twisting until out of sight, as it plunged into a further decline.' (Annotation on a colour reproduction published by the Welsh Gas Board.)

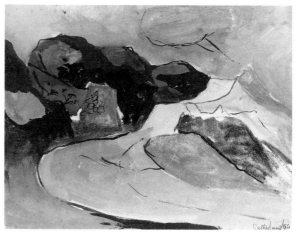

47

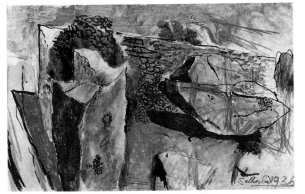

48

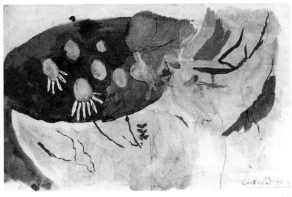

49

**48   Stones in an Enclosure** 1936

Inscribed 'Sutherland 1936' b.r.
Gouache, pencil and wash on paper,
$5\frac{1}{4} \times 8\frac{1}{2}$ (13.5 × 21.5)
First exh: *The Sutherland Gift to the Nation*,
Marlborough Fine Art, London, April 1979
(works not listed)
Repr: Sanesi, pl.9
*Picton Castle Trust*

The site is near Lleithyr, about two miles north of
St David's. Sutherland said that the rock, surrounded
by a rough wall, seemed to him like a monument.

**49   Camomile Flowers in Landscape** 1936

Inscribed 'Sutherland 1936' b.r.
Gouache on paper, 8 × 13 (20.5 × 33)
First exh: *Graham Sutherland*, Galleria Civica
d'Arte Moderna, Turin, October–November
1965 (3b, repr.)
Lit: *Sutherland in Wales*, p.33 repr.
Repr: Cooper, pl.6b (dated 1935); Hayes, pl.11
*Picton Castle Trust*

A study made at Porthclais.

50

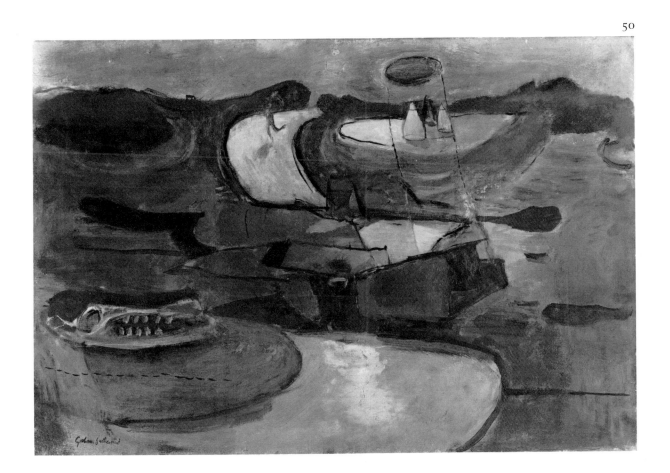

50   **Welsh Landscape with Roads** 1936

Inscribed 'Graham Sutherland' b.l. and 'Welsh
Landscape' on back of canvas in pencil
Oil on canvas, 24 × 36 (61 × 91.5)
First exh: *Recent Works by Graham Sutherland*,
Rosenberg & Helft, London, September –
October 1938 (5)
Lit: Hayes, p.58, repr. pl.17
Repr: Cooper, pl.9a
*Tate Gallery*

Painted like 'Thunder Sounding' (No.45) in yellowish
and reddish ochres, a colour range which gives a
sulphurous effect of light. The composition was
developed from the upper part of the drawing 'Valley
above Porthclais' (No.40), but with the introduction
of a running figure in the distance and a huge animal's
skull in the foreground, which add a note of strange-
ness and drama.

51   **Menu for the Double Crown Club
     56th Dinner** 1936

Inscribed 'G.S.' in the print b.l.
Letterpress from collage,
$10\frac{1}{8} \times 6\frac{3}{4}$ (25.6 × 17.2)
Lit: Pat Gilmour, *Artists at Curwen* (London
1977), p.82, repr.
Repr: *Signature*, No.5, March 1937, facing p.1
*Cambridge University Library*

The Double Crown Club was a dining club founded by
Oliver Simon in 1924, where people interested in the
arts of the book could meet. There was usually a
speaker on some aspect of book production, followed
by a lively debate. Members were invited in turn by the
committee to design and print a menu, and vied with
one another to produce something interesting and
original.

This one was designed by Sutherland for a dinner at
the Café Royal on 14 October 1936, at which Paul
Nash was to give a talk on 'Surrealism and the Printed
Book'. The design is appropriately indebted to Max
Ernst and employs the technique of his collage books
such as *Femmes 100 Têtes* and *Une Semaine de Bonté* –
Sutherland's most orthodox, if light-hearted, essay in
Surrealism. Pat Gilmour describes the imagery as
follows: 'Upside down is an engraved wine glass
holding a surprised fish, while a Double Crown Club
ham with a little head poking out of the frill, seems to
have forks as legs, and one of them holds a cigar, the
smoke from which is growing into a tiny monster.'
Sutherland had become a member of the Double
Crown Club at Oliver Simon's suggestion in 1935.

51

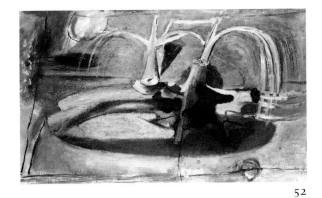

52

**\*52    Red Tree** 1936

Not inscribed
Oil on canvas, 22 × 36 (55.8 × 91.5)
First exh: *A Collection of Paintings by French and
English Artists*, Mayor Gallery, London,
February 1937 (32) as 'The Red Tree'
Lit: 'Graham Sutherland Explains His Art' in
*Illustrated London News*, CCXVIII, 19 February
1966, p.30
Repr: Cooper, pl.9b; Arcangeli, pl.5 in colour;
Hayes, pl.26 in colour (with the wrong
caption)
*Private collection, London*

Graham Sutherland told Andrew Causey (*Illustrated
London News, loc. cit.*) that this was one of his pictures
inspired by a found object, a piece of flotsam he had
seen washed up somewhere.

*The one field in which the surrealists helped me to widen
my range was in their propagation of the idea that there
was worthy subject matter for painting in objects the
painter would never have looked at before . . . Surrealism
helped me to realise that forms which interested me
existed already in nature, and were waiting for me to find
them.*

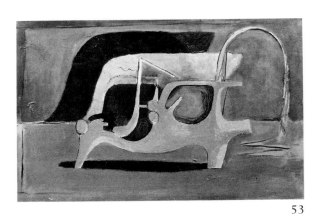

53

**53    Red Tree** 1936

Inscribed 'G. Sutherland' b.r.
Oil on canvas, 22 × 38⅛ (55.8 × 97.8)
First exh: *Young British Painters*, Thos Agnew &
Sons, London, January 1937 (36) as 'Tree No.2'
Repr: Myfanwy Evans (ed.), *The Painter's Object*
(London 1937), p.93 as 'Painting' 1936;
Hayes, pl.25 in colour (with the wrong
caption)
*B.P. International Ltd*

This was painted the same year as the other work
of this title (No.52) and seems to have been partly
abstracted from it; for instance there is a similar
shadow under the form, and the arched shape on the
right is clearly derived from the one in the other
picture. However the organic forms of the piece of
wood have given way to a flat abstract pattern, and
the atmospheric handling of the landscape has been
replaced by hard, solid colours. Sutherland seems
to have painted no further pictures quite like this,
presumably because he felt that, though interesting as
an experiment, it was the wrong direction for him to
take.

# Paintings and Drawings 1937-43

These works date mainly from 1937 up to the time when Sutherland became an official war artist in June 1940. This was the period when he had his first two one-man exhibitions of drawings and oils, at Rosenberg & Helft in September–October 1938 and at the Leicester Galleries in May 1940, and began to establish himself as a major oil painter. Taking themes derived mainly from Pembrokeshire, and usually painting from small squared-up studies in gouache, he began to work with increasing boldness, a marked rhythmical stylisation and a richer saturation of colour; moreover his images started to become conspicuously meta-morphic. The room also includes some of the few paintings and drawings of landscape themes which he was able to make during the early years of the war, up to the end of 1943.

---

54   **Brimham Rock** 1937

Inscribed 'Graham Sutherland' b.l. and again b.r.
Gouache on paper, 21 × 38 (53.3 × 96.5)
First exh: *Fifty Years of Shell Advertising 1919–1969*, 195 Piccadilly, London, June–July 1969 (64)
*Shell U.K. Ltd*

The original artwork for the lorry bill No.55.

55   **Brimham Rock** 1937

Inscribed 'Graham Sutherland' in the print b.l. and again b.r.
Lithograph, 30 × 45 (76.2 × 114.3)
Lit: Cooper, p.14 and footnote, repr. fig.3
*Joint Shell-Mex and B.P. Archive*

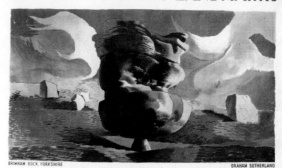

55

Brimham Rock is in Nidderdale, north-west of Harrogate. According to Douglas Cooper, Sutherland visited this site in the autumn of 1935 at the suggestion of Jack Beddington, who wanted it to figure as one of a series of Shell posters. The strangeness of the scene so impressed him that he wrote an article about it entitled 'An English Stone Landmark', which was published in *The Painter's Object*, edited by Myfanwy Evans, in 1937. The following passage, which seems to relate directly to his design, is an extract:

*Most singular of all is the huge conglomerate mass of stone to the right. Shaped like a growth which one sometimes sees attached to the nose of a peasant, it is divested, owing to the fact that it exists in stone, of the horror that such an infliction inspires. It is round in plan and divided into three distinct sections. The lowest and largest is shaped like a flattened sphere, rather broader than it is long, and the middle section is attended by much corrugation and eruption, which, extended to the section above, almost attains to an efflorescent character. The whole mass is poised, like an acrobat's ball on his stick, on a small inverted cone of stone.*

   *The setting sun, as it were precipitating new colours, turns the stone, rising from its undulating bed of bright green moss and blackened heather, yellow, pink and vermilion. . . .*

The last of Sutherland's lorry bills for Shell-Mex and B.P. Ltd, it was published at the very end of 1937. It was printed by the Baynard Press and belongs to the series known as 'Landscapes – "To Visit Britain's Landmarks"'

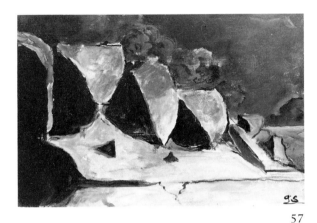

57

### 56    Landscape, Green, Pink and Brown  1937

Not inscribed
Gouache and pastel on paper,
13 × 20 (33 × 50.8)
First exh: *Recent Works by Graham Sutherland*,
Rosenberg & Helft, London, September –
October 1938 (24)
Repr: Cooper, pl.10a
*Private collection*

The rhythms running through the composition have become more vigorous and turbulent.

### 57    Estuary with Rocks  *c.*1937–8

Inscribed 'GS' b.r. and 'PICTON CASTLE /
FOUNDATION' and 'ESTUARY WITH ROCKS' on
back of canvas
Oil on canvas, $10\frac{5}{8}$ × $16\frac{1}{4}$ (27 × 40.5)
First exh: *The Sutherland Gift to the Nation*,
Marlborough Fine Art, London, March –April
1979 (works not listed)
Lit: *Sutherland in Wales*, p.20, repr. p.21 in
colour
Repr: *Observer Magazine*, 1 April 1979, p.46 in
colour; Sanesi, pl.12 in colour
*Picton Castle Trust*

No early exhibition has been traced for this work, but the date 1937–8 given in the Picton catalogue is probably more or less correct. It appears to have been based on a gouache inscribed 'July 12. 1936' (repr. *Graham Sutherland: Recent Acquisitions . . . ,* Marlborough Fine Art, London, October 1966, No.7), and is one of Sutherland's earliest oils of Sandy Haven, an estuary in south Pembrokeshire which became very important to him later on, during his second Pembrokeshire period. The rocks of red sandstone, with the reddish beach in front of them, are a feature there, and in the strong Pembrokeshire light the dark shadows create a contrapuntal effect.

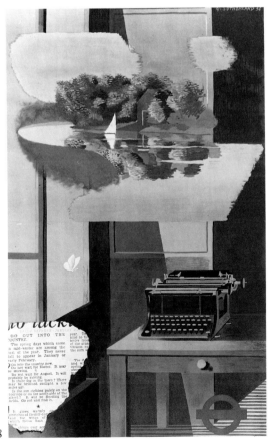

58

### 58    Go out into the Country  1938

Inscribed 'G. SUTHERLAND 38' in the print t.r.
Lithograph, 40 × 25 (101.5 × 63.5)
Lit: 'River into Office' in *Art and Industry*, XXIV,
1938, p.182 repr.; Pat Gilmour, *Artists at
Curwen* (London 1977), p.83
Repr: Tom Purvis, *Poster Progress* (London
1939), p.100; Michael F. Levy and Roy Strong,
*London Transport Posters* (Oxford 1976), pl.58
in colour
*London Transport Executive*

Sutherland's last poster for the London Passenger Transport Board. The theme suggested was 'a river coming right into an office'. As is recorded in *Art and Industry* in May 1938:

*After much mutual discussion this was the result, which is causing much talk and admiration. Sutherland's problem was to capture the 'story telling' and 'advertising' contrast – that is the grim office versus delights of the open air, which meant combining rigid binding lines with softer easy lines and colours, yet still retaining pictorial unity.*

The poster was made from a painting in gouache which included an area of collage (a cutting from the *Daily Express* of January 1938 saying that it may be snowing at Easter, raining in August, and one should go out into the country now), and was printed by lithography in thirteen colours by the Curwen Press.

**59    Welsh Mountains** 1938

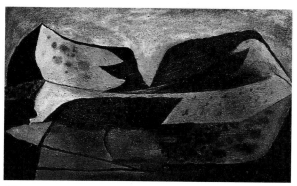

59

Not inscribed
Oil and sand on canvas, 22 × 36 (55.9 × 91.5)
First exh: *Recent Works by Graham Sutherland*, Rosenberg & Helft, London, September–October 1938 (14) as 'Landscape' 1938
Lit: Hayes, p.62, repr. pl.21 as 'Welsh Mountains' 1937
Repr: Cooper, pl.10b as 'Welsh Mountains' 1937; *Art Gallery of New South Wales: Picturebook* (Sydney 1972), p.52 in colour as 'Welsh Mountains' 1936
*Art Gallery of New South Wales, Sydney*

A grave and monumental picture with massive forms and heavy angular black shadows, close in style to the etching and aquatint 'Clegyr-Boia II' published in *Signature* in July 1938, and probably of the same rocky outcrop, known as Clegyr-Boia, west of St David's. It was by elimination probably the picture of this size exhibited in the 1938 Rosenberg & Helft exhibition as 'Landscape' 1938, and may have been abstracted from the watercolour 'Sun Setting between Hills' of 1937 (No.230).

**60    Clegyr-Boia II** 1938

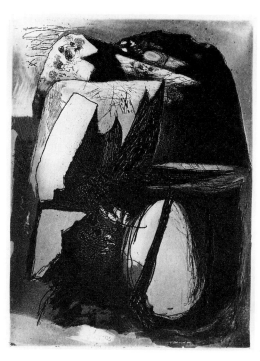

60

Inscribed 'Herons' in the plate b.l.
Etching and aquatint, $7\frac{3}{4} \times 5\frac{7}{8}$ (19.7 × 15)
Lit: Man No.37, n.p. and repr. as 'Clegyr-Boia' 1938; Pat Gilmour, *Artists at Curwen* (London 1977), p.83; Tassi No.33, pp.24, 65 and 221, repr. p.65 as 'Clegyr-Boia I (Landscape in Wales)' 1936 (the plates of Nos.33 and 34 have been transposed by mistake)
Repr: Cooper, pl.4a as 'Welsh Landscape' 1936
*Tate Gallery*

This print was used as the frontispiece to *Signature*, No.9, published in July 1938, and is listed in the table of contents as 'Clegyr-Boia'. That it was commissioned for *Signature* and made between March and May that year is confirmed by two letters from Sutherland to Oliver Simon dated 12 March 1938 and 26 May 1938. In the first he wrote: 'Many thanks for your

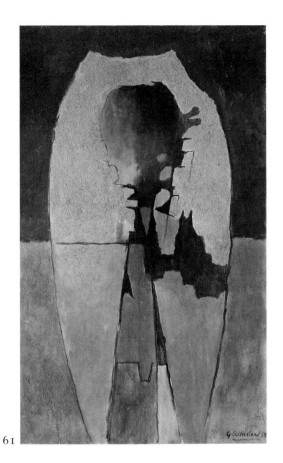

61

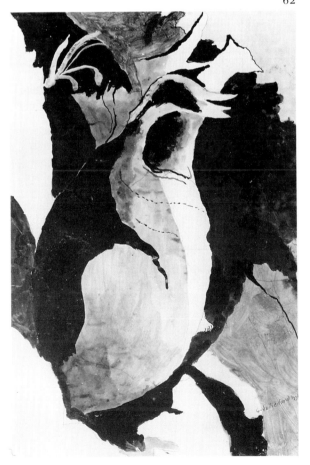

62

note and very attractive offer. I should be pleased to do the etching as suggested and will deliver same on or before May 13.' Then in the second letter: 'Herewith the copper plate. I will send the title to-morrow. Hitherto I have not been able to think of one . . . I am glad you liked the new etching better. It pleased me a good deal more . . . Let me see a proof of the etching before they start on the whole edition will you?' The other etching referred to must be the related print, Tassi No. 34, of which only a single proof exists which was found among Oliver Simon's papers. Tassi lists the present work as 'Clegyr-Boia I' and the related print as 'Clegyr-Boia II', but it is clear from this correspondence that they should be numbered the other way round.

These two prints were Sutherland's first use of aquatint as well as etching, and are quite different in style from his early group of etchings. The word 'Herons' half obliterated at the bottom centre was intended to be the title 'Herons Ghyl', which he later abandoned.

## 61 Red Monolith 1938

Inscribed 'G. Sutherland 38' b.r.
Oil on canvas, $39\frac{1}{4} \times 24\frac{1}{4}$ ($99.7 \times 61.5$)
First exh: *Recent Works by Graham Sutherland*, Rosenberg & Helft, London, September – October 1938 (8)
Lit: Hayes, p.66, repr. pl.28
Repr: Cooper, pl.13; Sanesi, pl.16
*Hirshhorn Museum and Sculpture Garden, Smithsonian Institution, Washington*

One of Sutherland's first monumental 'presences', painted from a gouache made the previous year which was based on a tree form found at Sandy Haven. The form has been almost completely isolated from its setting and presented close up, while the shapes and colours are paraphrased with great freedom. After having begun his career by working in black and white and then using very restrained colours, Sutherland had begun by now to attain his full powers as a colourist, producing rich saturated colour harmonies.

## 62 Hollow Tree Trunk 1938

Inscribed 'G. Sutherland 1938' b.r.
Watercolour on paper,
$22\frac{3}{8} \times 15\frac{3}{8}$ ($56.8 \times 39.1$)
First exh: *Recent Works by Graham Sutherland*, Rosenberg & Helft, London, September – October 1938 (21)
Repr: *Studio*, CXLVI, 1953, p.34; Cooper, pl.19b; Hayes, pl.31
*Laing Art Gallery, Tyne and Wear County Council Museums*

Though based on drawings of a tree form found in Sandy Haven, this gives a strong impression of an amphora or of some marine life, such as a sea-anemone in a rock pool. The patterned contrasts of dark and light produce an intricate rhythmical overall design.

**63  Western Hills** 1938/1941

Not inscribed (the original frame bore
signature, title and original price)
Oil on canvas, 22½ × 36 (57 × 91.5)
First exh: *Recent Works by Graham Sutherland*,
Rosenberg & Helft, London, September –
October 1938 (13) as 'Hills' 1938
Lit: Douglas Hall, 'Sutherland's "Western
Hills"' in *Burlington Magazine*, CXI, 1969,
pp.32,35, repr. p.34
Repr: Sackville-West, 1943, pl.20 as 'Western
Hills'; Hayes, pl.29 in colour
*Scottish National Gallery of Modern Art,
Edinburgh*

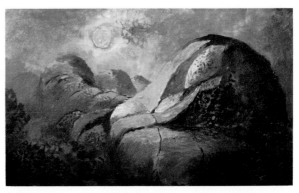

63

This picture was first painted in 1938 and exhibited at
Rosenberg & Helft under the title 'Hills', then re-
worked in 1941 and exhibited at the Redfern Gallery
in August–September that year as 'Western Hills'.

**64  Four Studies for 'Gorse on Sea Wall'** 1938–9

Not inscribed
Ink and watercolour on paper, t.l. 2¾ × 2⅛
(7 × 5.3); t.r. 3⅛ × 2¼ (8 × 5.7); b.l. 2⅝ × 2⅛
(6.7 × 5.3); b.r. 3⅛ × 2¼ (8 × 5.7)
First exh: *Graham Sutherland*, Galleria Civica
d'Arte Moderna, Turin, October–November
1965 (10, repr. upside down)
Repr: Cooper, pl.18; Arcangeli, pl.15
*Private collection*

Four studies for 'Gorse on Sea Wall' (No.65), cut out of
their original sheets and mounted together. They
appear to have been done in the following order: (1)
top right, (2) bottom right, (3) bottom left, (4) top left.

There is a reproduction in *Horizon*, V, 1942, p.232
of a sheet with these four drawings differently ar-
ranged, together with a further landscape-shaped
study which seems to have preceded them and which
shows the gorse in a more realistic, less polyp-like form
and bent sideways instead of standing upright. The
margins of the sheet were inscribed '1938' top right,
'Studies/for/Gorse on Sea Wall/1939/ completed'
bottom right and 'St. Bride's' bottom right.

**\*65  Gorse on Sea Wall** 1939

Inscribed 'G. Sutherland 1939' b.l.
Oil on canvas, 24½ × 19 (62.2 × 48.2)
First exh: *Recent Paintings by Graham
Sutherland*, Leicester Galleries, London,
May 1940 (8)
Lit: Melville, n.p., repr. text illustration 6b and
text illustration 27 in colour; Hayes, p.72, repr.
pl.33 in colour
Repr: Sackville-West, 1943, pl.15 in colour;
Cooper, pl.II in colour
*Ulster Museum, Belfast*

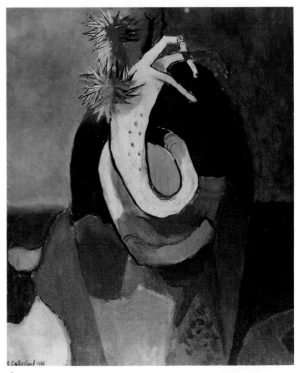

65

66

Based on a piece of twisted, wind-blown gorse on the
cliff edge, seen in a lane leading to St Bride's Bay, this is
one of Sutherland's key early masterpieces, and the
first picture in which one can see very clearly the
metamorphosis of a plant form into an image like an
animal, which also makes allusions to the human
body. The sinuous, coiled form raises its polyp-like

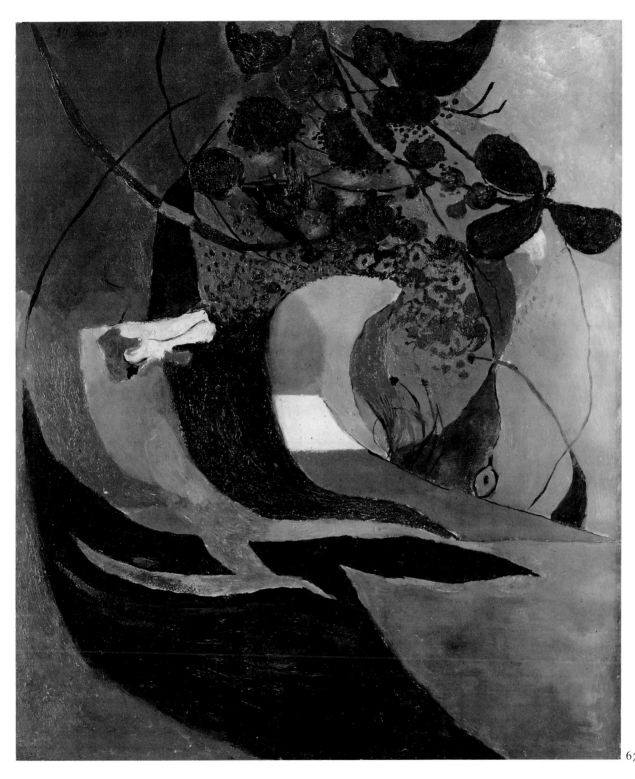

67

extremity aloft like a cobra poised to strike, with its tentacles groping and gesturing menacingly. Despite the presence of two prickly green shoots attached to the form, it is unclear whether it is plant or animal or both, and whether it is real or imaginary. This ambiguity, this feeling of something ominous and of being on the edge of a dream or nightmare, is underlined by the muted but brooding colour harmonies.

Whether consciously or not, a correlation exists between the heightening of the sense of drama in Sutherland's work at this period and the onset of war and its tensions.

66  **Five Studies for 'Entrance to a Lane'**
1939/1943

The study at top inscribed 'July 9' t.r.; the one at left centre 'July 10 3.30−4.' b.l.; the one in centre 'July 10. 4. 5.30−6. b.l.; the one right centre 'July 11.4.5.30. 6.' b.l.; the one at bottom not inscribed
Ink and watercolour on paper, t. $4\frac{7}{8} \times 8\frac{1}{8}$ (12.5 × 20.7); c.l. $5\frac{5}{8} \times 4\frac{3}{4}$ (14.3 × 12); middle c. $5\frac{5}{8} \times 4\frac{3}{4}$ (14.3 × 12); c.r. $5\frac{5}{8} \times 4\frac{3}{4}$ (14.3 × 12); b. $4\frac{7}{8} \times 3\frac{7}{8}$ (12.5 × 9.8)

First exh: *Studies by Graham Sutherland*, Roland,
Browse and Delbanco, London, October–
November 1947 (67)
Repr: Cooper, pl.16a–c (16a the drawing
middle c., 16b c.l., 16c c.r.) and pl.54a (the
bottom drawing); Arcangeli, pl.22
*The Very Rev. Walter Hussey*

The upper four drawings were all done in July 1939
as studies for the oil painting 'Entrance to a Lane'
(No.67), and three of them are not only inscribed with
the exact dates but with the time of day (in the
afternoon, when there was a particular effect of light
and shade). The drawing at the top, which is land-
scape-shaped, is the earliest and appears to have been
the starting point for this composition.

The drawing at the bottom was reproduced by
Melville (text illustration 10a) with the date 1943,
and is a study not for 'Entrance to a Lane' but for the
later variants of this theme made in 1944–5 such as
'Lane Opening' (No.121).

## 67   Entrance to a Lane  1939

Inscribed 'Sutherland 39' t.l.
Oil on canvas mounted on hardboard,
24 × 20 (61.5 × 50.75)
First exh: *Recent Paintings by Graham
Sutherland*, Leicester Galleries, London, May
1940 (30) as 'Approach to Woods'
Repr: Sackville-West, 1943, pl.7 in colour;
Cooper, pl.17; Hayes, pl.36 in colour
*Tate Gallery*

The site is a lane leading up from the west side of Sandy
Haven. Sutherland has paraphrased and simplified it
to produce a close-knit design of sweeping curves,
with the further part of the lane, where it dips out of
view, in strong sunlight and picked out in brilliant
white and yellow. Comparison with the preparatory
drawings shows that the tree originally conspicuous
on the left has been eliminated, though its leafy
branches still swing overhead.

## 68   Sheet of Four Studies  1939

The study at top inscribed 'Sutherland/39' b.r.;
the one at left centre 'Sutherland.' b.r. and 'ed
Trees under Mynydd Pen Cyrn. Christmas Day
1939' along bottom; the one centre right
'Sutherland. 1939' b.l.; and the one at bottom
'Sutherland Sept.24/39' t.r.
Ink and watercolour,
overall size 11¾ × 8¾ (29.8 × 22.1)
First exh: *Works by Henry Moore, John Piper,
Graham Sutherland*, Temple Newsam, Leeds,
July–September 1941 (146) as 'Three Studies
of Trees'
Repr: Cooper, pl.24
*The Trustees of the Cecil Higgins Art Gallery,
Bedford*

The drawing at the top is a study for 'Tree Forms in
Estuary' (No.71), the one centre left is a squared-up
study for 'Association of Oaks' (No.70), and the one
centre right is related to 'Midsummer Landscape'
(No.76), all of 1940. The first word of the inscription

68

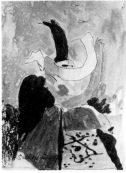

69

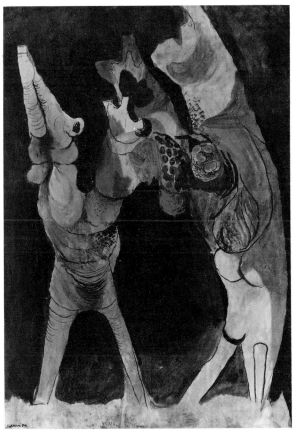

70

on the drawing at left centre was trimmed in the course of mounting. No larger version of the drawing at the bottom has been traced, though there may be one. All are tiny but highly finished studies cut out of larger sheets or sketchbooks and stuck on to a mount. When first exhibited at Leeds in 1941 under the title 'Three Studies of Trees', it was without the study centre right.

**69   Two Studies for 'Midsummer Landscape' and 'Blasted Tree'** 1940 and 1937

Left-hand study inscribed 'G.S.1940' t.r.; right-hand study inscribed 'Sutherland 1937' b.l.
Both ink and watercolour on paper,
left-hand study $4\frac{1}{4} \times 3\frac{1}{4}$ (10.8 × 8.3);
right-hand study $4\frac{1}{2} \times 3\frac{3}{8}$ (11.5 × 8.5)
First exh: (right-hand study only) *Graham Sutherland*, Haus der Kunst, Munich, March–May 1967 (99c, repr.); (the pair framed together) *FAS 100*, Fine Art Society, London, March–April 1976 (137)
Repr: right-hand study Cooper, pl.11b
*Mr and Mrs James Kirkman*

Two small studies framed together, the left-hand one for 'Midsummer Landscape' 1940 (No.76) and the right-hand one for 'Blasted Tree', a large watercolour of 1938.

**70   Association of Oaks** 1940

Inscribed 'G. Sutherland 40' b.l.
Gouache, watercolour and pencil on paper mounted on board, $27 \times 19\frac{1}{8}$ (68.6 × 48.6)
First exh: *Recent Paintings by Graham Sutherland*, Leicester Galleries, London, May 1940 (22)
Lit: Sackville-West, 1943, p.14, repr. pl.10
Repr: Cooper, pl.25
*Scottish National Gallery of Modern Art, Edinburgh*

Painted from the small squared-up study now incorporated in 'Sheet of Four Studies' (No.68), which is dated 'Christmas Day 1939' and inscribed 'ed Trees under Mynydd Pen Cyrn'. Mynydd Pen-Cyrn is a mountain about seven miles west of Abergavenny and three miles south-west of Crickhowell.

The truncated tree forms have become like a pair of figures, and there is also something phallic about them. Edward Sackville-West aptly remarked on their quality of 'sinister mystery, of wordless plotting'.

**71   Tree Forms in Estuary** 1940

Inscribed 'Sutherland 1940' t.l. and 'Tree Forms in Estuary' on the back board
Watercolour and ink on paper,
$18\frac{1}{4} \times 26\frac{3}{8}$ (46.3 × 67)
First exh: *Recent Paintings by Graham Sutherland*, Leicester Galleries, May 1940 (10)
Repr: Cooper, pl.31
*Private collection*

A study for this, dated 24 September 1939, forms part of the 'Sheet of Four Studies' (No.68).

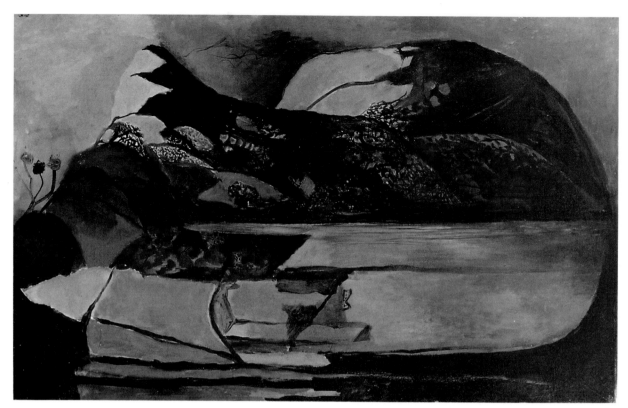

72

## 72    Black Landscape 1939-40

Inscribed 'BLACK LANDSCAPE / GRAHAM
SUTHERLAND / 70 guineas' on back of canvas
(probably not by the artist)
Oil and sand on canvas, $32\frac{1}{4} \times 52$ (82 × 132)
First exh: *Recent Paintings by Graham
Sutherland*, Leicester Galleries, London,
May 1940 (17)
Repr: Arcangeli, pl. 11
*Tate Gallery*

73

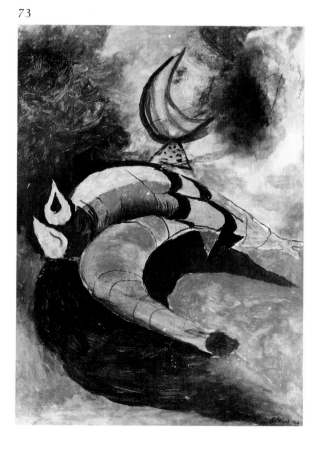

Sutherland painted this in 1939-40 from a water-
colour of 1937 which then belonged to Kenneth
Clark, but is now in the Glasgow City Art Gallery. It is
based on a view near Porthclais, probably of Clegyr-
Boia, and is one of a number of very dark paintings of
this period, painted with black, grey and a single
colour (here suffused with pink). This produces a
mysterious effect of light and darkness, a sort of
magical and slightly ominous twilight.

## 73    Fallen Tree against Sunset 1940

Inscribed 'Sutherland 1940' b.r.
Oil on canvas, $26\frac{1}{2} \times 20$ (67.3 × 50.8)
First exh: *Recent Paintings by Graham
Sutherland*, Leicester Galleries, London,
May 1940 (27)
Repr: Sackville-West, 1943, pl. 14; Arcangeli,
pl. 30 in colour; Hayes, pl. 147
*Borough of Darlington Art Gallery*

A study in gouache for this composition which used to
belong to the late Lord Lee of Fareham is inscribed by
Sutherland on its plywood backing: 'Painted from

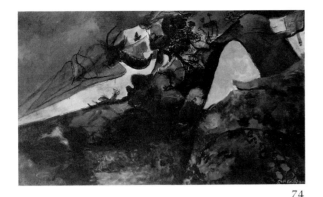

74

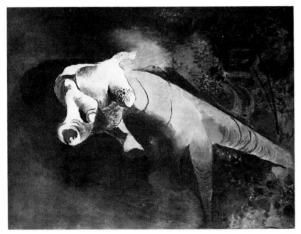

75

76

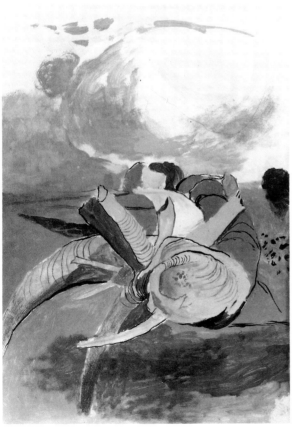

impressions received after watching peculiar sunset over a moss-covered valley. Object is a dead tree trunk covered with moss.' An inscription on another of the preliminary drawings records that this was at Crickhowell.

The presentation has now become much more dramatic, with the forms seen bursting forwards end-on in violent foreshortening, and emphasised by strong black shadows. In contrast to 'Black Landscape' (No.72) of the same period, there is a blaze of reds, greens and yellows.

### 74 Road and Quarry 1940

Inscribed 'Sutherland 1940' b.r.
Oil on canvas, $21\frac{3}{4} \times 35\frac{3}{4}$ ($55 \times 91$)
First exh: *Recent Paintings by Graham
Sutherland*, Leicester Galleries, London,
May 1940 (15)
Repr: *Konstrevy*, XXIV, 1948, p.86
*Private collection*

Probably inspired by a view near Llangattock quarries, in the area around Crickhowell where he spent about a week over Christmas 1939, and where he saw scenery much more mountainous than any to be found in Pembrokeshire.

### *75 Green Tree Form: Interior of Woods 1940

Not inscribed
Oil on canvas, $31 \times 42\frac{1}{2}$ ($79 \times 107.5$)
First exh: *Recent Paintings by Graham
Sutherland*, Leicester Galleries, London,
May 1940 (23)
Lit: Hayes, p.78, repr. pl.39 in colour
Repr: Sackville-West, 1943, pl.3 in colour;
Cooper, pl.23c
*Tate Gallery*

A fallen tree, lying on a steep grassy bank, with a lane on the right. The broken tuberous roots of the tree, seen close up and dramatically lit, look like snouts, and the tree has become a sort of threatening monster which seems to lunge forward on two pole-like legs. The greens are of a luxuriant saturation and depth, and contribute to the emotional effect as well as being descriptive.

### 76 Midsummer Landscape 1940

Not inscribed
Gouache on paper, $27 \times 19$ ($68.6 \times 48.3$)
First exh: *Modern English Painting*, Reid &
Lefevre, London, June–July 1940 (10)
Lit: Hayes, p.76, repr. pl.38
Repr: Cooper, pl.27
*Birmingham Museums and Art Gallery*

A study dated 1939 of this root form, turned end-on, forms part of the 'Sheet of Four Studies' (No.68), and a later study, dated 1940, is incorporated in No.69. The Birmingham City Art Gallery owns a further sheet of five studies for this composition which is inscribed 'Summer 1940'. In the final work the placing of the 'legs' in relation to the road behind generates an impression of powerful rotating energy, echoed in the sky.

**77   Mountain Road with Boulder** 1940

> Inscribed 'Sutherland 1940' b. towards r.
> Oil on canvas, 24½ × 44 (62.2 × 111.7)
> First exh: *Modern English Painting*, Reid &
> Lefevre, London, June–July 1940 (9)
> Repr: Cooper, pl.III in colour; Arcangeli, pl.28
> in colour; Hayes, pl.40 in colour
> *Private collection*

This was probably also inspired by the artist's visit to the mountains of south-central Wales, but the composition has become so stylised and imaginatively transformed that it has departed a long way from its source. Animated by strong rhythms, by sweeping curves and counter-curves, it glows with colours of a tawny richness. In view of its particularly Blake-like character, it is significant that its first owner was the well-known Blake enthusiast and collector Kerrison Preston.

**78   Green Tree Form** 1940

> Inscribed 'Sutherland 40' b.l.
> Oil on canvas, 23¾ × 21½ (60.5 × 54.5)
> First exh: *Graham Sutherland*, Buchholz Gallery,
> New York, February–March 1946 (4)
> Repr: Melville, text illustration 12b;
> *Connoisseur*, CXLVIII, June 1961, p.20
> *The British Council*

The final and most concentrated version of the 'Green Tree Form' theme, in which the threatening snouts and phallic character create a nightmarish image of anguish.

**79   Design for 'The Wanderer' I** 1940

> The squared-up grid is lettered from A
> onwards, but the drawing is otherwise not
> inscribed
> Gouache on paper, 8 × 10 (20.3 × 25.4)
> First exh: *Works by Henry Moore, John Piper,
> Graham Sutherland*, Temple Newsam, Leeds,
> July–September 1941 (157)
> Lit: 'Plays and Pictures: a New Ballet by
> Frederick Ashton at the New Theatre' in *New
> Statesman and Nation*, XXI, 1941, p.110; Dance
> Critic, 'English Ballet in Wartime' in *Penguin
> New Writing*, No.13, April–June 1942,
> pp.112–13; Michael Ayrton, 'The Decor of
> Sadler's Wells Ballets, 1939–1946' in *The
> Ballet Annual*, I, 1947, pp.74,79; Mary Clarke,
> *The Sadler's Wells Ballet: a History and
> Appreciation* (London 1955), pp.161–2
> Repr: Cooper, pl.30a; Arcangeli, pl.27 in colour
> *The Hon. Colette Clark*

The only time Sutherland was commissioned to do any work for the theatre was when he designed the two backcloths and the costumes for Frederick Ashton's new ballet *The Wanderer*, first performed by the Sadler's Wells Ballet at the New Theatre, London, on 27 January 1941. Danced to the Fantasy for pianoforte in C major, known as 'The Wanderer', by Schubert, it was a choreographic fantasy in four

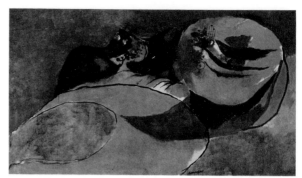

77

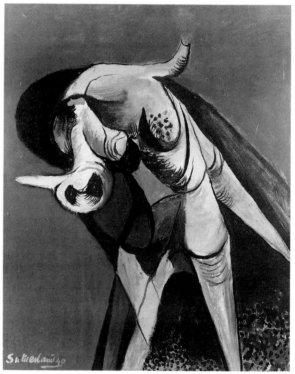

78

79

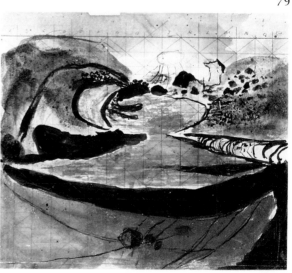

80

81

82

scenes. There was no precise story, but the dance critic of *Penguin New Writing* summarized the theme as follows:

*In the microcosm of his [the Wanderer's] own intellectual and spiritual being he is by turns victim and observer of the passions, inhibitions and lures of human life. Youth, Love, Ambition, evade or entice him, till he is lifted above them in the finale, neither crucified nor triumphant, but in intellectual detachment.*

In the first production, the principal roles were danced by Robert Helpmann and Margot Fonteyn.

Though Sutherland's costumes (rather ill-made under hasty wartime conditions) came in for a good deal of criticism, the two backcloths were widely admired and were felt to be in sensitive accord with the music and the choreography.

**80 Design for 'The Wanderer' II** 1940

The squared-up grid is lettered from A onwards, but the drawing is otherwise not inscribed
Gouache on paper, 8 × 9 (20.3 × 22.8)
First exh: *Works by Henry Moore, John Piper, Graham Sutherland*, Temple Newsam, Leeds, July–September 1941 (156)
Lit: as for the preceding work
Repr: Sackville-West, 1943, pl.13 in colour; Cooper, pl.30b
*The Hon. Colette Clark*

This design was adapted from the painting 'Mountain Road with Boulder' 1940 (No.77), but the colours are completely different.

**81 Tree Form** 1941

Inscribed 'Sutherland 41' b.r.
Oil on canvas mounted on board, 16 × 12 (40.5 × 30.5)
First exh: *Works by Henry Moore, John Piper, Graham Sutherland*, Temple Newsam, Leeds, July–September 1941 (138)
Repr: Sackville-West, 1943, pl.28; Cooper, pl.32a
*Leeds City Art Galleries*

The knotted tree form, with its thick scaly bark, looms out of the darkness like a monster.

**\*82 Red Landscape** 1942

Inscribed 'Sutherland 1942' b.r.
Oil on canvas, $26\frac{3}{4}$ × $39\frac{1}{4}$ (68 × 99.8)
First exh: *British Painting 1925–1950: First Anthology*, New Burlington Galleries, London, May–June 1951 (99)
Repr: Sackville-West, 1943, pl.9 in colour; *Das Kunstwerk*, I, No.10–11, 1946–7, p.52 in colour; *Studio*, CXLIX, 1955, p.47 in colour
*Southampton Art Gallery*

Painted from studies made in 1940. It appears to be a view of Carnllidi seen from the neighbourhood of Lleithyr Farm, where Sutherland stayed twice in 1940, from 2 to 9 August and again from 16 September to 10 October.

### 83  Study for the Cover of 'Poetry London'  1943

Inscribed 'POETRY LONDON' at the top, as part of the design
Pastel on paper, $6\frac{1}{2} \times 5\frac{1}{4}$ (16.5 × 13.5)
*Private collection*

This was one of Sutherland's studies for the cover of the magazine *Poetry London*, the issue No.9 of May 1943 that also contained his colour lithographs inspired by Francis Quarles' 'Hieroglyphics'. The design which was used showed a single lyre bird (the symbol of the magazine) with its head held low and its plumy tail raised in the air.

83

### 84  Study for one of the Illustrations to Francis Quarles' 'Hieroglyphics'  1943

Inscribed 'Sutherland' t.l. and with the verse beginning 'So have I seen th' illustrious prince of light' at the bottom
Gouache, ink, wax crayon and chalk on paper, $9\frac{1}{2} \times 7\frac{3}{8}$ (24.2 × 18.8)
*The Trustees of the British Museum*

A study for one of the lithographs made for *Poetry London* (Man 44B, the right-hand one of the pair).

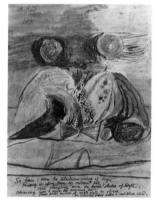

84

### 85  Three Illustrations to Francis Quarles' 'Hieroglyphics'  1943

All three prints are inscribed at the bottom (in the print) with verses from the 'Hieroglyphics' beginning 'Ev'n so this little world of living clay' (Man No.44A), 'So have I seen th' illustrious prince of light' (Man No.44B), and 'So have I seen a well built castle stand' and 'So have I seen the BLAZING TAPER shoot' (Man No.44C). Man No.44A is signed 'Sutherland' b.l., Man No.44B is signed 'Sutherland' b.r., Man No.44C is inscribed 'Sutherland.43' in the print b.l. and signed 'Sutherland' b.l.
Lithographs (raw umber, grey, black, yellow), $9\frac{5}{8} \times 7\frac{1}{2}$ (24.5 × 19); $9\frac{5}{8} \times 7\frac{1}{4}$ (24.5 × 18.5); $9\frac{5}{8} \times 14\frac{5}{8}$ (24.5 × 37)
Lit: Man Nos.44A, B and C, n.p. and repr.; Tassi, Nos.46–8, pp.74–5 and 223, repr. in colour pp.74 and 75
*Private collection*

These three colour lithographs were made specially for issue No.9 of *Poetry London*, and the lithographs were printed at the Baynard Press on the front and back of a single sheet of paper. The copies bound into the magazine were folded in the middle, the large image with the candle serving as a centre spread. A further fifty copies, signed by the artist, were sold separately. They were the only prints he made between 1940 and 1945, while he was serving as an official war artist.

Sutherland had been introduced to the poetry of Francis Quarles (1592–1644) and that of the Jesuit Emblemists of the seventeenth century by David Gascoyne shortly after the beginning of the war. What he admired above all in their work was the visual

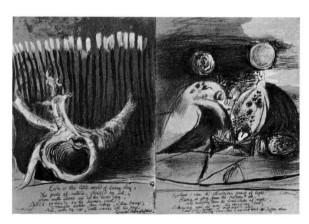

85

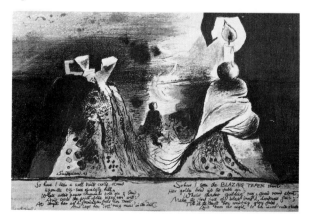

images they projected. The emblem, in the sense used by them, was a symbolic picture with a motto and an exposition and was one of the last European manifestations of a medieval habit of mind.

The full title of the poem which inspired these lithographs was 'Hieroglyphics of the Life of Man', and the passages transcribed underneath the images are in fact the opening four verses (out of eight) of the final Hieroglyphic xv, and appear in the poem in the following order: (1) 'So have I seen th' illustrious prince of light...' (2) 'So have I seen a well-built castle stand...' (3) 'So have I seen the blazing taper shoot...' (4) 'Ev'n so this little world of living clay ...'.

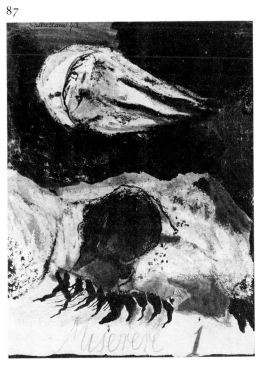

86

## *86 Folded Hills 1943

Not inscribed
Oil on canvas, $19\frac{1}{2} \times 26\frac{1}{2}$ (49.5 × 67.3)
First exh: *The Association of the Friends of the Bristol Art Gallery: First Loan Exhibition*, Bristol Art Gallery, May–June 1947 (62)
Repr: Cooper, pl.52a
*Mrs Neville Burston*

This picture is closely related to one of the lithographs done to illustrate the 'Hieroglyphics of the Life of Man' (No.85) and was apparently made about the same time. (The lithographs were published in the May 1943 issue of *Poetry London*, and this picture was sold by the Lefevre Gallery to its first owner in the following month.) To a degree unusual in Sutherland's oils it is what one might call a landscape of the mind rather than being based on something actually seen, and the round, swelling, breast-like hills give it a strongly erotic quality (landscape as a metaphor for the female body).

87

## 87 Miserere I 1943

Inscribed 'Sutherland 43.' t.l. and Miserere I' b.c.
Ink, gouache and crayon on paper,
$6\frac{3}{4} \times 5$ (17.2 × 12.7)
First exh: *Graham Sutherland*, Whitla Hall, Queen's University, Belfast, November–December 1959 (39)
Repr: David Gascoyne, *Poems 1937–42* (London 1943), page before p.1
*Ronald Alley*

In addition to designing the cover for issue No.9 of *Poetry London* and making the set of colour lithographs, Sutherland also made a series of illustrations for David Gascoyne's book *Poems 1937–42*, published by Editions: Poetry, London (Nicholson and Watson) in 1943. The book reproduces eight designs, including those for the front and back covers, all of which are exceptionally metaphysical and Blake-like, in keeping with the visionary intensity of Gascoyne's poetry. Each one inside the book serves as introduction to a particular group of poems, but they are creations in parallel rather than illustrations in the strict sense.

# Work as an Official War Artist 1940-5

Sutherland was employed as an official war artist from 1940 to 1945, and this selection of his work covers all his principal themes: bomb damage in South Wales and London, blast furnaces, tin mining in Cornwall, limestone quarrying, opencast coal mining and finally, after the liberation of France, views of the damage done by the R.A.F. to railway marshalling yards and flying bomb depots. With three exceptions, the works shown are all definitive versions acquired by the War Artists' Advisory Committee and presented after the war to museums up and down the country. An exhibition of some of Sutherland's preliminary studies for his war drawings and paintings, showing his working methods, can be seen from 12 May to 4 July at the Imperial War Museum.

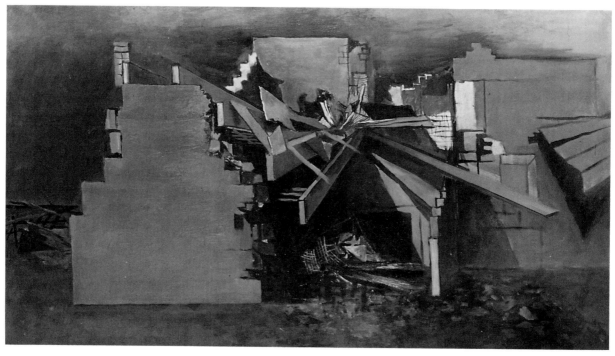

88

## 88  Devastation 1940: Farmhouse in Wales  1940

Not inscribed
Oil on canvas, $25\frac{3}{8} \times 44\frac{5}{8}$ (64.5 × 113.4)
First exh: *Graham Sutherland 1924–1951: a Retrospective Selection*, Institute of Contemporary Arts, London, April–May 1951 (34)
Repr: Sackville-West, 1943, pl.17 in colour; *Sutherland: The Wartime Drawings*, pl.2
Cheltenham Art Gallery and Museum Service

As his first major commission from the War Artists' Advisory Committee, Sutherland visited South Wales from the end of August 1940 until 16 September to make drawings of bomb damage, and by 23 October had completed seven gouaches, one oil (this work) and a folio of studies. A squared-up drawing for this painting in the National Museum of Wales in Cardiff is inscribed 'House near Cardiff 3 bombs' and 'Sept. 5–10. Aberthaw Cardiff'. West and East Aberthaw are villages on the coast about eleven miles south-west of Cardiff, close to the R.A.F. station at St Athan, and the farmhouse was presumably destroyed during an attack on the aerodrome.

Though a dramatic image, with the splayed rafters seen in bold foreshortening, this picture is still rather stiff and frontal compared with the drawings Sutherland was to do later on.

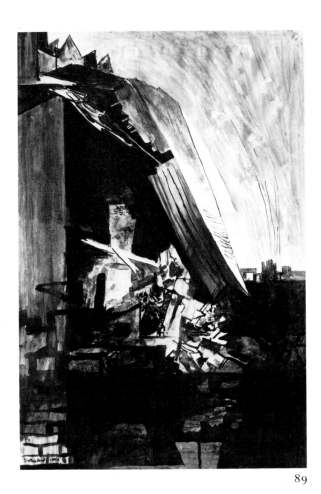

89

## 89 Devastation 1940: Study of Collapsed Roof 1940

Inscribed 'Sutherland 1940' b.l.
Ink, gouache and watercolour on paper
mounted on millboard,
$31\frac{5}{16} \times 21\frac{1}{16}$ (79.5 × 53.5)
First exh: *National War Pictures*, Royal
Academy, London, October–November 1945
(64)
Repr: *The Listener*, xxv, 1941, p.113;
*Sutherland: The Wartime Drawings*, pl.4
*City of Manchester Art Galleries*

This is also a scene of bomb damage in South Wales,
probably in Swansea, where he went to make studies
once the air raids on cities had begun. The subjects he
covered in Wales included farmhouses, a Masonic
hall, a public house, a hospital, a solicitor's office and
town houses.

## 90 Devastation 1941: City, Twisted Girders (2) 1941

Inscribed 'Sutherland 1941' b.r.
Ink, charcoal and gouache on paper,
$25\frac{3}{4} \times 44\frac{1}{4}$ (65.5 × 112.5)
First exh: *National War Pictures*, Royal
Academy, London, October–November 1945
(73)
Repr: J.B. Morton, *War Pictures by British
Artists: Blitz* (London 1942), pl.41; Sackville-
West, 1943, pl.27 in colour; Hayes, pl.49 in
colour
*Ferens Art Gallery, City of Kingston-upon-Hull*

The Blitz on London started on the afternoon of
7 September 1940 and lasted, with one or two breaks,
for the next eight months. On his completion of the

90

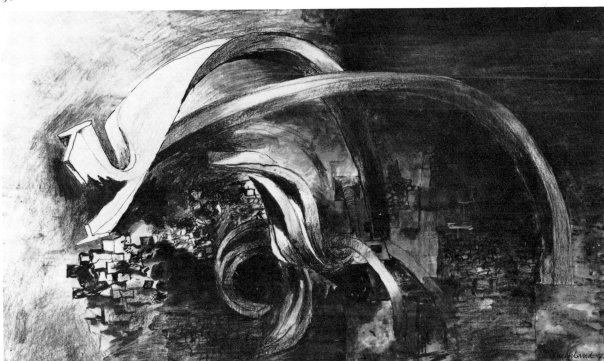

Welsh studies, Sutherland began work on London themes, travelling to and fro between Trottiscliffe and London, and also spending a few nights in London in hotels or with friends. Confronted by scenes of extreme devastation, he was not only deeply moved by their tragic implications but became fascinated by the way different types of material would respond to violent explosions – some shattered completely, others bent and twisted into strange, expressive shapes. Here the girders rear like a mortally wounded animal.

Another quite different picture known as 'Devastation 1941: City, Twisted Girders (1)' belongs to the Brighton Art Gallery.

91    **Devastation 1941: City, Fired Offices with Ventilator Shaft** 1941

Inscribed 'Sutherland 41' b.r.
Ink, chalk, wax crayon and wash on paper,
$30\frac{7}{8} \times 20\frac{7}{8}$ ($78.5 \times 53$)
First exh: *British Artists of the Second World War*, Arts Council touring exhibition, February–November 1965 (68)
Repr: *Connoisseur*, CVIII, 1941, p.36; J.B. Morton, *War Pictures by British Artists: Blitz* (London 1942), pl.43
*City of Manchester Art Galleries*

A scene of total devastation and silence.

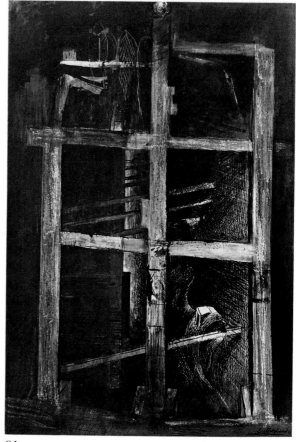

91

92    **Devastation 1941: City, Ruined Machinery in a Mantle Factory** 1941

Inscribed 'G. Sutherland 41' b. towards r.
Ink, chalk and gouache on paper,
$29 \times 21\frac{3}{8}$ ($73.7 \times 54.5$)
First exh: Cheltenham Festival Exhibition, July 1964
Lit: *Sutherland: The Wartime Drawings*, p.19, repr. pl.29
*Cheltenham Art Gallery and Museum Service*

Sutherland said of this work (quoted in *Sutherland: The Wartime Drawings*, p.19):

*At the beginning I was a bit shy as to where I went. Later I grew bolder and went inside some of the ruins. I remember a factory for making women's coats. All the floors had gone but the staircase remained, as very often happened. And there were machines, their entrails, hanging through the floors, but looking extraordinarily beautiful at the same time. And always there was the terrible smell of sour burning.*

*93    **Devastation 1941: an East End Street** 1941

Inscribed 'Sutherland 1941' t.r.
Ink and gouache on paper mounted on millboard, $25\frac{1}{2} \times 44\frac{3}{4}$ ($64.5 \times 114$)
First exh: *Contemporary British Art*, Royal Agricultural Hall, Gezira, Cairo, January 1945 (81)
Repr: Eric Newton, *War Pictures at the National Gallery* (London 1942), n.p.; Sackville-West, 1943, pl.21 in colour; *Sutherland: The Wartime Drawings*, pl.33
*Tate Gallery*

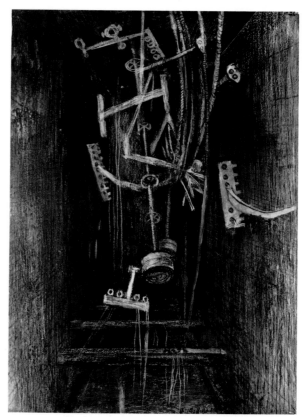

92

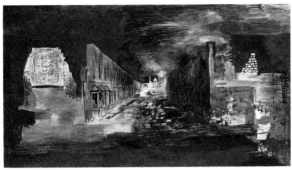

93

On 16 May 1941 Sutherland wrote to the Secretary of the War Artists' Advisory Committee: 'I am now immersing myself in the East End of London and finding it profoundly interesting and moving. In addition to making drawings I would like to take some photographs as supplementary material. . . . It would be a great help as it is difficult to draw in some places without rousing a sense of resentment in the people.'

As he recalled later: 'I became tremendously interested in parts of the East End where long terraces of houses remained: they were great – surprisingly wide – perspectives of destruction seeming to recede into infinity and the windowless blocks were like sightless eyes' (*Sutherland: The Wartime Drawings*, p.19).

There were also studies for this picture (a scene at Silvertown in east London) which are asymmetrical and in which one side of the street predominates. The heavy black sky and dramatic lighting are however recurrent features, as is the strange pipe or worm-like object in the far distance, towards which the eye is drawn.

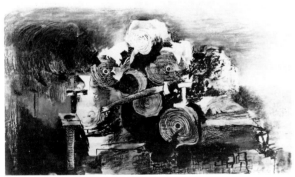

94

94 **Devastation 1941: East End, Burnt Paper Warehouse** 1941

Inscribed 'Sutherland 1941' b.r. and 'DEVASTATION 1941/EAST END. BURNT PAPER WAREHOUSE/Graham Sutherland.' on cardboard backing
Ink, crayon and oil on paper mounted on board, $26\frac{1}{2} \times 44\frac{3}{4}$ (67.5 × 114)
First exh: *National War Pictures*, Royal Academy, London, October–November 1945 (959)
Repr: *Sutherland: The Wartime Drawings*, pl.43
*Tate Gallery*

A burnt-out paper warehouse on the banks of the Thames at Wapping. Like 'Devastation 1941: an East End Street' (No.93) it belongs to the second batch of studies of bomb damage in London, completed by July 1941.

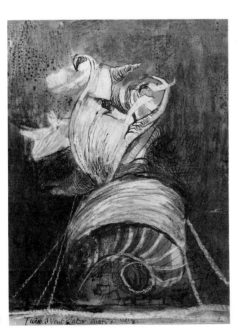

95

95 **Devastation 1941: City, Twisted Ventilator Shaft** 1941

Inscribed 'Twisted Ventilator shaft. City' b.l.
Ink, chalk and gouache on paper,
$9\frac{7}{8} \times 7\frac{1}{2}$ (25 × 19)
First exh: *Sutherland: Disegni di Guerra*, Palazzo Reale, Milan, June–July 1979 (21, repr.)
Repr: *Daily Telegraph Magazine*, 10 September 1971, p.25 in colour; Sanesi, pl.28; *Sutherland: The Wartime Drawings*, pl.21 in colour
*Private collection*

This drawing was not submitted to the War Artists' Advisory Committee, so its place in the sequence is uncertain; but it demonstrates exceptionally clearly the way in which, in Sutherland's eyes, a twisted metal shape could take on a form similar to the uncoiling of a bud and the principles of organic growth.

**96    Feeding a Steel Furnace** 1941

Not inscribed
Oil on canvas, $35\frac{1}{2} \times 34$ (90 × 86.5)
First exh: *National War Pictures*, Royal
Academy, London, October–November 1945
(322)
Repr: *Sutherland: The Wartime Drawings*, pl.113
*Tate Gallery*

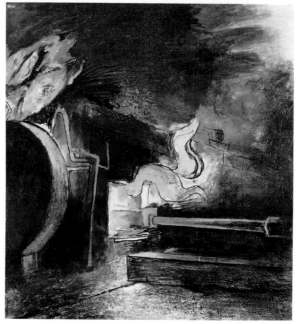

96

At the end of September 1941, after the bombing of
London had died down, Sutherland was sent to Wales
again to make studies of the large blast furnaces at
the Guest, Keen and Baldwin Steel Works at Cardiff,
and spent nearly three weeks there and at Dowlais
collecting material. This necessitated being present at
variable times, and at different factories, in order to
watch operations such as a 'tap' at the exact time they
occurred.

Already before the war he had become fascinated by
the way forms could be modified by emotion, partly
under the influence of Picasso's studies for 'Guernica'
in which faces become distorted by tears and mouths
open in fear. 'I had seen aspects of this idea in certain
kinds of destruction. So did I, too, in the steel works. As
the hand feeds the mouth so did the long scoops which
plunged into the furnace openings feed them, and the
metal containers pouring molten iron into ladles had
great encrusted mouths' (*Sutherland: The Wartime
Drawings*, p.104). The glare of the flames leaping from
the furnace and the intense heat are vividly suggested.

**97    A Foundry: Hot Metal has been Poured into
Moulds and Inflammable Gas is Rising** 1942

Not inscribed
Gouache on paper mounted on hardboard,
$36\frac{1}{8} \times 43$ (91.75 × 109)
First exh: *National War Pictures*, Royal
Academy, London, October–November 1945
(906)
Repr: Cecil Beaton, *War Pictures by British
Artists, Second Series: Production* (London
1943), pl.16; Cooper, pl.43f
*Tate Gallery*

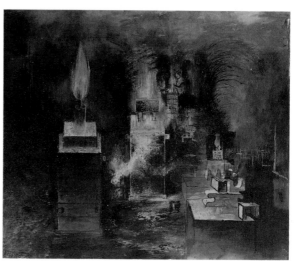

97

Reproduced by Cecil Beaton and Douglas Cooper
under the title 'Manufacturing Bombs'.

**98    Teeming Pit: Tapping a Steel Furnace** 1942

Inscribed 'Sutherland 1942' b.r.
Ink, gouache and chalk on paper,
$19\frac{1}{2} \times 14\frac{1}{2}$ (49.5 × 37)
First exh: *National War Pictures*, Royal
Academy, London, October–November 1945
(332)
Repr: Sackville-West, 1943, pl.29 in colour;
Cecil Beaton, *War Pictures by British Artists,
Second Series: Production* (London 1943), pl.30;
*The Artist*, XXVII, March 1944, p.19 in colour
*The Trustees of the Imperial War Museum*

Teeming is the process of pouring molten steel into the
ingot moulds in steel manufacture.

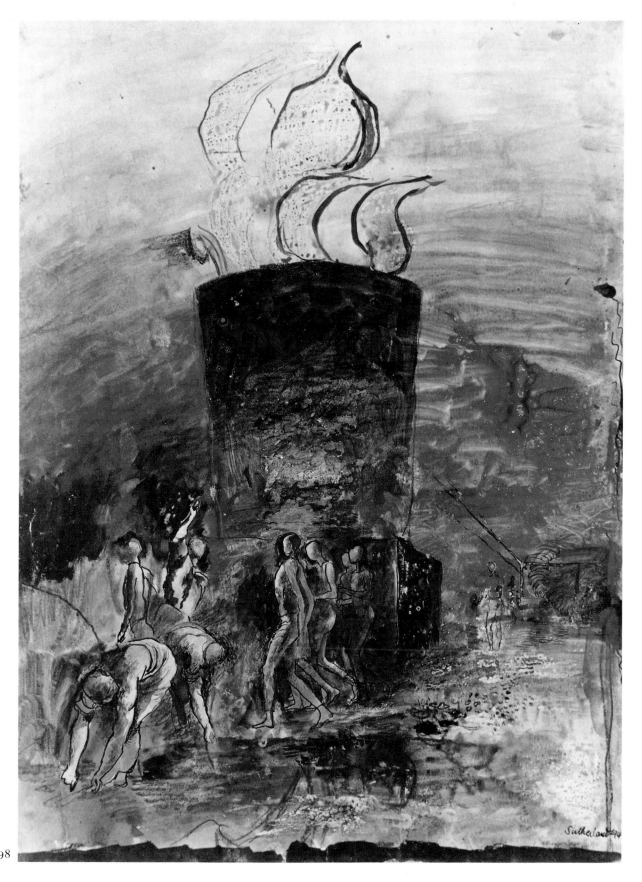

98

As Sutherland said later: 'I have always liked and been fascinated by the primitiveness of heavy engineering shops with their vast floors. In a way they are cathedrals. . . . And yet the rite – a word I use carefully – being performed when men are making steel is extraordinary; and how primitive it all really is in spite of our scientific age' (Noel Barber, *Conversations with Painters*, London 1964, pp.47–8).

Though small figures appear in some of these blast furnace pictures, they are still completely anonymous.

99 **Slag Ladles** 1942

Inscribed 'Sutherland' b.l.
Gouache, pastel and ink on paper,
$20\frac{1}{4} \times 14\frac{7}{8}$ ($51.5 \times 37.8$)
First exh: *National War Pictures*, Royal
Academy, London, October–November 1945
(71)
Repr: Eric Newton, *War Pictures at the National
Gallery* (London 1942), n.p. in colour;
Sackville-West, 1943, pl.23 in colour; John
Piper, *British Romantic Artists* (London 1946),
facing p.41 in colour
*The Trustees of the Imperial War Museum*

100 **Blast Furnaces: Exterior** 1942

Not inscribed
Watercolour and gouache on paper,
$19\frac{1}{2} \times 14\frac{1}{2}$ ($49.5 \times 37$)
First exh: *National War Pictures*, Royal
Academy, London, October–November 1945
(905)
Repr: Cecil Beaton, *War Pictures by British
Artists, Second Series: Production* (London
1943), pl.31; *Sutherland: The Wartime
Drawings*, pl.102
*Birmingham Museums and Art Gallery*

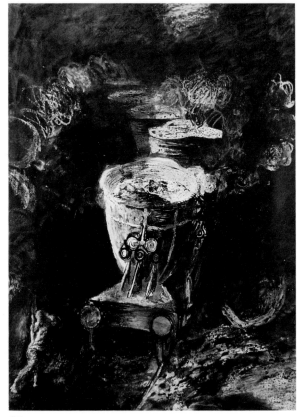

99

101 **Men Probing a Furnace** 1942

Not inscribed
Ink, chalk and gouache on paper,
$9\frac{5}{8} \times 15$ ($24.5 \times 38$)
First exh: *Graham Sutherland*, Galleria Civica
d'Arte Moderna, Turin, October–November
1965 (21, repr.)
Repr: Arcangeli, pl.42 in colour; *Sutherland: The
Wartime Drawings*, pl.126
*Private collection*

This has sometimes been known as 'Men Probing a
Furnace, Swansea'; however like a similar but upright
drawing at Picton it belongs to the Cardiff series.

100

*102 **Tin Mine – a Declivity** 1942

Inscribed 'Sutherland' b.l.
Pen, chalk and watercolour on paper mounted
on board, $18\frac{3}{4} \times 37\frac{1}{4}$ ($47.5 \times 94.5$)
First exh: *Decade '40s: Painting, Sculpture and
Drawing in Britain 1940–49*, Arts Council
touring exhibition, November 1972–June
1973 (104)
Repr: Sackville-West, 1943, pl.31 in colour;
Cooper pl.46a; Hayes, pl.48 in colour
*Leeds City Art Galleries*

As his next assignment from the War Artists' Advisory
Committee, Sutherland was sent to make drawings of
tin mining in Cornwall. His first visit started at the

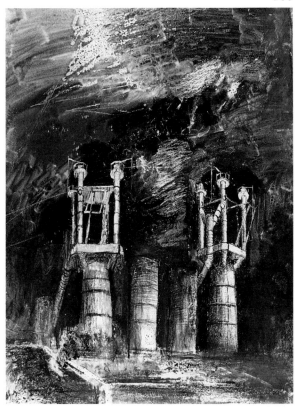

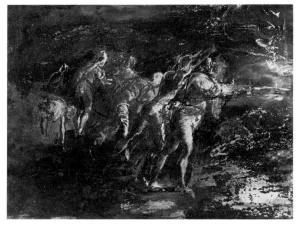

101

102

beginning of June 1942 and lasted for about three weeks, during which he spent the morning shifts underground at various levels. He stayed in Penzance and worked mainly in the Geevor Mine at Pendeen, but also visited other mines in the area.

*To make drawings of the mines had only the vaguest relation to the war but I was certainly presented with a new world – and a world of such beauty and such mystery that I shall never forget it. . . . The search for the diagonally descending vein of metal took the miners through a hole in the floor of the level tunnels via a high and narrow passage, shored with struts, terminating through a similar hole in the roof of the tunnel on the level below. This passage revealed precipitous perspectives of extraordinary and mysterious beauty in which the men, brilliantly lit, would be seen from above.*
*. . . In places the tunnels would converge in a central junction where all was light and where there were many figures and trucks. All was humid: the walls dripped water and the only light normally was from the acetylene lamps fixed to each man's helmet.*
[Sutherland: The Wartime Drawings, pp. 70–71].

The view here is of the meeting of several tunnels, with the trucks running down an inclined plane. A miner can be seen pushing a truck in the distance, the light from his lamp illuminating the walls around him. There is a womb-like sense of enclosure.

103

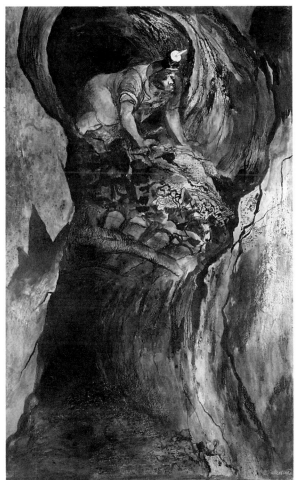

### 103 Tin Mine: Emerging Miner 1942

Inscribed 'G. Sutherland' b.r.
Gouache on paper mounted on board,
46 × 28¾ (116.8 × 73)
Repr: Eric Newton, *War through Artists' Eyes* (London 1945), p. 93; *Leeds Arts Calendar*, No. 3, winter 1947, p. 10; *Sutherland: The Wartime Drawings*, pl. 89
*Leeds City Art Galleries*

Sutherland annotated one of his studies for this work as follows (the word stope denotes the area from which tin ore is being extracted):

*Suggest miner in distance coming round curve of stope (very strong feeling of shut-in-ness and weight of stone). Miner emerges from entrance of stope. Very mysterious. Approach associated with noise of boots and falling stones and with approaching light of lamp. Remember light flesh colour derived from light reflected from close walls.*

The drawing was deliberately made large enough to give an impression of the actual scale of the mine tunnel.

### 104 Two Miners Drilling 1942–3

Inscribed 'Sutherland' b.r.
Watercolour, gouache and crayon on paper
mounted on board, 22 × 25 (56 × 50.7)
First exh: Gulbenkian Gallery, People's Theatre,
Newcastle-upon-Tyne, 1971
Repr: *Tyne and Wear County Council Museums:
War Artists* (Newcastle-upon-Tyne 1981), n.p.
*Laing Art Gallery, Tyne and Wear County Council
Museums*

This work and No.105, 'Miner Probing a Drill Hole',
were in the final batch of three tin mine drawings
apparently begun by 2 November 1942 but not
finished until after a further visit to Cornwall from 16
to 28 November and not delivered until the following
year. All three give particular prominence to the
human figure, and it seems that Sutherland felt he
needed to make some further studies before complet-
ing them.

Here the two miners are engaged in drilling in a
confined space. The procedure was to bore holes in
the diagonally or vertically ascending lodes of tin-
containing rock from below, and then blast the rock so
that it would fall down and could be loaded into
trucks.

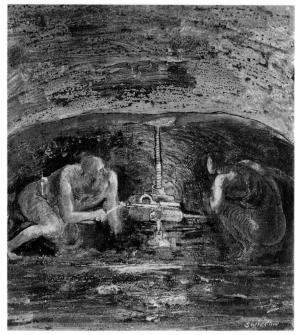

104

### 105 Miner Probing a Drill Hole 1942–3

Inscribed 'Sutherland' b.r.
Gouache and black crayon on paper mounted
on board, 22 × 20 (56 × 51)
First exh: *National War Pictures*, Royal
Academy, London, October–November 1945
(916)
Repr: *Sutherland: The Wartime Drawings*, pl.81
*Tate Gallery*

At least two of the drawings for this (*Sutherland: The
Wartime Drawings*, pls.79 and 80) are much more
realistic and show the miner wearing a helmet with a
lamp and in ordinary baggy working clothes. The final
drawing was possibly influenced by Henry Moore's
'Shelter Sketches', and the figure is very sculptural.

### 106 Tin Mine: Crouching Miner c.1943

Not inscribed
Ink, gouache and chalk on paper,
22½ × 17 (57 × 43)
First exh: *Sutherland: Disegni di Guerra*, Palazzo
Reale, Milan, June–July 1979 (72, repr. in
colour)
Repr: *Sutherland: The Wartime Drawings*, pl.72
in colour
*Private collection*

This drawing, though highly finished, was one of
those Sutherland kept and did not hand over to the
War Artists' Advisory Committee, so there is no record
of its date of delivery. However its emphasis on the
human figure suggests that it was done towards the
end of the tin mine series.

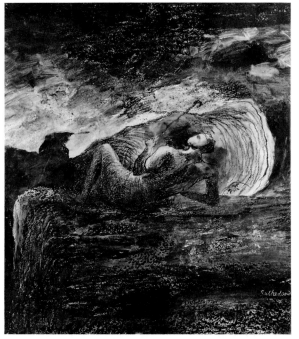

105

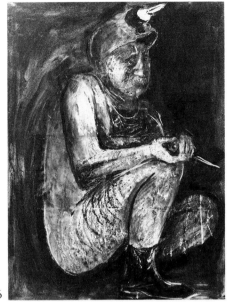

106

Later he recalled:

*Under ground I did a number of portraits. This was mainly to distract the attention of the miners from what I was really drawing. . . . The heads I did were small and naturalistic, as suited their purpose; but the deeper significance of these men only gradually became clear to me. It was as if they were a kind of different species – ennobled under ground, and with an added stature which above ground they lacked, and my feeling was that in spite of the hardness of the work in this nether world, this place held for them – subconsciously perhaps – an element of daily enthralment . . . often too, one would come across a miner sitting in a niche in a wall – like a statue, immobile.* [Sutherland: The Wartime Drawings, p.71].

In this case the forms are very solid and extremely simplified, like a piece of sculpture, but the figure is nevertheless very much an individual personality. It was Sutherland's largest and most finished study of the human figure to date.

**107  Limestone Quarry: Worked Terraces** 1943

Not inscribed
Wash, chalk and ink on paper mounted on plywood, $25\frac{9}{16} \times 29\frac{1}{2}$ (65 × 75)
First exh: *National War Pictures*, Royal Academy, London, October–November 1945 (892)
*City of Manchester Art Galleries*

After completing his work on the tin mines, Sutherland was next sent to make studies of limestone quarrying at Buxton in Derbyshire, where there were quarries belonging to the Lime Division of Imperial Chemical Industries Ltd. The ones he visited were mainly Hindlow and Buxton Central, which had both quarries and kilns; most of the stone was used for making into soda ash. Here a row of trucks can be seen waiting to be loaded.

107

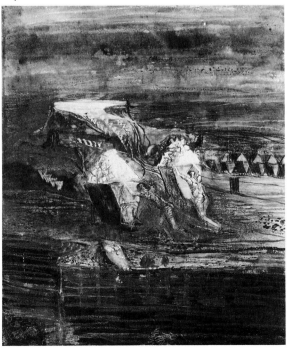

**108  Limestone Quarries: General View II** 1943

Not inscribed
Watercolour, gouache and crayon on paper mounted on board, $22\frac{1}{2} \times 19\frac{5}{8}$ (57 × 49.7)
First exh: *National War Pictures*, Royal Academy, London, October–November 1945 (904)
Repr: *Tyne and Wear County Council Museums: War Artists* (Newcastle-upon-Tyne 1981), n.p. (wrongly under 'Earth Removed from Coal')
*Laing Art Gallery, Tyne and Wear County Council Museums*

Sutherland made few drawings in the quarries except for studies of different shapes of boulders and rocks, but he took many written notes of possible ideas, situations, figure positions and so forth. Most of the real work was done when he got back to the place where he was staying. He began then to make a lot of drawings in a notebook of possible ideas for pictures, and drew different figure positions of men drilling and loosening stones from the surface of the cliff face.

108

**109  Limestone Quarries: Loosening Stone (2)  1943**

> Inscribed 'Sutherland 43' b.r.
> Ink, wax crayon and gouache on paper,
> $25\frac{1}{2} \times 22\frac{5}{8}$ (64.8 × 57.5)
> First exh: *Contemporary British Art*, Royal Agri-
> cultural Hall, Gezira, Cairo, January 1945 (82)
> *Sheffield City Art Galleries*

This is an extreme example of the imaginative trans-
formation to which Sutherland could sometimes
subject his material. The process of making these war
drawings involved, as he said, '... trying to find a way
between *reporting and description* of the subject and *the
creation of forms through feeling*'. (From a letter pub-
lished in Michael Rothenstein, *Looking at Paintings*,
London 1947, p.37.)

Another study of men loosening stone on the
quarry face, known as 'Limestone Quarries:
Loosening Stone (1)', belongs to the British Council.

**110  Opencast Coal Production: Dragline Bucket
Removing Earth  1943**

> Inscribed 'Sutherland.' b.r.
> Wash, chalk, pencil, charcoal and ink on paper
> mounted on millboard, $27\frac{1}{2} \times 26$ (69.3 × 66.1)
> First exh: *A Selection of Paintings and Drawings
> from the Rutherston Collection*, Arts Council
> touring exhibition, 1955 (48, repr.)
> *City of Manchester Art Galleries*

The idea of making studies of opencast coal mines was
suggested to Sutherland by the War Artists' Advisory
Committee in July–August 1943, and the studies
were made in Wales, at Pwll-du near Abergavenny.
Opencast mining had been introduced during the war
to provide an extra, relatively easy source of coal. The
earth was removed by dragline buckets to expose the
shallow seams of coal.

**111  Opencast Coal Production: Dragline Depositing
Excavated Earth  1943**

> Inscribed 'Sutherland 43' b.l.
> Gouache and chalk on paper mounted on
> board, $27\frac{1}{2} \times 26$ (70 × 66)
> First exh: *Graham Sutherland: Drawings of
> Wales*, Welsh Arts Council touring exhibition,
> June–October 1963 (38)
> Repr: *Leeds Arts Calendar*, No.3, winter 1947,
> p.11; Cooper, pl.47b
> *Leeds City Art Galleries*

**112  Press for Making Shells  1944**

> Inscribed 'Sutherland 44' b.r.
> Oil on hardboard, $30\frac{3}{8} \times 18$ (77.2 × 45.9)
> First exh: *National War Pictures*, Royal
> Academy, London, October–November 1945
> (900)
> Repr: Cooper, pl.44d as 'Hydraulic Press,
> Woolwich'; Arcangeli, pl.40; Hayes, pl.59 in
> colour
> *City of Manchester Art Galleries*

This work and No.113, 'Furnaces', are from a second
series of blast furnaces and steel foundries, made in
1944 at Woolwich Arsenal.

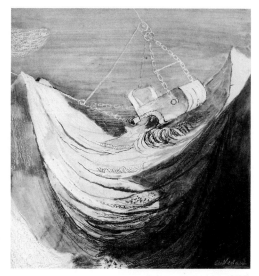

110

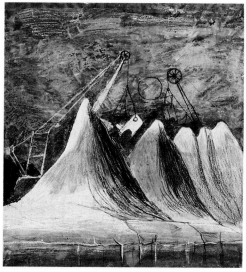

111

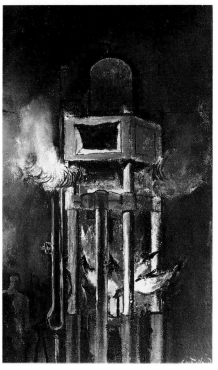

112

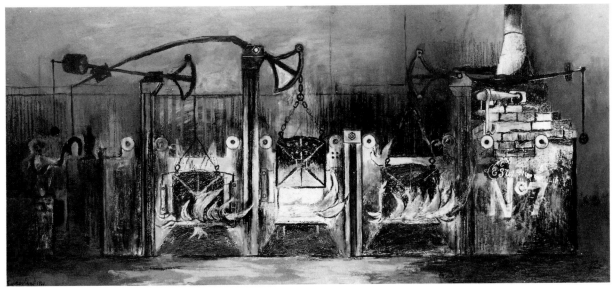

113

113 **Furnaces** 1944

Inscribed 'Sutherland 1944' b.l.
Gouache and crayon on paper mounted on
hardboard, $27\frac{1}{8} \times 60$ $(69 \times 152)$
First exh: *National War Pictures*, Royal
Academy, London, October–November 1945
(907)
Lit: Michael Rothenstein, *Looking at Pictures*
(London 1947), pp. 36–7, repr. p. 37 in colour
Repr: Melville, text illustration 19a
*Tate Gallery*

Here the furnaces become like the faces of ravenous
monsters waiting to be fed.

114

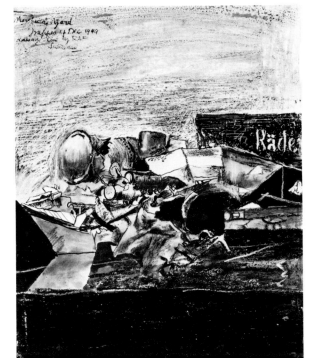

114 **Marshalling Yard, Trappes: Damage Done by
the R.A.F.** 1944

Inscribed 'Marshalling Yard / Trappes 14 Dec
1944 / damage done by RAF / Sutherland'
t.l.
Gouache, wax crayon, and pen and ink on
paper, $16\frac{1}{4} \times 13\frac{1}{4}$ $(41.3 \times 33.6)$
Repr: *Leeds City Art Gallery: A Selection of the
Paintings, Sculpture, Drawings, Watercolours and
Prints* (Leeds 1977), pl. 85
*Leeds City Art Galleries*

As his last assignment for the War Artists' Advisory
Committee, Sutherland was sent to France in
December 1944 to make studies of the damage done
by the R.A.F. to railway marshalling yards and flying
bomb depots, and also possibly the submarine pens at
Brest. He was billeted in Paris and made daily trips
from there west to Trappes, beyond Versailles, and
north to St-Leu-d'Esserent, near Chantilly (the visit
to Brest did not materialise). He arrived in Paris on
9 December and returned on 24 December; it was the
first time he had ever been abroad.

*115 **Marshalling Yard, Trappes: Damage Done by the R.A.F.** 1945

Inscribed 'Trappes' b.r.
Oil on hardboard, $50\frac{1}{2} \times 41\frac{1}{4}$ (128.3 × 104.8)
Repr: *Leeds Arts Calendar*, No.3, winter 1947,
p.9; Cooper, pl.48d
*Leeds City Art Galleries*

The smashed and crumpled locomotive lies on its side like a slaughtered animal – like a bull killed in a bullfight. This was the largest of Sutherland's last three oils for the War Artists' Advisory Committee; the others were both flying bomb depot subjects.

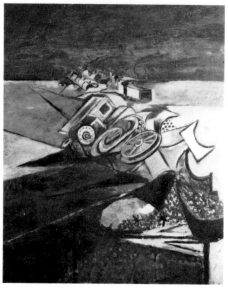

115

116 **Flying Bomb Depot, the Caves, St-Leu-d'Esserent** 1945

Inscribed 'St. Leu d'Esserent' b.l.
Gouache, pastel and wax crayon on tinted paper, $11\frac{1}{2} \times 18\frac{3}{8}$ (29.2 × 46.7)
Repr: *Burlington Magazine*, cxx, 1978, p.34
*The Trustees of the Imperial War Museum*

The flying bombs were stored at St-Leu-d'Esserent in caves which had originally been used by the French for growing mushrooms and which had been fortified by the Germans. These caves were very heavily bombed by the R.A.F., and holes were blasted through their roofs, opening them up to the sky. In this case the resulting drawing is not unlike Paul Nash's famous First World War painting of no-man's land, known as 'We Are Making a New World'.

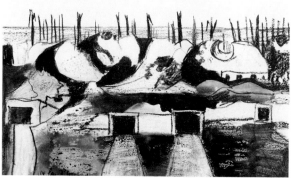

116

# 1944-7: 'The Crucifixion', 'Thorn Trees', etc.

Sutherland ceased to be an official war artist in April 1945, and was able to resume full-time the development of his earlier themes. However, the commission to paint a 'Crucifixion' for the Church of St Matthew's, Northampton, led him to make his first religious works and to depict the human figure for the first time on a life-size scale. The series of 'Thorn Trees' and 'Thorn Heads' also developed indirectly out of this preoccupation with the Crucifixion. His works tended to become bolder and more simplified, and he began to heighten the tonality and use brighter colours. His exhibition at the Buchholz Gallery, New York, in 1946 was his first one-man show outside Britain and marked the beginning of his international reputation.

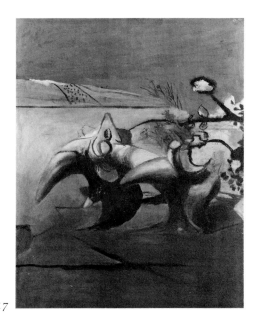

117

### 117 Horned Forms 1944

Not inscribed
Oil on hardboard, 32 × 25¼ (81 × 64)
First exh: *Quelques Contemporains Anglais*, 28 Avenue des Champs Elysées, Paris, November 1945 (41)
Repr: *Horizon*, XII, July 1945, between pp.24 and 25 in colour; Cooper, pl.59; Hayes, pl.65 in colour
*Tate Gallery*

This picture was painted in Sutherland's studio in Kent from a root form which he had found and brought home with him. He is seen holding this very root, this 'found object', in a photograph in the catalogue of his 1946 Buchholz Gallery exhibition. He made various studies of the shapes of the object in his studio, simplifying and paraphrasing them, and then created an imaginary landscape as a setting for it. A second larger version, which he painted afterwards for his New York exhibition, was bought by the Museum of Modern Art, New York.

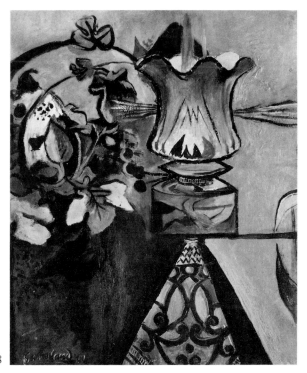

118

### 118 The Lamp 1944

Inscribed 'Sutherland 44' b.l.
Oil on hardboard, 28 × 25 (71 × 63.5)
First exh: *Recent Paintings by Francis Bacon, Frances Hodgkins . . . Graham Sutherland*, Lefevre Gallery, London, April 1945 (36)
Lit: Hayes, p.97
Repr: Cooper, pl.61c; Arcangeli, pl.47 in colour
*Dr and Mrs L. Bohm*

This is one of two oil paintings made in 1944 which were inspired by an actual paraffin lamp in the small room occupied by the Sutherlands in a cottage where they were staying at Sandy Haven in Pembrokeshire. The lamp appears in this case to be almost growing out of the nearby plant, like an exotic flower, and the background is an intense saturated orange (an example of Sutherland's occasional use of very strong, brilliant colour well before his move to the South of France). The other picture has more restrained colour and the placing of the forms is rather different.

**119 Twisted Tree Form** 1944

Not inscribed
Gouache, wax crayon, chalk and pencil on
paper mounted on hardboard,
$22\frac{1}{2} \times 18\frac{5}{8}$ (57.2 × 47.2)
First exh: *Recent Paintings by Francis Bacon,
Frances Hodgkins . . . Graham Sutherland*, Lefevre
Gallery, London, April 1945 (43)
Repr: Melville, text illustration 21a
*Laing Art Gallery, Tyne and Wear County Council
Museums*

One of Sutherland's last compositions with a violently
plunging centripetal rhythm.

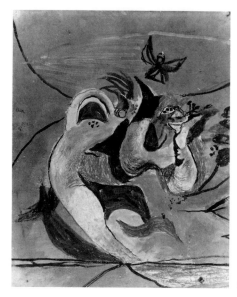

119

**120 Triple-tiered Landscape** 1944

Inscribed 'Sutherland' b.r.
Ink, pastel and watercolour on paper,
22 × 16 (56 × 40.6)
First exh: *Graham Sutherland 1924–1951:
a Retrospective Selection*, Institute of Con-
temporary Arts, London, April–May 1951 (6)
Repr: Cooper, pl.55; Hayes, pl.61
*Private collection, London*

The site is to the north of St David's, in an area of fields
rising to hills. The landscape surges upwards in stages,
and the thin, shadowy figure of a man denotes a
human presence.

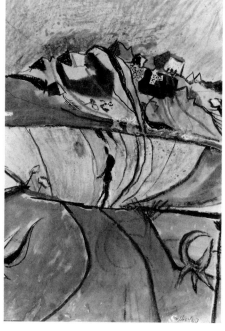

**121 Lane Opening** 1944–5

Inscribed 'Sutherland 44–45' b.l.
Oil on hardboard, $36\frac{3}{4} \times 28\frac{1}{2}$ (93.5 × 72.5)
First exh: *Recent Paintings by Francis Bacon,
Frances Hodgkins . . . Graham Sutherland*, Lefevre
Gallery, London, April 1945 (40)
Lit: Cooper, pp.37–8
Repr: Reginald Brill, *Modern Painting and its
Roots in European Tradition* (London 1946),
pl.42
*Mr and Mrs Denis O'Brien*

One of several oil paintings executed towards the end
of the war as variations on the theme of 'Entrance
to a Lane' of 1939 (No.67), and with more sinuous
designs.

120

**122 Corn Stook in Landscape** *c.*1945

Not inscribed
Ink, gouache and pencil on paper mounted on
card, $23\frac{3}{4} \times 16\frac{3}{4}$ (60.3 × 42.6)
First exh: *The Modern Movement in British
Water-Colour Painting*, Norwich Castle
Museum, December 1957–February 1958
(67)
*Whitworth Art Gallery, University of Manchester*

A scene to the north-northwest of St David's, looking
towards Carnllidi. The inclusion of the corn stook is a
sign of human cultivation, a first step towards such
later themes as the vine pergolas.

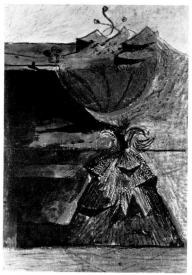

122

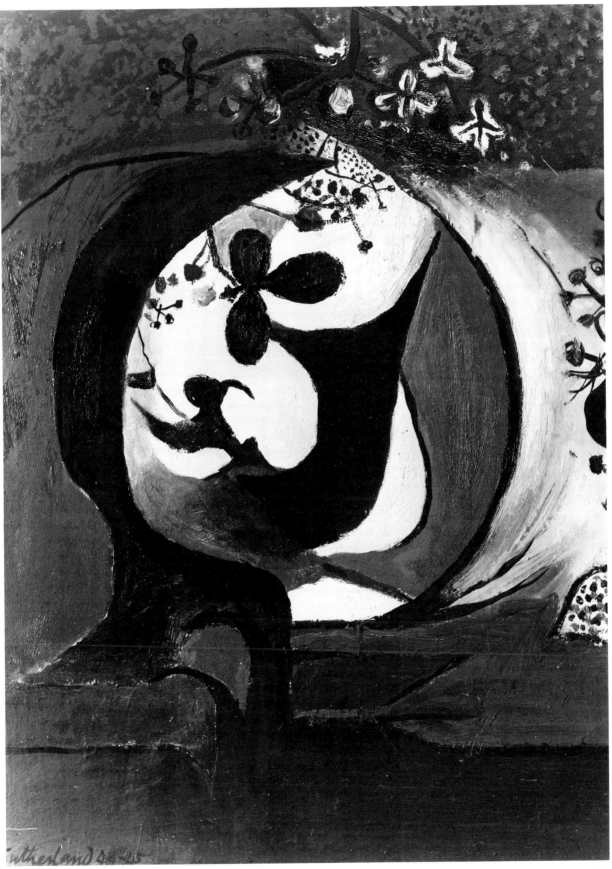

121

### 123 Landscape with Rocks 1945

Inscribed 'Sutherland 45' c.l.
Oil on hardboard, 37 × 28½ (94 × 72.4)
First exh: *Recent Paintings by Francis Bacon,
Frances Hodgkins . . . Graham Sutherland*, Lefevre
Gallery, London, April 1945 (39)
Lit: *Glasgow Art Gallery and Museum: Summary
Catalogue of British Oil Paintings* (Glasgow
1971), p.85, repr. p.64
Repr: Melville, text illustration 26a
*Glasgow Art Gallery and Museum*

This picture was developed from a series of drawings
and gouaches made in 1944 known as 'Landscape
with Pointed Rocks', but with the introduction of a
larger expanse of foreground. The site is a stretch of
rocky coastline just east of the mouth of Sandy Haven
estuary.

### 124 Thorn Tree 1945

Inscribed 'Sutherland 45' b.l.
Oil on canvas, 26 × 20 (66 × 56)
First exh: *Quelques Contemporains Anglais*,
28 Avenue des Champs Elysées, Paris,
November 1945 (45)
Lit: Graham Sutherland, letter to Curt Valentin
published in exh. catalogue *Graham Sutherland*,
Buchholz Gallery, New York, February–March
1946; Graham Sutherland, 'Thoughts on
Painting' in *The Listener*, XLVI, 1951,
pp.377–8, repr. p.377; Felix H. Man, *Eight
European Artists* (London–Melbourne–Toronto
1954), n.p.; Cooper, pp.32–3, repr. pl.80;
Graham Sutherland and Andrew Forge,
'Landscape and Figures' in *The Listener*, LXVIII,
1962, p.133; Ethel Moore (ed.), 'Letters from
31 Artists to the Albright-Knox Art Gallery' in
*Gallery Notes*, XXXI, No.2 and XXXII, No.2,
spring 1970, p.42
Repr: *Art News*, XLV, February 1947, p.25;
Melville, pl.2 in colour
*The Hon. Alan Clark M.P., Saltwood Castle*

In his 'Thoughts on Painting' published in 1951 (*loc.
cit.*), Sutherland described the origins of his thorn
pictures as follows:

*My thorn pictures came into being in a curious way.
I had been asked [in February 1944] by the Vicar of St
Matthew's, Northampton, to paint a Crucifixion. In the
autumn of that year I had been thinking of the form the
work was to take; in the spring of the following year the
subject was still very much in my mind. So far I had
made no drawings – and I went into the country. For the
first time I started to notice thorn bushes, and the
structure of thorns as they pierced the air. I made some
drawings, and as I made them, a curious change
developed. As the thorns rearranged themselves, they
became, whilst still retaining their own pricking, space-
encompassing life, something else – a kind of 'stand-in'
for a Crucifixion and a crucified head . . .*

*The thorns sprang from the idea of potential cruelty –
to me they were the cruelty; and I attempted to give the
idea a double twist, as it were, by setting them in benign*

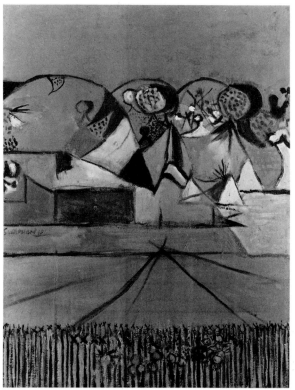

123

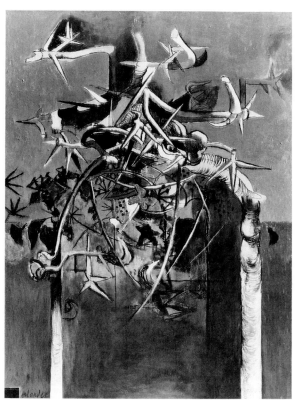

124

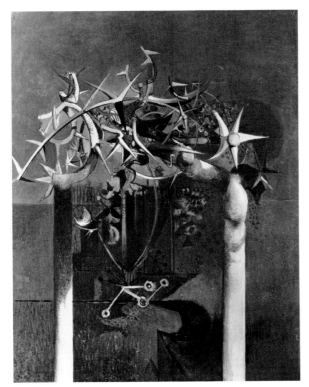

125

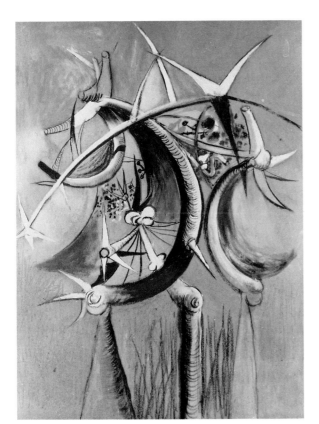

126

*circumstances: blue skies, green grass, Crucifixions under warmth . . . .*

In a later interview with Andrew Forge he explained that his preoccupation at the time had been to make the groups of thorns even more self-contained than they already seemed to be by

*. . . excluding a great deal of other stuff which was round the core in which I was interested, the fragment, if you like, that I was interested in. It was only that, I think, which makes it look so headlike. I wanted, naturally, to make the tune I was playing start and end, and therefore a neck of some sort seemed to be a way of doing it. . . . The actual studies objectively were pretty close and rather governed by what I saw.*

This picture is one of the first in the series, possibly the very first.

*125 **Thorn Tree** 1945-6

> Inscribed 'Sutherland' t.r.c.
> Oil on canvas, 50 × 39½ (127 × 101.5)
> First exh: *Recent Paintings by Ben Nicholson, Graham Sutherland . . .*, Lefevre Gallery, London, February 1946 (12)
> Lit: as for No.124 (except for the reproductions)
> Repr: *The Listener*, xxxv, 14 February 1946, p.216; Cooper, pl.81; Arcangeli, pl.58 in colour
> *The British Council*

This is either the third or fourth of the 'Thorn Tree' pictures. It is more strongly constructed and monumental than the first versions, more like a kind of open sculpture, with the thorn forms supported on two powerful legs.

126 **Thorn Heads** 1945-6

> Not inscribed
> Pastel and gouache on hardboard, 26½ × 19¾ (67.3 × 50.2)
> First exh: *Recent Paintings by Ben Nicholson, Graham Sutherland . . .*, Lefevre Gallery, London, February 1946 (13) as 'Thorns'
> Repr: Melville, pl.19 in colour; Cooper, pl.84b
> *Private collection*

'Thorn Heads' developed from the left-hand section of the British Council's 'Thorn Tree' picture and the corresponding part of a very similar picture now in the Albright-Knox Art Gallery in Buffalo. The heads are sickle-shaped, with what Sutherland called 'a sort of "pricking" and demarcation of a hollow headshaped space enclosed by the points' (from a letter of 24 January 1946 to Curt Valentin, published in the catalogue of his 1946 exhibition at the Buchholz Gallery, New York).

**127 Laughing Woman** 1946

Inscribed 'Sutherland 46' t.l.
Oil on canvas, $19\frac{1}{2} \times 16$ (49.5 × 40.6)
First exh: *Modern British Portraits*, Arts Council
touring exhibition, 1960–1 (33)
Lit: 'How Far Should an Artist Use a Camera?'
in *Daily Express*, 26 April 1958, p.5; John
Hayes in exh. catalogue *Portraits by Graham
Sutherland*, National Portrait Gallery, London,
June–October 1977 (note on No.15 and repr.)
Repr: Cooper, pl.163
*Private collection*

Sutherland said that this picture was done from a
newspaper photograph of a woman laughing. 'I never
knew who she was. But the expression caught my
attention and I used the idea to build a picture' (*Daily
Express, loc. cit.*).

**128 Study for 'Crucifixion'** 1946

Not inscribed
Oil on hardboard, $13 \times 9\frac{3}{4}$ (33 × 24.8)
First exh: *Graham Sutherland 1924–1951:
a Retrospective Selection*, Institute of
Contemporary Arts, London, April–May 1951
(44), dated 1944
Lit: Cooper, pp.32–3, repr. pl.77 (dated 1946)
*Kenneth Clark*

One of the early studies for the Northampton
'Crucifixion', showing a more schematic design, with
the body and arms hanging in a V shape from a curved
cross-bar. Sutherland afterwards abandoned this
idea, partly because he felt that the commission
demanded a more realistic treatment, and partly
because the wall which the picture was to occupy at
the end of the south transept would be more suitable
for a wider picture, with the arms extended sideways.

*129 **Crucifixion** 1946

Not inscribed
Oil on hardboard, 96 × 90 (243.8 × 228.5)
Lit: The Rev. Walter Hussey and John Piper,
'Religion Inspires a Modern Artist' in *Picture
Post*, 21 December 1946, pp.13–15, repr.
p.13 and with photographs of the unveiling
etc. pp.14–15; Marcus Whiffen, 'Graham
Sutherland's Crucifixion' in *Architectural
Review*, CI, 1947, pp.105–7, repr. pp.105–6
and detail p.107; Ernest Brandl, letter to the
editor in *Architectural Review*, CII, 1947, pp.70
and 72; *Art News*, XLVI, April 1947, p.21 repr.;
Benedict Nicolson, 'Graham Sutherland's
"Crucifixion"' in *Magazine of Art*, XL, 1947,
pp.279–81, repr. pp.279 and 281; The Rev.
Canon Walter Hussey, 'A Churchman
Discusses Art in the Church' in *Studio*,
CXXXVIII, 1949, pp.80, 95, repr. p.80; Melville,
n.p., repr. pl.14 (see also pls.67–9); Graham
Sutherland, 'Thoughts on Painting' in *The
Listener*, XLVI, 1951, p.378; Cooper,
pp.29–35, repr. pl.75, detail pl.74b; 'Graham
Sutherland Explains His Art' in *Illustrated
London News*, CCXLVIII, 19 February 1966,

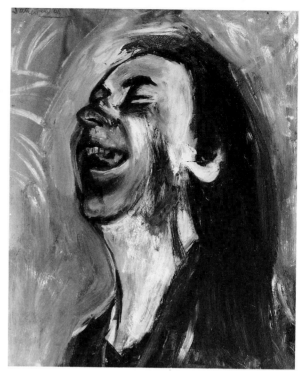

127

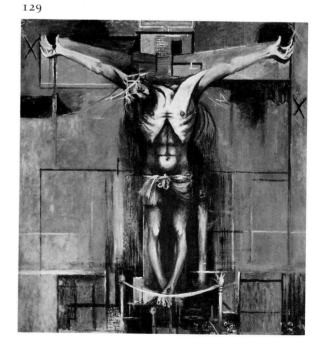

129

p.30; Graham Sutherland, 'Images Wrought from Destruction' in *Daily Telegraph Magazine*, 10 September 1971, p.28; Hayes, pp.24–6, 45–6, repr. pl.77 and detail pl.78
Repr: *Vogue*, CIII, March 1947, p.65 in colour
*St Matthew's Church, Northampton*

The Vicar of St Matthew's, Northampton, the Rev. Walter Hussey (later Dean of Chichester) commissioned Henry Moore to sculpt a 'Madonna and Child' for his church and Benjamin Britten and Michael Tippett to write pieces of music – an outstanding and all-too-rare example of the patronage of great contemporary artists by the Church. Feeling that he would also like to have a painting, he asked Moore if he thought there were any other artists who might do something for the church, and mentioned a few names, including Sutherland's. Moore replied that he thought the only one who might produce something good and appropriate was Sutherland.

At the unveiling of Moore's 'Madonna' on 19 February 1944, Hussey suggested to Sutherland that he might undertake an 'Agony in the Garden' for St Matthew's, in view of his interest in landscape, but Sutherland replied that he had already had the idea of doing a 'Crucifixion' of a significant size and would prefer to paint this subject. Hussey readily agreed to this suggestion. The painting was to be placed on the end wall of the south transept, facing the sculpture by Henry Moore which is at the end of the north transept.

Sutherland did not begin systematic work on this commission until April 1946, but in the meantime had painted his series of 'Thorn Trees' and 'Thorn Heads' inspired by the notion of the crown of thorns. He had also meanwhile come across a booklet published by the United States Office of War Information containing terrible photographs of Belsen, Auschwitz and Buchenwald, photographs showing the massacred corpses and starving survivors, many of the tortured bodies in positions which made them look like crucified figures. This both reminded him of the great 'Crucifixions' of Grünewald which were to serve as his prototype, and also made the whole idea of the depiction of Christ crucified much more real to him because of the continuing beastliness and cruelty of mankind.

Benedict Nicolson, writing soon afterwards, has described how Sutherland went through a long process of experimenting with different compositions, either in oil on panel or in charcoal or pencil, sometimes of the complete picture, sometimes of separate details, a few in miniature, and one important study seven feet high.

*Suddenly the railings, which curve around the feet of Christ, slip in and are retained; a skull appears at the foot of the cross, only to disappear in a subsequent sketch. The orange 'landscape' takes the place of the skull and, as the months pass, the purple of the background grows darker and darker. The later compositions show the figure slumped to one side, more anatomical, more emaciated, closer to the ascetic Christs of the thirteenth century than to Grünewald; but curiously enough in the final version Sutherland returns to the general scheme he had worked out in some of his earliest sketches*
[*Magazine of Art*, XL, 1947, p.280].

As he could not very well ask anyone else to pose for him, Sutherland slung himself up with cords under the armpits and sketched himself in a mirror, to discover what arms would look like in this position and how the stomach would be drawn inwards. Working in a garage near Wrotham in Kent, because the panel was too large to be squeezed into his studio, he knocked together a few old packing cases to act as a cross. The irregular, overlapping surfaces of his blocks of wood provided him with the idea of the cubist patterning of his background and of repeating the lines of the cross in the spaces below the arms. The little railing around the feet was introduced to remind the spectator that this picture must be contemplated from a certain distance, as it is too far removed in spirit from ordinary life to be approached.

The final picture was begun in June 1946 and finished in the autumn. Before its unveiling and dedication on 16 November 1946, Sutherland spent six days working on it in the church, adjusting the tones to suit the new conditions of light.

He said afterwards:

*The Crucifixion idea interested me because it has a duality which has always fascinated me. It is the most tragic of all themes yet inherent in it is the promise of salvation. It is the symbol of the precarious balanced moment, the hair's breadth between black and white. It is that moment when the sky seems superbly blue – and, when one feels it is only blue in that superb way because at any moment it could be black – there is the other side of the mirror – and on that point of balance one may fall into great gloom or rise to great happiness. . . . I would have liked to paint the Crucifixion against a blue sky – a blue background. . . . The colour which in fact I did use – a bluish royal purple, traditionally a death colour – was partly dictated by certain factors already in the church* [*The Listener*, XLVI, 1951, p.378].

**130 The Deposition 1946**

Inscribed 'Sutherland 23.11.46' b.r.
Oil on millboard, 59⅞ × 48 (152 × 121.9)
First exh: *Graham Sutherland 1924–1951: a Retrospective Selection*, Institute of Contemporary Arts, London, April–May 1951 (11)
Lit: Note on No.20 in exh. catalogue *Part of a Collection of Oil Paintings, Water Colours, Drawings and Sculpture Belonging to W.A. Evill, Esq. Shown to the Members of the Contemporary Art Society*, London, December 1947–February 1948; Cooper, p.35, repr. pl.73
Repr: *Studio*, CXXXVII, 1949, p.47; Melville, pl.15 in colour
*Fitzwilliam Museum, Cambridge*

As this picture is dated 23 November 1946, it must have been painted, or at any rate finished, after the Northampton 'Crucifixion'. Other related New Testament subjects which Sutherland worked on at the same period were a first version of 'Christ Carrying the Cross' (now lost or left at the drawing stage), of which he painted a second version in 1953, a 'Weeping Magdalen' dated 17 December 1946 and a small 'Entombment' made in 1947.

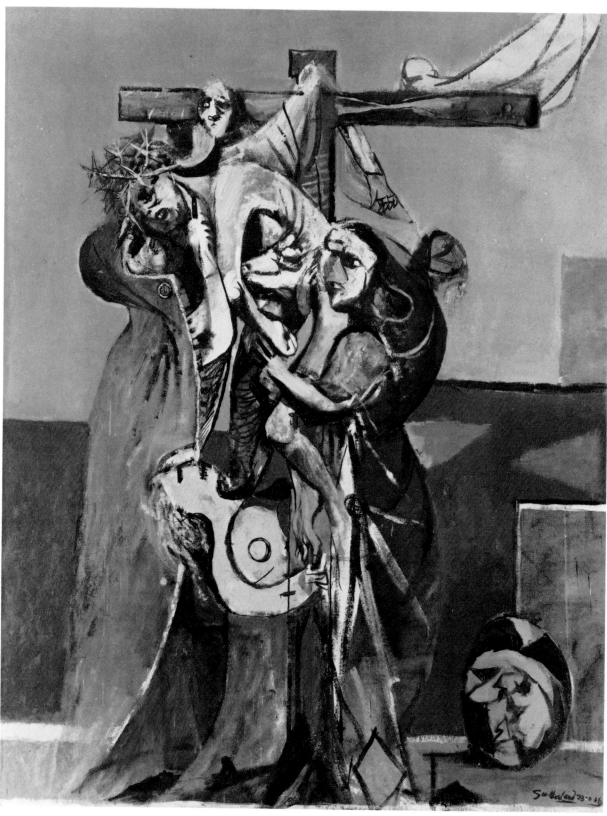

130

Mary Magdalen at the foot of the cross is in an attitude which recalls that of the left-hand figure in Picasso's 'Three Dancers' (now in the Tate Gallery), while the face at the top is that of one of the exe-cutioners helping to lower the body. The skull of Golgotha is on the right and the Green Hill of the City appears in the background. It is one of the most tortured and expressionistic of all Sutherland's works.

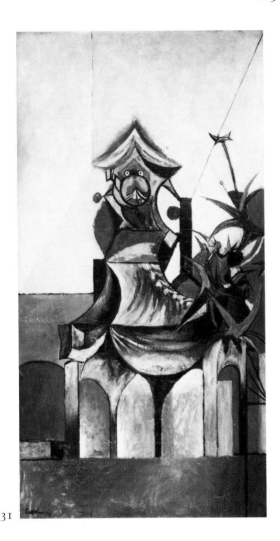

131

132

### *131 Chimère II 1946-7

Inscribed 'Sutherland 1946' b.l.
Oil on canvas, 70 × 36 (177.8 × 91.4)
First exh: *La Jeune Peinture en Grande Bretagne*,
Galerie René Drouin, Paris, January–February
1948 (48, repr.)
Lit: Cooper, p.46, repr. pl.71
Repr: Melville, pl.24 in colour (dated
1946–7); Arcangeli, pl.62
*Private collection*

This painting and the even larger 'Chimère I' of 1946
were developed from a series of drawings and gou-
aches of a fallen tree trunk made in 1945, known as
'Staring Tree Form'. As Douglas Cooper has pointed
out:

*Here Sutherland starts with a fallen tree-trunk – from
which a knot in the head seemed to glare at him like the
eye of a Cyclops – and reinterprets the object until he has
arrived at a dramatic and slightly grotesque apparition.
Posed as it is on a sort of throne, this creature has the
aloofness of a monument, yet as it fixes us with its eyes
so it disquiets us with its presence.*

Though signed and dated 1946, the painting seems
to have been completed in 1947 after Sutherland's
first visit to the South of France, since it appears in a
photograph of his Trottiscliffe studio in an unfinished
state (the lower part still somewhat unresolved)
alongside several small pictures of vine pergolas and
palm leaves. It is also more simplified than 'Chimère I',
with stronger outlines and originally with large areas
of saturated pink, orange and mauve (which have
now somewhat faded).

The title 'Chimère' was probably suggested by that
of a short article on Sutherland's 1946 New York
exhibition published in *Art News* in March 1946:
'Britain Now: the Chimeras of Sutherland'. Suther-
land's sketchbooks show that he was working on the
'Chimère' idea at the same time as he was making
studies for the Northampton 'Crucifixion'.

### 132 Crucifixion 1947

Inscribed 'Sutherland 47' t.r.
Oil on canvas, 22 × 18 (56 × 45.7)
First exh: *Graham Sutherland and Henry Moore*,
Institute of Contemporary Art, Boston, April
1953 (12)
Repr: J.P. Hodin, Giuseppe Marchiori and
others, *Figurative Art since 1945* (London
1971), pl.24
*Private collection*

A postscript to the Northampton 'Crucifixion', show-
ing a further variant of the idea. Sutherland seems to
have painted altogether at least eight oil studies of the
'Crucifixion' in 1946–7, with considerable variations
in size, design and background colour.

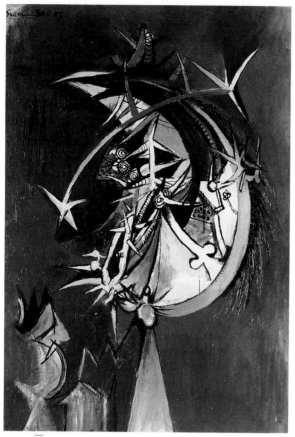

133

133  **Thorn Head** 1947

Inscribed 'Sutherland 30.iii.47' t.l.
Oil on canvas, $43\frac{3}{4} \times 30\frac{1}{2}$ ($111 \times 77.5$)
First exh: *Colour Pure and Atmospheric*, Roland,
Browse and Delbanco, London, May–June
1947 (17) as 'Thorns'
Repr: Melville, pl.17; Cooper, pl.83c
*The Roland Collection*

A 'Thorn Head' still related to the left-hand sections of
the later 'Thorn Tree' pictures, but with the head seen
in greater isolation, against a background of a differ-
ent colour, and crowded with sharp, spiky forms
evoking anguish.

# 1947-61: Move to the South of France

Sutherland made his first visit to the South of France in 1947 and from then on spent part of each year there, buying a house at Menton in 1955. This led first to the use of more brilliant colours and a preoccupation with Mediterranean motifs such as vine pergolas and palm palisades, then from 1949 to about 1957 to a series of 'standing forms' and 'presences'. His work was exhibited at the Venice Biennale in 1952, and the exhibition was afterwards shown in an enlarged form in Paris, Amsterdam and Zurich, and in May–August 1953 at the Tate Gallery. This was also the period when he painted his first and most controversial portraits. From 1953 up to the end of 1961 much of his time was taken up with work on the Coventry Tapestry.

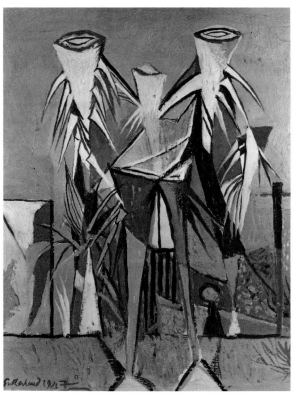

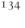
134

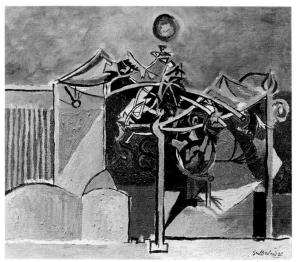
135

*134 **Palm Palisade** 1947

> Inscribed 'Sutherland 1947' b.l.
> Oil on canvas, $19\frac{1}{2} \times 15\frac{1}{2}$ (49.5 × 39.5)
> First exh: XXVI Venice Biennale, June–October
> 1952 (British Pavilion 24)
> Repr: Melville, pl.1 in colour; Cooper, pl.93d;
> Hayes, pl.72 in colour
> *Private collection*

Confronted in the South of France with landscape and vegetation of a kind that was completely new to him, Sutherland tended at first to emphasise their exoticism by choosing themes such as palm palisades, vine pergolas, cacti, banana leaves and cicadas. The palm leaves, with their spiky fronds, also had obvious affinities with the thorn trees he had been painting shortly before.

The high-keyed colours of these pictures evoke the constant bright, warm Mediterranean light.

135 **Green Vine Pergola** 1948

> Inscribed 'Sutherland 48' b.r.
> Oil on canvas, $18\frac{7}{8} \times 22\frac{1}{2}$ (48 × 57)
> First exh: *Graham Sutherland Paintings*,
> Hanover Gallery, London, June–July 1948
> (14)
> Repr: Melville, pl.39; Cooper, pl.90a
> *Musées Royaux des Beaux-Arts de Belgique,
> Brussels*

The neatly cultivated vineyards of Provence now provided subject matter (no longer the stark wildness of Pembrokeshire), and his pictures of vine pergolas usually include a figure tending the vines.

136 **Large Vine Pergola** 1948

> Inscribed 'Sutherland 48' b.l.
> Oil on canvas, $37 \times 68\frac{1}{8}$ (94 × 173.5)
> First exh: *Graham Sutherland Paintings*,
> Hanover Gallery, London, June–July 1948
> (23), incorrectly as 'Large Palm Pergola'
> Repr: *Harper's Bazaar*, XXXIX, July 1948,
> pp.46–7 in colour; Cooper, pl.88e as 'Large
> Vine Pergola'
> *The British Council*

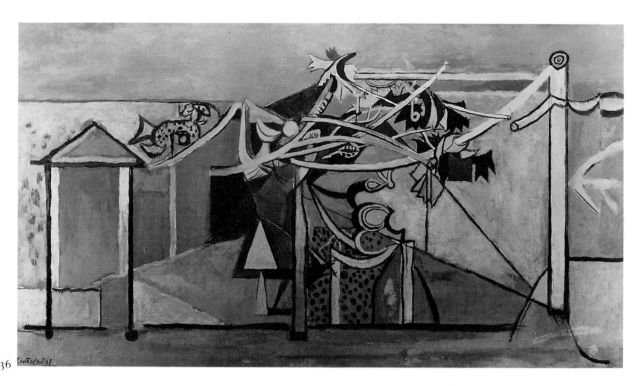

136

This picture illustrates Sutherland's increasing in-
debtedness to Picasso and Matisse at this date, and his
ambition to become a European or international artist
rather than just an English one. The brilliant colour
range of pink, yellow and soft pale blue evokes
shimmering sunlight, while the decorative overall
design incorporates a mysterious figure – a personage
almost woven into the foliage and half seen, half
unseen.

*137 **Cigale I** 1948

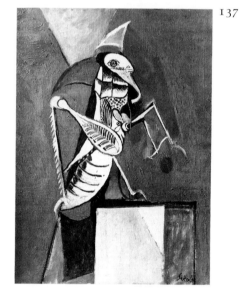

137

    Inscribed 'Sutherland' b.r.
    Oil on canvas, 27 × 20 (68.5 × 50.8)
    First exh: *Graham Sutherland Paintings*,
    Hanover Gallery, London, June–July 1948
    (16)
    Repr: Melville, pl.34 in colour; Cooper, pl.98b;
    Hayes, pl.82 in colour
    *Redfern Gallery and James Kirkman Ltd*

This picture and 'Cigale II', also painted in 1948, were
Sutherland's first oil paintings of animals. Both have
an heraldic character, and show the cicada perched
side-on in silhouette on a sort of plinth, in a boldly
patterned design. The background in this case is vivid
scarlet and green, and quite unrealistic.

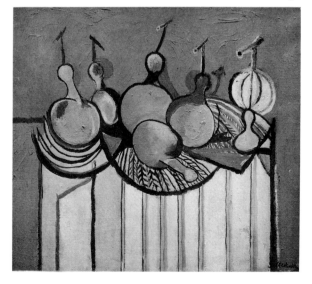

138

138 **Still Life with Gourds** 1948

    Inscribed 'Sutherland 1948' b.r.
    Oil on canvas, $18\frac{1}{2} \times 21\frac{3}{4}$ (47 × 55.3)
    First exh: *Graham Sutherland Paintings*,
    Hanover Gallery, London, June–July 1948 (8)
    Repr: Melville, pl.46 in colour; Cooper, pl.96b;
    Arcangeli, pl.72 in colour
    *Richard S. Zeisler*

One of the very few still lifes of a traditional kind, with
objects arranged on a table.

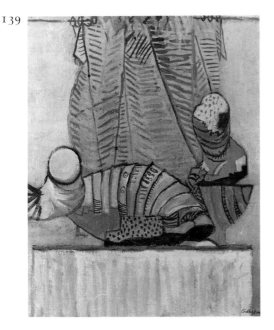

139

### 139 Articulated Form 1949

Inscribed 'Sutherland' b.r.
Oil on canvas, $20\frac{7}{8} \times 17\frac{1}{8}$ ($53 \times 43.5$)
First exh: *Graham Sutherland: Mostra Antologica*,
Galleria Bergamini, Milan, February–March
1981 (44, repr.), misdated 1951
*Private collection*

While staying in 1949 in a house in St-Jean-Cap-
Ferrat which had a little beach outside the garden,
Sutherland kept finding things on the beach, 'things
which were organic in the same way that my earlier
trees were organic, and which appeared to be figura-
tive in a sense' (*The Listener*, LXVIII, 1962, p.133). In
this case the form has been posed on a plinth in front of
a curtain. It was probably soon after painting this that
Sutherland made the first of his 'standing forms'.

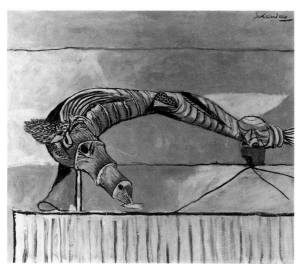

140

### 140 Turning Form 1949

Inscribed 'Sutherland 1949' t.r.
Oil on canvas, $18\frac{3}{8} \times 22$ ($46.8 \times 55.8$)
*Private collection*

Here a maize or root form has given Sutherland the
idea of a living creature with legs and a long snout.
The 'found objects' he picked up in the South of
France, on the beach and elsewhere, had by now
started sometimes to take on a more imaginative,
metamorphic character, like those in his earlier
works.

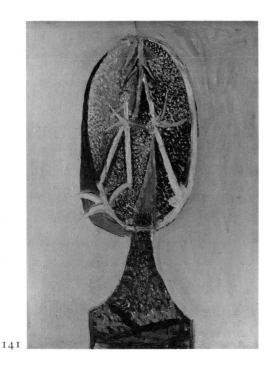

141

### 141 Thorn Head 1949

Inscribed 'Sutherland 1949' b.r.
Oil on canvas, $22\frac{7}{8} \times 16$ ($60.7 \times 40.6$)
First exh: *Matthew Smith, W.A. Oepts, French
and English Paintings*, Redfern Gallery, London,
March–April 1950 (129)
Repr: *The Artist*, XXXIX, 1950, p.142; Cooper,
pl.111a
*Scottish National Gallery of Modern Art,
Edinburgh*

Also known as 'Thorn Head: Green Background'. The
thorn head has become a compact, free-standing
object like a sculpture.

### *142 Standing Form against a Hedge 1950

Inscribed 'Sutherland 50' b.r.
Oil on canvas, $53 \times 46$ ($134.6 \times 116.8$)
First exh: *Graham Sutherland Recent Paintings*,
Hanover Gallery, London, June–August 1951
(6)
Repr: Herbert Read, *Contemporary British Art*
(Harmondsworth 1951), colour pl.6; Melville,
pl.66; Cooper, pl.VIII in colour
*The Arts Council of Great Britain*

Sutherland started to paint pictures of 'standing
forms' in 1949 partly because of his interest in found
objects, objects which appeared to be figurative in a
sense and which he wanted to place in an environ-
ment, and partly because he was staying in a house at

St-Jean-Cap-Ferrat which had an old garden, with creeper-covered hedges and old walls. He told Andrew Forge (*The Listener*, LXVIII, 1962, p.133):

*They were figures in a way, they were presences anyway, that filled this setting of shadows, and with walls which were cutting off the rest of the view, as it were, so you only saw the sky over the top. It was a sort of cross between a garden statue such as one might see in Italy, or in a château in France, or in an old garden in England, for that matter. It was a thing in a setting; and that was really one of the reasons why those were used in that way. I know they could have been used in other ways, because I was fascinated by the actual growth of the things themselves. But they were, in a way, a half-way house. . . . I hope they were friendly, in the sense that when you see a man standing in a garden – in that curious limbo of sunshine and shadow – you are extremely, delicately, conscious that there is a face there. For a moment, you hardly think there is anyone there. Then you think there is someone there. Then you think that you do recognize the features. But it is this half lost quality which I think tends to make them menacing.*

The form in this particular picture is root-like and partly metallic, with a definite head, torso and legs, and is standing on a pedestal in front of a hedge. It is very strongly modelled, like a piece of sculpture, and is illuminated by the sunlight falling on to it which also throws some parts into shadow. Sutherland had previously made another large picture of a very similar form placed indoors, against a curtain.

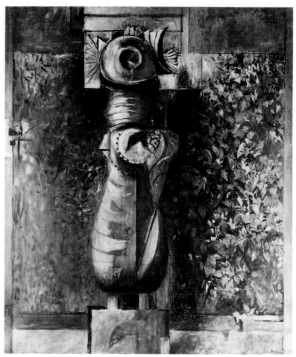

142

*143 **Two Forms in a Terraced Landscape** 1951

> Inscribed 'G. Sutherland 1951' t.l.
> Oil on canvas, 17 × 36⅝ (43 × 93)
> First exh: *Graham Sutherland Recent Paintings*,
> Hanover Gallery, London, June–August 1951
> (16)
> Repr: Cooper, pl.105b
> *Private collection*

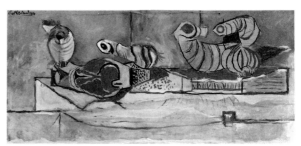

143

One of the most metamorphic of all the South of France pictures, in which root forms become like worms and at the same time take on a strongly erotic, phallic character. The rather strident colour range of yellow, pink, red and green is completely unrealistic.

144 **Horizontal Form in Grasses** 1951

> Inscribed 'Sutherland 51' t.l.
> Oil and cotton wool on canvas, 20⅛ × 36⅛
> (51 × 92)
> First exh: *Graham Sutherland Recent Paintings*,
> Hanover Gallery, London, June–August 1951
> (13)
> Repr: Cooper, pl.105c; Arcangeli, pl.90
> *Peter Meyer*

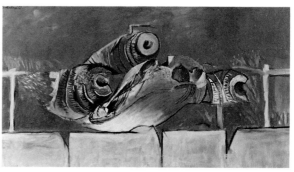

144

Sutherland told the owner that the background (wall, fence and grass) was a derelict corner of Nice racecourse, which struck him as a total contrast to the rest of the course. In painting parts of the form itself he incorporated a little cotton wool to give texture.

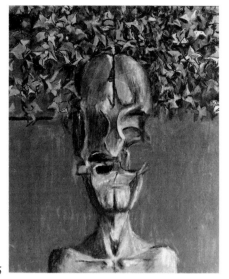

145

### 145 Head II 1951

Inscribed '58 / HEAD (1951) / II / (oil)' on back of canvas
Oil on canvas, 24 × 20 (61 × 50.8)
First exh: *Graham Sutherland*, Musée National d'Art Moderne, Paris, November–December 1952 (58)
Repr: Sackville-West, 1955, pl.27; Cooper, pl.117d
*Private collection*

Also sometimes known as 'Head against Bougainvillea'. The first version, in which the skull-like head and the foliage are both more precise in shape, and the head is somewhat broader, was first exhibited at the Hanover Gallery in June–August 1951 and is now in the National Gallery of Canada in Ottawa.

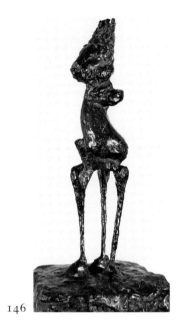

146

### 146 Standing Figure 1952

Not inscribed
Bronze, height 16 (40.5) on wooden base
Lit: Cooper, p.47, repr. fig.8 as 'Standing Figure' 1952
*Private collection*

The sculptural character of his 'standing forms' led Sutherland to make some actual experiments with sculptures at the same period, modelling in plaster forms similar to those in his paintings. According to Douglas Cooper, he made altogether about six sculptures in 1950–4, all of which were eventually destroyed except this one (which was cast in bronze in 1959 in an edition of three for Marlborough Fine Art). The plaster appears in a photograph by Felix Man taken at Villefranche in 1952 (Man, *Eight European Artists*, London–Melbourne–Toronto 1954, n.p.). However in fact one other sculpture (No.151) of this period has also survived.

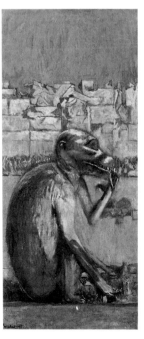

147

### 147 Cynocéphale I 1952

Inscribed 'Sutherland 1952.' b.l.
Oil on canvas, $52\frac{1}{8} \times 23\frac{5}{8}$ (132.5 × 60)
First exh: XXVI Venice Biennale, June–October 1952 (British Pavilion 63)
Repr: *Art News*, LII, March 1953, p.37; Cooper, pl.124a
*Hirshhorn Museum and Sculpture Garden, Smithsonian Institution, Washington*

*Cynocéphale* is the French name for a dog-faced baboon. Sutherland told Paul Nicholls that this picture and a second, more colourful version of the same year stemmed from the fact that he knew an old violinist in the South of France who had a pet monkey, and they were also influenced to some extent by his interest in Egyptian art.

**\*148  Three Standing Forms in a Garden II  1952**

> Inscribed '3 STANDING FORMS / IN A GARDEN
> (II) / 1952 (OIL)' on back of canvas
> Oil on canvas, $52\frac{3}{8} \times 45\frac{3}{8}$ (133 × 116)
> First exh: *Graham Sutherland*, Musée National
> d'Art Moderne, Paris, November–December
> 1952 (56)
> Lit: Andrew Révai, *Graham Sutherland*
> (Paulton 1966), p.7, repr. p.7 and pl.VII in
> colour; Hayes, p.30, repr. pl.89 (wrongly
> dated 1951)
> Repr: Sackville-West, 1955, pl.30; Cooper,
> pl.121
> *Private collection*

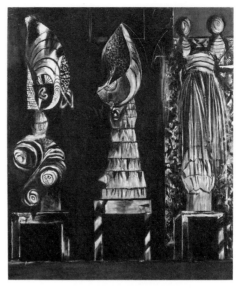

148

The first version of this composition, painted in 1951,
is now in the Minneapolis Institute of Arts, and there is
also a third, slightly smaller version, which is much
more colourful.

According to Andrew Révai, these works were
painted from sketches done in the South of France
from roots, tree-forms and hanging maize. As he said:
'The trellis on the right, with its elements of a
naturalistic landscape, enhances the awe-inspiring
quality of these three "presences".' The forms are
lined up in a row and each one is placed on a definite
pedestal.

**149  Standing Forms II  1952**

> Inscribed 'STANDING FORMS / 1952 / (II) / OIL'
> on back of canvas
> Oil on canvas, $70\frac{7}{8} \times 55\frac{1}{2}$ (180 × 141)
> First exh: *Graham Sutherland*, Musée National
> d'Art Moderne, Paris, November–December
> 1952 (64, earlier version repr.)
> Repr: Arcangeli, pl.94 in colour
> *Tate Gallery*

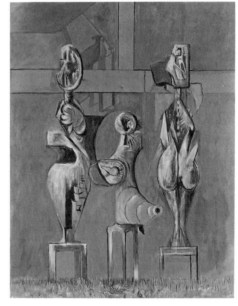

149

Here the forms are tuberous, with some suggestion of
the naked human figure. The form on the right
particularly resembles a human body, with skull-like
head, shoulders, backbone and buttocks. There is
grass growing at the bottom, and some object not
visible in the picture throws weird shadows on to the
background. The colours are a strange combination of
sulphur yellow and purple.

Commenting on the element of ambiguity in his
own work, Sutherland declared:

*People have said that my most typical images express a*
*dark and pessimistic outlook. That is outside my feeling*
*. . . the precarious tension of opposites – happiness and*
*unhappiness, beauty and ugliness, so near the point of*
*balance – are capable of being interpreted according to the*
*predilections and needs of the beholder – with*
*enthusiasm and delight, or abhorrence, as with the taste*
*of bitter-sweet fruit* [*The Listener*, XLVI, 1951, p.378].

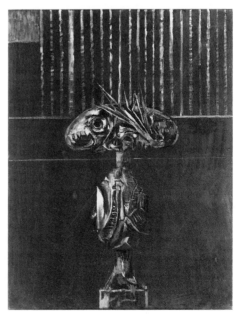

150

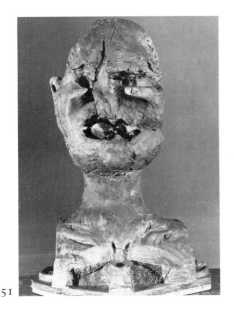

151

152

### 150 Head III 1953

Inscribed 'TATE / HEAD III / 1953' on back of canvas
Oil on canvas, 45 × 34¾ (114 × 88.5)
First exh: *Paintings and Drawings by Graham Sutherland*, Tate Gallery, May–August 1953 (*77*)
Repr: Sackville-West, 1955, pl. 31; Cooper, pl. 127; Arcangeli, pl. 98 in colour
*Tate Gallery*

Though the emphasis is on the enormous flattened head, this creature or 'presence' also has a rudimentary neck, body and legs, and is standing on a plinth. The scaly forms suggest those of an insect or crustacean. Its frontality and the way it fixes one with a penetrating gaze may indicate some influence of Giacometti, whose work Sutherland admired. The forms are treated as though lit from the left and are subtly modelled by light and shade. Instead of crude, flat areas of colour, the paint is applied with brush-strokes of considerable delicacy.

### 151 Grotesque 1954

Not inscribed
Painted plaster, height 20⅝ (52.5)
First exh: *Graham Sutherland*, Haus der Kunst, Munich, March–May 1967 (not in catalogue)
*Private collection*

This seems to have been one of the last of Sutherland's early sculptures, as it appears in an unfinished state in photographs of Sutherland's studio in the South of France taken in 1954 (for instance, in the photograph reproduced as frontispiece to the monograph by Douglas Cooper). It can be compared to the skull-and-shoulders-like form in 'Head I' and 'Head II' of 1951.

### 152 Thorn Tree 1954

Inscribed 'SUTHERLAND 1954' b.l.
Oil on canvas, 53 × 24 (134.6 × 61)
First exh: *Britisk Kunst 1900–1955*, Kunstforeningen, Copenhagen, April 1956 (*90*)
Lit: Cooper, p. 48, repr. pl. 140; Andrew Révai, *Graham Sutherland* (Paulton 1966), p. 8, repr. p. 8 and pl. x in colour; Hayes, pp. 37, 48, 132
Repr: Arcangeli, pl. 104 in colour
*Private collection*

Sutherland has described (in a manuscript note in the Tate Archives) how his interest in the thorn tree theme revived in the spring of 1954 when he went for a walk on a high mountain behind Monte Carlo and overlooking Peille. On a plateau in a declivity in the ground he found very tightly compact miniature bushes growing close to the ground. He started to make drawings, some in a vague cross form, and these led to this painting and one now in the Galerie des 20. Jahrhunderts in West Berlin, in which structure was his first concern.

In both these pictures there is a compact tangle of barbed twigs forming a definite cross. The Berlin

painting is wider in format, with an extensive cross-bar. Both show the thorn tree against a beautiful blue background, contrasting the symbol of anguish with a lyrical beauty.

### 153 Hydrant II 1954

Inscribed 'HYDRANT II Oil / 1954 /
G. Sutherland' on back of canvas
Oil on canvas, 44 × 35⅜ (111.8 × 90.5)
First exh: *Graham Sutherland: Gemälde und
Zeichnungen*, Haus am Waldsee, Berlin,
September–October 1954 (56)
Lit: Cooper, p.48, repr. pl.136
*Tate Gallery*

Sutherland's interest in machines was due in part to his early training as an engineer, but also, even more, to his interest in the correspondence between machine and mechanical forms and natural forms. Already during the war, when he painted factory subjects and started looking at machinery again, he had begun to see a curious similarity between machine forms and natural forms; then in the 1950s and early 1960s he made a small number of works like this, with a combination of machine and animal and vegetable forms. As he told Edwin Mullins: 'You know, the mechanical principle of intake and evacuation has a strange parallel to the human state, and to the tree state' (*Daily Telegraph Magazine*, 3 November 1967, p.28).

When asked on another occasion about the influence of his Catholicism on his work, he explained:

*The Church objectifies the mysterious and the unknown. It gave my aspirations towards certain ends a more clearly defined direction than I could ever have found alone. It gave me a conception of a system whereby all things created, human and otherwise, down to the smallest atom – and its constituents – are integrated. It widened and superseded my vague pantheism.*

(Robert Melville, 'A Meeting with Graham Sutherland' in *World Review*, December 1949, p.63).

### 154 Cypress Cones 1956

Inscribed 'Sutherland. 1956'. b.r.
Oil on canvas, 40 × 30 (101.5 × 76.2)
First exh: *La Peinture Britannique Contemporaine*,
Salle Balzac, Paris, October 1957 (90)
Repr: *Art News*, LV, October 1956, p.56; Cooper,
pl.146
*Mr and Mrs I. Bloomfield*

### 155 Still Life with Apples and Scales 1957

Inscribed 'GS 20.V.57' b.r. and 'STILL LIFE
WITH APPLES / & SCALES / 20.V.57' on back of
canvas
Oil on canvas, 25½ × 21½ (64.8 × 54.5)
First exh: *Five English Painters*, Arthur Jeffress
(Pictures), London, July–August 1957 (22)
Lit: Cooper, p.48, repr. pl.148
Repr: *Architectural Review*, CXXII, 1957, p.270
*Crane Kalman Gallery*

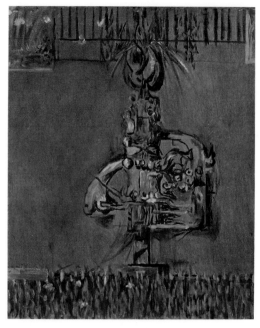

153

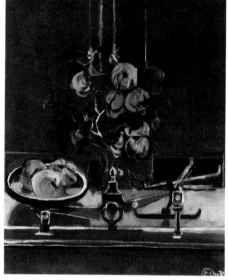

155

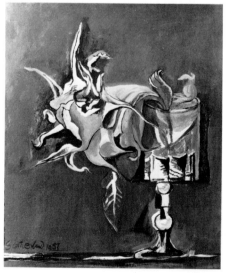

156

In 1955 Sutherland had painted several pictures of branches of apple trees laden with fruit, and this theme is combined here with that of a pair of scales in sunlight, with strong shadows (a theme which he developed further in two large pictures of scales, without apples, in 1959 and 1961). As Douglas Cooper has pointed out, an interest in equilibrium and a rotating or pendulum movement was one of the new features of this period.

Sutherland had begun by now in some of his pictures to depict nature in a much more straightforward, realistic way.

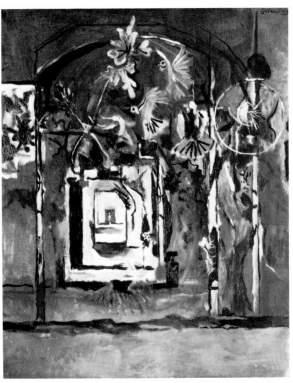

157

### 156 Datura Flowers in Glass 1957

Inscribed 'Sutherland 1957' b.l.
Oil on canvas, $18 \times 15\frac{1}{2}$ ($46 \times 39.5$)
First exh: *Graham Sutherland*, Galatea-Galleria d'Arte Contemporanea, Turin, January–February 1963 (13)
Repr: *Sunday Times Colour Section*, 18 March 1962, p.18 in colour
*Galleria Bergamini, Milan*

The large trumpet-shaped flowers of the datura, which grew in his garden at Menton, close to the Villa Blanche, greatly appealed to Sutherland, who drew and painted them a number of times. This picture originally belonged to Somerset Maugham.

### *157 Path in Wood No.3 1958

Inscribed 'Sutherland. 1958' t.r.
Oil on canvas, $39\frac{1}{4} \times 31\frac{3}{4}$ ($99.7 \times 80.5$)
First exh: *Recent Paintings by Graham Sutherland*, Paul Rosenberg, New York, November–December 1959 (9, repr.)
Lit: Cooper, p.42 and footnote
*Private collection*

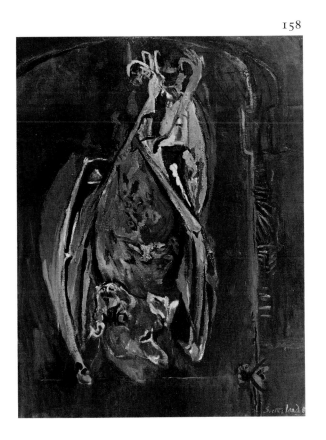

158

This is perhaps the finest of several paintings of this theme, a view down a shadowy pergola towards a lighted distance with a far-off figure, and birds flitting about the trees in the foreground. The depth is suggested mainly through the stage-by-stage diminution of the trellis-work and by the colour modulations. Sutherland told Douglas Cooper about 1959 that he had begun since 1954 to have a much better understanding of Cézanne's work, 'and I find myself drawing closer to his fragmentary analyses in recent subjects such as certain "Wood Interiors"'. No doubt this was helped by direct contact with the landscape of Provence which Cézanne had painted.

### 158 The Bat 1958–9

Inscribed 'Sutherland 58.' b.r.
Oil on canvas, $39\frac{1}{4} \times 32$ ($99.5 \times 81.5$)
First exh: *Recent Paintings by Graham Sutherland*, Paul Rosenberg, New York, November–December 1959 (12), dated 1958–9
*Private collection*

In the later 1950s Sutherland began progressively to extend the range of his animal themes, and painted several pictures of bats and toads, as well as a heron (No.160) and an eagle. The bat is seen here hanging upside-down. Sutherland made his studies of bats in the natural history museum at Nice.

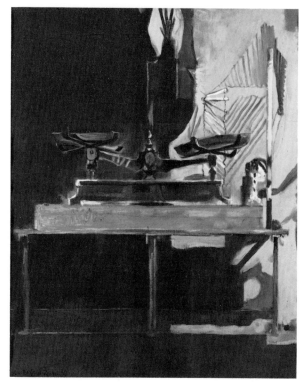

**\*159 The Scales** 1959

> Inscribed 'Sutherland 20.VI.59' b.l.
> Oil on canvas, 50 × 40 (127 × 101.5)
> First exh: *Recent Paintings by Graham Sutherland*, Paul Rosenberg, New York, November–December 1959 (15, repr.)
> Repr: Cooper, pl.154; Arcangeli, pl.116 in colour
> *Marlborough Fine Art (London) Ltd*

There are several snapshots of this old pair of kitchen scales posed in the sunlight outside Sutherland's house at Menton, with other objects carefully grouped around it so as to produce strange shadows on the wall behind. Two show the scales placed like this on a stone slab (possibly a lithographic stone) resting on a metal base, with a small, narrow, upright window in the centre and a kind of screen supported on two bamboo legs which casts shadows in stripes. This is a rare instance of Sutherland elaborately setting up an arrangement of still-life objects to paint from, or at any rate as a starting point for his work.

159

160

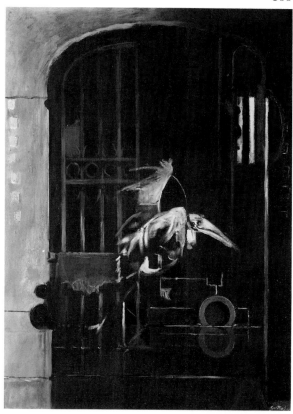

**\*160 Dark Entrance** 1959

> Inscribed 'Sutherland' b.r.
> Oil on canvas, 52 × 38½ (132 × 97.8)
> First exh: *Recent Paintings by Graham Sutherland*, Paul Rosenberg, New York, November–December 1959 (14, repr.)
> Lit: Editorial, 'The Pleasant Place of All Festivity' in *Apollo*, XCIV, 1971, pp.174–5 (a very similar later version of 1961 repr. p.175 in colour)
> Repr: *Art News*, LVIII, December 1959, p.17; Cooper, pl.153; René Huyghe, Jean Rudel, *L'Art et le Monde Moderne* (Paris 1970), Vol.2, p.311 in colour
> *The Phillips Collection, Washington*

One of a relatively small number of paintings inspired by Venice, which Sutherland visited for the first time in 1950 and where he returned for two or three weeks or so almost every summer for the rest of his life. In 1957 and 1958 he even painted two rather Sickert-like and extremely uncharacteristic views of Santa Maria della Salute and San Marco by night.

Here a heron is seen by a water-gate, the entrance to an abandoned shed for gondolas. His treatment of animal themes has become much more realistic, and he has begun to place the animals in lifelike settings.

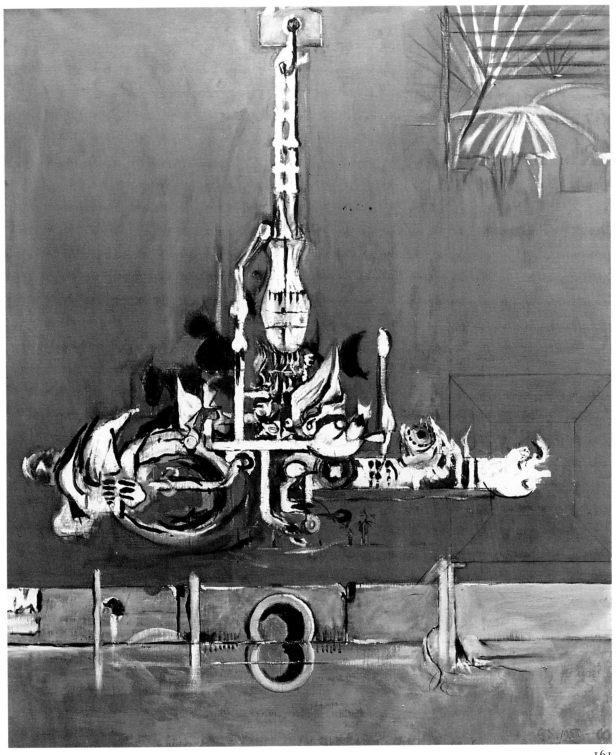

161

**161 Hanging Form over Water** 1959–60

Inscribed 'G.S. 1959–60' b.r.
Oil on canvas, 65 × 55 (165.1 × 139.6)
First exh: *Masters of Modern Art*, Marlborough
Fine Art, London, June–August 1960 (86,
repr.)
Repr: *Burlington Magazine*, CVII, 1965, p.51
*Southampton Art Gallery*

The hanging form theme dates from 1955 and grew
out of the late 'standing form' pictures, but with the
form suspended from the top instead of standing, and
usually depicted over water, with reflections.

This picture is one of the works by Sutherland
which Arthur Jeffress bequeathed to the Southampton
Art Gallery, together with his portrait.

# Large Mural Commissions:
# 'The Origins of the Land' and the Coventry Tapestry

This room is devoted mainly to Sutherland's two largest mural commissions: the painting 'The Origins of the Land', commissioned in 1950 for the Land of Britain pavilion at the Festival of Britain, and the vast tapestry (far too large to be shown here and in any case impossible to borrow) of 'Christ in Glory in the Tetramorph' commissioned in 1952 for the new Coventry Cathedral designed by Sir Basil Spence and installed in 1962. The studies illustrate the principal stages in the development of these two projects and also, it is hoped, provide insight into Sutherland's method of working.

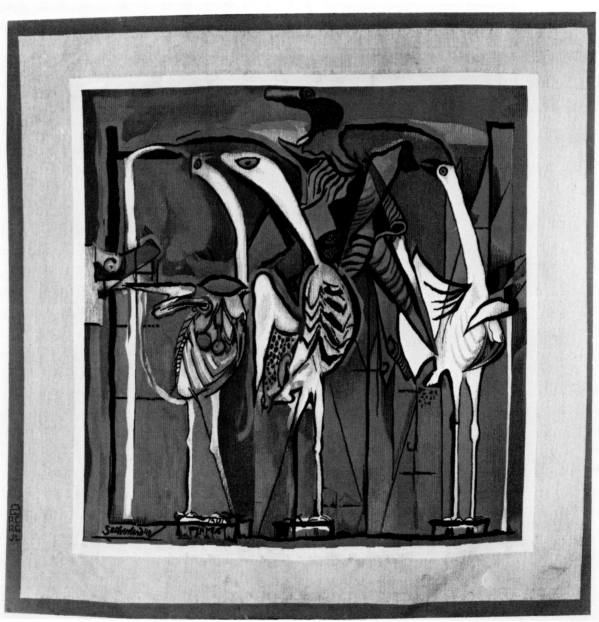

162

**162  Wading Birds** 1949

> Inscribed 'Sutherland 1949' within the design
> b.l., and 'RC / RG / JL [with monogram]' in the
> border b.l.
> Tapestry, 78 × 78 (198 × 198)
> First exh: *Recent Tapestries by the Edinburgh
> Tapestry Company*, Arts Council touring
> exhibition, 1950 (5)
> Lit: R.M. (Melville), 'Contemporary British
> Tapestry' in *The Ambassador*, No.7, July 1949,
> pp.128–9, a preliminary gouache repr. p.127;
> exh. catalogue *Master Weavers: Tapestry from
> the Dovecot Studios 1912–1980*, Edinburgh
> International Festival exhibition, August–
> September 1980, pp.60 and 138, repr. p.60
> Repr: *Architectural Review*, CVII, 1950, p.212;
> Arcangeli, pl.82; Hayes, fig.13
> *Vancouver Art Gallery*

In 1949 the Edinburgh Tapestry Company wove the
first two tapestries from Sutherland's designs: this one
and a tapestry-carpet which was bought by the
collector Wilfred Evill. Under Sir Francis Rose, who
had recently been appointed artistic adviser, the
company had embarked on an adventurous policy of
approaching well-known British artists whose easel
works had pronounced decorative qualities, and
asking if they were prepared to contribute designs for a
nominal fee. Sutherland submitted several designs in
gouache for them to work from.

The tapestry, which is unique, was woven by
Ronald Cruikshank, Richard Gordon and John Loutitt,
whose initials appear in the left-hand border, together
with the dovecot symbol which is the emblem of the
company. The colours are predominantly mustard
yellow and purple, but at this period of post-war
shortage there was a deliberate policy of limited colour
palettes which did not include purple wool. This
colour was therefore produced by a mixture of red and
blue threads.

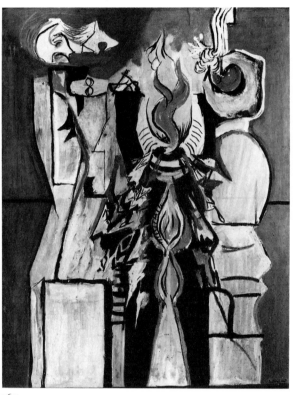

163

**163  Study for 'The Origins of the Land'** 1950

> Inscribed 'Sutherland' b.r.
> Gouache on paper, $29\frac{3}{4} \times 19\frac{1}{4}$ (75.7 × 49)
> Repr: Exh. catalogue *Graham Sutherland:
> Mostra Antologica*, Galleria Bergamini, Milan,
> February–March 1981 (on cover in colour,
> but not exhibited)
> *Private collection*

The organisers of the Festival of Britain exhibition, to
be held on the South Bank from 4 May to 30 September
1951, wrote to Sutherland on 6 April 1950 inviting
him to paint a mural for the Land of Britain pavilion,
and to submit sketch designs to half or quarter scale by
the beginning of May. After Sutherland had asked for
and obtained an extra month to prepare his designs,
the contract was signed on 25 April. However in the
end, partly owing to illness, the designs were not
delivered until 12 July. In the meantime, Sutherland
had made a large number of studies, mostly in gou-
ache, trying out different themes and gradually work-
ing out the composition. An exhibition (not fully

complete) of studies for the picture, held at the Redfern Gallery in 1952, included no less than eight studies classified as large size, fourteen as medium size and thirty-one as small size.

The Land of Britain, the first pavilion visitors were meant to see on entering the exhibition, was devoted to the themes of the forces of nature; past climates and conditions; the earth in labour; episodes from the past; the last 60 million years; and Britain's mineral wealth and scenery. Sutherland's mural was intended to set the mood for the pavilion.

In this fairly early study, with a red background, the theme is volcanic activity and the bursting of hot lava through the earth's crust.

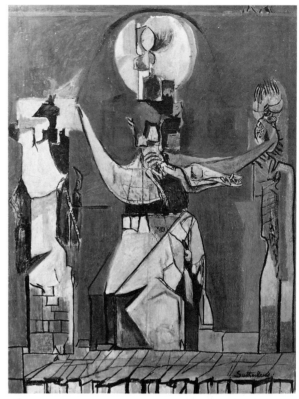

164

**164 Study for 'The Origins of the Land' 1950**

> Inscribed 'Sutherland.' b.r.
> Gouache on paper mounted on canvas,
> 39 × 30¼ (99 × 77)
> *Private collection*

A monumental variant, with three pillars of rock; a pterodactyl is taking flight from the one in the centre, while primitive plant forms sprout from the top of the one on the right.

**165 Pterodactyl: Study for 'The Origins of the Land' 1950**

> Inscribed 'Sutherland. 51.' t.r.
> Gouache and crayon on paper,
> 13¼ × 29¾ (33.7 × 75.6)
> First exh: *Graham Sutherland: Ideas and Studies for the Festival Painting 'The Origins of the Land'*, Redfern Gallery, London, November – December 1952 (number uncertain)
> Lit: Cooper, p.45, repr. pl.112b
> *Marlborough Fine Art (London) Ltd*

165

The pterodactyl was included to evoke bird life and the distant past, and Sutherland found the model for it in a natural history museum. The date 1951 seems to have been added some years later and is probably incorrect.

**166 Study for 'The Origins of the Land' 1950**

> Not inscribed
> Pencil, gouache, wax crayon and coloured pencil on paper, 27¾ × 18⅞ (70.5 × 48)
> First exh: *Graham Sutherland: Ideas and Studies for the Festival Painting 'The Origins of the Land'*, Redfern Gallery, London, November – December 1952 (303)
> *The British Council*

A study which marks a significantly later stage, with a row of 'standing forms' in the lower section and the pterodactyl at the top, and a change from a reddish palette to yellow. The two middle 'standing forms' both appear in the final composition, but the other two are replaced or eliminated. (However the right-hand one later inspired a large major painting, 'Standing Form' of 1952.) The rock shapes at the extreme top are already fairly close to those in the final picture.

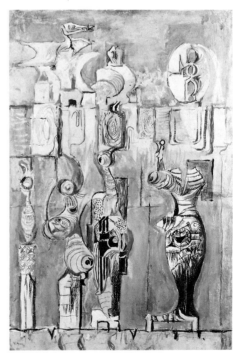

166

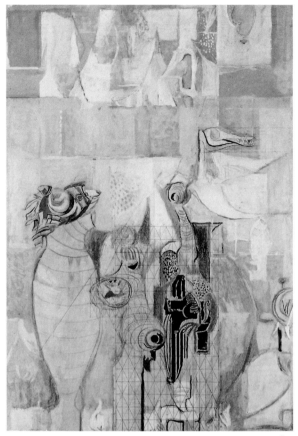

167

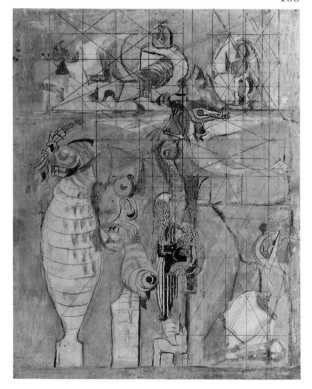

168

**167  Study for 'The Origins of the Land'  1950**

Not inscribed
Gouache, pencil and crayon on board,
$49\frac{1}{2} \times 34$ ($125.7 \times 86.4$)
First exh: *Picture of the Month*, Whitechapel Art
Gallery, London, September 1974
*Private collection*

This is the largest of the studies for 'The Origins of the
Land', a quarter the size of the final painting in its
original form, and is thought to be the sketch design
which Sutherland delivered to the Festival of Britain
Office on 12 July 1950; it was in any case the study
from which the picture was painted. Photographs of
the big picture in course of execution (Cooper,
pls.113c and d) show that the upper part was origin-
ally similar to this, though Sutherland later decided to
cut off part of the canvas at the top and on the right-
hand side, and change these sections of the com-
position. In the course of working out his new design
he appears to have repainted parts of this study and
obliterated certain areas.

**168  Study for 'The Origins of the Land'  1951**

Inscribed 'to my friends K & Jane / with
affection aug.19 1951' b.l.
Pencil, ink, crayon, gouache and oil on paper,
$25 \times 19\frac{7}{8}$ ($63.5 \times 50.6$)
First exh: *Graham Sutherland: Ideas and Studies
for the Festival Painting 'The Origins of the Land'*,
Redfern Gallery, London, November –
December 1952 (308)
Repr: Cooper, pl.114a
*Tate Gallery*

Since this study shows the composition in its final
form, it would appear to have been executed while the
large picture was being painted, as the final working
out of the design. The upper part and the right-hand
side, where the changes were made, are heavily
squared up for enlargement.

**\*169  The Origins of the Land  1951**

Not inscribed
Oil on canvas, $167\frac{1}{2} \times 129$ ($426 \times 328$)
First exh: *Festival of Britain Exhibition*, South
Bank, London, May – September 1951 (works
not numbered)
Lit: Cooper, pp.44 – 6, repr. pl.115 (pls.113c
and d show earlier stages of it in course of
execution)
Repr: *Studio*, CXLVI, 1953, p.51; Arcangeli,
pl.78 in colour; Hayes, pl.94 in colour
*Tate Gallery*

This, the large final picture, was painted at the Tate
Gallery, in a room in the basement which had served
at one time as Sir Edward Poynter's studio, when
Poynter was Director of the National Gallery. The
enlargement was carried out with the help of an
assistant. As already explained, Sutherland made
various alterations in the course of its execution and
reduced the canvas at the top and on the right, and

changed these parts of the composition. The painting was begun after Sutherland's return from a visit to France in January 1951 and finished in mid-March.

Concerning the subject matter, Sutherland told the Tate in a letter of 17 November 1957:

*As to the ideas I had when painting the picture, broadly speaking the picture is divided as if in sections through the crust of the earth. You will notice the layers one on top of the other. It is as if you were looking at a cliff face. In the foreground the forms (and this is a very generalized statement) represent the principles of organic growth, the pterodactyl is a hint of pre-history, while the rocks at the top of the cliff are intended to represent the action of water and wind on the earth's surface. There are some flames at the extreme base and they naturally represent a sort of symbolism of the heat of the interior of the earth.*

The rock formations at the top were derived from stones which Sutherland had found in a dry river-bed at Tourrette-sur-Loup, and the large 'standing form' at the bottom left was adapted from one in the painting 'Two Standing Forms against a Palisade' of 1949, of which the gouache No.249 is a later version.

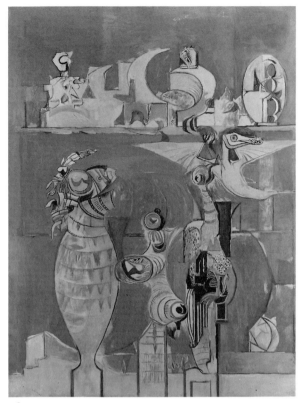

169

## 170  Christ in Glory with Two Emblems  1953

Not inscribed
Gouache on paper on board,
$24\frac{1}{2} \times 22$ (62.2 × 55.8)
First exh: *Sutherland: Christ in Glory in the Tetramorph*, Redfern Gallery, London, May – June 1964 (3)
Lit: Révai, pp.29 – 30, 99, repr. pl.2
*Civic Arts Trust, Herbert Art Gallery, Coventry*

In 1950 an architectural competition was initiated for the design of a new cathedral for Coventry to replace the old Gothic cathedral which had been destroyed by German bombs in November 1940. The results of the competition were announced in August 1951 and the architect chosen was Basil (later Sir Basil) Spence. His project included a huge tapestry to hang on the wall behind the altar, a tapestry which would be the largest in the world and which could be designed by a great contemporary artist. In fact he had in mind from the beginning that it should be designed by Sutherland, whose tapestry of 'Wading Birds' he had seen and admired (and later owned for some time), and whose 'Crucifixion' at Northampton had moved him greatly.

Sutherland was asked in November 1951 if he would accept the commission and agreed in the following January. He was told that the subject was to be Christ in Glory in the Tetramorph, illustrating Chapter IV, verses 2, 3, 6 and 7 of the Book of Revelation, and that the tapestry must be theologically sound.

He spent the first year pondering the theme and studying the various ways it had been treated in the past, particularly during the Romanesque and Byzantine periods. He wanted to produce a design which would be basically in the Romanesque tradition but which would be rethought in modern terms, so that the forms would have the quality of life and

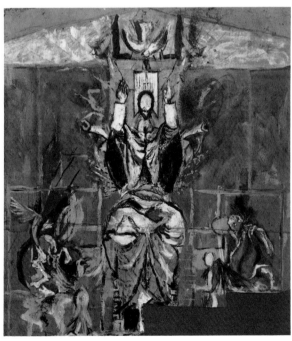

170

immediacy. Then in 1953 he began making a large number of drawings 'without very much purpose, to clear the ground'. At this stage he was still not certain what kind of figure he wanted.

This early study shows the arms raised. Right from the beginning Sutherland was playing with the possibilities of three alternative poses: with the arms raised, horizontal or lowered. This composition has no mandorla and contains only two of the four emblems of the Evangelists.

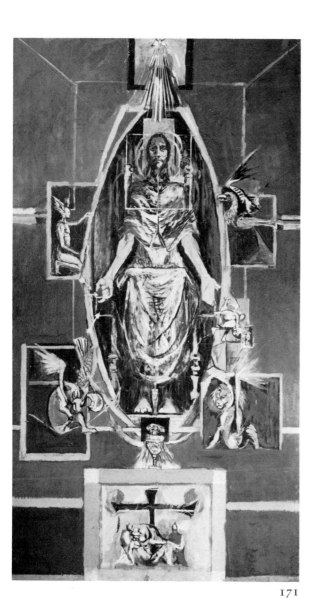

171

### 171 The First Cartoon 1953

Not inscribed
Oil on gouache on board,
$79\frac{1}{2} \times 43\frac{1}{2}$ (201.9 × 110.5)
First exh: *Graham Sutherland*, Marlborough Fine Art, London, June 1962 (not listed in catalogue, repr.)
Lit: Révai, pp.32–5, 49, 68–9, 74–5, 86, repr. in colour as frontispiece
Repr: *Studio*, CLXVII, 1964, p.202 in colour; Hayes, pl.114
*Civic Arts Trust, Herbert Art Gallery, Coventry*

After experimenting with a number of different treatments, and trying out miniature designs now and then in a model of the cathedral to see what the scale looked like, Sutherland decided that the time had come to make some positive statement and painted this cartoon. The figure itself was done fairly quickly, but there was a good deal of alteration in the surrounding panels. The Bishop of Coventry, the Provost and other representatives of the Reconstruction Committee came with the architect to inspect it at Sutherland's house on 30 December 1953, expressed their approval and invited him to continue.

This design shows the seated figure of Christ surrounded by a mandorla. His arms are extended downwards, showing off the wounds in the hands, and there is a standing figure of a man between his feet (an innovation of Sutherland's which he derived from Egyptian sculpture). Rays of light entering from above symbolise the Holy Ghost, while the four panels with the Emblems of the Evangelists are Man (the Emblem of St Matthew, top left), the Eagle (the Emblem of St John, top right), the Calf (the Emblem of St Luke, bottom left) and the Lion (the Emblem of St Mark, bottom right). A further small panel on the right, showing St Michael fighting the dragon, 'who is called the devil and Satan' (Book of Revelation), was included because the cathedral is dedicated to St Michael. Below the feet is a chalice with a dragon, and finally, at the bottom, a panel depicting the Pietà. As the original intention was to finish the interior in pinky-grey stone, the background is in a series of dullish green tones, rather like old velvet: a muted colour scheme with the figures looming out of a comparatively dark ground.

However, soon after submitting this cartoon, Sutherland began to feel that the pose with the arms extended downwards was too sentimental.

**172  Study for the Whole Tapestry** 1954

Not inscribed
Gouache on paper, 46¾ × 25½ (118.7 × 64.8)
First exh: *Graham Sutherland*, Marlborough
Fine Art, London, June 1962 (not listed in
catalogue)
Lit: Révai, p.100, repr. pl.5
*H.R.H. The Prince Philip, Duke of Edinburgh*

A study made shortly before the second cartoon, to try
out a different pose with the hands folded in the lap.
There is still a Pietà at the bottom, but with the
Annunciation on the left and the Visitation on the
right. A dove at the top symbolises the Holy Ghost. The
position of the emblems is different from that in the
final version.

**173  The Second Cartoon** 1954–5

Not inscribed
Oil, gouache and collage on board,
79½ × 43½ (201.9 × 110.5)
First exh: *Sutherland: Christ in Glory in the
Tetramorph*, Redfern Gallery, London,
May–June 1964 (67)
Lit: Révai, pp.29, 35, 49, 69, 86, 100–1, repr.
pl.7 (the illustration omits the lower section)
Repr: Hayes, pl.115 (without the lower section)
*Civic Arts Trust, Herbert Art Gallery, Coventry*

While staying at Roquebrune in January 1954,
Sutherland started to do another version with the
arms horizontal. Then, after an interval, he began to
make a cartoon based on this version. He took this to
Coventry together with the original version which
they had already seen, and appeared before the Re-
construction Committee on 12 January 1955 at a first
meeting, showing the two cartoons side by side and
asking them to choose between them. They preferred
this second one (which was the one Sutherland him-
self also favoured), but made one or two suggestions.

In this version the mandorla has been omitted and
the sleeves have been enlarged like priest's vestments
to fill the space created by the raised arms. Instead of
the Pietà, there was originally a triptych at the
bottom, with a Madonna and Child in the centre and
two side panels of the Annunciation and the Visitation,
but Sutherland was not happy with this solution and
subsequently painted out these scenes and substituted
a single panel of the Crucifixion in the centre, much as
in the final design.

**174  Christ Seated** 1954–5

Inscribed 'G.S. 1954–5.' b.r.
Oil on board, 55½ × 20 (141 × 50.8)
First exh: *Graham Sutherland*, Belfast Museum
and Art Gallery, November–December 1959
(26)
Lit: Révai, pp.30, 102, repr. pl.15
*Herbert Art Gallery, Coventry*

An early finished painting showing Christ wearing
classical drapery like winding sheets, and with his feet
crossed – features which Sutherland subsequently
discarded as being too reminiscent of traditional
representations.

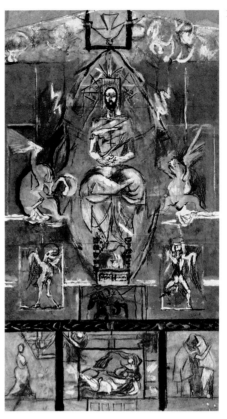

172

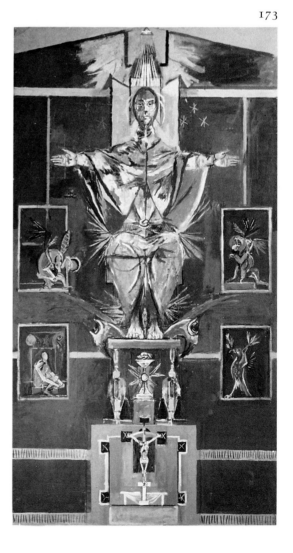

173

174

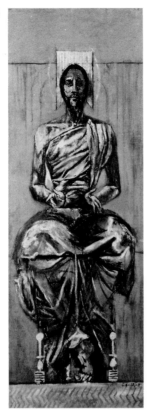

175

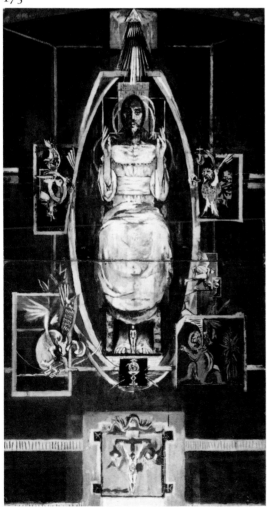

**\*175  The Final Cartoon** 1957–8

Not inscribed
Oil, gouache and collage on board,
79 × 43½ (201.9 × 110.5)
Lit: Cooper, pp.35–6, repr. pl.158 and detail
pl.159; Basil Spence, *Phoenix at Coventry: The
Building of a Cathedral* (London 1962), p.62,
repr. pl.32 in colour, and detail pl.33 in
colour; Révai, pp.69–70, 86–7, 101, repr.
pls.8 and 9
Repr: *The Builder*, CXCIV, 1958, p.577 in colour
*The Provost and Council of Coventry Cathedral*

Sutherland felt that the second cartoon was not the
solution either and that he could do better; so he
started to prepare a third cartoon. He took this with
him to Coventry in September 1957 and showed it to
the Reconstruction Committee, who approved it.
However, as soon as he reached home, he realised that
he disliked the design that had just been approved, and
started not to make another cartoon but to strip this
third one of its inconsistencies and to redraw some of
the panels, such as the St Matthew panel at the top
left-hand corner. The figure and face of Christ were
substantially altered and in many respects simplified.
All this had to be done in a fairly short time because
the authorities were anxious to get the weaving
started and to issue a press release. The final cartoon
(this one, which is the third in its repainted state) was
then sent to France, to the weavers, on 20 February
1958.

The figure of Christ as finally represented is decor-
ative and hieratic and at the same time a figure which
is a palpable presence, influenced both by Byzantine
models and by Egyptian royal figures of the Fourth
and Fifth Dynasties. It is surrounded by a mandorla
to which the boxes containing the four beasts are
attached as though the parts were bound together
with bands of brass, and the lines at the back suggest a
limited space like the end of a room. The figure is
constructed almost geometrically, in a series of ovals
separated by squares culminating in the head. As Basil
Spence had been obliged on the grounds of expense to
abandon his original plan to line the interior of the
cathedral with pinky-grey stone, and substitute a
hard pumice-like plaster of pure white, it was possible
to make the colours stronger and more positive than
in the first versions.

The tapestry was woven by the firm of Pinton Frères
at Felletin, near Aubusson, under the artistic direction
of Mme Marie Cuttoli. At Spence's suggestion, the
cartoons were made less than one-eleventh the size of
the tapestry, both in order to preserve the freshness
of the study and because it would have been so difficult
to make a cartoon the full size of the tapestry itself
(74 ft 8 in × 38 ft). The enlargement was made by
photographing this cartoon in sections and then
blowing up the prints to the scale of the tapestry, so
that the weavers could use the photographs for form
and tone, and the cartoon for colour. But this process
also required Sutherland to do some overpainting on
the enlarged photographs (starting at the bottom and
working upwards) in order to make the drawing more
precise and also to carry out certain small last-minute
modifications.

## 176 Trial Woven Panel of the Eagle 1958–9

Not inscribed
Tapestry, 117 × 78½ (297.2 × 200.4)
Lit: Basil Spence, *Phoenix at Coventry: The Building of a Cathedral* (London 1962), p.62;
Révai, p.87
Repr: Cooper, pl.160
*Lady Spence*

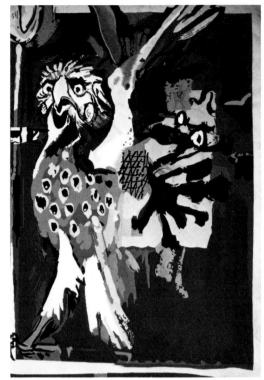

176

Basil Spence wrote that when he and his wife called at Felletin in 1958 to see how M. Pinton was getting on, he told him that he was stuck; the full-size photographs had arrived, but there were many parts that needed Sutherland's decision and guidance and although he had written to him he had received no reply. 'As I was now getting anxious about time, I ordered a trial piece of one of the beasts and told M. Pinton to do the interpretation, using the enlarged photographs for tone and line and the original painting for colour but without Graham's guidance on the spot. This he did, and produced a masterpiece.'

Sutherland and Spence went over to France on 27 February 1959 to inspect this trial panel, executed on the same scale as the final tapestry, and were both delighted with it. The co-operation between the artist and the weavers proceeded smoothly from then on.

177

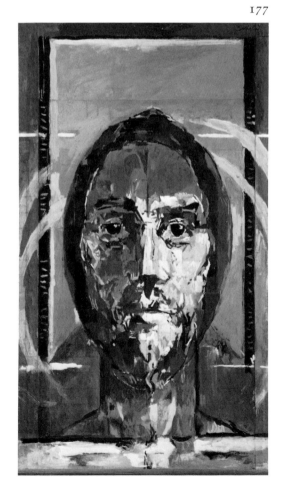

## 177 Head of Christ 1963

Inscribed 'Sutherland. / 15.1.63' t.r.
Gouache on paper mounted on board,
39½ × 23½ (100.3 × 59.7)
First exh: *Graham Sutherland*, Kunsthalle, Basle, February–March 1966 (121)
Lit: Révai, pp.58–9, 104, repr. pl.25
Repr: *Studio*, CLXVII, 1964, p.205; *Illustrated London News*, CCXLVIII, 19 February 1966, p.31
*Private collection*

This picture is almost exactly the same as the head in the tapestry itself, but was executed about a year after the tapestry was completed. Other by-products of the tapestry include oil paintings of the Eagle: Emblem of St John ('Night Bird') and the Emblem of St Matthew, both made in 1958.

Sutherland told Andrew Révai: 'The final head really derived from a hundred different things – photographs of cyclists, close-ups of people, photographs of eyes, Egyptian art, Rembrandt and many others.' However, rather surprisingly, he denied that there was any influence of El Greco.

# The Portraits: 1949 Onwards

From 1949, when Sutherland painted his first portrait, portrait painting became an important part of his work. His first portraits, such as those of Somerset Maugham, Edward Sackville-West, Helena Rubinstein and the ill-fated one of Sir Winston Churchill, became widely famous and were usually either of friends or of distinguished elderly sitters with very strong personalities and well-marked features. From the late 1950s, however, he began to accept a wider range of commissions. Most of the later portraits remained unknown until the exhibition of his portraits at the National Portrait Gallery in 1977, and two of those shown here (of Mrs Emery Reves and Lord Airlie) have never been exhibited before.

---

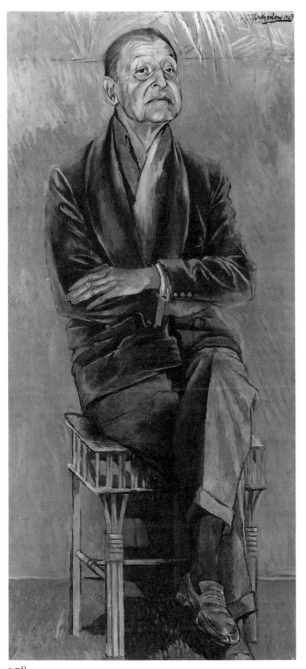

178

*178 **Somerset Maugham** 1949

> Inscribed 'Sutherland 1949' t.r.
> Oil on canvas, 54 × 25 (137 × 63.5)
> First exh: *Graham Sutherland 1924–1951:
> a Retrospective Selection*, Institute of
> Contemporary Arts, London, April–May 1951
> (32)
> Lit: 'Art' in *Time*, LIII, 13 June 1949, p.29
> repr.; Bernard Denvir, 'Paint Reveals' in *Leader
> Magazine*, 9 July 1949, p.32 repr.; Cyril Ray,
> 'Sutherland: Portrait of the Artist' in *Sunday
> Times*, 17 May 1953, p.5, photograph of
> Sutherland standing beside the portrait repr.;
> 'Turning Point by Graham Sutherland' in
> *Daily Express*, 25 September 1961, p.6;
> Cooper, pp.50, 52, 56–8, repr. pl.164; Noel
> Barber, *Conversations with Painters* (London
> 1964), pp.51, 53; John Hayes in exh.
> catalogue *Portraits by Graham Sutherland*,
> National Portrait Gallery, London, 1977,
> pp.12–14, 42–5, repr. p.45 in black and
> white, detail p.10 and p.19 in colour; Hayes,
> pp.31–3, repr. pl.88 in colour and detail
> pl.110
> *Tate Gallery*

W. Somerset Maugham (1874–1965), the novelist, short-story writer and dramatist.

This was Sutherland's first portrait and therefore marked the opening of a new phase in his art. According to his own account, he had occasionally met Maugham while staying at St-Jean-Cap-Ferrat and was invited one day to have lunch with him together with a friend. He was very impressed by Maugham and his whole setting, and on the way back said to his friend that, if he ever painted portraits, Maugham would be the kind of person he would like to paint. His friend reported this to a mutual friend, who told Maugham. Then Maugham wrote to him, asking if he would paint him. Sutherland was reluctant and at first refused. However, when Maugham persisted, he agreed to undertake it purely as an experiment, with no commitment on either side.

Work on the portrait began on 17 February 1949. Maugham gave him about ten sittings, more or less consecutively, of one hour a day, which Sutherland

devoted entirely to drawing. Then he began to paint the definitive portrait away from the model, but while he was working requested a few more sittings to make detailed drawings of the ears, mouth and so on. The portrait was finished early in June.

Maugham is depicted seated on a bamboo stool against an orange background similar to the colour of the robes worn by Buddhist monks, and with palm fronds above – a setting chosen because of his long interest in and association with the East, and the fact that he was the interpreter *par excellence* of the Englishman in the East. His features are furrowed and gnarled like one of Sutherland's own 'found objects', but his expression is aloof and sardonic.

Maugham called the portrait 'magnificent' and added, 'There is no doubt that Graham has painted me in a mood and with an expression I sometimes have, even without being aware of it.'

179 **Two Studies (recto and verso) of the Head for the Portrait of Somerset Maugham** 1949

Recto inscribed 'Sutherland. 1949' t.l., verso inscribed 'Sutherland. 1949.' b.r.
Recto in Indian ink, pencil, chalk, charcoal and grey wash, verso in Indian ink, charcoal, chalk and pencil, both on paper,
12 × 10 (30.5 × 25.4)
First exh: *'In our View': Some Paintings and Sculpture Bought by Hans and Elsbeth Juda between 1931–1967*, Graves Art Gallery, Sheffield, May–June 1967 (135, both sides repr.)
Lit: Cooper, p.58, recto repr. pl.164; John Hayes in exh. catalogue *Portraits by Graham Sutherland*, National Portrait Gallery, London, 1977, p.42, recto repr. No.21, verso repr. No.20
Repr: Andrew Révai, *Graham Sutherland* (Paulton 1966), recto repr. fig.3
*Fitzwilliam Museum, Cambridge*

A double-sided drawing of the head of Somerset Maugham made in connection with the portrait, and based on a drawing which was traced on to the canvas. The drawing on the verso is in reverse (facing to the left) and is more heavily inked.

Sutherland described the genesis of these studies in a letter of 5 December 1967 to the Fitzwilliam Museum:

*The original working drawing was made on tracing paper, and when it seemed (during the process of tracing) that the drawing was going to suffer, I made your two drawings at the same time as I was making the portrait in order that if I needed a further reference, in view of the damage to the original drawing, they would be at hand. Previous to the drawing on tracing paper I did make one other drawing a good deal weaker than the ones you have, and subsequently I made some detail drawings of the nose, eyes, etc., and that is just about the sum of the work actually done in preparation for the portrait itself as regards the head.*

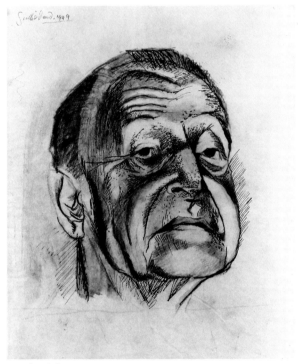

179 (recto)

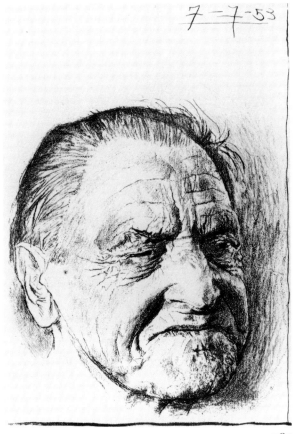

180

### 180 Somerset Maugham II 1953

Inscribed '7–7–53' in the print t.r.
Lithograph (black chalk), 8⅞ × 9⅞ (22.5 × 25)
Lit: Man No.57, n.p. and repr.; Tassi No.62,
pp.29, 87 and 225, repr. p.87
*Victoria and Albert Museum, London*

A portrait lithograph of Somerset Maugham, made as a frontispiece for a limited edition of his novel *Cakes and Ale*, published by W. Heinemann Ltd in 1954 to commemorate his eightieth birthday. It was based on further drawings made from life, drawings from which Sutherland afterwards painted a further portrait of the head and shoulders only, which is signed and dated 1954–5. It is now in the Beaverbrook Art Gallery, Fredericton, New Brunswick, Canada.

Maugham had aged considerably since his portrait of 1949, and his face had become much more wizened and wrinkled.

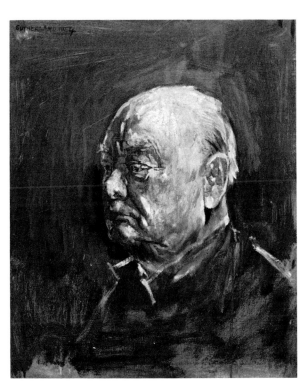

181

### 181 Study of Sir Winston Churchill 1954

Inscribed 'SUTHERLAND 1954' t.l.
Oil on canvas, 24 × 20 (61 × 50.8)
First exh: *Graham Sutherland*, Galleria Civica d'Arte Moderna, Turin, October–November 1965 (98, repr.)
Lit: 'Prime Minister Sits for Portrait' in *The Times*, 27 August 1954, p.6; 'Sutherland: I Expect Criticism' in *Daily Mail*, 30 November 1954, p.1, definitive portrait repr.; '"I Wanted to Paint Premier as a Rock": Mr Sutherland's Aim' in *Daily Telegraph*, 4 December 1954, p.1; '"Sir Winston Churchill, K.G." by Graham Sutherland' in *Illustrated London News*, CCXXV, 1954, pp.991, definitive portrait repr.; Cooper, pp.58–9, this study repr. pl.168; Giorgio Soavi, *Protagonisti: Giacometti, Sutherland, de Chirico* (Milan 1969), pp.166, 169; 'Churchill – the Image' in *Radio Times*, 30 November – 6 December 1974, pp.10–12, 15; John Hayes in exh. catalogue *Portraits by Graham Sutherland*, National Portrait Gallery, London, 1977, pp.49–55, this study repr. p.54; Ian Bradley, 'Churchill Portrait Destroyed' in *The Times*, 12 January 1978, p.1, detail of definitive portrait repr.; 'Londoner's Diary: Sutherland's Churchill – Will He Resurrect It?' in *Evening Standard*, 12 January 1978, p.16; Frances Gibb, 'Churchill May Be Repainted' in *Daily Telegraph*, 13 January 1978, pp.1 and 36; Craig Seton, 'Sculptor on What Sir Winston Really Felt' in *The Times*, 13 January 1978, pp.1 and 2; Ian Jack, 'Why Portraits Can Hurt – by Sutherland' in *Sunday Times*, 15 January 1978, p.4; 'What the Experts Say . . .' in *Sunday Times*, 15 January 1978, p.5, detail of definitive portrait repr.; Craig Seton, 'Servants "Ordered to Destroy Painting"' in *The Times*, 16 January 1978, p.2; 'Miss Sarah Churchill Says Portrait was "Monstrous"' in *The Times*, 19 January 1978, p.4; Charles Lawrence and Richard Holliday, 'I Burnt the Portrait of Sir Winston' in

*Sunday Telegraph*, 12 February 1978, p.1;
Charles Lawrence and Richard Holliday,
'Birthday Pledge to Winston Sealed Picture's
Fate' in *Sunday Telegraph*, 12 February 1978,
p.3; Mary Soames, *Clementine Churchill*
(London 1979), pp.445–6, 501–5; Hayes,
pp.134–5, this study repr. pl.104, the
definitive portrait repr. pl.105
Repr: *The Atlantic Advocate*, L, September 1959,
p.63 in colour
*Private collection*

Sir Winston Churchill (1874–1965), the statesman,
historian and writer; Prime Minister 1940–5 and
1951–5.

Sutherland was commissioned to paint a portrait of
Sir Winston Churchill by an all-party committee from
both Houses of Parliament to be given to him as a
present on his eightieth birthday. Sittings began at
Chartwell on 26 August 1954 and continued on and
off for about four weeks at Chartwell and Chequers.
Churchill wanted to be painted in his robes as a Knight
of the Garter, and Sutherland began by making
several oil studies of him standing dressed like that,
but the M.P.s insisted on his being represented as the
House always knew him, in striped trousers, waist-
coat and spotted bow tie. Then Churchill wanted to
pose on a dais, raised above the painter. Before
starting work on the definitive portrait in his own
studio, away from the sitter, Sutherland made from
life about twelve pencil or charcoal studies, six oil
sketches, and several detail drawings of the hands,
eyes, nose, mouth, shoes, etc.

The final portrait showed Churchill seated facing
the viewer in a four-square pose, legs apart, hands
gripping the arms of the chair, an expression of grim
determination on his face. Sutherland said that this
pose was chosen partly because he had in mind from
the beginning the Churchill who had stopped the
enemy and saved Britain, and partly because Churchill
took up a pose on the dais in the studio which was very
much like his original conception. At the time of the
sittings efforts were being made to oust Churchill from
the premiership and he kept telling Sutherland that
his colleagues wanted him out: 'But I am a rock', he
would say, and took up a pose like that.

Churchill only saw the finished portrait a few days
before the presentation ceremony on 30 November,
his eightieth birthday. He took an instant loathing to
it and even considered refusing to accept it. At the
ceremony in Westminster Hall, before both Houses of
Parliament, he remarked of it with wryness: 'The
portrait is a remarkable example of modern art. It
certainly combines force and candour . . .'.

The portrait disappeared from view almost im-
mediately afterwards. All requests to reproduce it or to
borrow it for exhibitions were turned down. Enquiries
as to its whereabouts received evasive answers. Only
after Lady Churchill's death in December 1977 was it
revealed by her executors that she had had it de-
stroyed on her own initiative some time in 1955 or
1956 because it weighed so much on her husband's
mind.

The sketch shown here, though quite different in
pose and expression from the definitive portrait, is

regarded as the finest of all Sutherland's surviving oil
studies of Churchill. Whereas during the other sittings
Churchill had tended to show his 'bulldog' expression,
the foundations of this portrait were laid in one after-
noon when he was in a sweet, melancholy and reflec-
tive mood. He had gone over to the window to dictate a
letter to his secretary; and, as the sun was low, his skin
seemed transparent.

## 182 The Hon. Edward Sackville-West, later Lord Sackville 1953–4

Not inscribed by the artist
Oil and gouache on canvas,
$66\frac{3}{4} \times 30\frac{3}{8}$ (169.5 × 77.2)
First exh: *British Portraits*, Royal Academy,
London, November 1956–March 1957 (794)
Lit: Cooper, pp.56–8, repr. pl.169a; John
Hayes in exh. catalogue *Portraits by Graham
Sutherland*, National Portrait Gallery, London,
1977, pp.56–8, repr. p.57 and p.23 in colour;
Hayes, p.136, repr. pl.106 in colour
Repr: *Burlington Magazine*, XCIX, 1957, p.29
*Private collection*

The Hon. Edward Sackville-West (1901–65), the
distinguished musicologist and writer, noted es-
pecially for his weekly musical articles in the *New
Statesman and Nation* during the war years which
championed young British composers such as Britten
and Tippett, and for his publication with Desmond
Shawe-Taylor of *The Record Guide*. He succeeded his
father as fifth Baron Sackville in 1962, but died three
years later. He was a guest of Kenneth Clark's at Upton
House in Gloucestershire at the same time as the
Sutherlands in the early months of the war and wrote
the first book on Sutherland, published in the Penguin
Modern Painters series in 1943 and reissued in a
revised edition in 1955.

The proposal that he should paint a portrait of
Edward Sackville-West was first put to Sutherland at
the opening of his exhibition at the Tate in May 1953,
the idea being that he should have an opportunity to
paint someone whom he had known well for some
years (which was not the case with his two previous
sitters, Maugham and Beaverbrook), and who was
also a friend of the collector. Work on the commission
was begun in the week beginning 17 November
1953, but its completion was delayed by the Churchill
portrait and it was not finished until December 1954.

Douglas Cooper records that Sutherland began in
this case by making three or four slight drawings from
life; then an oil sketch from life; then more drawings
from life; then a head and shoulders study in oils; and
lastly the definitive portrait. Whereas the portraits of
Maugham and Beaverbrook were based mainly on
drawings, which partly accounts for their linear em-
phasis and a certain tendency towards caricature, this
one was done mainly from oil sketches and shows a
corresponding gain in tonal nuances, and in sub-
tlety of modelling and characterisation. The sitter is
shown perched on a high stool, his hands neurotically
clasped, his expression tense, almost anguished. Frail,
pale and slight, he was very highly strung and subject
to fits of intense melancholy.

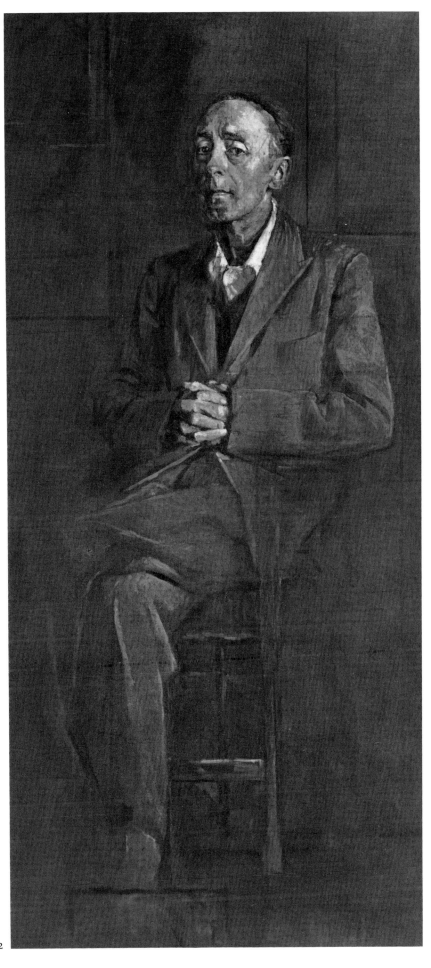

182

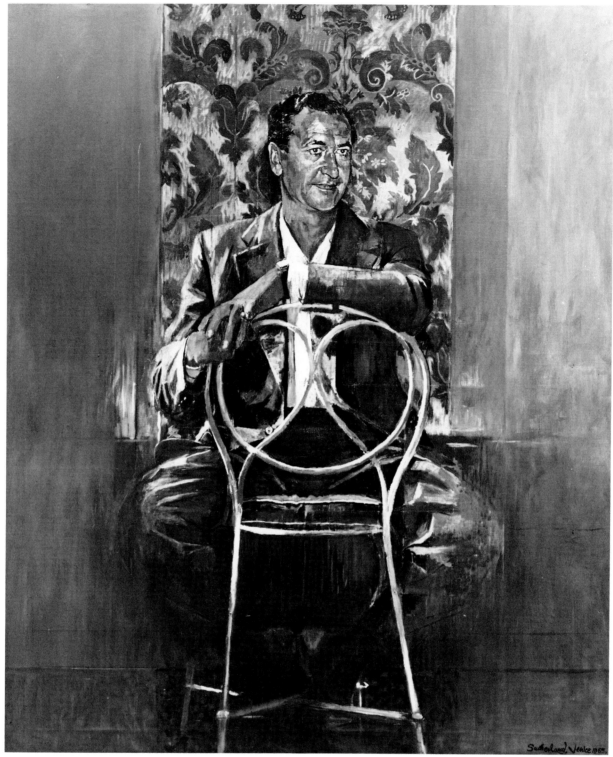

183

### 183 Arthur Jeffress 1955

Inscribed 'Sutherland. Venice 1955.' b.r.
Oil on canvas, 57¼ × 48 (145.5 × 122)
First exh: *Graham Sutherland*, Arthur Jeffress,
London, June–July 1955 (1)
Lit: Express Staff Reporter, 'Graham
Sutherland's Latest' in *Daily Express*, 4 June

1955, p.3 repr.; Cooper, p.59, repr. pl.170;
John Hayes in exh. catalogue *Portraits by
Graham Sutherland*, National Portrait Gallery,
London, 1977, pp.59–61, repr. p.61
Repr: *Studio*, CL, 1955, p.94
*Southampton Art Gallery*

Arthur Jeffress (1905–61), an American citizen who came of a Virginian family, had close ties with England and was educated at Harrow and Cambridge. Of independent means and a collector of pictures, he was first a director of the Hanover Gallery and then opened the Arthur Jeffress Gallery in Davies Street in 1954. He not only dealt in Sutherland's pictures but was a personal friend, and the Sutherlands regularly stayed with him at his house in Venice when on their summer visits to that city.

Sittings for the portrait began in Venice in July 1954, when Sutherland painted two small studies of his head (one of him outdoors and the other indoors, as in the final portrait). Jeffress sat to him altogether about eighteen or nineteen times. The portrait was finished in May 1955 and first exhibited at Jeffress' own gallery in the following month.

Sutherland has given a vivid description of Jeffress: 'Romantic, even exotic, the physical character of his countenance – with its black humorous eyes and (especially after the long summer sun) its warm brown colouring – reminded one strongly of the faces of certain figures in the paintings of Eugène Delacroix, whose works he admired so much.' The exoticism of his appearance was underlined in the portrait by the inclusion in the background of the sumptuous red damask which decorated the walls and covered the bed in his lavish 'Empire' bedroom.

184

## *184 Helena Rubinstein (Princess Gourielli) Seated 1957

Inscribed 'Sutherland 1957' b.r.
Oil on canvas, 61¾ × 36½ (156.8 × 92.7)
First exh: *Graham Sutherland*, Haus der Kunst, Munich, March–May 1967 (57, repr.)
Lit: *Sunday Times*, 14 April 1957, p.18, photograph by Felix Man of Sutherland at work on this portrait in his studio at Trottiscliffe; Cooper, p.60; Helena Rubinstein, *My Life for Beauty* (London 1965), p.95, repr. pl.38; Giorgio Soavi, *Protagonisti: Giacometti, Sutherland, de Chirico* (Milan 1969), p.165; John Hayes in exh. catalogue *Portraits by Graham Sutherland*, National Portrait Gallery, London, 1977, pp.63–5, repr. p.65; 'Artist Misses Portrait of Churchill' in *Daily Telegraph*, 24 June 1977, p.3
Repr: *The Atlantic Advocate*, L, September 1959, p.59 in colour; Arcangeli, pl.227; Hayes, pl.107
*In the collection of the Helena Rubinstein Foundation*

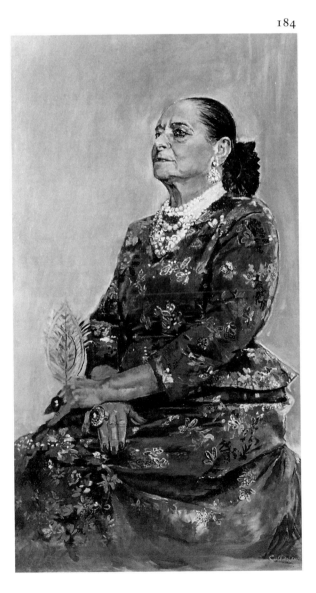

Helena Rubinstein (1882–1965), the pioneer of skin care, beauty authority, philanthropist, patron of the arts and art collector. Born in Cracow, she emigrated to Australia in 1902 and opened a beauty salon there which rapidly developed into a world-wide business of beauty salons, face creams and cosmetics. Her second husband was a Georgian, Prince Artchil Gourielli-Tchkonia.

The commission was begun in Paris in April 1956. Sutherland said that he could not see at first how to

paint her, until she told him she had just bought a new
dress by Balenciaga, an embroidered red evening
gown. He asked her to put it on and she looked like an
empress. Sutherland then made a number of drawings
of her until she had to return to the United States and,
before she left, snipped a piece of fabric from the hem
of the dress to carry away with him, to be sure of
reproducing the colour and texture exactly. The first
version was accidentally burnt in his studio at
Trottiscliffe in December 1956. He then worked on
two versions concurrently, this one of her seated and
the other of her standing, three-quarter length, with
her hands on her hips, and finished them in April
1957.

When she first saw them, Helena Rubinstein was
greatly taken aback and did not like them at all.

*They were both incredibly bold, domineering
interpretations of what I had never imagined I looked like.
I had never seen myself in such a harsh light. Yet later,
when they were exhibited at the Tate Gallery [where
they were on show together in October–December
1957], although I scarcely recognized myself through
Sutherland's eyes, I had to admit that as paintings they
were indeed masterpieces*
[*My Life for Beauty*, p.95]

The standing portrait was bought by Lord Beaverbrook
and is now in the Beaverbrook Art Gallery in Frederic-
ton, Canada. Both show Helena Rubinstein, who was
tiny, less than five feet tall, from a low viewpoint to
enhance her regal appearance.

Photographs taken by Felix Man of Sutherland
working on this portrait in his studio show the picture
without the fan, which seems to have been added at
the last moment.

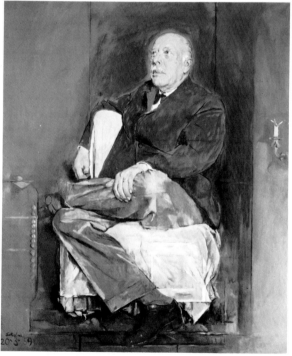

185

**\*185  Max Egon, Prinz zu Fürstenberg** 1958–9

> Inscribed 'Sutherland / 20.3.59' b.l.
> Oil on canvas, 65 × 55 (165.1 × 139.7)
> First exh: *Graham Sutherland*, Galleria Civica
> d'Arte Moderna, Turin, October–November
> 1965 (114, repr. in colour)
> Lit: Cooper, p.60, repr. pl.xv in colour; John
> Hayes in exh. catalogue *Portraits by Graham
> Sutherland*, National Portrait Gallery, London,
> 1977, pp.66–70, repr. in colour and in black
> and white; 'Terence Mullaly Meets Graham
> Sutherland: Portrait of an Artist' in *Daily
> Telegraph*, 18 June 1977, p.14; Hayes, p.139,
> repr. pl.109 in colour (see also fig.16)
> *Joachim Fürst zu Fürstenberg*

Max Egon, Prinz zu Fürstenberg (1886–1959) was
a Bavarian aristocrat and landowner noted for his
patronage of modernism, who established a festival of
the most advanced music at his residence, Schloss
Donaueschingen. Sutherland recorded that his first
impression of him was of someone very tall, very
upright and enormously correct. But later he also
revealed his subtle side, as a solitary man prone to
melancholy who liked to be alone in his hunting lodge
in the woods. 'He looked like an English colonel and

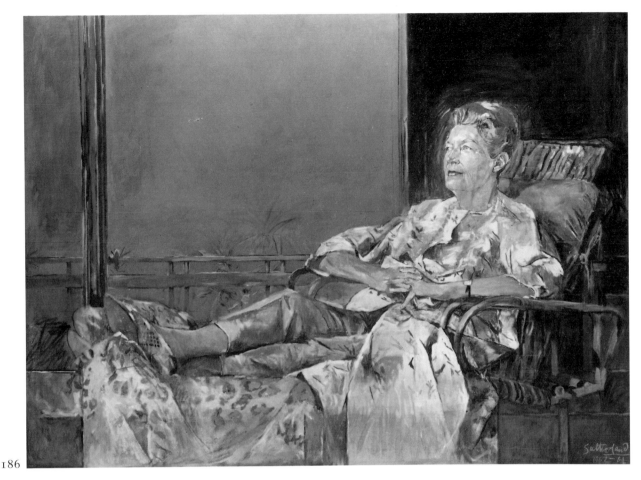

186

talked like a mystic,' Sutherland said. When he first posed he spontaneously took up a position with one leg over the other and maintained exactly the same position every day.

The commission was begun in July 1958, when Sutherland made drawings and two oil studies of the head and shoulders from life at Schloss Donaueschingen. Then the large portrait was painted from these in Sutherland's studio at Trottiscliffe and finished in March 1959. The guttering candle does not appear in any of the studies and was added at a late stage as a 'picturesque' accent.

Unfortunately the candle proved prophetic, for although the portrait gave the Prince great pleasure, he fell ill and died within hours of seeing it for the first time.

### 186  The Hon. Mrs Reginald Fellowes  1962–4

Inscribed 'Sutherland / 1962–64' b.r.
Oil on canvas, $51\frac{1}{8} \times 65$ (130 × 165)
First exh: *Graham Sutherland*, Kunsthalle, Basle, February–March 1966 (122)
Lit: 'Portrait of the Remarkable Mrs Fellowes' in *Daily Express*, 11 February 1964, p.3 repr.
*Comtesse Alexandre de Castéja*

The Hon. Mrs Reginald 'Daisy' Fellowes (1890–1962), daughter of the Duc Decazes, who married first Prince Jean de Broglie and then the Hon. Reginald Fellowes, who died in 1953. She was one of the richest and most colourful women of her generation, a famous society hostess with the reputation of being one of the best-dressed women in the world.

Sutherland completed the sketches for the portrait barely a month before her sudden death in Paris in December 1962. He said shortly after the picture was finished over a year later:

*I completed the sketches after 10 sittings with her in Venice and went straight back to my studio in the South of France and started on the portrait right away while her memory was fresh in my mind.*

*She was a sort of work of art herself; a woman of enormous taste. She was the last of the belle époque.*

### 187  Dr Konrad Adenauer  1963

Not inscribed
Oil on canvas, $28\frac{3}{4} \times 23\frac{5}{8}$ (73 × 60)
First exh: *Graham Sutherland*, Kunsthalle, Basle, February–March 1966 (131)
Lit: Cooper, p.56; John Hayes in exh. catalogue *Portraits by Graham Sutherland*, National Portrait Gallery, London, 1977, pp.75–9, repr. p.76; 'Artist Misses Portrait of Churchill' in *Daily Telegraph*, 24 June 1977, p.3; exh. catalogue *Sutherland malt Adenauer: Bilder, Fotos, Dokumente*, Konrad-Adenauer Stiftung, Sankt Augustin, September 1978; Hayes, p.148, repr. pl.120
Repr: J.P. Hodin, Giuseppe Marchiori and others, *Figurative Art since 1945* (London 1971), pl.25
*Staatsgalerie, Stuttgart*

Dr Konrad Adenauer (1876–1967), the Chancellor of
West Germany from 1949 to 1963 and one of the
foremost statesmen of the post-war period.

Sutherland had wanted for some years to paint Dr
Adenauer's portrait and had been invited by the
German Ambassador, Hans von Herwarth, to meet
him at the Embassy in London in April 1958. After
protracted negotiations, Adenauer agreed to sit to him
at his holiday home at the Villa Collina at Cadenabbia
in April 1963, but Sutherland was unable to come at
the last minute because of illness. The sittings eventu-
ally took place at the Villa Collina from 2 to 9 Septem-
ber later the same year, shortly before Adenauer
formally gave up office on 15 October, only a few
weeks away from his eighty-eighth birthday.

There were altogether nine or ten sittings, from half
to three-quarters of an hour each, which took place
out of doors, on the terrace. Adenauer sat in a wicker
chair with a plain folding screen behind him as back-
ground; Sutherland first made some pencil drawings,
then painted this oil sketch of his head. The large
definitive portrait, showing him posed frontally,
three-quarter length, seated against a background of
leaves, was painted afterwards from May 1964 to
February 1965 away from the model and without any
further sittings. Both pictures were shown to
Adenauer on 9 March 1965 at Bonn, and he said he
was very pleased Sutherland had depicted him as a
'thinking man'. He thought the sketch was particu-
larly successful in catching his personality.

The oil sketch, which was executed nine-tenths in
front of the model, is perhaps the most brilliant of
Sutherland's portrait studies done from life.

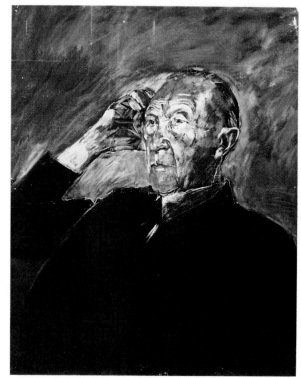

187

### 188  Lord Clark of Saltwood, O.M., C.H. 1963–4

> Inscribed 'G.S. 1963–4' b.r.
> Oil on canvas, 21½ × 18 (54.6 × 45.7)
> First exh: *Paintings and Watercolours by
> Graham Sutherland*, Lefevre Gallery, London,
> April–May 1975 (18, repr. in colour)
> Lit: John Hayes in exh. catalogue *Portraits by
> Graham Sutherland*, National Portrait Gallery,
> London, 1977, pp.73–4, repr. p.74: 'Artist
> Misses Portrait of Churchill' in *Daily Telegraph*,
> 24 June 1977, p.3; Kenneth Rose, 'Albany at
> Large' in *Sunday Telegraph*, 13 January 1980,
> p.2 repr.
> Repr: *Burlington Magazine*, CXVII, 1975, p.411
> *National Portrait Gallery, London*

Lord Clark (Kenneth Clark), the art historian, writer
and collector who was Director of the National Gallery
from 1934 to 1945.

His first meeting with Sutherland dates from 1934
and they soon became close friends. He bought a
number of works from him; arranged his first one-
man exhibition of drawings and paintings at Rosen-
berg & Helft's and wrote the catalogue introduction
for it; had Sutherland and his wife Kathleen as guests
at his house in Gloucestershire for a year at the be-
ginning of the war; and, as Chairman of the War
Artists' Advisory Committee, saw to it that he was
enrolled as one of the official war artists.

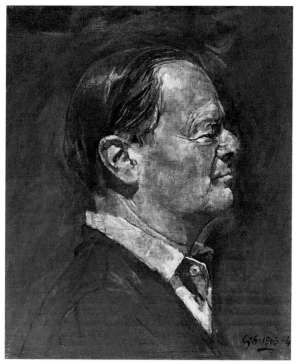

188

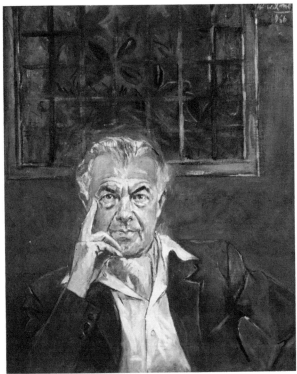

189

Studies for this portrait and for a second, larger portrait showing him three-quarter length with his right hand raised were made in the garden of Sutherland's house in Kent. Work on the portraits was begun in February 1962 and completed in December 1964. The choice of a profile pose in this case, and the limitation of the figure to a head and shoulders, consciously echoes the fifteenth-century Italian tradition of the profile portrait.

### 189 Emery Reves 1966

Inscribed 'Sutherland / 1966' t.r. and
'G.S.1966.E.R.' on back of canvas
Oil on canvas, $25\frac{5}{8} \times 21\frac{1}{4}$ (65 × 54)
First exh: *Portraits by Graham Sutherland*,
National Portrait Gallery, London,
June–October 1977 (84, repr.)
Lit: Roger Berthoud, 'The Idealist Who Sold
Churchill to the World' in *The Times*,
7 September 1981, p.8, detail repr.
*Mrs Emery Reves*

Emery Reves (1904–81), Hungarian-born literary agent, entrepreneur, collector and connoisseur. The Co-operation Press Service, founded by him in Paris in 1930 to spread international understanding by publishing the views of one country in others, acted as literary agent for many leading European statesmen, including Winston Churchill. Churchill became a close friend, and in his old age, between 1955 and 1960, spent much of his time as a guest of Mr and Mrs Reves at their villa in the South of France.

A passionate and discriminating collector of French Impressionist paintings, furniture, carpets, porcelain and other objets d'art, he was a friend and neighbour of Sutherland, and commissioned his portrait from him in 1965. The definitive portrait was started in March 1966 and completed in June. Though Reves sat to Sutherland in a white coat and the yellow spotted bow tie which he often wore, the final portrait shows him in a dark coat and an open-necked shirt.

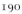
190

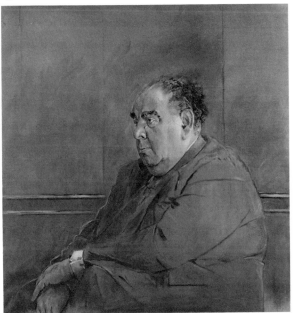

### 190 Lord Goodman, C.H. 1973–4

Not inscribed
Oil on canvas, $37\frac{3}{4} \times 37\frac{3}{4}$ (94.5 × 94.5)
First exh: *Portraits by Graham Sutherland*,
National Portrait Gallery, London,
June–October 1977 (97, repr.)
Lit: 'Londoner's Diary: Lord Goodman's
Portrait – by Sutherland' in *Evening Standard*,
27 April 1973, p.20; 'Skinflint's City Diary' in
*Spectator*, CCXXXII, 1974, p.748; William
Feaver, 'Sutherland's Lawyer' in *Sunday Times
Magazine*, 14 July 1974, p.28, repr. p.29 in
colour; 'Artist Misses Portrait of Churchill' in
*Daily Telegraph*, 24 June 1977, p.3; Ian Jack,
'Why Portraits Can Hurt – by Sutherland' in
*Sunday Times*, 15 January 1978, p.4
Repr: *Burlington Magazine*, CXVII, 1975,
p.328a; Hayes, pl.153
*Tate Gallery*

Lord Goodman, though a lawyer by profession, is especially noted for his services to the arts. The posi-

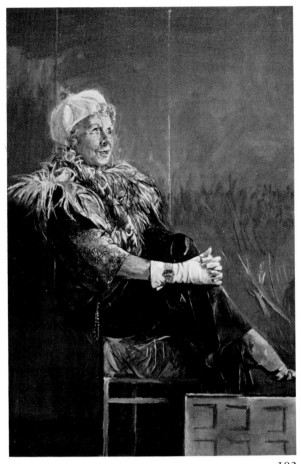

### 191 Self-Portrait 1977

Inscribed 'G.S. 1977' b.r.
Oil on canvas, $20\frac{5}{8} \times 19\frac{7}{8}$ ($52.5 \times 50.5$)
First exh: *Portraits by Graham Sutherland*,
National Portrait Gallery, London,
June–October 1977 (101)
Repr: *Burlington Magazine*, CXIX, 1977, p.581;
Hayes, frontispiece
*National Portrait Gallery, London*

This picture was painted specially for the exhibition of Sutherland's portraits at the National Portrait Gallery, and was signed and dated at the Gallery with a biro. Sutherland said that he tried to express the anxiety he felt when he faced a subject for the first time.

Apart from a 'Study for Self-Portrait at a Casino' of 1952, which showed him playing roulette in a casino, it was his first painted self-portrait.

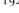
192

### 192 Mrs Emery Reves 1978

Not inscribed
Oil on canvas, $66 \times 43\frac{7}{8}$ ($167.5 \times 111.5$)
*Mrs Emery Reves*

Mrs Wendy Reves, whose husband Emery Reves Sutherland had painted (No.189) in 1965–6.

### 193 The 13th Earl of Airlie 1978–9

Not inscribed
Oil on canvas, $75 \times 48$ ($190.5 \times 122$)
*The Earl of Airlie*

The thirteenth Earl of Airlie, Chairman of Schroders Ltd since 1977 and Deputy Chairman of General Accident Fire & Life Assurance Corp. Ltd; the elder brother of the Hon. Angus Ogilvy.

The sittings for this work began almost immediately after the completion of the portrait of Mrs Reves and it was Sutherland's last finished portrait. Apart from the portrait of Lord Bath painted in 1970–1, which has a road and some trees in the background, it is the only one of his portraits to show a full-length figure in a landscape setting.

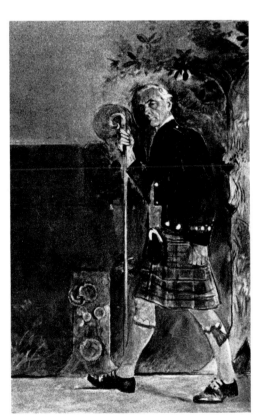
193

# Paintings 1962-7 and 'A Bestiary'

This room covers the period between the completion of Sutherland's work on the Coventry Tapestry at the end of 1961 and his return to Pembrokeshire themes in 1968. The paintings of this period show a wide range of themes such as landscape motifs of the South of France and Venice, fountains, machine forms of a semi-organic character, interiors and various kinds of animals. His interest in animal themes, real and imaginary, received its summing up in the series of colour lithographs 'A Bestiary and Some Correspondences' made in 1967–8.

---

**194  Dark Landscape** 1962

> Inscribed 'Sutherland. / 25.v.62' b.l.
> Oil on canvas, 51¼ × 38¼ (130 × 97)
> First exh: *Graham Sutherland*, Marlborough
> Fine Art, London, June 1962 (24)
> Lit: Graham Sutherland and Andrew Forge,
> 'Landscape and Figures' in *The Listener*, LXVIII,
> 1962, p.134; Hayes, p.150, repr. pl.123 in
> colour
> Repr: *Apollo*, LXXVII, 1963, p.485; Arcangeli,
> pl.132 in colour
> *Private collection*

Most of Sutherland's landscapes of this date were based on subjects within a short distance of his house at Menton – the various little paths and entrances going down through trees – and the site of 'Dark Landscape' was in his own garden, literally only twenty-five yards from his house. His ideas in this case were, he said, very similar to those he had when painting 'Entrance to a Lane' (No.67) in 1939.

The free brushwork is typical of a number of works of about this time.

**195  Machine against Black Ground** 1962

> Inscribed on back of canvas 'MACHINE /
> AGAINST / BLACK / GROUND' and '24.V.62 /
> 25V62 / 26V62 / 4.VI.62 / Sutherland'.
> Oil on canvas, 56¼ × 48¼ (143 × 122.5)
> First exh: *Graham Sutherland*, Marlborough
> Fine Art, London, June 1962 (not in catalogue)
> Repr: *Architectural Review*, CXXXIV, 1963,
> p.131; Arcangeli, pl.123 in colour; Hayes,
> pl.130 in colour (upside-down)
> *Otto Preminger*

A hybrid machine-cum-plant form. Sutherland said that the small lamp which appears on the right in this picture and in 'Machine No.II' of 1959 was based on one in a corner of the Fondamenta di S. Geronimo in Venice.

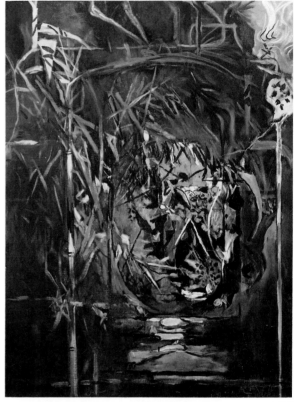

194

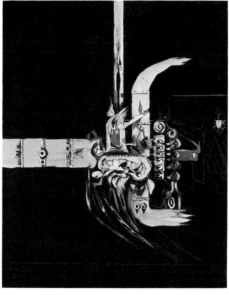

195

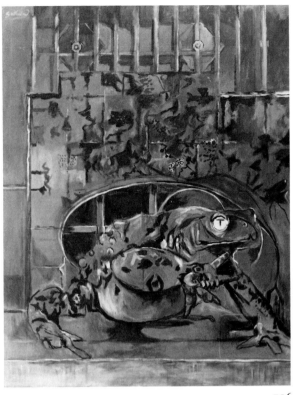

196

### 196 The Toad 1962

> Inscribed 'Sutherland' t.l.
> Oil on canvas, 50 × 40¼ (127 × 102.2)
> First exh: *The Dunn International*, Tate Gallery,
> November – December 1963 (89, repr.)
> *Private collection*

Sutherland picked up this toad on the road home from Menton in 1958 and kept it in the bathroom in water, then drew it the next day. Before releasing the toad he also had a series of photographs taken of it, including a couple more or less in the attitude of this work, and several of it in a small glass tank which were used for his painting 'The Tank' of 1959.

He painted altogether five largish pictures of it between 1958 and 1962, of which this was the last, with the toad enlarged to monumental proportions, and with a kind of grille in the background suggesting captivity.

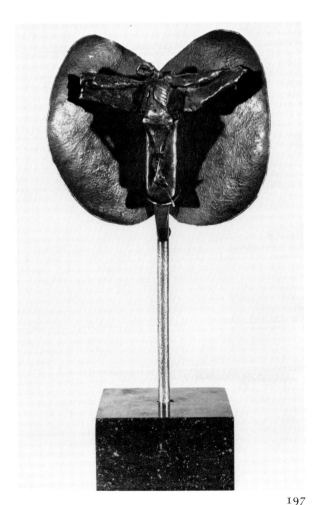

197

### 197 Crucifix Figure 1962-4

> Not inscribed
> Sterling silver on bronze and marble base,
> height 23 (58.5)
> Lit: G.H., 'The Cross of Ely now on Exhibition in
> Australia' in *Connoisseur*, CLVII, 1964, p.101,
> the Ely sculpture repr. p.101 and detail on
> cover in colour; 'Ely Cathedral Rejects Altar
> Cross' in *The Times*, 28 May 1965, p.14, Ely
> sculpture repr.
> *Private collection*

The most ambitious sculpture Sutherland ever helped to make, and the only one he made on commission, was a gold and silver altar cross for Ely Cathedral, forty-two inches high and weighing one hundredweight, which he created in collaboration with Louis Osman, the architect-goldsmith. Exceptionally complex in form, it included a square metal plate raised on a high stand and framed at the sides and top and bottom by fingers of gold symbolising the authority of God, and with a small crucifix figure at the centre, set in a heart suggesting continuing life. The silver forms, including the crucifix, were cast by the Morris Singer Foundry in London and then enamelled in black niello, and the sculpture was made up altogether of no less than forty-five separate parts. The initial idea and the overall design were Osman's; Sutherland's contribution was to make the crucifix figure, the heart shape behind it and the fingers.

Though completed in April 1964, it was then sent away on exhibition for some months. When finally placed in position on the high altar in the following year, it was found that the way the surface was broken up made it very hard to see, and the cathedral authorities decided reluctantly that they could not accept it. It now belongs to Mrs Emery Reves.

This sculpture is one of an edition of nine casts of the central composition of Christ and the heart, mounted separately, commissioned in 1964 by Marlborough Fine Art.

**\*198  The Captive**  1963-4

> Inscribed 'Sutherland / August 1963–
> Jan.1964' b.r. and 'THE CAPTIVE / Aug 1963
> Jan 1964 / G.S.' on back of canvas
> Oil on canvas, 55 × 48 (139.5 × 122)
> First exh: *Recent Paintings by Graham
> Sutherland*, Paul Rosenberg, New York,
> May–June 1964 (3)
> Lit: Editorial, 'The Pleasant Place of All
> Festivity' in *Apollo*, XCIV, 1971, pp.174–5;
> Hayes, p.154, repr. pl.126
> Repr: *Burlington Magazine*, CVII, 1965, p.648;
> Arcangeli, pl.142
> *Gesellschaft der Freunde der Ausstellungsleitung
> Haus der Kunst, Munich*

One of Sutherland's pictures influenced by Venice, in this case specifically by the panels with lions in high relief on the façade of the Ospedale di San Marco. He said in the film *Lo Specchio e il Miraggio* of 1969:

*I am specially fascinated by the panels of the lions with the false perspective of the* trompe l'oeil, *and I sometimes feel a little bit like Cézanne with regard to Poussin, and I would like to do over again those panels, those* trompe l'oeil, *on nature . . . . I must have been influenced by these two panels when I painted two pictures of animals in space, in a particular space: one was a prisoner . . . .*

The forms of the animal were however suggested by a shape at the side of a lane in Kent which reminded him of a hippopotamus. The idea of depicting it as a captive came from Goya's drawings of prisoners: the creature not only has its forelegs chained but appears to be imprisoned in a dark and gloomy dungeon with a heavily barred window.

198

**199  Seated Animal**  1965

> Inscribed 'G. Sutherland / 23.vi.65' t.r.
> Oil on canvas, 57 × 48 (145 × 122)
> First exh: *The Marlborough Exhibition Summer
> 1965*, Marlborough Fine Art, London,
> July–September 1965 (47)
> Lit: Andrew Révai, *Graham Sutherland* (Paulton
> 1966), p.8, repr. p.8 and pl.XVI in colour;
> Hayes, p.179, repr. pl.159 in colour
> Repr: *Burlington Magazine*, CVII, 1965, p.481;
> Arcangeli, pl.155 in colour
> *Private collection*

The animal crouches and gropes. It is part monkey, part human and part machine, an amalgam intended to express the tragic inescapability of the human condition, and the face in mysterious dark shadow was meant to represent Sutherland himself. The oval shape at the top was derived from a piece of decorative iron-work which Sutherland had found and had had incorporated in an outside wall of his house at Menton, the Villa Blanche.

It was the second of the two paintings influenced by the façade of the Ospedale di San Marco (see No.198).

199

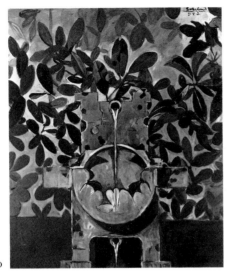

200

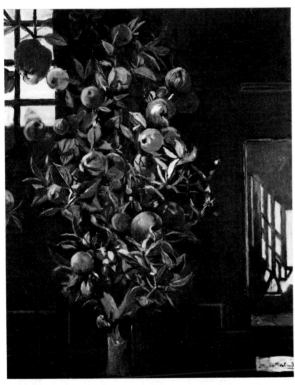

201

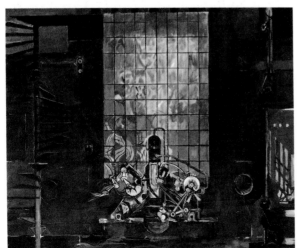

202

*200 **Blue Fountain – Autumn** 1965

> Inscribed 'Sutherland. / 21.v.65.' t.r.
> Oil on canvas, 57 × 48 (145 × 122)
> First exh: *The English Eye*, Marlborough-
> Gerson Gallery, New York,
> November–December 1965 (84, repr.)
> Lit: Andrew Révai, *Graham Sutherland*
> (Paulton 1966), p.8; Hayes, p.152, repr.
> pl.125 in colour
> Repr: Arcangeli, pl.154 in colour; *Art
> International*, XIX/3, 20 March 1975, p.43
> *Private collection*

In 1963 Sutherland made a number of sketches of the village fountain at Castellar, in the hills around his house at Menton, developing these into a series of paintings with the central theme of water running over stonework. Between 1963 and 1966 he made altogether about twelve oil paintings of fountains or cisterns, some based on formal fountains such as the one at Castellar and some on small waterfalls in the hills or water gushing out of a stone wall into a water-tank, and sometimes with erotic and anatomical overtones.

In this particularly fine and resplendent example, the composition is more or less symmetrical and the forms, partly in shadow, partly in light, are offset by the golden glow of light which diffuses from behind through the patterned background of leaves.

201 **Fruit Tree with Open Door** 1965

> Inscribed 'Sutherland' b.r. and 'FRUIT TREE
> WITH / OPEN DOOR / GS. 1965.' on back of
> canvas
> Oil on canvas, 39 × 31⅞ (99 × 81)
> *Private collection*

This was probably painted in Venice, as the doorway and shadows on the right are the same as those in 'Interior' 1965 (No.202).

*202 **Interior** 1965

> Not inscribed
> Oil on canvas, 102⅜ × 114¼ (260 × 290)
> First exh: *Graham Sutherland*, Galleria Civica
> d'Arte Moderna, Turin, October–November
> 1965 (141, repr.)
> Lit: 'Graham Sutherland Explains His Art' in
> *Illustrated London News*, CCXLVIII, 19 February
> 1966, p.29, repr. p.30; Edwin Mullins,
> 'Transmitting a Tortured Landscape' in *Daily
> Telegraph Magazine*, 3 November 1967, p.28,
> repr. p.31 in colour; Giorgio Soavi,
> *Protagonisti: Giacometti, Sutherland, de Chirico*
> (Milan 1969), pp.129–30, 138, 143–5, repr.
> p.140; Hayes, p.155, repr. pl.128
> Repr: *XXe Siècle*, No.38, June 1972, p.91;
> Arcangeli, pl.160
> *Private collection*

While staying in Venice in the summer of 1965 at the Hotel Cipriani on the Giudecca, Sutherland asked the manager to find a studio for him in which he could

make as much mess as he liked, as he had some lithographs to do. Then when he saw the marvellous quality of the light in the enormous boat-builder's shed which the hotel had found for him, he decided at once to make some drawings. Soon afterwards he heard that the Tate had refused to lend the big 'Origins of the Land' for his Turin exhibition because it was in poor condition. Knowing that Turin would need a big picture as a climax to the exhibition, he ordered a large canvas to be delivered when he got back to Venice in September. The picture was finished in seventeen days, an exceptionally short time for him since his major pictures frequently took two months.

The composition was based on one of the large windows in this huge derelict space and on the iron spiral staircase beside it (which Sutherland turned into a rising fan-like form by leaving out the handrail). Light filtering through the window and the foliage of an abandoned garden outside casts mysterious shadows and reflections in the interior. Because there were marks on the floor made by machines which had once been used there, Sutherland had the idea of putting an imaginary machine into this space: a pump just working away without anyone around. Its forms were suggested partly by his own knowledge of machines and the mechanical principle of intake and evacuation, and partly by the forms of a small twisted piece of bark. The cat on the right, the only living creature present, is painted in a style influenced by Egyptian art. The proportions of the window to the sides are 5:8, and this is one of his few paintings carefully worked out in a mathematical way.

After finishing this picture, his largest painting ever apart from 'The Origins of the Land', he painted a second slightly smaller upright picture of the same interior in 1966-7. The building was then demolished to make way for the Cipriani's present swimming pool.

### 203  The Braziers and a Monument  1967

Inscribed 'The Braziers and a Monument' and 'Sutherland 1967' on back of canvas
Oil on canvas, $71\frac{1}{2} \times 56\frac{1}{4}$ (181.5 × 143)
First exh: *Recent Acquisitions*, Marlborough Fine Art, London, July–August 1967 (61, repr. in colour) as 'The Braziers'
Repr: *XXe Siècle*, No.38, June 1972, p.93; Arcangeli, pl.163 in colour
*Colección Bartolomé March Servera*

A composition of a more complicated kind than usual, combining a number of different objects and with the braziers placed in front of the 'monument' like votive offerings at a shrine. A man's head appears at the bottom, peering anxiously over the top of a wall. Sutherland had introduced a 'spectator' into his second large 'Interior' of 1966-7, the figure of a man standing outside the window, to the side, and looking in. The idea is one that he got partly from certain etchings by Rembrandt, such as the 'Virgin and Child with a Cat', in which a similar sort of thing occurs.

### 204  A Bestiary and Some Correspondences  1967-8

A series of twenty-six colour lithographs (twenty-five plates and one frontispiece) issued in an edition of seventy plus ten artist's proofs. Each print except the frontispiece inscribed $\frac{6}{70}$ b.l. and 'Sutherland' b.r.; the frontispiece inscribed 'Sutherland' b.r. but not numbered
*Victoria and Albert Museum Library, London*

I  Frontispiece to a Bestiary  1968

Lithograph (black, green),
$19\frac{1}{4} \times 12\frac{5}{8}$ (49 × 32)
Lit: Man No.73, n.p. and repr.; Tassi No.81, pp.105, 222, repr. p.105 in colour

II  Beetles I  1967

Inscribed '8.VI.67' in the print t.r.
Lithograph (three greens, violet, black),
$19\frac{7}{8} \times 26\frac{1}{8}$ (50 × 66.5)
Lit: Man No.74, n.p. and repr.; Tassi No.82, pp.32-3, 106, 220, repr. pp.106-7 in colour

III  Beetles II (with electric lamp)  1968

Lithograph (black, dark green, light green, grey), $25\frac{1}{2} \times 19\frac{7}{8}$ (65 × 50.5)
Lit: Man No.75, n.p. and repr.; Tassi No.83, pp.33, 108, 220, repr. p.108 in colour

IV  Lion  1968

Lithograph (black), $25\frac{1}{4} \times 19\frac{1}{2}$ (64 × 49.5)
Lit: Man No.76, n.p. and repr.; Tassi No.84, pp.33, 109, 223, repr. p.109

V  Ram's Head (full face)  1968

Inscribed '5.II.68' in the print b.l. (in reverse)
Lithograph (violet, black),
$26 \times 19\frac{5}{8}$ (66.25 × 50)
Lit: Man No.77, n.p. and repr.; Tassi No.85, pp.110, 225, repr. p.110 in colour

VI  Ram's Head (facing left)  1968

Inscribed '20.III.68' in the print b.r.
Lithograph (yellow ochre, black),
$17 \times 15\frac{3}{8}$ (43 × 39)
Lit: Man No.79, n.p. and repr.; Tassi No.87, pp.33, 112, 225, repr. p.112 in colour

VII  Ram's Head (with rocks and skeletons)  1968

Lithograph (black, violet, flesh),
$25\frac{3}{4} \times 19\frac{3}{4}$ (65.5 × 50)
Lit: Man No.80, n.p. and repr.; Tassi No.88, pp.32-3, 113, 225, repr. p.113 in colour

VIII  Armadillo  1968

Lithograph (two mushrooms, sienna, violet, black), $25\frac{1}{2} \times 19\frac{7}{8}$ (65 × 50.5)
Lit: Man No.81, n.p. and repr.; Tassi No.89, pp.32, 114, 220, repr. p.114 in colour

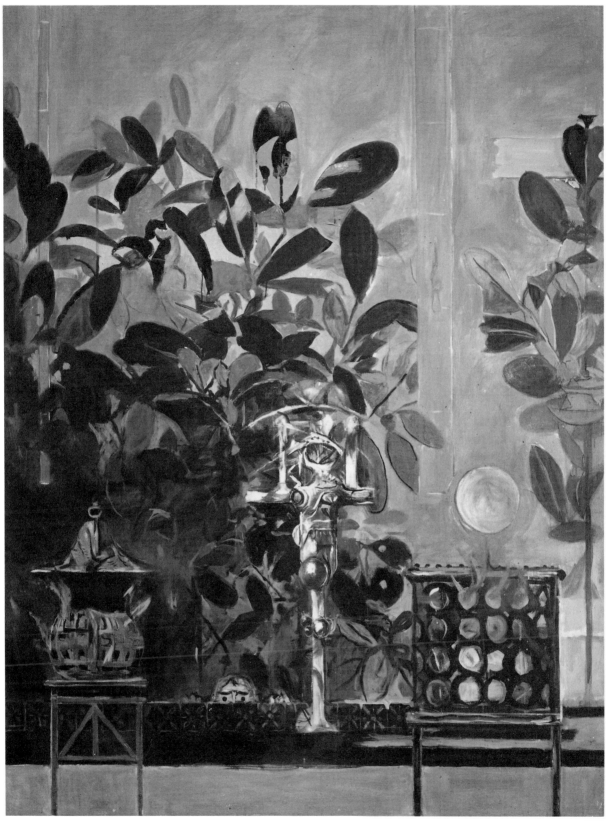

203

IX    Toad 1967

Inscribed 'Sutherland / 28.IV.67' in the print b.r. (in reverse)
Lithograph (two greens, yellow, black), 26 × 19⅞ (66 × 50.5)
Lit: Man No.82, n.p. and repr.; Tassi No.91, pp.32, 115, 227, repr. p.115 in colour

X    Bird and Mouse 1968

Lithograph (black, blue, yellow, two greys), 26 × 20 (66 × 51)
Lit: Man No.83, n.p. and repr.; Tassi No.92, pp.116, 220, repr. p.116 in colour

XI    Ants 1968

Inscribed '5.II.68' in the print b.r.
Lithograph (black, yellow ochre), 25¼ × 19⅝ (64 × 49.75)
Lit: Man No.84, n.p. and repr.; Tassi No.93, pp.33–4, 117, 220, repr. p.117 in colour

XII    Cynocephalus 1968

Lithograph (two greys, red, pink, blue, black), 26 × 19⅝ (66 × 50)
Lit: Man No.85, n.p. and repr.; Tassi No.94, pp.118, 221, repr. p.118 in colour

XIII    Bird (about to take flight) 1968

Inscribed '1.III.68' in the print t.l.
Lithograph (two yellows, blue, green, black), 25¾ × 19⅝ (65.5 × 50)
Lit: Man No.68, n.p. and repr.; Tassi No.95, pp.33, 119, 220, repr. p.119 in colour

XIV    Chauves-Souris (interior) 1967

Inscribed '9.XI.67' in the print b.l. (in reverse)
Lithograph (black, grey, yellow, violet), 25¼ × 19¼ (64 × 49)
Lit: Man No.87, n.p. and repr.; Tassi No.96, pp.120, 221, repr. p.120 in colour

XV    Chauve-Souris (in a looking glass against a window) 1968

Lithograph (black, grey, violet), 25⅝ × 19⅞ (65 × 50.5)
Lit: Man No.88, n.p. and repr.; Tassi No.97, pp.33, 121, 221, repr. p.121

XVI    Sheet of Studies (heads) 1968

Inscribed '10.IV.68' in the print b.r.
Lithograph (black, yellow), 23⅞ × 19¼ (60.75 × 49)
Lit: Man No.89, n.p. and repr.; Tassi No.98, pp.34, 122, 226, repr. p.122 in colour

XVII    Sheet of Studies (organic forms) 1968

Lithograph (black, pink), 26 × 19½ (66 × 49.5)
Lit: Man No.90, n.p. and repr.; Tassi No.99, pp.34, 123, 226, repr. p.123 in colour

XVIII    Sheet of Studies (comparisons: machines and organic forms) 1968

Lithograph (black, yellow), 26 × 19¾ (66 × 50.25)
Lit: Man No.91, n.p. and repr.; Tassi No.100, pp.34, 124, 226, repr. p.124 in colour

XIX    Owl (rose ground) 1968

Lithograph (two roses, grey, biscuit, black), 26¼ × 19⅞ (66.5 × 50)
Lit: Man No.92, n.p. and repr.; Tassi No.102, pp.126, 224, repr. p.126 in colour

XX    Emerging Insect 1968

Inscribed '23.III.68' in the print b.c.
Lithograph (two roses, red, green, yellow, black), 26 × 19½ (66 × 49.5)
Lit: Man No.93, n.p. and repr.; Tassi No.103, pp.32, 127, 221, repr. p.127

XXI    Three Organic Forms 1968

Inscribed '7.II.68' in the print t.r.
Lithograph (black), 24¾ × 19⅞ (63 × 50.5)
Lit: Man No.94, n.p. and repr.; Tassi No.101, pp.33, 125, 227, repr. p.125

XXII    Insect (simulating seeds) 1968

Lithograph (two reds, two greens, two blues, yellow, black), 19⅝ × 25¾ (50 × 65.5)
Lit: Man No.95, n.p. and repr.; Tassi No.105, pp.33, 129, 221, repr. p.129 in colour

XXIII    Bird Form (full face) 1968

Lithograph (black, blue), 23 × 12¾ (58.5 × 32.5)
Lit: Man No.96, n.p. and repr.; Tassi No.104, pp.128, 220, repr. p.128 in colour

XXIV    Submerged Form 1968

Lithograph (black, green, yellow), 19⅝ × 25⅜ (50 × 64.5)
Lit: Man No.97, n.p. and repr.; Tassi No.106, pp.130, 226, repr. p.130 in colour

XXV    Chained Beast 1967

Inscribed '15.XI.67' in the print b.l. (in reverse)
Lithograph (black, beige, violet), 26 × 20 (66 × 52)
Lit: Man No.98, n.p. and repr.; Tassi No.108, pp.32, 132, 221, repr. p.132 in colour

XXVI    Hybrid 1968

Inscribed '3.IV.68' in the print b.c. (in reverse)
Lithograph (black, orange), 20⅝ × 17¾ (52 × 45)
Lit: Man No.99, n.p. and repr.; Tassi No.109, pp.33–4, 133, 223, repr. p.133 in colour

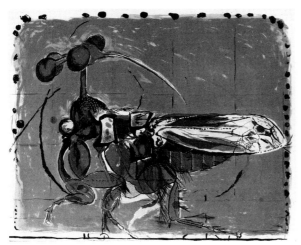

204 XXII

204 XXV

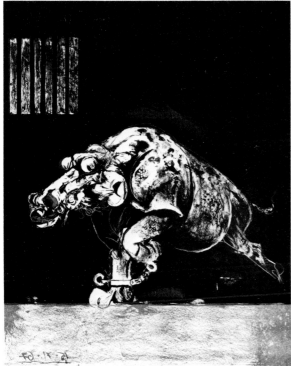

In 1965, H.R. Fischer of Marlborough Fine Art suggested to Sutherland that he should undertake the illustration of a book, with either engravings or lithographs. After some thought Sutherland decided to make a series of lithographs, loosely linked with the idea of a bestiary. Though he was aware of the traditional medieval bestiaries, the idea of his bestiary sprang from the fact that he had been painting a series of pictures of animals, and had also been making a number of studies of animals for the Coventry Tapestry. At the same time his bestiary fell into a wider category than the old bestiaries, since he was involved not only with realistic and hybrid animals, but with machines and their relations to organic forms. He had shortly before read 'Constant Companions', the catalogue of an exhibition of 'mythological animals, demons and monsters, phantasmal creatures and various anatomical assemblages' organised by the Art Department of the University of St Thomas, Houston, Texas, in 1964.

As Simon E. D'Uxionne pointed out in the catalogue of the exhibition of the 'Bestiary' at Marlborough Fine Art, London, in 1968, the works which gradually emerged fell into four categories:
1. Animals, birds and insects – more or less 'straight' (e.g. 'Beetles I and II', 'Lion' and 'Ram's Head')
2. Animals and birds which derive their form from corresponding forms in nature, 'found objects' and the rest, which suggested the subject (e.g. 'Chained Beast')
3. Correspondences between the principles of organic forms and those of machines and the human animal (e.g. the three 'Sheets of Studies' and 'Three Organic Forms')
4. Subjects which are hybrids (e.g. 'Hybrid').

Some of these designs were based on paintings or drawings he had made a few years before, but others were new images. He spent part of 1965, and the whole of 1966, preparing his themes, experimenting with his iconography and establishing his ideas with a great number of drawings, watercolours and sketches.

Then in January 1967 he began transferring the images to the stone or the zinc plate, continuing throughout that year and for some months in the next; the series was finished in April 1968. The printing was carried out by Fernand Mourlot in Paris, but every touch on the zinc, stone or transfer paper was made by Sutherland himself without the intervention of an artisan. The series was published by Marlborough Fine Art (London) Ltd.

# 1968-80: Return to Pembrokeshire Themes

Sutherland revisited Pembrokeshire in 1967 for the first time for over twenty years. Fascinated once again by the distinctive landscape of the area, he returned there in 1968 for a longer visit and his work from then on was again devoted mainly to Pembrokeshire themes, especially motifs taken from the small estuaries at Sandy Haven and Picton in the southern part of the county. He also made a number of further prints in his last years, including two major suites, 'The Bees' and 'Apollinaire'.

---

*205 **U-shaped Form** 1968

> Not inscribed
> Oil on canvas, 43 × 66⅛ (110 × 168)
> Repr: Arcangeli, pl.169 in colour
> *Private collection*

Though Sutherland paid his first return visit to Pembrokeshire in 1967 during the making of the film on his work for Italian television, he was only there for two days, and his second Pembrokeshire period did not really begin until the following year, when he went back again for a longer stay after the completion of his work on the 'Bestiary'. The U-shaped form which inspired this and several other pictures (sometimes with considerable modifications) is a tree form that he found on Picton beach, a favourite area of his in this last period and less than a mile from Picton Castle where the Graham Sutherland Gallery was later opened in 1976. This particular form was lying tilted at an angle.

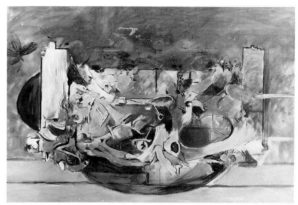

205

206 **Conglomerate I** 1970

> Not inscribed
> Oil on canvas, 42½ × 37 (108 × 94)
> First exh: VIIIe Biennale Internationale de
> Menton, Palais de l'Europe, Menton,
> July–September 1970 (485, repr. in colour)
> Repr: Arcangeli, pl.201
> *Private collection*

This is the first of four oil paintings based on a piece of conglomerate rock that Sutherland found on the beach at Picton. He was fascinated by its protuberances and hollows, and its great variety of shapes, making a surface so complex that one could lose one's way trying to draw it. The oil paintings grew out of a number of studies in watercolour. The rock was actually lying on the ground, but in the paintings he raised it up parallel to the picture plane.

207 **Trees on a River Bank** 1971

> Inscribed 'Sutherland.' b.r.
> Oil on canvas, 37⅜ × 43¼ (95 × 109.5)
> First exh: *Sutherland: Sketchbook*, Galleria
> Bergamini, Milan, October–November 1974
> (9, repr. in colour)
> Repr: Arcangeli, pl.165 in colour; Sanesi,
> pl.93; Hayes, pl.135 in colour
> *Giorgio Soavi, Milan*

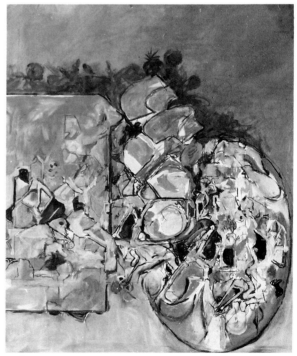

206

Trees on the bank of the River Cleddau, but combining motifs from two different areas more than three miles apart. The curvilinear tree form on the left, which appears again in 'Form over River' of 1971–2 (No.209), is by the shore at Picton, but the tree in the centre, which also figures in 'Trees with G-shaped Form I' of 1972 and 'Foot' 1972 (Nos.211 and 212), is beside the private beach at Benton Castle.

A concentration on the lower parts of the trees, their trunks, their roots and their attachment to the earth, is characteristic of many of these late Pembrokeshire works.

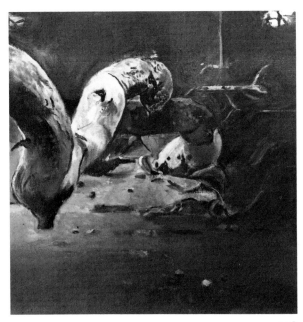

208

**208 Picton** 1971–2

> Not inscribed
> Oil on canvas, $20\frac{7}{8} \times 19\frac{3}{4}$ (53 × 50)
> Lit: 'Graham Sutherland – Metamorphosis of Objects in a Landscape' in *The Listener*, XCVIII, 1977, p.231; Hayes, p.169, repr. pl.146 in colour
> Repr: Sanesi in colour, pl.94 and on cover (the colours completely inaccurate)
> *Private collection*

Based on an oak tree along the bank of the estuary at Picton, where the undercutting of the banks of soft shale by the tide has caused the trees to grow into a most unusual variety of twisted shapes in order not to fall over. Sutherland said

*The trees are eroded by the tide and wind and they are small oaks, really; I suppose you would call them dwarf oaks. They have the most extraordinarily beautiful, varied and rich shapes which detach them from their proper connotation as trees. One does not think of them so much as trees, more as figures; they have the same urgency that certain movements of figures can have in action* [*The Listener*, XCVIII, 1977, p.231].

Contrasting this picture with earlier paintings of tree forms such as 'Fallen Tree against Sunset' of 1940 (No.73), John Hayes has described how

*. . . the looser, less substantial tree and root forms have been energized into flowing rhythms which interlock in a more complex, perhaps more cerebral, invention. . . . In this evening scene the tree forms derived, as so often, from his favourite oak, beautifully placed in the canvas, are gently lit and occupy a shallow space, but they seem to spring out against the greys modulating from beach to background, a stifling gloom only relieved by an opening in the branches at the top of the canvas.*

209

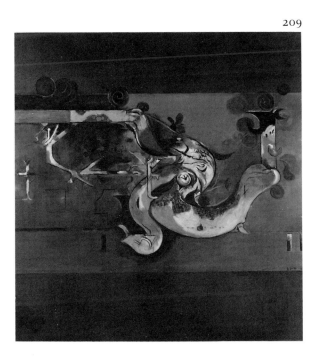

**209 Form over River** 1971–2

> Inscribed 'G.S. 1971–2' b.r. and 'Form over River 1972' on back of canvas
> Oil on canvas, $70\frac{3}{4} \times 68\frac{3}{8}$ (180 × 174)
> First exh: IXe Biennale Internationale de Menton, Palais de l'Europe, Menton, July–September 1972 (works not numbered, repr. in colour in an earlier state)
> Repr: Arcangeli, pl.205 in colour; Sanesi, pl.92 in colour (the colours inaccurate)
> *Tate Gallery*

This painting is one of a number based on a very special tree on the river bank at Picton which has grown into extraordinarily complex twisted and knotted shapes. ('Picton', No.208, was probably inspired by this same tree.)

In a letter to the Tate shortly after the painting's acquisition, Sutherland explained:

*As with all my other 'organic forms' – especially those deriving from the country here, it was the result of a chance encounter. Always one in a thousand such encounters are meaningful to me or productive, but those which are, have in their structure a movement and an equilibrium which straight away finds a response in my own make up. Several studies were made in notebooks in an attempt to crystallise the movement and to shed as many extraneous elements as possible – to give the 'tune' a beginning and an end, and accordingly to change certain elements which were in fact those which detracted from the unit. The colour was used to emphasise the mood of the ambience but only in certain aspects was it the actual colour of the object. You will notice that certain stable elements were used to calm the movement and give it point. Probably five or six watercolours were made in varying sizes apart from the sketch book drawings – all horizontal in shape, before the final painting was done.*

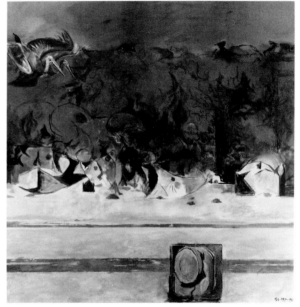

210

### 210 Estuary with Birds 1971–2

Inscribed 'GS. 1971–1972' b.r.
Oil on canvas, $69\frac{1}{2} \times 67\frac{7}{8}$ (176.5 × 172.5)
First exh: *Graham Sutherland*, Marlborough Galerie, Zurich, October–November 1972 (11, repr. in colour)
Lit: *Sutherland in Wales*, p.20, repr. p.22 in colour; Rosalind Thuillier, 'With Graham Sutherland in Pembrokeshire' in *Arts Review*, XXIX, 1977, p.416
Repr: Arcangeli, pl.206 in colour; *Country Life*, CLX, 1976, p.156
*Picton Castle Trust*

A view across the estuary at Sandy Haven, looking east, with a pair of herons coming in to land. The pinkish rock is a typical feature there, while the square form in the foreground was based on a piece of mudstone commonly found along this stretch of shore. The strong winds blowing in from the sea tend to flatten the foliage of the trees, with the strange result that one sometimes sees, as here, a cow grazing in the fields above a wooded embankment actually looking over the tops of the trees.

Though this is one of Sutherland's more complete landscapes in that it takes in a wide span of the scene instead of concentrating on a few details, it is characteristic of many of his late works in being completely frontal, with a compression of the space and an emphasis on lines parallel to the edges of the picture; the straight horizontal lines are contrasted with the rhythmical undulation of the pink rocks. It is also very thinly and fluidly painted, with the paint almost stained into the canvas.

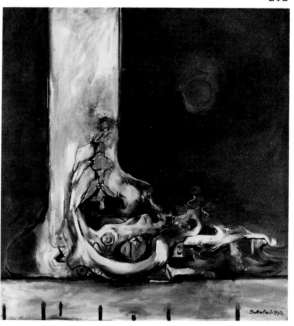

212

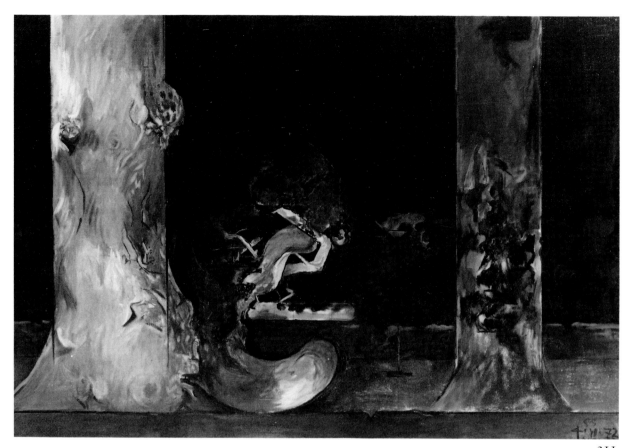

211

**211  Trees with a G-shaped Form I** 1972

Inscribed 'G.S / 4.VII.72 / 6.VII.72' b.r.
Oil on canvas, 46 × 67¾ (117 × 172)
First exh: *Graham Sutherland*, Marlborough
Galerie, Zurich, October–November 1972 (17,
repr. in colour)
Repr: *Art International*, XVII, April 1973, p.42;
Arcangeli, pl.216 in colour; Sanesi, pl.96
*National Museum of Wales, Cardiff*

Based on tree forms beside the private beach at Benton
Castle which also appear in 'Trees on a River Bank'
of 1971 (No.207). They have become much more
formalised and monumental, with an emphasis on
spacious emphatic verticals and horizontals, con-
trasted with bold curving forms. When asked about
this almost classical sense of balance in his late work,
Sutherland explained:

*I have always felt the need for an element of equilibrium.
In my earlier groping way I found this difficult: even
impossible. As I have become older, I have tried to control
the unbalance – to control and place the areas which
were to me the most fascinating – in a more logical way
and to allow the movements of the centres of vitality to
proliferate and repeat themselves as in a fugue, (Johann
Sebastian Bach: the 48 Preludes and Fugues are among
my favourite things), but contained and controlled'*
[Interview with Paul Nicholls published in exh.
catalogue *Graham Sutherland*, Mazart s.a., Bissone,
November–December 1976].

The black sky and rich glowing greens of the veg-
etation give a sense of brooding and silence, with the
forms set against a mysterious inky darkness.

**212  Foot** 1972

Inscribed 'Sutherland. 1972' b.r.
Oil on canvas, 39⅜ × 37⅜ (100 × 95)
First exh: *Graham Sutherland: Opere Recenti*,
Galleria Bergamini, Milan, May–June 1973 (5,
repr. in colour)
Repr: *Epoca*, 3 June 1973, p.86 in colour; *XXe
Siècle*, No.41, December 1973, p.51
*Private collection*

This appears to have been based on the same tree on
Benton Castle beach as Nos.207, 211 and 269. A
photograph of Sutherland drawing this tree is repro-
duced on p.10.

**\*213  Forest with Chains II** 1973

Inscribed 'Sutherland / 1973' b.r.
Oil on canvas, 70⅛ × 67¾ (178 × 172)
First exh: *Graham Sutherland: Opere Recenti*,
Galleria Bergamini, Milan, May–June 1973
(2, repr. in colour)
Repr: *Epoca*, 3 June 1973, p.84 in colour; *XXe
Siècle*, No.41, December 1973, p.48; Sanesi,
pl.105 in colour
*Private collection*

Sutherland described the origins of this theme in a
note which he wrote to accompany a colour repro-
duction of a watercolour version of 1972 in the
Sutherland Gallery at Picton:

*The site is the Private Beach at the foot of Benton Castle.
The beach is thickly fringed with oak trees on a steep
incline from the River Cleddau. It should be remembered*

*that I do not consider myself a landscape or scenic painter. Objects are taken out of their context and often a 'found object' in one place is used in another. But here the chains and the setting were on the same beach – but apart. I was interested in this heap of rusting half disintegrating chains, and the convolutions and varied colours set against the rising oaks. There was total silence. The chains, greatly enlarged, I drew and redrew trying to make the mass at once full of variety, yet compact. I studied the tree first and later seeing the chains decided to combine the two in one work.*

This large oil painting differs from the Picton watercolour chiefly in having not one but two trees, framing the composition symmetrically to left and right, and in including in the background the stone wall and doorway from Monk Haven, some ten miles to the west, which appear in various other pictures of this period, such as 'St Ishmaels' (No.221). The heap of rusting chains, which in reality is only eighteen inches wide, is displayed in one of the showcases in this room, alongside other 'found objects'. Sutherland denied that the chains had any symbolic significance for him.

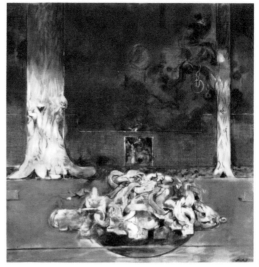

213

**214 Study: Landscape with Roads** 1973

> Inscribed 'G.S 1973' b.r.
> Oil on canvas, $20\frac{7}{8} \times 19\frac{3}{4}$ (53 × 50)
> First exh: *Graham Sutherland: Opere Recenti*, Galleria Bergamini, Milan, May–June 1973 (20, repr.) as 'Study: Landscape with Roads'
> Repr: Sanesi, pl.102 in colour
> *Private collection*

This is one of the few late works not inspired by the small estuaries in the southern part of Pembrokeshire but by the area west of St David's where he had worked extensively in the mid-1930s, and it depicts his favourite motif of the Y-shaped junction of roads near Porthclais. Like several other late works (including No.266 and, to a lesser extent, No.215), it seems to have been developed from the pen and ink drawing 'Valley above Porthclais' of 1935 (No.40), though the space is somewhat flattened and the main lines of the composition have a more geometric character. Here the colours are mainly blazing yellowish and reddish ochres, evocative of warm summer or autumnal sunlight.

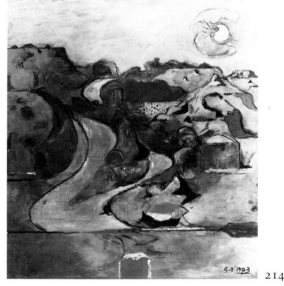

214

**215 Landscape with Mounting Roads** 1973

> Inscribed 'Sutherland 1973' b.r.
> Oil on canvas, $39\frac{3}{8} \times 31\frac{7}{8}$ (100 × 81)
> First exh: *Graham Sutherland: Opere Recenti*, Galleria Bergamini, Milan, May–June 1973 (16, repr. in colour)
> Repr: *XXe Siècle*, No.41, December 1973, p.47
> *Private collection*

This was again based partly on the roads near Porthclais, but combined here with a large rounded form on the left apparently derived from studies of rock formations made elsewhere.

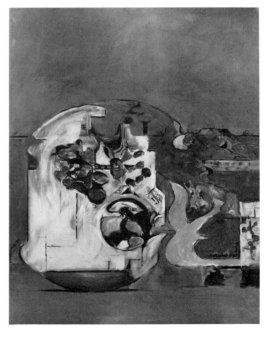

215

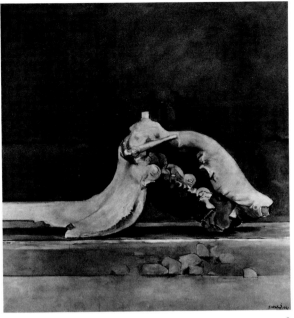

216

### 216 Undulating Form 1973

> Inscribed 'Sutherland. 1973' b.r.
> Oil on canvas, $70\frac{7}{8} \times 67$ (180 × 170)
> First exh: *Graham Sutherland: Opere Recenti*,
> Galleria Bergamini, Milan, May–June 1973
> (3, repr. in colour)
> Repr: Sanesi, pl.103; Arcangeli, pl.220 in
> colour; Hayes, pl.145
> *Private collection*

A grave and monumental composition developed out of a piece of tree form about twenty inches long which is on view in the exhibition, with the other 'found objects'. As regards the colours of these late works, Sutherland told Paul Nicholls:

*If I have felt in recent years in some work that I prefer to work almost monochromatically this is because the particular problem presented demands such treatment. But from time to time in the last few years . . . you will find a large number of works with saturated red or yellow grounds. Some themes seem to demand a heightened chromatic scale – some seem more real, some more solemn without it* [Interview published in exh. catalogue *Graham Sutherland*, Mazart s.a., Bissone, November–December 1976].

### 217 Study of a Rock Formation II 1973

> Inscribed 'G.S. 1973' b.l.
> Oil on canvas, $20\frac{7}{8} \times 19\frac{3}{4}$ (53 × 50)
> First exh: *Graham Sutherland: Opere Recenti*,
> Galleria Bergamini, Milan, May–June 1973
> (23, repr.) as 'Study: Three Rocks II'
> Lit: Rosalind Thuillier, 'With Graham
> Sutherland in Pembrokeshire' in *Arts Review*,
> XXIX, 1977, p.416
> Repr: *Epoca*, 3 June 1973, pp.86–7 in colour
> *Private collection*

A rock form in Sandy Haven. Sutherland described it to Rosalind Thuillier as 'like three discs welded together and supported on a pedestal of rampant oak roots'.

217

### 218 Boulder with Hawthorn Tree 1974

> Inscribed 'G.S. 1974' b.r.
> Oil on canvas, $44\frac{1}{8} \times 66$ (112 × 167.5)
> First exh: *The Sutherland Gift to the Nation*,
> Marlborough Fine Art, London, March–April
> 1979 (works not listed)
> Lit: *Sutherland in Wales*, p.20, repr. p.25 in
> colour; Hayes, p.174 (an almost identical
> version of 1975 repr. pl.155 in colour)
> Repr: *Country Life*, CLX, 1976, p.156; Sanesi,
> pl.107 in colour
> *Picton Castle Trust*

The idea for this picture, which Sutherland described as 'one of my less complicated works', came on seeing a hawthorn tree in full blossom near the farms at Sandy Haven, and the bird is one he actually saw on that occasion. He combined the tree with a rock of which he had made some studies, and introduced the

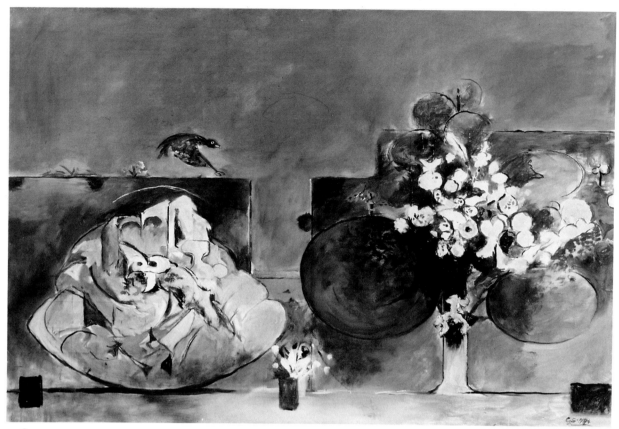

218

wall, with a gap showing a glimpse of the sea, in order to give a sense of three dimensions. The scene is in the spring and the sky is dark with spring rain.

The composition is asymmetrical but very carefully balanced, with contrasts between curves and straight lines, and the forms are built in shallow layers parallel to the picture plane.

*219 Rock Hut 1974

> Inscribed 'Sutherland / 1974' r. towards
> bottom
> Oil on canvas, $68\frac{7}{8} \times 68\frac{7}{8}$ (175 × 175)
> First exh: *Sutherland: Sketchbook*, Galleria
> Bergamini, Milan, October–November 1974
> (11, repr. in colour)
> *Private collection*

219

This composition grew out of a large number of studies of a rock face in red sandstone in Sandy Haven, some in great detail, which Sutherland began to simplify. He said that he did not know at first what kind of picture to make, then remembered the ancient rock huts on St David's Head, some of which had originally been covered with turf roofs, and turned the cliff face into a rock hut. He added the furnace both to emphasise the primitive element and to introduce a correspondence between large and small forms in the same work.

The glowing red and pink forms under a black sky have a monumental spaciousness and solemnity.

**220  Bird over Sand** 1975

> Inscribed 'G.S. / 1947' b.r.
> Oil on canvas, $43\frac{1}{4} \times 39\frac{1}{2}$ (110.5 × 100)
> First exh: *The Sutherland Gift to the Nation*,
> Marlborough Fine Art, London, March–April
> 1979 (works not listed)
> Lit: *Sutherland in Wales*, p.20, repr. p.27 in
> colour
> Repr: *Country Life*, CLX, 1976, p.157; Sanesi,
> pl.113 in colour
> *Picton Castle Trust*

A bird in flight over Sandy Haven, at low tide.

**221  St Ishmaels** 1976

> Inscribed 'G.S. 1976' b.l.
> Oil on canvas, $70\frac{1}{8} \times 68$ (178 × 172.7)
> First exh: *The Sutherland Gift to the Nation*,
> Marlborough Fine Art, London, March–April
> 1979 (works not listed)
> Lit: 'Graham Sutherland – Metamorphosis of
> Objects in a Landscape' in *The Listener*, XCVIII,
> 1977, p.231
> Repr: Sanesi, pl.111 in colour; *Prospettive
> d'Arte*, No.16, March–April 1978, p.6 (the pic-
> ture reproduced in *Sutherland in Wales* is not
> this work, but an earlier version of 1974–5)
> *Picton Castle Trust*

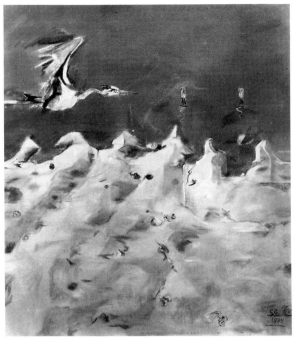

220

Sutherland has given a detailed and exceptionally
complete commentary on this work:

*It is a complicated painting – it certainly was
complicated for me. The basic idea was of an oak-tree
straining away from a bank and overhanging a space. The
rest of the painting is taken from another part altogether.
The whole theme is a sort of interpretation, but in the
centre is a wall which, in fact, in reality, in nature, is far
bigger than that, and it contains a walled forest. It is one
of the most strange things I have ever seen, with many
trees, and the tops of the trees covering, almost as a roof,
the inside of the wall. I have had, of course, to simplify it
because there was too much material. The time of day is
late afternoon on a dull day, with the sun just breaking
through between the interstices of the branches, which
are straining from the ground which is above. . . . It has
got a place-name [as title] because I could not think of
anything else. It is called 'St Ishmaels', which is the tiny
hamlet which has this walled forest in it. But this
particular area was found on Picton beach here, where
the trees are eroded by the tide and the wind . . .'*
[From an interview with Bryan Robertson published
in *The Listener*, loc. cit.].

The picture therefore brings together two motifs
which are actually about twelve miles apart: the
twisted tree at Picton which he had drawn and
painted many times, and the stone wall enclosing a
wood at Monk Haven. The square form on the right
with a horizontal slit in it was derived from a kind of
block house, of which there are a number along the
coast, while the circle was suggested by looking
through a camera viewfinder (though he did not in
fact take any photographs for this work). He said that
the forms at the top were introduced to stabilise the
composition.

221

**222  The Bees** 1976–7

A series of fourteen (or in the case of the
standard edition) twelve aquatints issued in an
edition of 100 copies
Lit: Exh. catalogue *Sutherland: Bees*,
Marlborough Fine Art, London, June–July
1977 (every print repr. in colour)
Each print inscribed 'Sutherland' b.r. and
embossed with a dry stamp with the mark of
the artist and the printer 2RC
*Picton Castle Trust*

I  Metamorphosis: Egg, Larvae, Pupae 1977

Etching and aquatint (yellow, red, violet, green,
brown, black), $22\frac{3}{4} \times 18$ (56.5 × 45.6)
Lit: Tassi No.179, pp.205, 224, repr. p.205 in
colour
Passed for edition 15 April 1977

II  Hatching I 1977

Etching and aquatint (yellow, green, black),
$22\frac{3}{4} \times 18$ (56.5 × 45.6)
Lit: Tassi No.180, pp.205, 223, repr. p.205 in
colour
Passed for edition 14 April 1977

III  Hatching II 1977

Etching and aquatint (yellow, violet, black),
$22\frac{3}{4} \times 18$ (56.5 × 45.6)
Lit: Tassi No.181, pp.206, 223, repr. p.206 in
colour
Passed for edition 2 March 1977

IV  Nuptial Flight. The Dispatch of a Queen by
Post 1977

Etching and aquatint (pink, dark sienna, yellow
ochre, light green, grey, black),
$22\frac{3}{4} \times 18$ (56.5 × 45.6)
Lit: Tassi No.182, pp.206, 224, repr. p.206 in
colour
Passed for edition 14 February 1977

V  The Court 1976

Etching and aquatint (warm yellow, cold
yellow, violet, brown, black),
$22\frac{3}{4} \times 18$ (56.5 × 45.6)
Lit: Tassi No.183, pp.207, 221, repr. p.207 in
colour
Passed for edition 10 December 1976

VI  Figure of Eight Dance: Orientation to Sources of
Nectar and Pollen 1977

Etching and aquatint (yellow, violet, black),
$22\frac{3}{4} \times 18$ (56.5 × 45.6)
Lit: Tassi No.184, pp.207, 221, repr. p.207 in
colour
Passed for edition 15 April 1977

VII  Round Dance: Orientation to Sources of Nectar
and Pollen 1977

Etching and aquatint (yellow, red, orange, light
beige, black), $22\frac{3}{4} \times 18$ (56.5 × 45.6)
Lit: Tassi No.185, pp.208, 226, repr. p.208 in
colour
Passed for edition 15 April 1977

VIII  Bee and Flower 1977

Etching and aquatint (grey, dark orange,
black), $22\frac{3}{4} \times 18$ (56.5 × 45.6)
Lit: Tassi No.186, pp.208, repr. p.208 in colour
Passed for edition 26 February 1977

IX  Wild Nest 1977

Etching and aquatint (light orange, green,
black), $22\frac{3}{4} \times 18$ (56.5 × 45.6)
Lit: Tassi No.187, pp.209, 228, repr. p.209 in
colour
Passed for edition 25 February 1977

X  Primitive Hive I (Skep) 1977

Etching and aquatint (yellow ochre, grey-blue,
black), $22\frac{3}{4} \times 18$ (56.5 × 45.6)
Lit: Tassi No.188, pp.209, 225, repr. p.209 in
colour
Passed for edition 14 February 1977

XI  Primitive Hive II 1977

Etching and aquatint (red, green-brown,
black), $22\frac{3}{4} \times 18$ (56.5 × 45.6)
Lit: Tassi No.189, pp.210, 225, repr. p.210 in
colour
Passed for edition 15 April 1977

XII  Bee Keeper 1977

Etching and aquatint (yellow, black-yellow,
black), $22\frac{3}{4} \times 18$ (56.5 × 45.6)
Lit: Tassi No.190, pp.210, 220, repr. p.210 in
colour
Passed for edition 27 February 1977

XIII  Expulsion and Killing of an Enemy 1976

Etching and aquatint (yellow, black),
$22\frac{3}{4} \times 18$ (56.5 × 45.6)
Lit: Tassi No.191, pp.211, 221, repr. p.211 in
colour
Passed for edition 10 December 1976

XIV  Fight between Workers and Drones 1977

Etching and aquatint (yellow, violet, brown,
black), $22\frac{3}{4} \times 18$ (56.5 × 45.6)
Lit: Tassi No.192, pp.211, 221, repr. p.211 in
colour
Passed for edition 2 March 1977

222 I

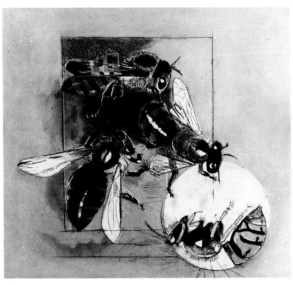

222 XIII

223

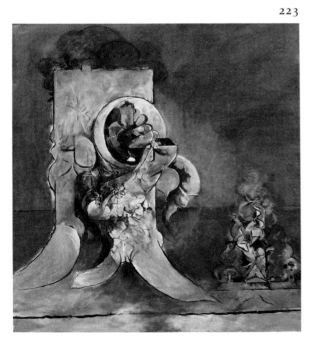

The idea of making a series of prints inspired by the life of bees, including the latest discoveries about their habits, was suggested to Sutherland by Dr and Mrs Bernhard Baer, who also provided him with research material. As Dr Baer points out:

*What urged him to probe the life of the bees in this suite is the existence of a strange hermetic world, perfectly ordered and full of dramatic incidents: mutual help within the hive and fierce tribal exclusivity; the dance of the foraging bees to indicate distance and direction of sources of nectar and pollen; the emergence of the queen who proceeds to kill all rivals in their cells; the mating flight of the queen pursued by drones who die in the act of copulation; the exodus of the swarm to found new colonies.*

The plates were etched in collaboration with Eleonora and Valter Rossi, using advanced aquatint techniques which they had perfected for achieving gradual transitions of tones, and effects of great transparency and luminosity, and were printed under their supervision in the 2RC Studio in Rome; the aquatints were conceived and produced over the period October 1976–May 1977. The edition was published jointly by Marlborough Fine Art Ltd, London, and 2RC Editrice of Rome.

### 223  Oak with Setting Sun  1977

> Inscribed 'Sutherland 1977' t.l.
> Oil on canvas, $55\frac{1}{8} \times 53\frac{1}{8}$ (140 × 135)
> *Private collection*

The setting sun is seen through an aperture in the trunk glistening like a jewel. The tree is conceived as a highly stylised flattened form whose chopped-off limbs gesture like arms, and is contrasted with a small pyramidal bonfire on the right.

### 224  Thicket: with Self-Portrait  1978

> Inscribed 'Sutherland / 1978' b.r.
> Oil on canvas, $39\frac{3}{8} \times 39\frac{3}{8}$ (100 × 100)
> Lit: Hayes, p.179, repr. pl.160 in colour as 'The Thicket'
> *Private collection*

A painting which is to some extent Sutherland's artistic testament. In it he included himself, aged and frail, drawing with an obsessive concentration the tangle of natural forms around him which proliferate and threaten to engulf him; he is of the same stuff and same colours as they are, being himself also a part of nature. It is likewise the artist wrapped in his solitary struggle with his art.

The self-portrait was adapted from a photograph of himself drawing in the open air in Pembrokeshire taken by Gilbert Adams and published in *Arts Review*, XXIX, 1977, p.416, but with slight changes which have the effect of making him look considerably older. The setting, on the other hand, was based on his garden at Menton.

Though it has sometimes been known simply as 'The Thicket', Sutherland inscribed a photograph of it on the back 'Thicket: with Self-Portrait'.

### 225 Path through Wood 1979

Inscribed 'G.S. 1979' b.r.
Oil on canvas, 68 × 68 (173 × 173)
First exh: *Graham Sutherland: Mostra Antologica*,
Galleria Bergamini, Milan, February–March
1981 (70, repr. in colour) as 'Path through
Wood' 1979 (Jardin à la Villa Blanche)
Lit: Hayes, p.182, repr. pl.163
*Private collection*

Finished in April 1979, this was Sutherland's last
major painting. The composition was developed from
'Thicket: with Self-Portrait', but without the figure
and with the forms more clarified and monumental.
The swirling surge of the vegetation is held in check by
a geometrical framework of rectangles and sweeping
arcs – a balance of movement and stasis. Greens
predominate but are offset by silvery greys and
touches of violet.

It was based, like 'Thicket: with Self-Portrait', on
forms in the garden of his house at Menton, the Villa
Blanche.

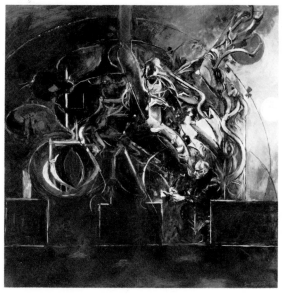

224

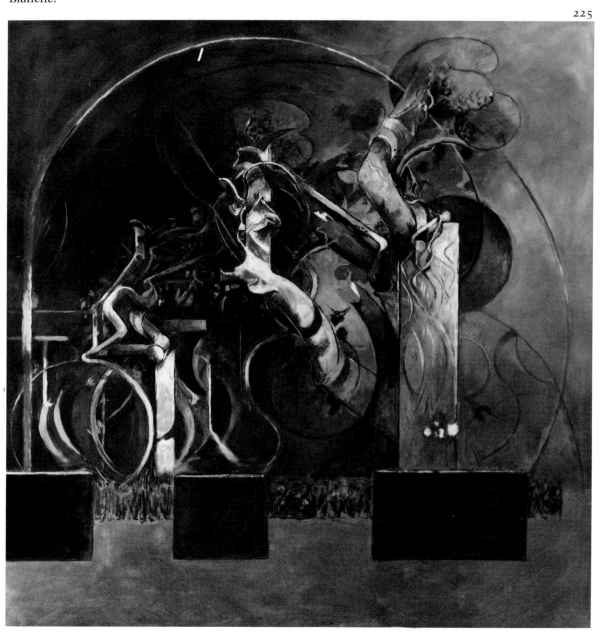

225

## 226 Apollinaire: Le Bestiaire ou Cortège d'Orphée 1978–9

A series of aquatints produced in an edition of 112 copies, the standard edition (such as the one exhibited here) containing fifteen aquatints, and the Edition de Tête and the copies Hors Commerce containing seventeen
Lit: Exh. catalogue *Sutherland: Apollinaire*, Marlborough Fine Art, London, November–December 1979 (every print repr. in colour)
Each print inscribed $\frac{36}{75}$ b.l. and 'Sutherland'. b.r.
*Victoria and Albert Museum Library, London*

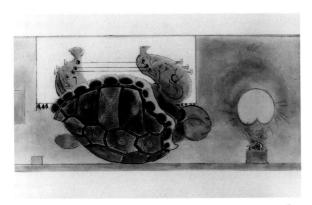

226 II

I   Orpheus 1979

Etching and aquatint (green, black) with dark beige tissue paper collage,
$19\frac{1}{2} \times 15\frac{3}{8}$ (49.5 × 39)
Passed for edition 21 March 1979

II   The Tortoise 1979

Etching and aquatint (yellow, brown, black),
$18\frac{1}{8} \times 29\frac{1}{2}$ (46 × 75)
Passed for edition 2 March 1979

III   The Lion 1979

Etching and aquatint (brown, black),
$7\frac{1}{2} \times 8\frac{1}{2}$ (19 × 21.5)
Passed for edition 21 March 1979

IV   The Snake 1979

Etching and aquatint (yellow, green, red, black), $19\frac{3}{4} \times 14\frac{5}{8}$ (50 × 37)
Passed for edition 20 February 1979

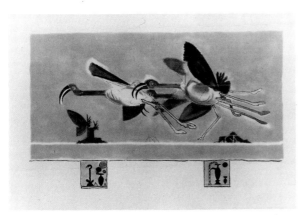

226 XIV

V   The Mouse 1979

Etching and aquatint (yellow, ochre, black),
$19\frac{1}{2} \times 15\frac{3}{8}$ (49.5 × 39)
Passed for edition 27 February 1979

VI   The Elephant 1979

Etching and aquatint (red, ochre, black),
$19\frac{1}{2} \times 15\frac{3}{8}$ (49.5 × 39)
Passed for edition 21 February 1979

VII   Orpheus 1979

Etching and aquatint (green, blue, black),
$5\frac{7}{8} \times 5\frac{7}{8}$ (15 × 15)
Passed for edition 18 February 1979

VIII   The Fly 1978

Etching and aquatint (yellow, green, black),
$19\frac{1}{4} \times 29\frac{1}{2}$ (49 × 75)
Passed for edition 29 October 1978

IX    The Flea 1979

Etching and aquatint (yellow, red, brown, black), $19\frac{1}{4} \times 14\frac{5}{8}$ (49 × 37.2)
Passed for edition 21 February 1979

X    The Grasshopper 1979

Etching and aquatint (yellow, green, black), $9 \times 8\frac{7}{8}$ (23 × 22.5)
Passed for edition 18 February 1979

XI    Orpheus 1979

Etching and aquatint (green, black), $19\frac{1}{4} \times 29\frac{1}{2}$ (49 × 75)
Passed for edition 7 June 1979

XII    The Octopus 1979

Etching and aquatint (beige, violet, black), $19\frac{3}{4} \times 15\frac{3}{4}$ (50 × 40)
Passed for edition 27 February 1979

XIII    The Sirens 1979

Etching and aquatint (ochre, green, black), $19\frac{1}{4} \times 29\frac{1}{2}$ (49 × 75)
Passed for edition 26 February 1979

XIV    Ibis 1979

Etching and aquatint (yellow, green, brown, black), $19\frac{1}{4} \times 29\frac{1}{2}$ (49 × 75)
Passed for edition 2 March 1979

XV    The Ox 1979

Etching and aquatint (yellow, green, black), $19\frac{3}{4} \times 15\frac{3}{8}$ (50 × 39)
Passed for edition 28 February 1979

Sutherland described the genesis of these prints – his last major work – in a note written for the catalogue of their exhibition at Marlborough Fine Art and dated Menton, 14 October 1979:

*When in 1976, I was asked by Professor Maria Luisa Belleli to make drawings for 'Le Bestiaire, ou Cortège d'Orphée' [which she had just translated into Italian and planned to publish in a bilingual edition], I was to some extent dismayed. I don't always feel really at home making illustrations, tending to feel that I am a prisoner of the text. Moreover, I have to admit that at the time I knew very little about Apollinaire, except as an activator during the revolutionary years of literature and painting in Paris. But I read the poems and very especially the notes, and in the summer of 1978 decided to have a try, and produced a few gouaches. Encouraged by Professor Belleli I continued, and the more I thought of the poems, the more I felt that the work might be within my capacity after all – and who in truth, could resist such a line as 'among the heavenly hierarchies . . . we can see beings of unknown shape and surprising beauty'?*

*Roger Little writes of the references to Greek mythology as being 'tied in with a delicious (sometimes malicious) sense of humour, using animals as a vehicle for comment on humans'. I have not attempted to accompany all the poems, some of which, for various reasons, I could make nothing of at all. And, I have added one or two images that have no direct reference to the poems, but which refer, perhaps, to the difficulties of life and living.*

The plates were etched by Sutherland in his studio at Menton with the technical advice of Eleonora and Valter Rossi, and printed at 2RC in Milan under their supervision. The aquatints were created and produced over the period December 1978 to November 1979, and published jointly by Marlborough Fine Art (London) Ltd and 2RC Editrice, Milan.

# Watercolours and Drawings over 60 Years

This selection consists of a number of watercolours and drawings of different periods which could not be fitted into the rooms with the oils for reasons of space or excessive light, and at the same time serves as a recapitulation of Sutherland's development (excluding the war drawings and the portraits). The making of drawings and watercolours, especially gouaches, was of great importance to him during most of his career. Late to develop as an oil painter, he first found his way as a draughtsman and watercolourist, and always handled watercolour and gouache with particular freshness and vitality. Many of his early oil paintings were executed from small studies in gouache carefully enlarged.

---

227

229

**227  Two Men Smoking** 1918

> Inscribed 'G V SUTHERLAND 1918' b.l.
> Watercolour on paper, $6\frac{3}{4} \times 4\frac{11}{16}$ ($17 \times 11.9$)
> First exh: *Graham Sutherland: Mostra Antologica*, Galleria Bergamini, Milan, February–March 1981 (4, repr.)
> Lit: Sackville-West, 1943, pp.5–6
> *Private collection*

Painted in 1918, when Sutherland was fourteen or fifteen; the initials in the signature stand for Graham Vivian. It was done while he was still a pupil at Epsom College, where, according to Edward Sackville-West, he began to draw 'but for himself alone, without tuition or encouragement', because he did not like the scientific bias of the education and was acutely miserable.

The drawing, with two men in period costume outside what appears to be an inn, seems to have been modelled on Victorian or Edwardian book illustrations.

**228  Rhosson** 1934(?)

> Inscribed 'Graham Sutherland.' b.l.
> Ink and watercolour on paper,
> $14 \times 22$ ($35.5 \times 56$)
> First exh: (?) London Group, London, November 1934 (252) as 'Rhosson'
> *The Hon. Alan Clark M.P., Saltwood Castle*

Though dated 1935 when shown in the Sutherland retrospective exhibition at the Institute of Contemporary Arts in 1951, it is probably the watercolour of this title exhibited at the London Group in November 1934, in which case it was done during his first visit to Pembrokeshire. Rhosson is a hamlet due west of St David's, close to the coast.

**229  Rocky Landscape with Gateway** c.1937

> Not inscribed
> Gouache and watercolour on paper,
> $12\frac{7}{8} \times 19\frac{3}{4}$ ($32.7 \times 45.2$)
> First exh: *A Collection of Contemporary English Painting*, Tate Gallery, April–June 1946 (69) as 'Landscape'
> Repr: R.H. Hubbard, *The National Gallery of*

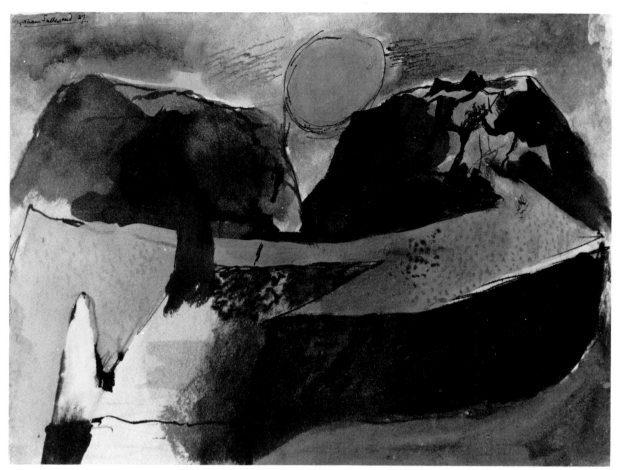

230

Canada Catalogue of Paintings and Sculpture:
*Vol.II. Modern European Schools* (Ottawa 1959),
p.152 (as 'Landscape (I)'); Cooper, pl.8e (as
'Rocky Landscape with Gateway' 1936)
*National Gallery of Canada, Ottawa*

Clearly a Pembrokeshire scene, though the site has
not been identified.

### 230 Sun Setting between Hills 1937

Inscribed 'Graham Sutherland 37' t.l.
Watercolour on paper, $9\frac{7}{8} \times 14$ (25 × 35.5)
First exh: *English Watercolours*, C.E.M.A. touring
exhibition, 1943 (58)
Repr: Sackville-West, 1943, pl.1 in colour;
Cooper, pl.14a; Hayes, pl.22
*Kenneth Clark*

The sun passing behind the rocky crags of Clegyr-
Boia, west of St David's. Everything seems to swing to
the right and the whole scene is flooded with golden
light from the setting sun.

### 231 Welsh Hills 1937

Inscribed 'Sutherland 37.' b.l.
Watercolour and ink on paper,
$11\frac{1}{2} \times 8\frac{1}{2}$ (29.2 × 21.5)
*Private collection*

232

233

234

### 232 Four Studies for Fallen Tree, Purbeck 1937

Inscribed 'Sutherland' and 'Ideas / for picture / 1937' t.r. of upper sheet; 'Sutherland' t.r. of lower sheet
Ink and watercolour on two sheets of paper mounted together on a larger sheet,
$10\frac{1}{2} \times 8\frac{1}{2}$ (26.5 × 21.5)
First exh: *Graham Sutherland*, Akademie der Bildenden Künste, Vienna, December 1953–January 1954 (3)
Repr: Cooper, pl.5f (the upper two drawings only, and dated 'probably 1935–6');
Arcangeli, pl.9
*The Trustees of the British Museum*

Inscribed 'Ideas for picture 1937', and similar but not identical in theme to two works shown in his first one-man exhibition at Rosenberg & Helft: the oil 'Tree Trunk Sprawling' and the large watercolour 'Damp Tree Roots', both of which were painted in 1938.

### 233 Studies of Interlocking Stones 1937/9

Inscribed '1940' on the support r.c.
Ink and watercolour on paper, overall dimensions $7\frac{3}{8} \times 3\frac{7}{8}$ (18.7 × 9.8)
First exh: *Studies by Graham Sutherland*, Roland, Browse and Delbanco, London, October–November 1947 (71)
Repr: *Horizon*, v, 1942, p.229; Cooper, pl.21 as 'Sheet of Three Studies'
*The Roland Collection*

Douglas Cooper reproduced this as 'Sheet of Three Studies', adding: 'Two Studies of interlocking stones in landscape, 1939; landscape study, 1937'. The sheet of paper on which they are mounted is however inscribed 1940, so these dates seem uncertain. The site is a remote area west-southwest of St David's, close to the coast.

### 234 Green Tree Form: Interior of Woods 1939

Inscribed 'G. Sutherland 1939' b.l.
Ink and watercolour on paper,
$27 \times 18\frac{1}{2}$ (68.5 × 47)
First exh: *Recent Paintings by Graham Sutherland*, Leicester Galleries, London, May 1940 (11)
Repr: *Horizon*, v, 1942, p.231; Cooper, pl.22
*Private collection*

A dramatic image of the up-ended roots of a tree in the woods. Sutherland afterwards painted two oils of the same theme, Nos.75 and 78; the latter is clearly adapted from this in composition.

### 235 Precipitous Road to Hills 1940

Inscribed 'Sutherland MCMXXXX' b.l.
Gouache on paper, $18 \times 26\frac{1}{2}$ (45.7 × 67.3)
First exh: *Recent Paintings by Graham Sutherland*, Leicester Galleries, London, May 1940 (6)
Repr: Sackville-West, 1943, pl.12
*Private collection, London*

Painted from a small squared-up drawing inscribed 'Road above Llangattock Dec 26 1939'. Llangattock lies close to Crickhowell in south-central Wales, and there are steep mountainsides nearby, with twisting roads.

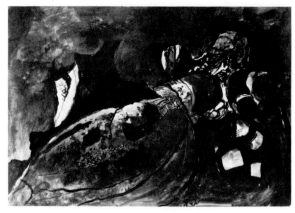

236

### 236 Rocky Landscape with Sullen Sky 1940

Inscribed 'Sutherland 1940' b.l.
Gouache on paper, 19 × 27 (48.2 × 68.5)
First exh: *Recent Paintings by Graham Sutherland*, Leicester Galleries, London, May 1940 (25)
*The Harris Museum and Art Gallery, Preston*

This is probably a view in the same region as No.235.

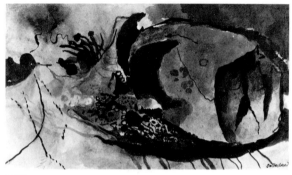

237

### 237 Small Boulder 1940

Inscribed 'Sutherland' b.r.
Watercolour and gouache on paper, $5\frac{1}{4} \times 9\frac{3}{8}$ (13.3 × 23.8)
First exh: *The Private Collector*, Tate Gallery, March–April 1950 (287, repr. in colour)
Repr: Sackville-West, 1943, pl.5 in colour; Robin Ironside, *Painting since 1939* (London 1947), facing p.10 in colour; Arcangeli, pl.25 in colour
*Private collection*

In his letter to Colin Anderson first published in *Horizon* in April 1942, Sutherland described how 'Sometimes, through sheer laziness, I would lie on the warm shore until my eye, becoming riveted to some sea-eroded rocks, would notice that they were precisely reproducing, in miniature, the forms of the inland hills.'

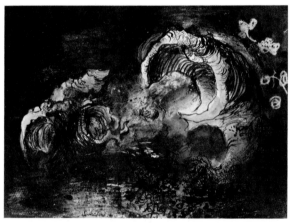

238

### 238 Dwarf Oaks 1941

Inscribed 'Sutherland. 1941' b.c. towards l.
Gouache, watercolour, ink and chalk on paper, 10 × 14 (26 × 36.5)
First exh: *Florida Collects*, John and Mable Ringling Museum of Art, Sarasota, 1976
Repr: *The Listener*, XXVI, 1941, p.657
*Mr and Mrs James Kirkman*

239

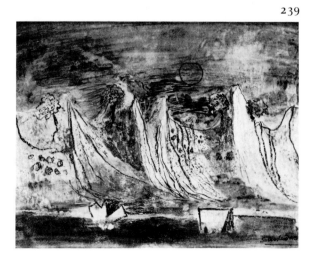

### 239 Pointed Hills 1943

Inscribed 'Sutherland 43' b.r.
Ink, chalks and watercolour on paper, $10\frac{3}{4} \times 14\frac{1}{2}$ (27 × 37)
First exh: *The Modern Movement in British Water-Colour Painting*, Norwich Castle Museum, December 1957–February 1958 (66)
Repr: Sanesi, pl.33
*Private collection*

A strange moon-like landscape of barren mountain peaks, probably suggested by his studies of opencast coal mines made in the latter half of 1943.

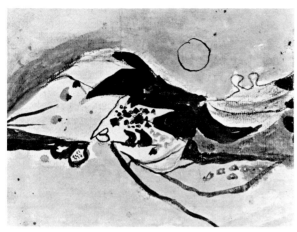

240

## 240 Pembrokeshire Landscape 1944

Not inscribed
Gouache on paper, 9 × 11 (22.9 × 28)
First exh: *Studies by Graham Sutherland*, Roland,
Browse and Delbanco, London,
October–November 1947 (43)
Lit: Melville, n.p., repr. text illustration
4 in colour
Repr: *The Listener*, XXXVIII, 1947, p.906;
Cooper, pl.50a
*The Roland Collection*

Probably a view of Carnllidi. In an undated note of
about 1950 in the Tate Archives, Sutherland made
the following comments about this work:

*This little sketch was made as the culmination of the
previous 8 or 9 years research into the idea of giving
landscape forms a figurative significance. I wanted to give
to landscape forms the independence of movement
hitherto the characteristic only of the figure or the objects
of still life, – to isolate landscape forms and give them the
separate bulk and contour which we associate with the
figure: – and to* stain *them with colours intended to serve
a separating function for the forms in their new nature.*

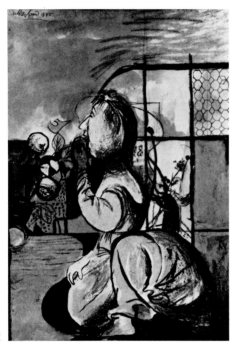

241

## 241 Woman in Garden 1945

Inscribed 'Sutherland 1945' t.l. and 'Top/30
Woman in garden / chalk ink gouache
1945 / Sutherland' on cardboard backing
Gouache, chalk and ink on paper,
20¼ × 14⅜ (51.5 × 36.5)
First exh: *Graham Sutherland*, Buchholz Gallery,
New York, February–March 1946 (30, repr.)
Repr: Cooper, pl.63a
*Private collection*

One of several works made in 1945 inspired by a
neighbour of his in Trottiscliffe, a Mrs Justice, who was
very fond of working in her garden. These included
three oils: one of her standing smiling enigmatically
against a background of plants and hedges ('Smiling
Woman') and two of her picking vegetables.

## 242 Still Life with Apples 1944

Inscribed 'G.S.44' b.r.
Gouache and chalk on paper,
6⅛ × 8 (15.5 × 20.3)
Repr: Cooper, pl.63b
*Private collection*

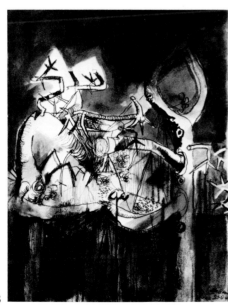

243

## 243 Thorns 1945

Inscribed 'Sutherland / Thorns 29.5.45' b.r.c.
Watercolour, chalk and ink on paper,
16⅛ × 12⅜ (41 × 31.5)
First exh: *Contemporary British Paintings and
Drawings*, British Council tour of South Africa,
1947–8 (115, repr.)
Repr: Cooper, pl.78a
*The British Council*

An early study of a thorn tree dated 29 May 1945, showing a stage just before the idea of the thorn trees had fully taken shape. Sutherland later spoke of the way the thorns automatically seemed to form themselves into definite groupings; all he had to do was to eliminate the inessentials in order to bring out the rhythm, 'almost as if one had taken a pruning knife and cut away things which were not necessary' (*The Listener*, LXVIII, 1962, pp.133–4).

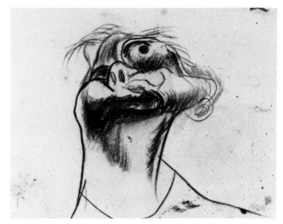

244

### 244 Stone Head 1946

> Not inscribed
> Black chalk on paper, $4\frac{3}{4} \times 6$ ($12 \times 15.2$)
> First exh: *Graham Sutherland 1924–1951: a Retrospective Selection*, Institute of Contemporary Arts, London, April–May 1951 (51)
> Lit: Melville, n.p., repr. pl.18b; Hayes, p.99, repr. pl.63
> Repr: Cooper, pl.74a
> *The Trustees of the British Museum*

This twisted grotesque face came out of the contemplation of a stone.

### 245 Cigale 1947

> Inscribed 'Sutherland 47' b.l.
> Ink, black chalk and watercolour on paper, $8\frac{3}{4} \times 11$ ($22 \times 28$)
> First exh: *Graham Sutherland Paintings*, Hanover Gallery, London, June–July 1948 (watercolour drawings 10)
> Repr: *Harper's Bazaar*, XXXIX, July 1948, p.45 in colour; Melville, pl.35 in colour; Cooper, pl.98e
> *Alistair Horne*

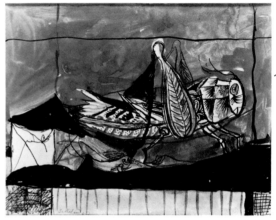

245

A study of a cicada made in the South of France. One of the earliest of Sutherland's studies of animals, possibly the very first of this series which was to last on and off for the next twenty years.

### *246 Articulated Forms 1948

> Inscribed 'Sutherland 1948' b.l.
> Ink, chalk and gouache on paper, $8\frac{3}{4} \times 11$ ($22.5 \times 28$)
> First exh: *Graham Sutherland*, Buchholz Gallery, New York, November–December 1948 (26) as 'Articulate [*sic*] Forms and Hills'
> Repr: Melville, pl.50 in colour (as 'Articulated Form'); Cooper, pl.101c (as 'Articulated Forms')
> *Ivor Braka, London*

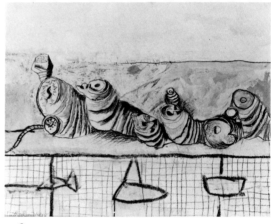

246

247

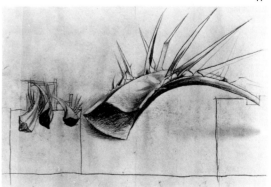

Root forms which take on the character of grubs. The strange colour combination of mauves, reds and greenish yellows matches in its sweetness and sourness the slightly disturbing and malevolent character of the forms.

The 'found objects' on display in this exhibition include the piece of root which appears to have inspired this work.

### 247 Study for Palm and Wall 1948

Inscribed 'Sutherland 1948' b.r. and 'Study for Palm over Wall / Sutherland' on the backboard
Black chalk on paper, $14 \times 21\frac{3}{4}$ ($35.5 \times 55.2$)
First exh: *Graham Sutherland 1924–1951: a Retrospective Selection*, Institute of Contemporary Arts, London, April–May 1951 (56)
Repr: Melville, pl. 30; Cooper, pl.94a
*Mrs Graham Sutherland*

The large palm leaf and the wall, but not the rest, appear in two oil paintings of 1948 called 'Palm and Wall' as part of more complex compositions, including other objects.

248

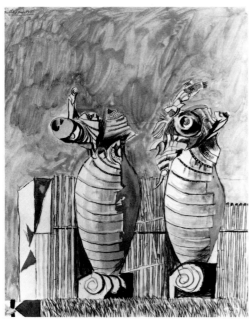

### 248 Study of a Palm Tree 1948

Not inscribed
Black crayon on tinted paper, touched with white, $10 \times 12\frac{1}{2}$ ($25.4 \times 31.8$)
First exh: *Graham Sutherland 1924–1951: a Retrospective Selection*, Institute of Contemporary Arts, London, April–May 1951 (55)
Repr: Melville, pl.60 in colour; Cooper, pl.100b
*Graphische Sammlung Albertina, Vienna*

### 249 Two Standing Forms against a Palisade II 1950

Inscribed 'Graham Sutherland 1950' t.l.
Gouache on paper, $26 \times 22\frac{1}{8}$ ($66 \times 56.2$)
First exh: xxvi Venice Biennale, June–October 1952 (British Pavilion 50)
*Bassetlaw District Council*

A variant in gouache of a slightly larger oil painting of 1949 which now belongs to the Art Gallery of Toronto and which was possibly the first of the 'standing form' pictures. Sutherland reused the form on the right in the lower part of 'The Origins of the Land' of 1951.

249

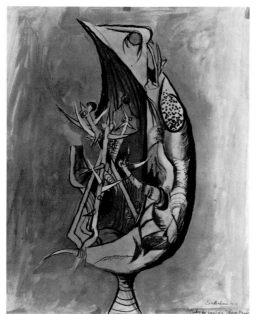

### 250 Thorn Head 1950

Inscribed 'Sutherland.1950 / Study for painting. Thorn Head' b.r.
Ink, crayon, watercolour and gouache on paper, $22\frac{1}{8} \times 18\frac{7}{8}$ ($56.1 \times 47.8$)
First exh: xxvi Venice Biennale, June–October 1952 (British Pavilion 49)
Repr: Cooper, pl.111d
*City of Salford Art Gallery*

A study for an oil painting of more or less the same size which is dated 1950–1. The oil is more simplified and different in colour, with silvery grey forms against a bright blue background.

250

**251  Mantis** 1953

Inscribed 'Graham Sutherland 53' b.r.
Charcoal on paper, $37\frac{3}{4} \times 24$ (96 × 61)
*Private collection*

This drawing probably served as a study for a very
colourful painting of a praying mantis made the same
year (Cooper, pl.98c), which is roughly the same size.
Sutherland also adapted it as a design for a piece of
Steuben glass, a vase on which the figure of the mantis
was engraved by a copper wheel. The Steuben Glass
Company of New York commissioned designs at this
time from seventeen British artists, also including
John Nash, Lawrence Whistler, John Piper and Lucian
Freud. (See *Art News*, May 1954, p.40ff. and *Studio*,
CXLIX, 1955, pp.148–51.)

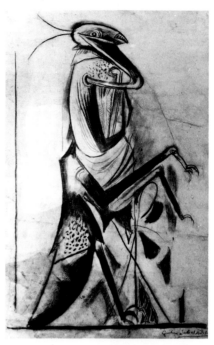

251

**252  Study** 1953

Inscribed '23.6.53' t.r.
Chalk and ink on paper,
$11\frac{3}{4} \times 8\frac{5}{8}$ (29.9 × 21.8)
First exh: *Graham Sutherland*, Akademie der
Bildenden Künste, Vienna, December
1953–January 1954 (53)
Repr: Cooper, pl.135
*Kunsthalle, Hamburg*

The large form is a sort of hybrid machine-animal.

**253  Study for 'Hanging Form over Water'** 1955

Inscribed 'Sutherland. 1955' b.r.
Gouache on paper, $11\frac{3}{4} \times 9\frac{3}{4}$ (30 × 25)
First exh: *Watercolours and Drawings by Oskar
Kokoschka, Henry Moore, Graham Sutherland*,
Marlborough Fine Art, London,
September–October 1962 (103, repr.)
Repr: Giorgio Soavi, *Protagonisti: Giacometti,
Sutherland, de Chirico* (Milan 1969), p.117 in
colour
*Giorgio Soavi, Milan*

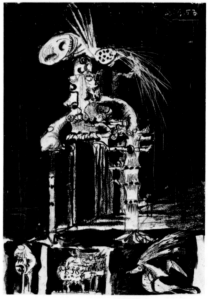

252

**254  Fauve** 1958

Inscribed 'Graham Sutherland / 1958 / To
Martyn Coleman, 27.6.58.' b.r.
Gouache on paper, slightly irregular,
$11\frac{5}{8} \times 8\frac{5}{8}$ (29.5 × 22)
*Private collection*

**255  Organic Form** 1962

Inscribed 'G.S. 1962' b.r.
Gouache, ink and crayon on paper,
$9\frac{7}{8} \times 13\frac{1}{4}$ (25 × 34)
First exh: *Watercolours and Drawings by Oskar
Kokoschka, Henry Moore, Graham Sutherland*,
Marlborough Fine Art, London,
January–February 1964 (79, repr.)
Repr: Arcangeli, pl.129
*Private collection*

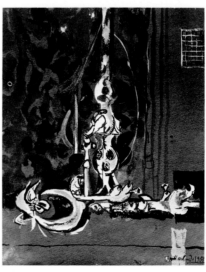

253

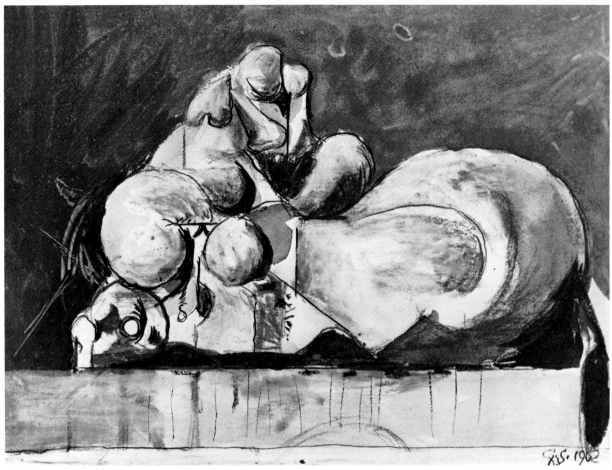

255

254

### 256 Study of Leaves 1965

Inscribed 'Pour Giorgio, my great affection /
Graham. 25.IV.68' b.r.
Gouache on paper, $13\frac{3}{8} \times 9\frac{1}{2}$ (34 × 24)
Repr: Giorgio Soavi, *Protagonisti: Giacometti,
Sutherland, de Chirico* (Milan 1969), p.116 in
colour (dated 1965); Sanesi, pl.74 in colour
*Giorgio Soavi, Milan*

This appears to be a study for the portrait of Dr Konrad
Adenauer seated three-quarter length against a pat-
terned background of leaves, a picture which was
begun in May 1964 and finished in February 1965.
(The oil sketch for this portrait is No.187). Photo-
graphs of the portrait in an unfinished state show that
this leafy background was added at a very late stage.

### 257 Three Studies for 'A Bestiary' c. 1965−7

The bottom left study (of the bat) is inscribed
'Etude Musée Histoire / Naturel Nice' b.r.
Pencil on paper, top study $9\frac{1}{2} \times 12\frac{3}{4}$
(24 × 32.5); bottom left $9\frac{1}{2} \times 6\frac{3}{4}$ (24 × 17);
bottom right $9\frac{1}{2} \times 6\frac{1}{2}$ (24 × 16)
Repr: Arcangeli, pl.141
*Private collection*

Studies for colour lithographs in the suite 'A Bestiary
and Some Correspondences' (No.204). The drawings

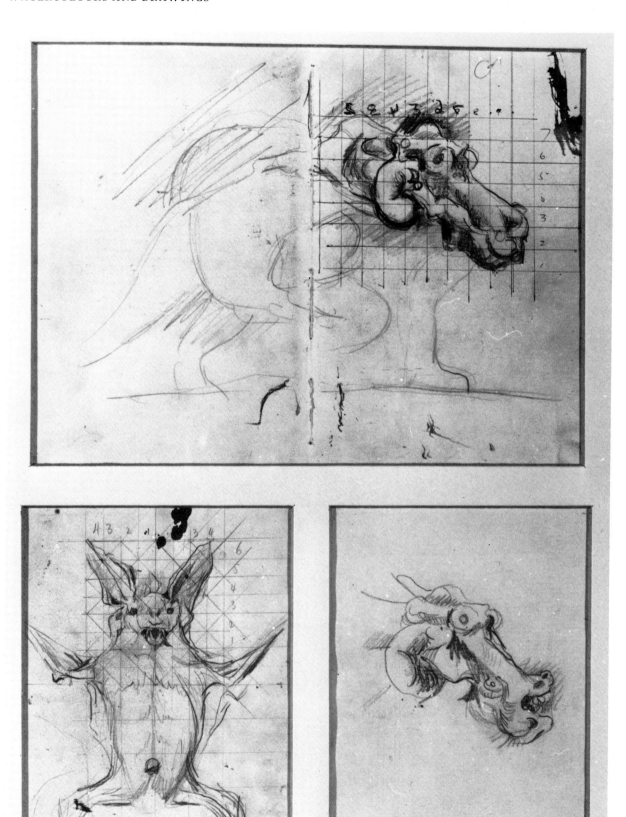

257

[178]

258

259

260

at the top and bottom right are both studies for 'Chained Beast' (adapted from the oil painting 'The Captive' of 1963–4, No.198 but printed the other way round). The one at the bottom left, apparently drawn from a specimen in the natural history museum at Nice, is an early study for 'Chauve-Souris (in a looking-glass against a window)', though in this the wings are folded against the sides and there are various other differences.

### 258  Sheet of Studies (Heads)  1968

Inscribed 'Sutherland. / 21.1.68' b.r.
Crayon, chalk and wash,
$26 \times 19\frac{7}{8}$ (66.2 × 50.5)
First exh: *Graham Sutherland: A Bestiary*,
Marlborough Fine Art, London, May–June
1968 (33)
Repr: Arcangeli, pl.182; Sanesi, pl.81
*Private collection*

Like 'Stone Head' of 1946, these studies were based on stones which suggested caricature-like human heads. Some of these stones, if not all, were ones which he picked up in a dry river-bed at Tourrette-sur-Loup. In fact a very similar drawing of the form at the top left (Sanesi, pl.79), also made in 1968, is inscribed 'souvenir de Tourettes' (*sic*).

The sheet was probably drawn as a study for a rather similar lithograph in the 'Bestiary' suite dated 10 April 1968, which is known by the same title.

### 259  Two Bats  1968

Inscribed 'Sutherland 1968' t.l.
Watercolour and pastel on paper,
$25\frac{7}{8} \times 19\frac{3}{4}$ (65.5 × 50)
*Private collection*

A study probably made during the last stages of his work on 'A Bestiary', though not directly connected with any of the lithographs in the series. The bat at the top is seen flying past the moon.

### 260  U-shaped Form  1969

Inscribed 'G.S. 1969' b.l.
Gouache on paper, $20\frac{1}{8} \times 26\frac{3}{4}$ (51 × 68)
Repr: Giorgio Soavi, *Tenero è il Mostro* (Milan 1977), p.115
*Giorgio Soavi, Milan*

The oil painting No.205 is an earlier version of the same theme.

### 261 Forest and Chains 1972

Inscribed 'Sutherland 1972' b.r.
Watercolour and gouache on paper,
$17\frac{3}{4} \times 25\frac{3}{4}$ (45 × 65.5)
First exh: *Sutherland: Sketchbook*, Galleria
Bergamini, Milan, October–November 1974
(12, repr. in colour)
*Private collection*

The oil painting No.213 of 1973 is a later development of this theme.

261

### 262 Thorn Tree 1973

Inscribed 'Sutherland 1973' t.l.
Gouache on paper, $23\frac{3}{4} \times 16\frac{3}{8}$ (60.2 × 41.5)
*Private collection*

One of the late variants on the thorn tree theme, based on thorn bushes found on a mountain track in France.

### 263 Landscape with Fields I 1974

Inscribed 'G.S. 1974' b.r.
Watercolour and gouache on paper,
$15\frac{3}{4} \times 28\frac{3}{4}$ (40 × 72)
First exh: *Sutherland: Sketchbook*, Galleria
Bergamini, Milan, October–November 1974
(17, repr.)
Repr: Sanesi, pl.108; Hayes, pl.143
*Private collection*

A study of outcrop rocks and fields near St David's, with the hedgerows forming sweeping rhythmical patterns. The movement is contained within two horizontals.

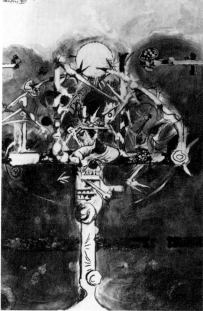

262

### 264 Form in a Desert with Fractured Stone 1974

Inscribed 'G.S 1974' b.r.
Watercolour, ink and pencil on paper,
$27\frac{1}{8} \times 26$ (69 × 66)
First exh: *Sutherland: Sketchbook*, Galleria
Bergamini, Milan, October–November 1974
(16, repr.)
*Private collection*

This watercolour seems to have been done as a study for the etching and aquatint 'Form in a Desert I' made in 1974. The upper form was based on a piece of bone, presented here in such a way that it appears to be enormous and set in a vast landscape, while the lower form was derived from the mudstones found at Picton Ferry and elsewhere, which split into curious shapes.

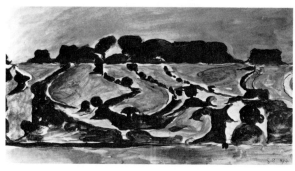

263

### 265 Rock Form II 1974

Inscribed 'G.S. 74' t.r.
Watercolour and gouache on paper,
$22\frac{1}{4} \times 30\frac{1}{8}$ (56.5 × 76.5)
First exh: *Graham Sutherland: Olii-Guazzi-Lito*,
Galleria Pananti, Florence, November–
December 1975 (works not numbered, repr.)
*Private collection*

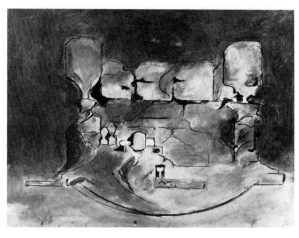

265

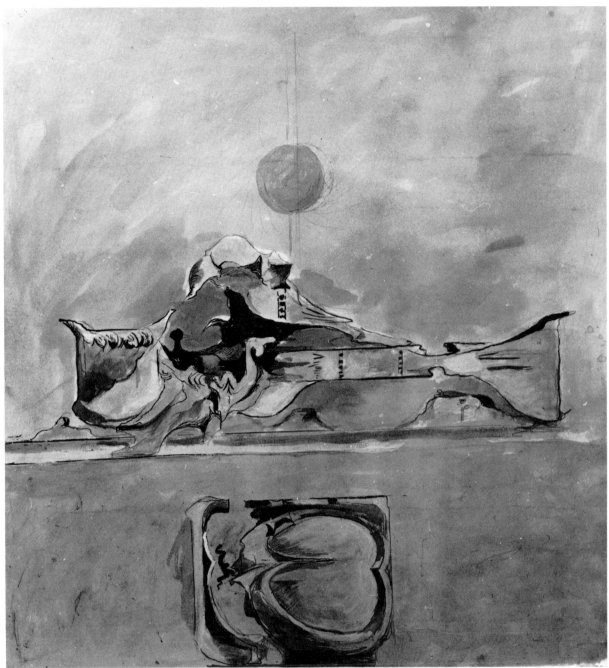

264

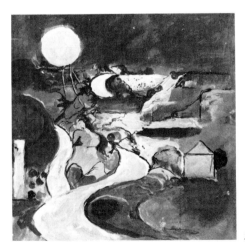

266

**\*266  Road at Porthclais with Setting Sun**  *c.*1975

Not inscribed
Gouache on paper, 14 × 14 (35.5 × 35.5)
*Private collection*

One of the works made at the end of Sutherland's life in
which he returned to the theme of the roads near
Porthclais which had first interested him forty years
before. As in a similar small oil of 1975 at Picton, the
golden disc of the sun is blazing in a black sky; the sky
and the landscape are treated almost like a photo-
graphic negative, 'dark with excess of light'.

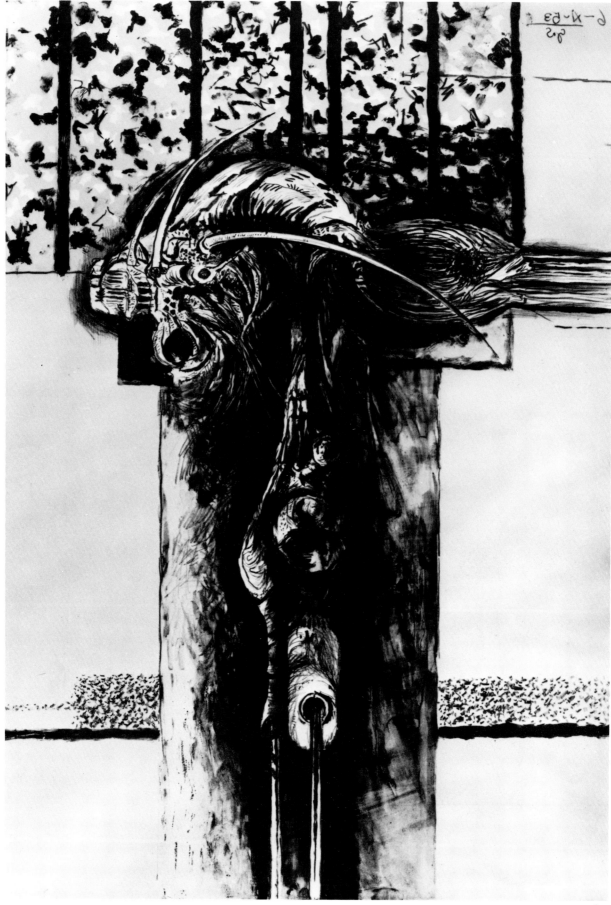

### 267 Predatory Form 1953

Inscribed 'Graham Sutherland. / epreuve
d'artiste.' b.r. and '6-XI-53 / G.S' in the print t.r.
(in reverse)
Lithograph (black, light Naples yellow),
$29\frac{3}{4} \times 21\frac{1}{4}$ (75.5 × 54)
Lit: Man No.53, n.p. and repr.; Tassi No.57,
pp.27, 83, 225, repr. p.83 in colour
*The Trustees of the British Museum*

A colour lithograph printed by Fernand Mourlot in
Paris and published by the Redfern Gallery, London, in
an edition of seventy-five.

268

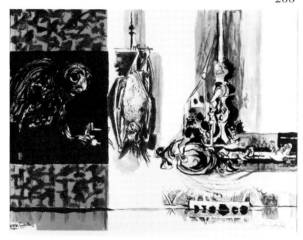

269

### 268 Hanging Form, Owl and Bat 1955

Inscribed 'Graham Sutherland $\frac{24}{25}$' b.r. and
'Sutherland. NOV 10 / 1955' in the print b.l. (in
reverse)
Lithograph (dark green, light green, violet,
black), 20 × $26\frac{3}{8}$ (51 × 67)
Lit: Man No.58, n.p. and repr.; Tassi No.63,
pp.29–30, 88 and 223, repr. p.88
*Victoria and Albert Museum, London*

A print which, as the title implies, combines the three
themes of an owl, a bat and a hanging form over
water. As the bat is hanging upside-down, it acts as a
linking image between the owl on the left and the
hanging form on the right. Sutherland also made two
further colour lithographs at the same time which are
variants of this theme, one, 'Hanging Form and Owl',
without the bat, and the other 'Hanging Form, Owl
and Bats', with two bats. All three were printed by
Fernand Mourlot in Paris and published by Berggruen
et Cie, Paris, this one in an edition of twenty-five plus
five artist's proofs.

### 269 La Foresta, il Fiume, la Roccia: La Foresta I
### (The Forest, the River, the Rock: The Forest
### I) 1972

Inscribed 'Sutherland.' b.l. and $\frac{55}{75}$ b.r.
Lithograph (black, stone grey, buff, emerald
green, pale yellow, pale bluish green),
$24\frac{3}{4} \times 18\frac{1}{2}$ (63 × 47)
Lit: Tassi No.121, pp.38, 146, 222, repr. p.146
in colour
*Tate Gallery*

This comes from a suite of six colour lithographs and a
frontispiece published by Siro Teodorani of Milan in
1972 in a portfolio entitled 'La Foresta, il Fiume, la
Roccia'. The images are all Pembrokeshire themes.
The lithographs were drawn on zinc by Sutherland at
Menton, and proofed and printed in the Teodorani
workshop in Milan.

This impression is from the standard edition of
seventy-five.

# List of Lenders

The Earl of Airlie 193
Ronald Alley 87
Arts Council of Great Britain 142

Bassetlaw District Council 249
Bedford, Cecil Higgins Art Gallery 68
Belfast, Ulster Museum 65
Bergamini, Galleria 156
Birmingham Museums and Art Gallery 76, 100
Bloomfield, Mr and Mrs I. 154
Dr and Mrs L. Bohm 118
BP International Ltd 53
Ivor Braka 246
British Council 78, 125, 136, 166, 243
British Museum 1, 7, 9, 11, 14, 15, 21, 84, 232, 244
Brussels, Musées Royaux des Beaux-Arts de Belgique 135
Mrs Neville Burston 86

Cambridge University Library 42, 51
Cardiff, National Museum of Wales 37, 211
Comtesse Alexandre de Castéja 186
Cheltenham Art Gallery and Museum Service 88, 92
The Hon. Alan Clark 124, 228
The Hon. Colette Clark 79, 80
Kenneth Clark 34, 128, 230
Cambridge, Fitzwilliam Museum 130, 179
Coalport 27
Coventry Cathedral 175
Coventry, Herbert Art Gallery 170, 171, 173, 174
Crane Kalman Gallery 155
Curwen Press 46

Darlington Art Gallery 73

H.R.H. The Prince Philip, Duke of Edinburgh 172
Edinburgh, Scottish National Gallery of Modern Art 63, 70, 141

Joachim Fürst zu Fürstenberg 185

Glasgow Art Gallery and Museum 123

Hamburg, Kunsthalle 252
Alistair Horne 245

Kingston-upon-Hull, Ferens Art Gallery 90

Imperial War Museum 98, 99, 116

Mr and Mrs James Kirkman 69, 238

Leeds City Art Galleries 81, 102, 103, 111, 114, 115
London Transport Executive 43, 44, 58

MacMillan and Perrin Gallery 18
City of Manchester Art Galleries 89, 91, 107, 110, 112
Marlborough Fine Art (London) Ltd 26, 159, 165

St Matthew's, Northampton 129
Peter Meyer 144
Munich, Gesellschaft der Freunde der Ausstellungsleitung Haus der Kunst 198

National Portrait Gallery 188, 191
National Postal Museum 41
Newcastle-upon-Tyne, Laing Art Gallery 62, 104, 108, 119

Mr and Mrs Denis O'Brien 121
Ottawa, National Gallery of Canada 229

Picton Castle Trust 35, 36, 38, 39, 40, 47, 48, 49, 57, 210, 218, 220, 221, 222
Otto Preminger 195
Preston, Harris Museum and Art Gallery 236
Private Collection 8, 12, 16, 45, 52, 56, 64, 66, 71, 74, 77, 83, 85, 95, 101, 106, 120, 126, 127, 131, 132, 134, 139, 140, 143, 145, 146, 148, 151, 152, 157, 158, 163, 164, 167, 177, 181, 182, 194, 196, 197, 199, 200, 201, 202, 205, 206, 208, 212, 213, 214, 215, 216, 217, 219, 223, 224, 225, 227, 231, 234, 235, 237, 239, 241, 242, 251, 254, 255, 257, 258, 259, 261, 262, 263

Redfern Gallery and James Kirkman Ltd 137
Mrs Emery Reves 189, 192
Roland Collection 133, 233, 240
Helena Rubinstein Foundation 184

Salford Art Gallery 250
Bartolomé March Servera 203
Sheffield City Art Galleries 109
Shell-Mex B.P. 22, 23, 24, 33, 54, 55
Giorgio Soavi 207, 253, 256, 260
Southampton Art Gallery 82, 161, 183
Lady Spence 176
Stuart Crystal 31
Staatsgalerie Stuttgart 187
Mrs Graham Sutherland 247
Sydney, Art Gallery of New South Wales 59

Tate Gallery 5, 6, 19, 50, 60, 67, 72, 75, 93, 94, 96, 97, 105, 113, 117, 149, 150, 153, 168, 169, 178, 190, 209

Vancouver Art Gallery 162
Victoria & Albert Museum 2, 3, 4, 10, 13, 17, 20, 25, 28, 29, 30, 32, 180, 204, 226
Vienna, Graphische Sammlung Albertina 248

Washington, Hirshhorn Museum and Sculpture Garden, Smithsonian Institution 61, 147
Washington, The Phillips Collection 160
Whitworth Art Gallery, University of Manchester 122

Richard S. Zeisler 138